W9-BRW-027

Praise for *The Last of His Kind*

"Nobody alive writes better about mountaineering." —Jon Krakauer

"Mr. Roberts takes us from one adventure to another, beginning in 1937 with twenty-seven-year-old Brad Washburn and a fellow mountaineer marooned in the subarctic Saint Elias Range in Canada's Yukon Territory facing a near-death experience fording the Donjek River." —*Washington Times*

"A worthy addition to the history of early mountaineering in America."
 —*Florida Times-Union*

"A breezy, readable volume that is one part adventure story and one part biography, which is as good a way as any to describe Washburn's life. . . . Tales, stunning and stirring, of mountaineering in the high peaks of Alaska, the Yukon, Europe, even lowly New England. . . . The stories of these as-cents are breathtaking, but they are as much a story of steely intelligence as they are of stubborn will." —*Boston Globe*

"A well-crafted biography of 'the greatest mountaineer in Alaskan history.' Because the author knows the world of climbing so well, as both practitioner and chronicler, he brings an insider's perspective to this life of mountaineer and photographer Bradford Washburn (1910–2007). As a longtime friend of his subject, Roberts writes with measured authority about Washburn. . . . Roberts's style effectively captures the suspense and danger of Washburn's adventures. A thorough and admiring portrait." —*Kirkus Reviews*

"Reading this excellent biography, you'll wonder why you have never heard of Bradford Washburn before this moment. . . . Washburn, who died in 2007, is one of those people who are legends in their own fields but little known outside them. This book could change that, for anyone with even the slight-est interest in mountain climbing." —*Booklist*

THE LAST OF HIS KIND

Also by David Roberts

The Mountain of My Fear (1968)

Deborah: A Wilderness Narrative (1970)

Great Exploration Hoaxes (1982)

Moments of Doubt (1986)

Jean Stafford: A Biography (1988)

Iceland: Land of the Sagas (with Jon Krakauer) (1990)

Mount McKinley: The Conquest of Denali
(with Bradford Washburn) (1991)

*Once They Moved Like the Wind: Cochise,
Geronimo, and the Apache Wars* (1994)

*In Search of the Old Ones: Exploring the Anasazi
World of the Southwest* (1996)

Escape Routes (1997)

*The Lost Explorer: Finding Mallory on Mount
Everest* (with Conrad Anker) (1999)

*A Newer World: Kit Carson, John C. Frémont, and
the Claiming of the American West* (2000)

THE LAST OF HIS KIND

The Life and Adventures of
BRADFORD WASHBURN,
America's Boldest Mountaineer

David Roberts

HARPER

NEW YORK • LONDON • TORONTO • SYDNEY

HARPER

Photographs on pages 1–15 of the insert copyright
by Bradford Washburn/courtesy of Panopticon Gallery. Photograph
on page 16 of the insert copyright by Kurt Markus.

The excerpt from *Among the Alps with Bradford* was originally
published by G. P. Putnam's Sons, the Knickerbocker Press, 1927.
Reprinted with permission of Applachian Mountain Club Books.

A hardcover edition of this book was published in 2009 by William
Morrow, an imprint of HarperCollins Publishers.

THE LAST OF HIS KIND. Copyright © 2009 by David Roberts. All rights
reserved. Printed in the United States of America. No part of this
book may be used or reproduced in any manner whatsoever without
written permission except in the case of brief quotations embodied in
critical articles and reviews. For information address HarperCollins
Publishers, 10 East 53rd Street, New York, NY 10022.

HarperCollins books may be purchased for educational, business, or
sales promotional use. For information please write: Special Markets
Department, HarperCollins Publishers, 10 East 53rd Street, New
York, NY 10022.

FIRST HARPER PAPERBACK PUBLISHED 2010.

Designed by Sunil Manchikanti

Library of Congress Cataloging-in-Publication Data has been
applied for.

ISBN 978-0-06-156095-8

10 11 12 13 14 OV/RRD 10 9 8 7 6 5 4 3 2 1

To Barbara Washburn—
the woman behind the great man,
first-class mountaineer in her own right,
and my cherished friend for more than four decades

Contents

THE LAST OF HIS KIND

Prologue

Donjek

The date was July 13, 1937. Brad Washburn and Bob Bates knew they would have to cross the Donjek River—not only to reach the nearest outpost of civilization, but simply to survive the most desperate adventure of their young lives. But on the map they carried, the vast lowland tundra through which the Donjek flowed north toward its eventual junction with the Yukon was a blank.

For the past twenty-two days, Washburn and Bates had been marooned in the heart of the subarctic Saint Elias Range, a few miles east of the Alaska border in Canada's Yukon Territory. Twenty-seven and twenty-six years old, respectively, Brad and Bob had already shared two mountaineering expeditions to the great ranges of the Far North. In addition, Brad had led three other ventures among the unclimbed peaks of Alaska and the Yukon. Despite their youth, the two best friends had already become masters of a discipline practiced at the time by relatively few men (and by a tiny handful of women) in the world.

Now, as they trudged eastward, they heard the deep roar of the river before they were close enough to see it. It was not until dusky midnight that the men reached its banks. "The Donjek is a terror," Brad wrote in his diary the next morning, "rushing like fury." Brad and Bob knew that the Donjek was a major river. What they had not fully reckoned was how the past three weeks' summer warmth had melted its glacial sources, causing the current to surge into pell-mell flood.

The only other thing the men knew about the river was that an old horsepackers' trail had worked out a difficult but manageable ford across it. The crossing, Brad and Bob had been told, attacked the Donjek on a flat gravel plain where the current "braided," separating into many smaller channels divided by sandbars. (Each of those channels ought to be far easier to wade than the river where it was united in a single course.) The raging torrent that the men now stared at, mesmerized and perplexed, was clearly impossible to ford.

The next day, Brad and Bob hiked along the shore until they came to what they guessed was the braided stretch the horsepackers had solved. But now it became obvious that the ford could be attempted only in low water—not in the height of midsummer flood. Knowing they had no hope of wading even the smaller channels, Brad and Bob decided to try to build a raft. They had only begun scrounging driftwood when the impossibility of such a project struck them. They had no axe, hardly any cordage to lash the logs together, and—most tellingly, as Brad wrote in his diary—"The river [is] so huge and divided into so many channels that a raft would have to be taken apart and rebuilt a thousand times to get across." (A driftwood raft would be too heavy to drag across the sandbars between channels.)

There was, however, a last resort. Twelve miles upriver to the south, the sprawling Donjek Glacier spilled out of the Saint Elias Range. From their gravel bar, Brad and Bob could just discern its snout in the distance. They were convinced that glacier was the source of the mighty

river. If they could climb across the snout, they could ford the river, as it were, on stable ice. To get there would require a jaunt of twenty-four miles up and back, as Brad noted with disgust in his diary, just to get to the Donjek's far bank a mere 300 yards away. In their played-out state, that detour would require an extreme effort. But the traverse of the glacial snout promised a ticket to Burwash Landing.

So, on July 14, Brad and Bob shouldered their packs once more and started trudging south. It was 9:00 P.M. before the men reached the near edge of the glacier's snout. Just as their hopes began to surge, Bob and Brad absorbed, in a stunned glance, the cruelest shock of the whole expedition.

The blank on the map had worked its treachery. As the men saw in that instant, the Donjek Glacier was not the true source of the river. It contributed only a minor tributary flow—for now Bob and Brad beheld a cataract full of seething rapids separating the snout from the east bank. The true source of the river must be some other glacier, farther south. As the men would discover the next day, that source was in fact the Kluane Glacier. And it lay fully twenty-two miles away from the snout of the Donjek.

A further detour of forty-four miles, up to the Kluane, across its snout, and back north, would be far too much for the emaciated, famished climbers to accomplish. With a fatalism born of despair, the men climbed up onto the stagnant ice to look for a campsite. A week before, they had chucked out their crampons—metal spikes strapped to the bottoms of one's feet, essential for traversing glaciers. The crampons would have served them well now, as they slipped and stumbled on the gritty ice.

Near midnight, they leveled out a morainal platform, crawled inside the tent—whose roof they vainly tried to prop up with an ice axe and a packboard—and lay sleepless, head to toe in their single sleeping bag. The men's mood, Brad recorded, was "utter dismay." Decades later

he would say, "That was the most miserable and frustrating night I've ever spent in the mountains."

The next day, July 15, Brad and Bob had a rough time just getting *off* the snout of the Donjek Glacier, at one point having to improvise a delicate rappel with their inadequate rope, their sole anchor a bollard—a prong of ice carved by Brad with his axe. Yet just as they stepped off the glacier, they spotted a possible deliverance from their predicament.

Immediately to the south, the Donjek braided once again across a gravel bar more than a mile wide. Bob and Brad counted the channels and realized there were some fifty of them. It was possible that the generous flatness of the terrain had here divided and conquered the mighty river sufficiently for the men to wade it.

Their only choice was to try. Even with their boots and trousers on, the pounding glacial water numbed the men's legs immediately and sent a kind of thermal shock wave through their bodies, culminating in intense headaches. Yet channel after channel succumbed, most of them rising no higher than knee-deep. It took the two men thirty-five minutes to reach the last two of the fifty-odd channels. Those last two channels were by far the deepest. By now, Bob and Brad were beginning to shiver with hypothermia.

They had manufactured a flimsy seventy-five-foot line by supplementing what was left of their climbing rope with cordage salvaged from their packboards. Now they tied either end of their "rope" around their waists. Bob was about five pounds heavier (and thus stabler) than Brad, so he inched first into the current, belayed by his partner. By midchannel, the water had risen to his waist. Barely in balance, Bob stared at the far shore (not at the current itself), and shuffled forward with agonizing slowness, lifting and planting one foot at a time. The river was too silty to see the gravel bottom; instead, Bob had to feel for it with his numbed feet.

At last he reached the far bank, then belayed Brad across. There was only one more channel to ford, but it was the widest and deepest of all.

Bob plunged in, and again the water rose to his waist. The channel was more than seventy-five feet wide, so when Brad had paid out all the rope, he had to step into the current himself. He could no longer belay his partner; instead, the two men had to move in concert, the seventy-five-foot line stretched taut between them.

Now the water rose above Bob's waist. He staggered, momentarily regained his footing, then lost it. He fell, dunking his whole body and his pack.

Almost miraculously, the rope gave Bob a second chance, as Brad stood still and planted his body to anchor the other man, keeping him from being swept downstream.

Gasping for breath, Bob started on, and Brad followed. Again the water rose above Bob's waist. And again, it knocked him off his feet. Brad braced for the pull, but the power of the current was too much. The rope jerked him suddenly off his own feet.

In that moment, the Donjek had won. As it repeatedly dunked the men's bodies and submerged their heads, with the rope now a useless impediment linking one man's fate to the other, the river carried the men like flotsam around one bend after another. With the straps of their fifty-pound packs binding the men's arms, they could not even try to swim. Swallowing water, vaguely hearing the mindless ground-bass roar of the river, Bob and Brad each had time to think, *So this is how it happens . . .*

How close can you come to dying, and not die? By all odds, Bob and Brad should have drowned in the Donjek River on July 15, 1937. Almost never have explorers found themselves in so dire a fix and managed to survive.

Had they drowned that day, in all likelihood their bodies would never have been found. The last anyone would have known about them would have been their bush pilot's report after he had dropped them off three weeks earlier, on June 22. The pilot knew the two men planned to head east, over a high ridge and out to Kluane Lake; but he would have known nothing about their progress beyond base camp.

In all likelihood, no one would have ever figured out what happened to Brad and Bob. The gear they had "chucked out" along the way would have been quickly buried by new snow, never to resurface.

Had Bob Bates and Brad Washburn drowned in the Donjek, they would be forgotten today, except within the small coterie of the cognoscenti of mountaineering history. By 1937, they had notched but a single Alaskan first ascent between the two of them. They were indeed at the peak of their game—but it was a game few cared about and even fewer played.

Instead, Brad and Bob would each live into his ninety-seventh year on Earth. And both men would go on to craft solid and satisfying careers. The trajectory of Bob's life—as a teacher at Phillips Exeter Academy in New Hampshire, coleader of the first two American expeditions to K2 (the world's second-highest peak, far more difficult than Everest), and first director of the Peace Corps in Nepal—was a distinguished one. The course of Brad's life, however, would take him along many an untrodden path, until the sheer range and virtuosity of his achievements would stamp him not only as one of a kind, but as one of a kind they don't make any more.

Before his death on January 10, 2007, Brad would be acclaimed as the greatest mountaineer in Alaskan history. He would be hailed, with the Italian Vittorio Sella, as one of the two finest mountain photographers ever. As a cartographer, he produced maps—of Mt. McKinley, Mt. Everest, the Grand Canyon, and other regions—that in terms of both precision and artistry surpassed anything that had come before

them. And at the age of only twenty-eight, he took over the moribund New England Museum of Natural History and transformed it during the next several decades into Boston's Museum of Science, one of the outstanding teaching institutions of its kind in the world.

No adventurer in the twentieth century had a more profound impact on his protégés and imitators than did Brad Washburn. And this is his lasting legacy—for almost single-handedly, following only his own headstrong intuitions, he revolutionized the arts of mountaineering and exploration in the great ranges.

1

Boy Adventurer

He was born Henry Bradford Washburn Jr. in Cambridge, Massachusetts, on June 7, 1910. There's no getting around the fact that Brad was a Boston Brahmin: he could trace his ancestry back to William Brewster, of the *Mayflower* and Plymouth Colony. But he was never rich, even when he was the director of the Museum of Science. An uncle who'd made a fortune in the wire goods industry put Brad through prep school. Entering Harvard in the fall of 1929, just as the Great Depression hit, Brad could barely finance his college education. A lifelong habit of penny-pinching was inculcated during those early years.

Brad's father, Henry Bradford Washburn Sr., was a minister who eventually became dean of the Episcopal Theological School in Cambridge. His mother, the former Edith Colgate, was the widow of his father's best friend, who had died of typhoid fever in 1902. Brad grew up with a half-sister, Mabel, from his mother's first marriage. Though fifteen years older, Mabel, whom Brad called "Sis," became his close friend and faithful correspondent throughout his teenage years. A year

and a half after Brad's arrival, his mother gave birth to another son, Sherwood ("Sherry"), who would go on to become a world-renowned physical anthropologist, one of the first experts to maintain that Piltdown Man was a hoax. (In a brilliant practical joke, several pranksters planted the jawbone of an orangutan and the skull of a modern man in a gravel pit in Sussex, England, in 1912, then claimed to have excavated an early protohuman, the so-called missing link. It took more than four decades for the forgery to be exposed.)

Judging by his writings and his achievements, Brad's character seems to have been fully formed at the age of eight. During the First World War, Brad's father moved the family to New York City, where he selected chaplains for military duty abroad. Already fascinated by the outdoors, Brad spent many a solitary hour fishing from the docks off the Hudson and East rivers. Though its publication was no doubt finagled by his father, Brad's first literary effort to see print was a five-paragraph essay that came out in *The Churchman* on May 12, 1919. It is called "Fishing: What a Boy Thinks."

Despite the idiosyncratic spelling that an editor wisely left intact, Brad already comes across as the self-taught expert confidently lecturing others about the proper way to do things:

> Fishing is a very bad habit when out of season. You should not fish to [*sic*] much because the fish are disterbed and move from place to place; they get scerd and wont bite. I have fished to eat. It is not good to fish for fun and after you have got a great many fish to throw them away or give them to the cat. God never intended them to be throne away, he ecspects them to swim around and chase their tales.

Despite his jaunty tone, the lad had a sensitive side: "I have never liked to take the hook out of the fishes mouth, it makes me feel bad and

I know the fish don't like it. They make a little grone and are off to the happy hunting ground."

But the young angler quickly reverts to practical instruction:

It is always best to stand at least ten feet from the water. I have always had good luck with a steel rod. The best store to get them is Abarcrombi and Fich, Madison Ave. and 45th St. Most people think that children living in a city have no chance to fish. That is not true because I have caught a lot of tomy cod off the 79th St. dock, New York.

All his life, Brad would prove to be something of a genius at tinkering with gear in the field. At the age of eight, he knew exactly how to manufacture the ideal tackle:

If you want to do this, solder a bell onto the end of a strong peace of wire, on the other end a screw. Fasten this on the dock by means of the screw. Have about a hundred feet of line to the wire and with about three hoocks on the end of the line with a sinker. Tie the loose end of the line to the wire and throe the line into the water. When the fish bite the bell will ring. Give the line a quick gerck and pull the fish off and rebait.

After the war, the family moved back to Cambridge. Many decades later, Brad would credit Miss Florence Leatherbee (it was always "Miss Leatherbee"), his fifth-grade teacher at Buckingham School, with kindling his interest in geography. "She showed us maps of the world," Brad would tell journalist Lew Freedman in 2005. "She had a Hammond Atlas and it showed where gold was found, and copper, and coal. Looking at it, you had the feeling of the world being a live place instead of just a map." At the age of fourteen, Brad drew his own first map, of Squam Lake, the family's summer retreat in New Hampshire.

Throughout his life, not entirely in jest, Brad would maintain that he became a mountain climber because he suffered from hay fever as a boy. In the summer of 1921, at age eleven, he started hiking up the low hills behind Squam Lake, where he discovered to his amazement that the higher he went, the less his hay fever bothered him. On July 21 of that summer, with his cousin, Brad made his first ascent of Mt. Washington, at 6,288 feet the highest peak in New England. Four years later, with his father and Sherry, Brad repeated the ascent in winter. Mt. Washington has a gentle topography, but especially in winter, thanks to its ferocious weather, it can be a dangerous climb. The crown of the Presidential Range has killed more climbers than any other American mountain. (The highest wind speed ever measured anywhere in the world, 231 miles per hour, was recorded at the summit observatory in 1934.)

Brad's parents were loving, involved, and indulgent, and Brad and Sherry shared a happy and adventurous childhood straight out of Tom Swift. The small but elite Buckingham School was situated only a few short blocks from the Deanery, the Washburn family house on Mason Street. (By now, Brad's father had become dean of the Episcopal Theological School.) Brad attended Buckingham through fifth grade, then switched to nearby Browne & Nichols for sixth and seventh grades, because beyond fifth grade, Buckingham tutored only girls. (In 1974, the two schools would merge, becoming Buckingham Browne & Nichols, or simply BB&N.)

In December 1922, three months into seventh grade at B&N, Brad was abruptly offered a "chance-vacancy" at the posh Groton School, in Groton, Massachusetts. He transferred in midterm from B&N, becoming overnight a boarder rather than a day student. Writing from Groton to his parents, Sherry, or Mabel every few days, twelve-year-old Brad was miserably homesick. To his mother on December 14, he put up a brave front: "It is a wonderful school. . . . I am having a fine time." To Sis, at about the same time, he confessed his real feelings: "I am sorely afraid that I cannot stay here much longer. I have been on

detention every day since I have been here. The work is far too hard for me."

During that first Groton year, Brad was in the infirmary a lot, for illnesses not specified in his letters. In an undated missive to his mother, he finally lets his guard down:

> *Gee but it's dreary up here. I am so far behind everybody is joking me about it and I would rather be in B + N. I do wish you could get me tutored or put back in B + N.*
>
> *It's just plain useless to hang around here. . . .*
>
> *P. S.: All my fruit has been stolen and it's no use to send any more as it goes like hot-cakes.*

Groton was only about thirty-five miles northwest of Cambridge, but Brad seemed to feel he had been exiled to a distant land. Still, the imperious and impatient leader Washburn would become emerges already in these early letters. Nearly every note to his parents begins with a demand.

> *Dear Ma,*
> *Will you please send up my track pants (2 pairs. a new sleeveless track jersey. my football jersey with the number off, my track shoes. . . . please send these as fast as possible.*

> *Dear Dad,*
> *I know you must have left my radio somewhere.*
> *If you can find it please ship it up full speed.*

> *Dear Ma,*
> *Please send me my "Louisville Slugger." Sherry knows which one I mean. Come on up for Easter?*

Brad signed his letters "Braddy," the nickname used by his family. He would spend nearly seven years at Groton, and thanks to his stumbling start in 1922, he suffered the ignominy of having to repeat first form (seventh grade) the following year. The homesickness wore off, but as late as 1928 (at age eighteen) he was still regularly demanding shipments of belongings from Cambridge. No longer "Braddy," he typically signed off these later letters to his parents, "Heaps of love to you both."

At the age of seventeen, Brad stood five foot seven and weighed only 112 pounds. Despite his slight stature, he went out for the football, baseball, and hockey teams. "I am rather stiff after two football practices," he wrote his parents in September 1928, "but I haven't been killed yet." Brad's greatest athletic success came in baseball as a pitcher, even though he never ascended beyond the "B" team. "I pitched the last 4 innings of the 2nd team Middlesex game last Wednesday," he wrote his parents. "The final score was 11-1 in our favor. They didn't get a hit off me + I struck out 5 of them."

In the middle of an earlier game that Brad pitched against Middlesex, in May 1927, a boy suddenly came running across the field, shouting, "Lindbergh's been sighted off the coast of Ireland!"

Many decades later, Brad would recall, "I was a good all-around athlete, but not a star at any one sport. I never ran track or long distances, but I had natural stamina that showed up in the mountains."

In prep school Brad expanded his fascination with the natural world. For his Groton biology teacher, a Mr. Siple, Brad made, as he wrote many years later, "a collection of all the ferns that grew within a mile of the school—I found over 20 variations. . . . That was my first scientific report."

At Groton, however, Brad remained for the most part an indifferent student. His bugaboo subject was Latin, in which he recorded a "D" in 1928. A report card from that same year renders his scores on a numerical scale. They range from 62 in math to 82 in "S. S."—not Social

Studies, but Sacred Studies (the influence of his theologian father no doubt giving him a boost). At the bottom of his report cards, Groton headmaster and founder Endicott Peabody (grandfather of the future governor of Massachusetts of the same name) would usually append an evaluative note. "Doing well," writes Peabody in November 1928. "We must take care that he does not have too many outside activities."

A curious circumstance, known to almost no one beyond his family, may help account for Brad's academic woes at Groton. In 2008, Washburn's widow, Barbara, and his daughter Betsy would insist that for all his life Brad suffered from dyslexia. The term was coined as early as 1887, but by the 1920s, the phenomenon was little understood. It is doubtful that Brad was ever clinically diagnosed as dyslexic, and his facility as a writer would seem to give the lie to any such condition. But Barbara (who spent many years tutoring young people with reading problems) and Betsy swore that Brad was an excruciatingly slow reader—that simply getting through a book from page one to the end required a major effort on his part.

Perhaps that reading disability lay behind the twelve-year-old's rueful complaint to his mother, "It's just plain useless to hang around here." And perhaps it helped turn Brad into a doer, rather than a scholar or a thinker. In any event, by the time he graduated from Groton (cum laude, despite his agonies), Bradford Washburn's extraordinary career had gotten off to a precocious start.

During teenage summers based out of Squam Lake, and during weekends year-round when he fled from school, Brad hiked the trails of the White Mountains every day he could. He specialized in the highest peaks, the Presidential Range, which stretches in an unbroken chain from Randolph, New Hampshire, to Crawford Notch, its summits thrusting above timberline despite their modest elevations. Brad had

become such an expert by the age of sixteen that he wrote a guide-book, titled *Trails and Peaks of the Presidential Range*. Illustrated with his own hand-drawn maps, the book was privately published by the same rich uncle who put the boy through Groton.

The text is mostly no-nonsense route directions, but here and there Brad strikes a tendentious pose, as in his discussion of the Carriage Road: "Autos ascend it to the summit of Washington every day. But this is not my subject! This book is written not for the city person who uses the Steel Horse to reach the summits, but for the mountain climber." Already formed in Brad's teenage prose was his lifelong penchant for exclamation marks and italics or underlinings. And already crystal-lized was the tone in which, even at age sixteen, he could voice the authority of a seasoned sage. About the Great Gulf Trail: "Care must be taken, as the Headwall is very loose rock, and a landslide is apt to be very serious if started." And already a stickler for detail, Brad lovingly annotates the amenities of every one of the huts in the range built and maintained by the Appalachian Mountain Club—an organization he had joined that year.

The summer of 1926 would prove a great watershed in the young adventurer's life. Brad's father, on a "semi-sabbatical" from his teach-ing duties at the Episcopal Theological School, spent from January through June in England, researching church history, and Brad, Sherry, and their mother joined him in July. After a bit of sightsee-ing, the family crossed the English Channel to France. Paris, Lyon, Geneva, and more sightseeing followed—but it was their father's whim to spend the end of July and most of August in and around Chamonix.

For any climber, to go from the White Mountains to the French Alps is to have one's mind blown. The Presidential Range rises out of the forests of northern New Hampshire in a series of gentle crests. From a distance, the massif looms as a bucolic silhouette, not unlike the rolling hills of England's Lake District. The standard trail up Mt.

Washington begins at Pinkham Notch, rising in an endless series of loops and switchbacks to the summit 4,000 feet above.

The Chamonix Alps, on the other hand, erupt spectacularly from the narrow valley of the Arve River. Wild pinnacles and near-vertical precipices made of a clean-cut brown granite soar toward the jagged skyline. Chamonix itself stands at an altitude of 3,400 feet. Mont Blanc, the highest peak in western Europe, rises to a summit 15,782 feet above sea level, a mere five miles south of the town's cramped, bustling streets. No other village in Europe—and none in the United States—huddles so far beneath such dominating crags.

What is more, the Chamonix Alps are heavily glaciated. To approach any of its main peaks, a climber must traverse permanent ice-fields crisscrossed by lethal crevasses. Over the last two and a half centuries, hundreds of voyagers have died after plunging into these deep fissures in the creeping glaciers, and many a body has never been retrieved.

No matter how ferocious the weather that brews around its upper slopes, the Presidential Range boasts not even a single perennial snow patch, let alone the merest vestige of a glacier. Before he arrived in Chamonix in 1926, Brad had never seen a glacier, let alone crossed a crevasse on a snow bridge.

At the age of sixteen, Brad was a demon hiker, but he had done no real technical climbing. And in the mid-1920s, the arts of rock climbing and mountaineering in the United States lagged hopelessly behind what was being practiced in Europe. Mountain climbing had, after all, been invented in the Alps. It is an oversimplification, but the first ascent of Mont Blanc in 1786—by a local physician, Michel Paccard, and a crystal hunter named Jacques Balmat—is commonly regarded as launching the "sport."

The cult of alpinism had everything to do with the Romantic revolution in attitude toward wild and unknown places. Before the second

half of the eighteenth century, the Alps were almost never described as "beautiful" or "sublime." During the Renaissance, travelers who approached the heights described them in print as "hideous wastes," the peaks as "monstrous excrescences" upon the surface of the earth. Not surprisingly, though the local guides who eventually facilitated the first ascents were French, Swiss, Italian, and Austrian, it was British "amateurs"—romantic adventurers weaned on Wordsworth and Shelley—who played the leading role in tackling the highest summits.

Between 1840 and 1865, during what came to be called the golden age of mountaineering, all the highest and most difficult peaks in the Alps were first ascended, one by one. The last to fall was the Matterhorn, in 1865, in a celebrated triumph-turned-tragedy, as four of Edward Whymper's team of seven fell 4,000 feet to their deaths on the descent, only an hour after reaching the top.

Virtually none of this ferment crossed the Atlantic Ocean. In 1868, the most difficult ascent yet performed in North America was accomplished by a party of seven that succeeded in reaching the summit of 14,259-foot Longs Peak in Colorado. Compared with the Matterhorn, Longs is—in the modern climber's dismissive epithet—a "walk-up." That 1868 ascent was led by William Byers, editor of the *Rocky Mountain News,* and geologist and explorer John Wesley Powell, neither of whom had any real climbing experience. (Powell, moreover, had only one arm, having lost the other in the Civil War battle of Shiloh.) On the flat, spacious summit, the putative first ascent party discovered a man-made pit carved out of the granite talus. It was an eagle trap, constructed and used by Indians (perhaps Arapahos), most likely long before 1868.

Sixty years later, the same disparity between American and European mountaineering still existed. The generation after Whymper had focused on attacking the most difficult ridges on the highest peaks, eventually tackling even the far more dangerous faces between the

ridges. By the late 1920s, the best French and Italian alpinists had begun to attempt such previously unthinkable challenges as the 4,000-foot-high, nearly vertical north face of the Grandes Jorasses, at the head of the Leschaux Glacier southeast of Chamonix.

In the United States, by 1926, the hardest alpine climb yet knocked off was perhaps the Ellingwood Arête on Crestone Needle, in the Sangre de Cristo Range of southern Colorado. Albert Ellingwood was a bold, skillful, self-taught climber, but he was not in the same league as the Italian Emilio Comici, or the German Anderl Heckmair—or for that matter, as such Chamonix guides as Georges Charlet and Alfred Couttet. In the Alps, a route such as the Ellingwood Arête might well have earned the withering guidebook phrase, "an easy day for a lady."

Thus the sixteen-year-old Brad, arriving in Chamonix at the end of July 1926, ought to have been intimidated by the stern pinnacles of the Petit Dru or the Aiguille du Midi, staring down on the claustrophobic town from such dizzy heights just to the south. But he was not. In a sense, Brad was prepared for the Alps, because his aunt and uncle had given him Roger Tissot's lavishly illustrated *Mont Blanc* for the previous Christmas. It was, Brad would testify decades later, "a book that, in essence, changed my whole life." Before he arrived in Chamonix, he had already "seen" the Petit Dru and the Aiguille du Midi. And now, from the window of the hotel room his family had rented, Brad could gaze to his heart's content at the impossibly high glacial dome of Mont Blanc to the south.

Within the first week, Brad and Sherry hired Chamonix guides to take them up the first technical climb of their lives. Their initial triumph was the pinnacle called the Aiguille de l'M—quite a serious outing. With the blithe insouciance of youth, Brad and Sherry sailed up the climb.

To be sure, the guides did all the leading, as Brad and Sherry followed, second on the rope. (No guide in the Alps would ever let a

novice client lead.) But the boys performed so well that their mentors were only too glad to sign on for further excursions.

Brad kept his first mountain diary that summer. Sixty-eight years later, in 1994, as he typed up a copy to be deposited in the Boston University archives, Brad annotated: "Mother insisted that I write this diary of our trip to Europe. It . . . started me off on 70 years of keeping log-books." Compared to Brad's later diaries, however, the 1926 journal was a halfhearted effort. The entries are telegraphic ("another BIG DAY") or summarily laconic ("Got good pictures on top and on return I got good ones also on the shoulder").

On August 3, still little more than a week after their arrival, the boys stood on the summit of Mont Blanc at the early hour of 10:00 A.M. (most climbers top out in late afternoon). The highest of the Chamonix peaks, unlike the aiguilles, is not a technical climb, but rather a long, long snow slog: the only hazards are weather, altitude, and crevasses. Still, for two American teenagers, one a chronic sufferer from hay fever, Mont Blanc was a true test of fortitude.

Brad wasn't finished. Leaving Sherry behind, he ventured east into Switzerland where, passed on by personal recommendation from one local guide to another, he traversed Monte Rosa (the second-highest peak in the western Alps), climbed the craggy Riffelhorn, and— his crowning achievement—reached the top of the Matterhorn on August 14.

In one month, at sixteen, Brad had amassed an alpine experience that could be matched by no more than a score of American climbers of any age.

Back at Groton, Brad wrote up his Monte Rosa traverse for the school magazine, the *Grotonian*. Striking the same cocky, all-knowing tone he had so automatically assumed in his eight-year-old essay on fishing,

Brad mixed enthusiasm for the climb with a world-weary scorn for the local accommodations. Thus the Bétemps hut, from which he and his Swiss guide set out for the summit, was "a squalid little cabin, having none of the comforts which are offered by the Appalachian Mountain Club Huts in New Hampshire." The food was no better: "At a quarter past one we took a hasty breakfast, composed of too much cheese and bread." (Dinner the night before had also been cheese and bread.)

Brad also wrote a pair of articles for *Youth's Companion,* a popular magazine that had been in existence since 1836, but which, sadly, would fold only two years later. "A Boy on the Matterhorn" appeared in the March 17, 1927, issue; "I Climb Mont Blanc," in the June 30 number.

These articles caught the eye of George Palmer Putnam, head of the publishing house G. P. Putnam's Sons, which had been founded (as Wiley & Putnam) by his namesake grandfather in 1838. Thirty-nine years old that spring, Putnam was not only one of the most successful publishers in New York, he was an explorer in his own right, having led wildlife-collecting expeditions to Greenland and Baffin Island for the American Museum of Natural History and the American Geographical Society. In 1931, he would marry—and manage the career of—Amelia Earhart.

In 1925, Putnam had launched a series of young adult nonfiction narratives that he titled Boys' Books by Boys. The first in the series was *David Goes Voyaging,* written by Putnam's own twelve-year-old son, recounting his three-month journey to the Pacific as part of an expedition led by the renowned oceanographer William Beebe (inventor of the bathysphere). That book was followed by two more David books, chronicling his father's expeditions to Greenland and Baffin Island, and then by *Deric in Mesa Verde* and *Deric with the Indians,* penned by the thirteen-year-old son of the cantankerous superintendent of Mesa Verde National Park, Jesse Nusbaum. The Boys' Books proved wildly

popular. By 1927, *David Goes Voyaging* was in its sixteenth printing, and all the books were translated into numerous foreign languages.

In Brad's articles for *Youth's Companion,* Putnam must have been beguiled by the mixture of almost naive enthusiasm with a tone of authoritative experience far beyond the writer's sixteen years. Of the trek up the highest peak in western Europe, Brad commented, "My climb up Mont Blanc was the best fun I ever had." On the other hand, "The Matterhorn is, in my opinion, the most beautiful mountain in Europe."

Brad could also conjure up a scene with vividness and wit. Descending Mont Blanc, he and his guide caught up with a party of Germans negotiating a crevasse field.

> One of the guides carelessly crossed on the run. One of the Germans tried to do the same thing. He slipped, the bridge of snow broke, and down he went. Luckily there was a little island of snow exactly in the middle of the crevasse on which the man alighted with a dull thud. If he hadn't hit that island—well, there would have been one less German!

Putnam wrote to Brad, asking if he'd like to contribute an account of his halcyon season in the Alps to the Boys' Books series. By then, in the summer of 1927, Brad and Sherry were back in Chamonix, pursuing another campaign among the high peaks and aiguilles. Brad agreed at once. On his way home, as he stayed in a pensione in Venice, he wrote *Among the Alps with Bradford* in ten days. (The manuscript shows very little evidence of second thoughts or revisions.) More than seven decades later, Brad would marvel out loud about the felicities of book publishing in the 1920s. "I turned in the manuscript to Putnam, as agreed, on the fifteenth of September, with a batch of pictures I'd taken. The book was on sale by November, pictures interleaved in

the right places in the text. Can you imagine a publisher doing that today?"

Among the Alps with Bradford turned out to be every bit as popular as its predecessors. Foreign editions included a version in Hungarian. Putnam was so pleased with Brad's book that he eventually commissioned two sequels.

In *Among the Alps,* the jaunty, hearty, can-do enthusiast of the youthful magazine pieces emerges full-blown. And Brad had the nerve to persuade his brother to write the foreword. Sherry duly reported: "You can hire a guide who will pull you up any difficult places there happen to be on a mountain, but Brad usually gets up by himself. He agrees with those who believe that mountain climbing is a test of sportsmanship, and feels that if he can't climb the difficult places without being pulled he really hasn't climbed the mountain."

The 1927 campaign had been even more ambitious than the previous summer's. By now Brad and Sherry had become acolytes of the great guides Georges Charlet and Alfred Couttet. The season's finest deed was a traverse of two of the steepest aiguilles, the Grand Charmoz and the Grépon—one of the most ambitious climbs any guide would take a client on. Brad and Sherry completed the grueling traverse not once, but twice, for Brad, by now a serious photographer, was so disappointed with the pictures he had taken on the weather-plagued first climb, he insisted on repeating it under fair skies to expose better photographs. And as if photography were not challenge enough, Brad had recruited the excellent local filmmaker Georges Tairraz to make a 16 mm movie of the climb.

The Charmoz-Grépon traverse was a more difficult ascent than anything that had been achieved in the United States by 1927. By now, Brad and Sherry were so well liked by their guides that Charlet and Couttet paired up with them to put up several minor but demanding new routes. Many decades later, Brad would reminisce, "Charlet said that most of his clients didn't want to be told what to do. But Sherry

and I wanted to know if we did something wrong or stupid, so that we wouldn't do it again." Brad would always insist, moreover, that Sherry was the better rock climber. "Georges used to say about him, 'Il grimpe comme un chat' ['He climbs like a cat']."

In *Among the Alps,* Brad focuses somewhat curiously on only two of his many ascents. The Charmoz-Grépon traverse was an obvious choice, but the young author elected to recount a 1927 attempt on Mont Blanc that was defeated by a fierce storm rather than his successful 1926 ascent. A short chapter was devoted to the Matterhorn, almost all of it a résumé of the tragic story of Whymper's first ascent in 1865. Of his own experience on the mountain, he wrote only, "It was a climb that I shall never forget as long as I live."

That Brad and Sherry were still boys in 1926 is underlined in Brad's charming account of a signal system he and Sherry worked out to reassure their parents. From a hut high on the Aiguille du Midi, at dusk, the brothers set off a Roman candle and a "red fire." "A moment later," Brad writes, "we saw a light blinking furiously from the window of the hotel far below us. We replied with a few flashes made by passing a hat before our candle."

As he seconds the famous Mummery Crack just below the summit of the Grépon, Brad plays up the drama:

With a heart beating like a pile-driver, I descended nearly to the bottom of the crack and crossed into it. I looked up a moment and saw Georges [Charlet] way at the top grinning down at me. He always laughed when I was in a bad fix, and I couldn't see anything at all that was funny about my situation! Then and there I made up my mind to climb that crack from top to bottom without being pulled one inch. Georges claimed I couldn't do it. I yelled to him to loosen up the rope entirely, and just to hold it so as to be a safeguard in case I should fall.

Sure enough, Brad conquers the redoubtable crack without a single tug on the rope from his guide. Sherry follows with equal aplomb.

Just as he did in his eight-year-old fishing article, at seventeen Brad frequently strikes the pose of a seasoned outdoorsman. "I think that that night at the Grands Mulets [hut] was the coldest that I have ever had," he writes, and, "There is nothing more terrifying, even to *look* at, than an avalanche." The last paragraph of the book, serving as coda to the failed attempt on Mont Blanc, is steeped in the worldly wisdom of a veteran who has battled the wilderness and learned its lessons:

> There's nothing like the game in which you match yourself against Nature. Give her your very best and fight to the end, but when you see that she has got the upper hand, turn, and don't be scared to admit defeat. It's the fool who sticks to it when it's impossible.

Brad's second book in the Putnam series, *Bradford on Mt. Washington,* is pure high jinks, as he treats even the miseries of a failed winter ascent as the stuff of a jolly lark. The captions to Brad's own photos perfectly fit the formula of Boys' Books by Boys: "Brad Cooks Some Bacon at the Shelter" (hunched eagerly over the stove); "The Author on One of the Snow Slopes" (grinning beneath parka hood as he leans under a gargantuan pack). As fodder for the book, Brad recruited George Putnam himself for a winter assault on Mt. Washington. The text does not indicate how the explorer of Baffin Island felt about the climb, which, like most winter attempts, was defeated by weather; but in a group photo, as the publisher slumps against a boulder at the base of Tuckerman Ravine, frost coating his hair and beard, an ice axe dangling useless from his right hand, he looks thoroughly unhappy.

In 1929, between high school and college, Brad returned to Chamonix for a third summer. By now he was the darling of his famous Chamonix guides. During the off-season, Georges Charlet corre-

sponded regularly in French with his teenage protégé, bringing him up to date on the latest catastrophes and near misses in the French Alps, signing himself "Votre dévoué guide." For several weeks that summer, Brad and Sherry climbed with their mentors, before Sherry departed for home. He would never climb again—retiring, at the age of seventeen, from what could have been a stellar mountaineering career.

Brad lingered on in Chamonix. By now, Couttet and Charlet treated him almost as an equal, letting him lead some of the pitches. And toward the end of that summer, with his favorite guides, Brad pulled off what in pure technical terms would be the greatest climb of his life. In the year 2000, Brad recalled that campaign: "Georges thought the two best unclimbed routes around Chamonix were the north face of the Aiguille Verte and the Walker Spur on the north face of the Grandes Jorasses. So Alfred went over to the hut beneath the Walker and spent a couple of days sitting there looking at the face with field glasses. I paid him ten bucks a day to do it. He came back and said, 'I don't like it. There's too much rock fall.'

"So we did the north face of the Verte instead."

In 1929, that monumental first ascent was one of the hardest routes yet put up anywhere in the Alps. Nearly eight decades later, it remains a touchstone in mountaineering history, under the sobriquet *la voie Washburn*. The Verte was far and away the hardest alpine route yet pioneered by any American-born mountaineer anywhere in the world. At the age of nineteen, Brad had matured into one of the three or four most talented and accomplished alpinists in the United States.

As he headed off to Harvard in the fall of 1929, Brad was not only a brilliant climber, but the author of two immensely popular books. And he had already launched a career as a public speaker, enthralling audiences with illustrated talks about his ascents. Those talks, as he put it decades later, "kept me in spending money" through his Depression-struck college days.

With the next summer, however, after his freshman year at Harvard, Brad's mountaineering career would veer off in a direction radically different from his apprenticeship in the Alps. That veering off was entirely of Brad's own volition and design, born of an exploratory itch he had scratched at least as far back as Miss Leatherbee's fifth-grade geography lessons. The new direction would change not only Brad's life, but the very course of American mountaineering.

2

Alaska Breakthrough

Back in October 1926, a speaker who visited Groton had made a profound impression on Brad Washburn. He was Captain John Noel, the official photographer and filmmaker on the 1924 expedition to Mt. Everest. At the end of the third British attempt on the world's highest mountain, on June 8 of that year, George Leigh Mallory and Andrew ("Sandy") Irvine had been glimpsed by a teammate pushing high along the northeast ridge, apparently only a thousand feet short of the 29,035-foot summit. Then clouds swallowed the mountain. Mallory and Irvine were never seen again.

Ever since, experts have fiercely debated the question of whether Mallory and Irvine could have reached the summit, twenty-nine years before Everest's official first ascent by Edmund Hillary and Tenzing Norgay on May 29, 1953. The general consensus comes down against such a remarkable deed, but there are still quite a few observers who believe Mallory (the finest British climber of his day) and his young protégé could have pulled it off.

In 1999, Mallory's body was found in a concave slope at 27,000 feet on the north face of the mountain, by the outstanding American mountaineer Conrad Anker. Naturally mummified, Mallory lay facedown, his arms outstretched, his bare hands frozen in an agonizing posture, as if he had tried to stop a long fall by digging his fingers into the slope. The rope, still tied to his waist, was severed a few feet from his body. The remains of Irvine have never been found.

That discovery made it seem almost certain that the duo had died in 1924 when they had fallen off the northeast ridge. In the plunge, the rope had evidently broken. But the position of Mallory's body did not settle the question about the summit. Had the pair fallen on the way up the mountain, shortly after their teammate had caught the last sight of them before the clouds moved in? Or on the way down from the summit as, exhausted, stumbling in the dark, one of them had made a misstep and pulled the other off?

Already, by 1926, Mallory and Irvine had become legend. For Brad, less than two months removed from his brilliant season in the Alps, Captain Noel's lecture had a galvanic effect. The sixteen-year-old wrote up the talk for Groton's *Third Form Weekly:* "It was a thrilling speech, illustrated by magnificent still pictures as well as 35mm movies." Then and there, Brad decided that no goal in his exploratory life would be dearer to his heart than an attempt to climb Everest.

After 1929 and the Aiguille Verte, however, Brad was perfectly positioned to apply the technical craft he had learned in the Chamonix Alps to his home mountains. One or two other Americans about a decade older than Brad had begun to do just that—notably Robert Underhill and Miriam O'Brien (who would become Miriam Underhill). Ranges such as the Tetons in Wyoming, the Rocky Mountains of Colorado, and the Sierra Nevada in California abounded with potential challenges for American climbers comparable to those of the Alps.

The first great breakthrough in American alpinism came in 1927.

It was no accident that it was performed not by Americans, but by a pair of brothers who had emigrated from Germany. That summer Joe Stettner, a coppersmith, and Paul Stettner, a photoengraver, rode their motor bikes from Chicago to Colorado. Trained in the German and Austrian Alps at a very high level, they were pleased to receive a box full of pitons shipped from Munich. (Pitons are metal spikes driven into cracks, greatly increasing safety on hard routes and even providing "aid" on otherwise unclimbable terrain. Their use was virtually unknown in America in 1927.) The Stettners bought a used rope in Estes Park and set out for the east face of Longs Peak—the steepest alpine precipice in Colorado.

In the remarkably fast time of seven hours, the plucky brothers blitzed their way up their 2,000-foot-long new route without incident. Indifferent to fame, the Stettners never bothered to write up their climb in a mountain journal. According to Chris Jones, in *Climbing in North America,* the route was nonetheless "the most demanding climb in the United States up to that time. It was not surpassed in Colorado until the 1940s."

As it would turn out, Brad never climbed in the Colorado Rockies, the Tetons, or the Sierra Nevada. When he was older, he liked to brag that he had "only pounded one piton in my life." (The pitons employed on such climbs as the Aiguille Verte were placed by the Chamonix guides.)

Two circumstances, in particular, turned Brad away from those home ranges. One was because he went to Harvard. The other was the eye-opening impact of Captain Noel's Groton visit.

The Himalaya, Brad realized at sixteen, was a whole different ball game from the Alps. None of their highest summits had been reached. Simply getting to the bases of the great mountains entailed complex expeditions in their own right. By 1926, the highest summit yet reached anywhere in the world was that of Trisul, a 23,360-foot

mountain in northern India that had been claimed by a small party led by the doughty explorer Tom Longstaff way back in 1907. To be sure, Mallory and Irvine had surpassed 28,000 feet on Everest, as had their teammate, Teddy Norton, in an attempt five days earlier.

Fourteen of the world's peaks are higher than the magical but arbitrary altitude barrier of 8,000 meters (26,246 feet). By 1926, only three of them had been attempted. The very first foray into these unknown realms was undertaken in 1895 by Alfred Mummery, the finest British climber of the generation after Whymper, when he set out to attack Nanga Parbat (then in India, now in Pakistan), the world's ninth-highest peak. Despite extensive experience in the Alps and Caucasus, Mummery seems to have drastically underestimated the scale of the Himalaya. Setting out on a reconnaissance with two porters, Mummery disappeared. No clue to the fate of the trio has ever been unearthed.

K2, the world's second-highest mountain, and a much more difficult climb than Everest, was attempted in 1902 and 1909. Neither party got anywhere on the mountain, although the second, led by one of the greatest mountain explorers of all time, the Italian Luigi Amedeo di Savoia, Duke of the Abruzzi, discovered the route that would lead to the first ascent in 1954. (The Abruzzi Ridge bears the duke's name today.) The three British Everest expeditions, in 1921, 1922, and 1924—all three spearheaded by Mallory—were extraordinary in that the last two each built on the lessons learned by the previous attempt, culminating in Mallory and Irvine's serious bid for the summit on June 8, 1924.

In a mirror reflection of the golden age in the Alps from 1840 to 1865, what would come to be known as the golden age of Himalayan mountaineering unfolded between 1950 and 1964, when all fourteen 8,000-ers were first ascended, beginning with the French on Annapurna in 1950 and ending with the Chinese on Shishapangma in

1964. In contrast to the style of the conquests in the Alps—small parties of gifted "amateurs" accompanied by local guides—the Himalayan campaigns unfurled as massive, nationalistic expeditions pitting the British, Germans, Austrians, Swiss, Italians, Americans, and even Japanese and Chinese against one another.

Contemplating Everest as he stared at Captain Noel's lantern slides that October evening in 1926, Brad heard the siren call of the unknown. However fierce a challenge the "last great problems" of the Alps promised their suitors—especially the Walker Spur on the Grandes Jorasses and the north face of the Eiger, both finally accomplished only in 1938—the Alps were a known range. Every face of every peak had been photographed and scrutinized with telescopes and binoculars, and most of them soared over cozy villages that had been settled since the late Middle Ages or the early Renaissance.

The Himalaya was also scattered with native villages. But as late as 1949, no Westerner had ever penetrated the Khumbu Valley to the foot of Everest on the south, the route by which the peak would finally be climbed in 1953. In 1950, as the French set out to attack Annapurna, the maps were so erroneous that the team squandered almost two months simply trying to find the mountain.

Yet for various reasons—some having to do with the politics of foreign visitation in Tibet and Nepal, others with the British monopoly of rights to Everest—Brad would never get the chance to tackle the world's highest mountain. No American would attempt Everest, in fact, before 1962. Instead, Brad's focus would alight upon another realm of pioneering exploration.

As soon as he started his freshman year, Brad joined the Harvard Mountaineering Club. The first collegiate climbing organization ever launched in the country, the HMC had been founded in 1924 by Henry Hall. Fifteen years older than Washburn, Hall was a Bostonian with a Brahmin pedigree every bit as certified as Brad's. Thirty-four years

old in 1929, Hall had climbed much in the Canadian Rockies and Interior Ranges, but his great claim to fame was having participated in the 1925 first ascent of Mt. Logan in the Yukon, at 19,550 feet the second-highest peak in North America. One of the most remote peaks on the continent, and in terms of sheer bulk the largest mountain in the world, Logan had succumbed only after an epic four-month struggle by a team of seven Canadian and U.S. climbers.

Basing their logistical plan on the British Everest expeditions, the Logan party started out in bitter cold in late February from the gold-rush town of McCarthy, Alaska. For two months, using dog teams and horse-drawn sleds, the members laboriously laid a series of gear and food depots up the 100-mile-long valley of the Chitina River and the Logan Glacier. It was not until mid-June that the team reached the mountain's massive summit plateau. Finally, on June 23, five members stood on the virgin summit. Sadly, Hall was not one of them, for he had taken on the thankless job of helping a teammate with badly frozen toes down to a lower camp.

On the descent from the final push, the five summiteers got separated and were temporarily lost in a whiteout. Given the agoraphobic blankness of the summit plateau, they could easily have lost their route for good, in which case all five would have perished. The British *Alpine Journal,* not prone to recognizing the deeds of upstart Americans, hailed the Logan ascent, noting, "Greater hardships have probably never before been experienced in any mountaineering expedition."

Under Henry Hall's leadership, the HMC was firmly oriented toward mountaineering in Alaska and Canada. Technical rock climbing, or mixed rock-and-ice work on steep faces, such as Brad had accomplished in the Alps, played only a minor part in the weekend activities of club members. Within the HMC, rock climbing was regarded strictly as a means to an end—training for the big ranges—not as a field for pioneering efforts in its own right. Given that other American climbers

were starting to probe the more daunting ridges and faces of the Rockies and the Tetons, the HMC was already, even by the standards of the day, conservative and backward looking.

Brad recognized that Alaska and the Yukon promised a world of mountain exploration through regions every bit as unknown as the Himalaya. The natural progression of his climbing career might have led him to return to the Alps in the summer of 1930, to attempt even more formidable walls than the north face of the Aiguille Verte—perhaps the Walker Spur on the Grandes Jorasses. Instead, for the summer after his freshman year, Brad organized an expedition to the Far North. Its objective was 15,330-foot Mt. Fairweather, which straddles the Alaska-Canada border 120 miles northwest of Juneau. One of the tallest coastal mountains in the world, Fairweather had been attempted once, but it was still unclimbed. For Brad, as he turned twenty, it loomed as a more tantalizing project than anything in the Alps—and as a challenge equal to that of the virgin prizes of the Himalaya.

Even before he entered Harvard, Brad had started giving public talks, illustrated with his own photos, about his campaigns in the Alps. As Brad told Lew Freedman in 2005, "When I began giving lectures I had no public speaking experience whatsoever. But I must have been reasonably good, otherwise they wouldn't have kept hiring me. I concentrated on the serious parts of climbing, but I also mixed in some jokes."

Sometime during that freshman year, Brad attracted the attention of a professional lecture agent based in Boston, one A. H. Handley. He told Brad that if he could spare a week from school, Handley could make him "a lot of money" by booking a whirlwind tour of clubs in the Chicago area. Crowds for the talks ranged from about a hundred to more than a thousand.

For Brad, proof that he had really arrived as a public speaker came when Gilbert Grosvenor, president of the National Geographic Society, invited him to speak in Constitution Hall. Brad titled his talk, about the breakthrough ascent on the Aiguille Verte, "Following a New Trail to Green Needle's Tip." The lecture, delivered on March 28, 1930—Brad was still only nineteen—was such a success that it launched a close, lifelong relationship between Washburn and the society. Brad would publish his first article in *National Geographic* magazine in 1935.

At Harvard, Brad was much happier than he had been at Groton. Perhaps the most influential teacher he had had since Miss Leatherbee was Professor Kirtley Mather, whose freshman geology course Brad deemed "wonderful." Many years later, he would write of Mather, "He opened my eyes about how our world was made—and I've been interpreting it in photography and maps ever since."

Brad chose, however, to major not in geology or geography but in French history and literature. With his three summers in Chamonix, he had had an immersion course in spoken French (though the Chamonix guides spoke a semi-impenetrable Savoyard patois). And at Groton he had read widely in the French classics.

Brad's love-hate relationship with foreign languages amounts to a puzzle. His distaste for Latin was so indelible that, decades later, penning notes about his recollections of prep school, he vowed, "I <u>hated</u> Latin and still wonder why it was such an important and unavoidable part of the Groton curriculum." But French came easily to Brad. All his life—despite years on end during which he had little chance to exercise his skill—he spoke French fluently, albeit with a flat American accent.

The abiding pleasure of Harvard, however, was the mountaineering club. At Groton, Brad had never found more than a single pal or two with whom to share his passion for the White Mountains. Instead, his brother, his cousin, and his father were his regular partners. But from the fall of 1929 through the next four years, Brad was part of

a small but rambunctious gang of hikers, skiers, and climbers who couldn't wait for the next weekend to head out to local crags such as Quincy Quarries and Joe English Hill, or in winter, up to Tuckerman and Huntington Ravines on Mt. Washington.

Almost from the start, however, Brad found himself at loggerheads with the club's founder. Henry Hall was a true "club man," in the Victorian sense. In 1929, as he would throughout the rest of his life, Hall attended every meeting of the HMC. He presided over the Advisory Council, an assemblage of distinguished alumni who pondered such weighty questions as how to finance a new stove for the HMC cabin. At the monthly Ad Council meeting, it was the undergraduate president's inviolable mandate to serve Duff Gordon amontillado sherry (Hall's favorite aperitif).

From the start, Hall had decreed that the HMC would never admit women. (Even as late as the 1960s, when a handful of Radcliffe students joined the Harvard "boys" on weekend outings, they were denied membership in the club.) Similarly, Hall had decreed that to become a member, a candidate must have climbed "three major glacier-hung peaks or their equivalent." Not coincidentally, that standard perfectly matched Hall's own experience in the Canadian Rockies, where every major peak was "glacier-hung." But it was a lot to ask of an incoming eighteen-year-old. (Again, the standard remained firmly in place as late as the 1960s. A lot of candidates slithered in under the umbrella of that ambiguous phrase "or their equivalent.")

By 1929, Brad easily qualified—he could count Mont Blanc, Monte Rosa, and the Matterhorn from his 1926 season alone as more than passing the grade. But many of Brad's fellow acolytes fell well short of Henry Hall's mark. Bob Bates, who would become one of the great American mountaineers of the century, had done little more before Harvard than hike in the White Mountains.

"To me the thing that made the club fun to be in was that we had a

mix of people," Brad said in 1980. "So I urged that we have an Associate Membership that would allow people like Bob Bates to get aboard. . . . To be an Associate Member, I suggested, all you had to do was express enthusiasm for or interest in climbing.

"I was bitterly criticized by some of the 'experts' in the club for bringing in people who weren't expert mountaineers." As he would throughout his life, however, Brad prevailed. "I think we brought in an awfully fine bunch of young people, who gave a great deal of fun and quality to the club." (Henry Hall's reaction to this opening of the floodgates is lost to history, but it cannot have been sanguine.)

If by the age of thirty-four, Hall had already become something of an éminence grise, another mountaineering mentor for the HMC undergraduates who was five years older than Hall had the opposite impact. Noel Odell had come to Harvard from his native England to serve for several years as a visiting professor of geology. It was Odell who, climbing alone in support of Mallory and Irvine on Everest in 1924, had caught the last glimpse of his friends before they vanished into the clouds on June 8. Odell had pushed on to Camp VI, whistling and yodeling in hopes of an answering cry. When he found bottled oxygen apparatus strewn chaotically within the tent, as if his teammates had made some desperate last-minute adjustment to their gear that morning, he began to fear the worst. Two days later, Odell climbed back to Camp VI, once more alone (the only man fit enough to perform the job). When he found the tent empty, he laid out two sleeping bags in the snow in a T formation—a prearranged signal to the rest of the party below that Mallory and Irvine must have perished.

Unlike Hall, Odell as he turned forty was still climbing at the highest level. He was especially brilliant as an ice climber, and he was happy to teach his craft to the Harvard undergraduates. Odell's Gully in Huntington Ravine on Mt. Washington commemorates the man's first ascent of that steep couloir of water ice.

"He was the greatest mountaineering figure in the world at the time," recalled Terris Moore, a grad student member of the HMC in 1929. "And he had been my boyhood hero." The next year, Moore would have the privilege of sharing a pioneering ascent of Mt. Robson, one of the most difficult peaks in the Canadian Rockies, with Odell. On that climb, Moore later avowed, he learned more about technical climbing from Odell than he had in several previous years of ambitious mountaineering put together.

By Brad's sophomore year at Harvard, not surprisingly, he had become the de facto leader of the HMC. The catalyst was a Model A roadster he had bought with the proceeds from his Putnam books. Brad named the auto Niobe, not out of erudite allusion to the woman whom Zeus turned to stone for bragging about the beauty of her children, but because on each drive up to the White Mountains, the HMCers passed a statue of Niobe on a hill above the center of Sandwich, New Hampshire.

Niobe became the unofficial club vehicle. And in 1931, when Brad and his cronies won permission from the Forest Service to build a new cabin near the base of Huntington Ravine, where the finest ice climbing in the East could be had, Niobe played an essential role. The Fire Trail, little broader than a hiking path, was the route of access to the cabin site.

"I drove Niobe most of the way up the Fire Trail," Brad reminisced in 2000. "I remember we had two big rolls of horrible roofing paper, each one of which weighed ninety pounds. Nobody wanted to carry the damned things, so we put them in the back of Niobe. We only had to backpack the rolls a quarter-mile or so.

"The only way to get the car turned around was to back it into the woods, then everybody lifted it around. We were all yelling and screaming and drunk with beer, and we just had an absolutely marvelous time."

Charlie Houston, three years younger than Brad, would also become one of the century's great mountaineers. In 1980, he recalled the cabin-building labor: "It was back-breaking. We used to leave Cambridge about 4:00 P.M. on Friday afternoon, get to Pinkham Notch, sleep out in the parking lot, or hike up to the site and reach it around 1:00 A.M." (Not everyone could fit in Niobe along with the roofing paper.) Yet the group effort cemented an unprecedented camaraderie within the HMC. "The effect of building the cabin on our gang was quite pro-found," Houston recalled. The cabin was officially opened on Washing-ton's birthday, 1932. It served as a base for several generations of ice climbers (many of whom had nothing to do with Harvard) until it was condemned as a fire hazard in the early 1960s and torn down.

Brad's HMC partners on expeditions to Alaska and the Yukon would eventually include some of the luminaries of American mountaineer-ing—not only Bob Bates and Charlie Houston, but H. Adams Carter and Terris Moore. That quintet would come to be known as the Har-vard Five. But Brad's teammates for the first expedition, to Mt. Fair-weather in 1930, were a relatively weak crew of five friends, several of whom had little more mountaineering experience than serving as "hut boys" hauling monstrous loads for the Appalachian Mountain Club.

And for the first and perhaps only time in his long life, Brad had no idea what he was getting into.

By 1929, the great ranges of Alaska and the Yukon—unlike the Hima-laya—had seen a few landmark first ascents. The marathon 1925 as-sault on Mt. Logan by Henry Hall's team of seven had been preceded, way back in 1897, by the Duke of the Abruzzi's astonishing success on Mt. Saint Elias. Soaring to 18,008 feet only twenty miles inland from the Gulf of Alaska, Saint Elias is the highest mountain that close to the ocean anywhere in the world. It was long thought to be the high-

est mountain in North America (it is fourth, after Mt. McKinley, Mt. Logan, and Orizaba, the Mexican volcano).

The duke's expedition was made up of six Italian "amateurs," four professional guides, and ten porters hired in Seattle. In style, the assault was a bizarre mixture of lavish and Spartan. To avoid the indignity of sleeping in direct contact with the ground, the gentlemen brought along brass bedsteads, which the porters hauled fifty-five miles from the beach to base camp. Yet high on the mountain, the team went light and fast. On July 31, all ten climbers reached the summit together.

One of them was Vittorio Sella, whose stunning large-format photographs illustrated the luxurious folio volumes the duke published after each of his expeditions. Though Washburn never met Sella, the Italian would become the single most important influence on Brad's aerial mountain photography—particularly in his dictum "Big scenery should be photographed with big negatives."

Mt. McKinley rises more than a hundred miles inland from the head of Cook Inlet. At 20,320 feet the highest peak in North America, it was long overlooked. It was named only in 1897, by a Republican prospector who had just gotten word that William McKinley Jr., who would never give a hoot about Alaska, had received the nomination for the presidency. Once it was recognized to be the apex of North America, McKinley would turn back no fewer than eleven expeditions seeking to make its first ascent.

One of those expeditions was composed of a gang of Fairbanks sourdoughs with no mountaineering training, who set off in 1910 for the mountain to settle a $5,000 saloon wager. Remarkably fit, two of them climbed all the way from a high camp at 11,000 feet to the north summit in a single day. They failed to make the first ascent only because they headed for that slightly lower north summit, to erect a flagpole that could be seen by their detractors in Fairbanks (the south summit is not visible from that lowland town).

In 1912, an expedition led by the talented painter-mountaineer Belmore Browne turned back after reaching a point that Washburn would later characterize as "a 200-yard stroll to the summit in good weather," when a sudden storm engulfed the climbers. It was Browne's third attempt on McKinley, and the bitterest disappointment of his life. Brad would later become good friends with Browne, whom he hired to paint dioramas for the Museum of Science.

McKinley was finally climbed the following year, by a team led by Hudson Stuck, Archdeacon of the Yukon. Stuck's party followed the route blazed by Browne's team in 1912.

Only one other landmark first ascent took place in Alaska before 1929. That was the climb of 16,390-foot Mt. Blackburn, a glaciated giant that is the highest summit in the Wrangell Mountains near the Canadian border. The peak had caught the fancy of a remarkable woman, Dora Keen, who, like Brad, had trained in the Alps. Keen had climbed Mont Blanc, Monte Rosa, and the Matterhorn in 1909 and 1910. On the second of two well-outfitted expeditions, in 1912, Keen stood on the summit with George Handy, a German-born miner whom she had recruited in Cordova, and whom she would later marry. Dora Keen was forty-one years old when she performed her triumph. Blackburn remains today the only major first ascent in Alaska led by a woman.

To put in perspective the challenge Brad faced on Mt. Fairweather in 1930, it may be helpful to draw a further comparison between the Himalaya and the great ranges of Alaska and the Yukon. The salient difference between the two mountain regions is altitude. Mt. Everest stands a full 9,000 feet higher than Mt. McKinley. The failure of expeditions in the 1920s and 1930s to reach the summits of any of the fourteen 8,000-meter peaks can be attributed directly to the ravages that thin air wreaks on human bodies. Mallory and Irvine were using bottled oxygen in 1924, but their apparatus was so heavy and unreliable that it may have hindered them as much as it helped.

Altitude is not only a formidable obstacle—it is a notorious killer. The Himalayan terrain above 26,000 feet has earned the Hollywoodish but entirely apt nickname "the Death Zone." Even today, all but the toughest climbers on the 8,000-meter peaks rely on bottled oxygen to function and survive at such altitudes. Until 1978, when Reinhold Messner and Peter Habeler reached the top of Everest without supplemental oxygen, it was widely believed that any such effort would cause irrevocable brain damage.

In Alaska and the Yukon, in contrast, altitude per se is a far less consequential matter, and almost no one uses supplemental oxygen there. In every other respect, however, the great ranges of the Far North are the equal of the Himalaya—and in three respects, the former may surpass the latter. The giant peaks of Alaska and the Yukon are every bit as big as Everest or K2. The climb up Everest from the south begins at 17,000 feet; the ascent of McKinley from the north, at only 5,000 feet. The two tallest precipices anywhere in the world, both topping 14,000 feet of vertical relief, are the Rupal Face of Nanga Parbat in Pakistan and the Wickersham Wall of Mt. McKinley.

Technically, the hardest peaks in Alaska and the Yukon stack up well against their counterparts in the Himalaya and the Karakoram. There remain today, in fact, more unclimbed peaks in Alaska than in Nepal.

The three aspects in which mountaineering in the Far North may be tougher than in Nepal or Pakistan have to do with glaciation, cold, and local villagers. Base camps on the 8,000-meter peaks are often located on gravel bars or even on grassy benches. Because the ranges of the Far North are so much more extensively glaciated, base camps on the high peaks are inevitably pitched on glaciers—making for far less comfortable living conditions, and even, thanks to crevasses, for more hazardous hangouts.

And because of the high northern latitudes from which they spring,

the biggest peaks in Alaska and the Yukon are actually colder than the Himalaya. McKinley has justly earned the sobriquet, "the coldest mountain in the world." Europeans and Asians climbing in Alaska for the first time consistently underestimate the cold, as the legions who have been injured or even killed by frostbite and hypothermia over the last four decades can attest.

Finally, the Himalayan giants are surrounded by inhabited valleys. Just a few miles below Everest base camp on the south side stand such bustling villages as Thyangboche and Namche Bazar. The nearest village to McKinley on the south is Talkeetna, sixty miles away by air, perhaps ninety by foot. And today just as in 1930, the nearest human habitation to Mt. Fairweather is the village of Yakutat, a hundred miles northwest along the coast.

The proximity of villagers allows nearly all Himalayan expeditions to count on scores of porters and dozens of Sherpas to haul loads to base camp, establish camps on the mountains, and (in the case of Everest nowadays) fix ropes all the way from base camp to the summit.

Alaska and the Yukon have no tradition of porterage. As a result, virtually every expedition has had to depend on its own members to haul loads, establish camps, and fix ropes.

This last exigency, more than anything else, presented a formidable obstacle to Brad's 1930 expedition. Even if the team had had the notion of hiring laborers out of Juneau to serve as porters, as the Duke of the Abruzzi had in Seattle, it could not afford the cost of such an extravagance. As it was, Brad's party could barely finance the hiring of a thirty-four-foot powerboat to carry the climbers from Juneau to their coastal launching point.

Fairweather had been attempted only once, in 1926, by a strong threesome: Allen Carpé, a research engineer whose specialty was cosmic rays; Andy Taylor, veteran horsepacker and hunter, who had come to the Klondike as a prospector way back in 1898; and Bill Ladd,

one of the luminaries of the American Alpine Club. The year before, Carpé and Taylor had been probably the strongest members of the team that had forged the first ascent of Mt. Logan after their four-month effort. At the time, Carpé might have been the leading American big-range mountaineer, the driving force of any party he joined. Short-tempered, he was not an easy man to get along with; behind his back, even friends called him "Cantankerous Carp." He sometimes terrified teammates, moreover, by sauntering across heavily crevassed glaciers unroped—a predilection that would prove his undoing only a few years hence.

Approaching from the coast to the west of the mountain, the trio reached 9,000 feet on Fairweather before being turned back by fiendish ice-and-snow obstacles. The men were surprised by how stout the mountain's defenses proved, but all three vowed to return.

Part of Brad's ambition in 1930, then, was to snatch a plum of a first ascent out of the clutches of the seasoned veterans who were Fairweather's passionate aspirants. Brad's effrontery at age twenty did not go unnoticed.

With a very nervous pilot running the motorboat, Brad's team wound through Icy Strait out to the Pacific, then waited out bad weather on a coastal point before pushing north. Finally, on the fourth try, the boat shot through a narrow channel into Lituya Bay, as the pilot timed the riptides perfectly so as to avoid a fatal stranding on the treacherous reefs that guard the inlet.

From the head of Lituya Bay, Brad's team was still twenty miles away from the foot of Mt. Fairweather—considerably farther than the beach from which the 1926 party had set out. A local prospector warned the young men that a landing on the outer shore of Cape Fairweather would be too dangerous, because of the huge breakers that crashed along the shore. The question was moot, for the boat's pilot was already too addled to think of attempting such a feat.

So Brad and his five game companions started humping loads alongside and across the gigantic Fairweather Glacier. Back in Cambridge, they had packed their rations with exquisite precision, in fifty matching bags, one for each day for six men. Now all that food and the concomitant gear meant one groaning backpack load after another, as the men ferried their goods toward the mountain. During several weeks of nonstop effort, they established seven successive camps along a difficult and dangerous route. At last, when the team thought it was positioned for the climb itself, despite being reduced to fifteen days' rations, they received the rudest of shocks.

A gentle rising snow slope blocked the view of the upper mountain. As Brad later wrote,

> I was the first to reach its top. I stopped short as if stunned. . . .
>
> A tremendous ice cliff four hundred feet high and absolutely vertical rose but a few hundred yards ahead of us beyond a level snow field. To the right were rock cliffs rising nearly vertically for a good 2000 feet. To the left . . . the glacier swept past us, seething in one of the grandest icefalls that I have ever seen.
>
> The way was blocked.

In camp that night, the team licked its wounds, gradually accepting the inevitable. The men would have to give up their attempt. The terrain ahead was simply too difficult, and if they ran out of food in bad weather, they could find their retreat cut off. Brad and his teammates rationalized their defeat, pretending to relish the free time they could now spend in mapping, geologizing, and shooting motion-picture footage. Slowly the team made its way back to Lituya Bay, where the motorboat pilot picked them up on schedule.

In his heart of hearts, Brad knew that his first Alaskan expedition had been an abject failure. Despite herculean backpacking, he and his

teammates had not even reached the mountain of which, back in Cambridge, they had dreamed of making the first ascent. They had not come close to matching the pioneering effort of Carpé, Taylor, and Ladd four years earlier.

Meanwhile, however, Brad had contracted with George Palmer Putnam for his third Boys' Book. It would not do to have *Bradford on Mt. Fairweather* read as a doleful tale of logistical errors, of cocky youths radically underestimating the Alaska wilderness. It would have to be packed with the same wry humor and spunky evocations of great days in the outdoors that the young author had poured into *Among the Alps with Bradford* and *Bradford on Mt. Washington*.

Brad did just that. His opening pages salute the northern frontier:

Alaska! The word alone thrills us with the glamour of exploration and adventure. Thousands of miles of unexplored rivers, vast expanses of virgin forest, glaciers, gold mines, pack trains—all these flash through our minds at the very mention of that magic country.

Of his team's objective, Brad writes, "Out of the hundreds of beautiful peaks [in Alaska] that still remain untouched by man, probably the most beautiful is Mount Fairweather." ("Untouched by man" may have been an unconscious dismissal of Carpé's 1926 attempt.)

Brad's day-by-day narrative abounds in homely evocations of chummy camaraderie: "Mosquitoes were the subject of discussion most of the night. One of the longest drawn-out arguments on the trip—and a trip of this sort has many long arguments—was among Gene, Ken, and Dick as to whether or not a mosquito can navigate in the rain." As he would throughout his life, Brad lavished adjectives on a glorious view—or equally important, on a glorious meal. Thus after a pair of teammates returned from a successful hunt, "The food for the next two days was above all our highest hopes. The grouse turned

out to be larger than a chicken and fed us all for one meal, besides making marvelous soup for the next day. The [mountain goat] kid gave us chops and then, later, liver and kidneys. Starvation Camp was forgotten in our exultation."

Yet the tension of failure hums between the lines of Brad's characteristically jaunty prose. It leaks out in the place names the team slapped on the landscape: Starvation Camp, Desolation Valley. And it pokes to the surface in passages in which Brad can no longer ignore the sheer misery of his team's toil:

> The nine days of packing out of Camp I and then the five more from Camp II to III are a nightmare as I look back at them. It seemed as if we'd never get through those terrible moraines above the bay. . . . Every night we'd peel off a layer of dripping clothes and hang them on the line outside. . . . Every morning we'd wring the water from our socks, squeeze into soaking boots, and start off again. . . . My boots, that weighed three and a half pounds before getting wet, weighed nine and a half pounds together with two pairs of wet socks after a day's run to Camp III.

Yet lest Putnam's teenage readers conclude that *Bradford on Mt. Fairweather* recounted a misadventure they themselves might have been heartily glad not to take part in, Brad closed his book with a nostalgic flourish: "But there isn't a one of us who wouldn't give a fortune to be back again in the shadow of old Fairweather packing in the rain, sleeping on the ice, eating bran-flakes and water, and playing hide-and-seek with the bears."

The next summer, in 1931, Allen Carpé, Andy Taylor, and Bill Ladd returned to Mt. Fairweather. Their fourth member was Terris Moore,

the Harvard business school student who had already befriended Brad, and with whom Brad would pull off one of his blithest expeditions in 1938. Benefiting from the knowledge gained on the 1926 attempt, the four men established a high camp within a day's shot of the summit. But then relentless storms engulfed the mountain. Inside the tent, morale plunged as the rations dwindled.

According to Moore, at one point Carpé inveighed, "If we don't climb this goddamned mountain now, that son of a bitch Washburn will come back and do it next year." Finally Ladd and Taylor volunteered to descend, so that Moore and Carpé might eke out the food supply long enough to go for the summit. In *Climbing in North America,* Chris Jones recounts that triumphant push:

> The wind was so violent that Carpé and Moore felt sure the tent would rip apart. Huddled inside, they took down the pole and clung to the flapping canvas through the night. When the storm passed, there were a couple of feet of new snow. In places they had to crawl on hands and knees to distribute their weight as they struggled toward the summit.

Fairweather would be Carpé's last first ascent. The next year, on Mt. McKinley's Muldrow Glacier, he and his new partner, Theodore Koven, both died when they skied unroped into a crevasse. Carpé's body was never found. One of the greatest American mountaineers of his generation remains virtually forgotten today.

Almost eighty years later, it is hard to know how Brad really felt about Alaskan mountaineering after his Fairweather debacle. In an article he wrote about the trip for *The Sportsman* magazine, with no pressure to edify young readers, Brad admitted that his first expedition to the Far North had been a "great disappointment," a "bitter introduction to Alaska mountaineering." Yet the bluff, resilient tone in which

Brad narrated even the most disheartening setbacks in *Bradford on Mt. Fairweather* was more than mere literary posturing. That tone sprang naturally from the combative, can-do optimism with which Brad went at life itself. Even a total defeat in the mountains was a grand adventure ("grand" being one of Washburn's favorite adjectives).

Yet in the summer of 1931, Brad returned not to Alaska but to Chamonix. The year before, as he had toured the United States giving lectures about his climbs, Brad had met Burton Holmes, a flamboyant entertainer who has been credited with inventing the "travel film lecture." Holmes was impressed with the movie footage Brad had brought back from the Alps. Now, in 1931, he commissioned Brad to make a commercial film of an ascent of Mont Blanc by the regular "tourist" route. Brad spent most of the summer shooting the film. Already, both still photography and motion-picture making had become serious hobbies for the young adventurer. But in terms of mountaineering achievement, the summer after his sophomore year at Harvard represented his least ambitious climbing season since 1928, when he had stayed home to ramble through the White Mountains.

When he came back from France to learn that Carpé and Moore had bagged the first ascent of Fairweather, Brad was further dismayed. But Alaska—or perhaps the sting of defeat itself—had gotten under his skin. For the summer of 1932, he rounded up another gang of cronies. Their number included Bob Bates, who would become Brad's best friend.

The failure of the 1930 expedition had chastened Brad, but also goaded him. In 1932—uncharacteristically, in view of his subsequent career—he chose as an objective not an unclimbed Alaskan mountain, but an attempt to make the second ascent of Fairweather.

Brad had inherited the then-current style of Alaskan mountaineering from his predecessors, including Henry Hall's team on Mt. Logan. That style was inherently slow and tedious, relying on the accretive

buildup of camps well stocked by multiple-load carries. But it was a style completely at odds with Brad's temperament. In 1983, in a profile published in *American Photographer,* Brad commented about his large-format aerial picture-taking, "A lot of people have said to me, 'You must have an enormous amount of patience.' Actually, I'm impatient as hell. I'm just stubborn."

No truer self-assessment would ever issue from Brad's mouth. It was impatience that spoke in Brad's letter to his father from Groton demanding that he find his radio and "ship it up full speed." It was stubbornness that made him play varsity football even though he weighed only 112 pounds.

Now, in 1932, stubbornness dictated plugging away at Fairweather even though Carpé and Moore had snatched its first ascent. And impatience drove Brad to tinker with the received expedition formula, to find a faster and easier way to get to the base of the mountain.

Ever since childhood, when Brad had accompanied his mother on his first flight—a sightseeing tour over Boston Harbor—Brad had been fascinated by airplanes. In 1926, his first view of the Alps had come not on the drive into Chamonix, but when his parents had hired two pilots to fly the family from Lyon to Geneva in a pair of already antiquated World War I biplanes. As the seventeen-year-old graybeard wrote in *Among the Alps,* gazing at the Mont Blanc massif from midheight, Brad was thrilled by "the most wonderful ride that I have ever taken."

Now it was Brad's intuition to hire a bush pilot with a floatplane to land his 1932 party on a lake close to Fairweather's base, eliminating the long, risky approach by motorboat and the arduous load-ferrying operation from Lituya Bay that had defeated the 1930 attempt. Brad was not the first mountaineer to apply aircraft to the assault of Alaskan mountains. That very spring, more than a month before Brad's team would approach Fairweather, Allen Carpé had talked the daring pilot Joe Crosson into attempting a ski-equipped landing at 5,700 feet on

the Muldrow Glacier on Mt. McKinley. Not without trepidation, Crosson flawlessly pulled off the first mountain ski-landing anywhere in the world. That plucky deed saved the party a twenty-five-mile hike in from Wonder Lake, which would have necessitated a ford of the treacherous McKinley River—but it did not save the team from its terminating tragedy, when Carpé and Koven skied into the crevasse that killed them.

In the summer of 1932, everything worked like clockwork until the plane circled over the lake Brad had chosen for a landing place. To the party's shock, they saw at once that the lake's surface was frozen solid. There was no choice but to backtrack and land on Lituya Bay. The team had thereby leapfrogged over the uncertain approach by motorboat from Juneau. But now, the same interminable load-ferrying ordeal toward the dead-end ice cliff was the climbers' only option.

As Brad would recall decades later, "I made a snap decision: I said the hell with Fairweather." The team would instead turn its efforts toward another peak, Mt. Crillon. At 12,726 feet, it was more than 2,500 feet lower than Fairweather, but it was a giant mountain in its own right, second highest in the range, and it had never been attempted or even approached. It would also turn out to be every bit as difficult as Fairweather.

From the head of Lituya Bay, Brad's team headed east up the North Crillon Glacier, in almost the opposite direction from the Desolation Valley of 1930. This approach meant three weeks of grueling backpacking not unlike the gauntlet of two years before. Route finding proved intricate and deceptive, as the team eschewed a direct approach up the icefall-scored South Crillon Glacier in favor of a roundabout itinerary farther south. At the end of all their toil, the party had reached 7,000 feet on a subsidiary ridge south of the mountain, but it had no time left to attempt the ascent.

The 1932 expedition had been only a little more successful than

the 1930 fiasco on Fairweather. Three years later, in his *National Geographic* article, Brad would admit that his 1932 team had been "overconfident at the start, [and] exasperated at the close of summer." But by now at least Brad knew he had discovered the route by which Crillon could be climbed. Stubborn as ever, he started planning a 1933 expedition as soon as he got back to college.

By his junior year at Harvard, Brad had come under the academic sway of the geographers and geologists who taught in the newly established Institute for Geographical Exploration. It was thanks to these professors (including Noel Odell) that Brad determined to mix real science with his mountain climbing. Geology and mapmaking would play central roles in Brad's 1933 Crillon attempt, as in most of his subsequent expeditions.

Later in the twentieth century, all kinds of attempts to link "science" to mountain climbing would come to be viewed with a jaundiced eye. All too often, the gathering of specimens or the recording of data would prove transparent boondoggles cooked up to raise funding for wilderness larks. Even today, such unholy alliances abound, as teams purport to climb Everest in support of breast cancer research or dogsled through the Arctic to document global warming.

There is no doubt, though, that Brad was serious about his geology and cartography. And in that respect, he was firmly lodged in an honored tradition of scientific exploration. Modern readers of Robert Falcon Scott's legendary diary of his trek to the South Pole in 1911–12 and the deaths of his team of five on the return journey are incredulous to learn that to the very end, when every ounce of expendable baggage needed to be thrown out, Scott kept thirty pounds of rocks—geological samples—on his sledge. And Apsley Cherry-Garrard's account of the same expedition, *The Worst Journey in the World* (one of

the finest expedition books ever written), vividly recounts the midwinter journey to Cape Crozier undertaken by "Birdie" Bowers, Edward Wilson, and himself to collect penguin eggs. The biological theory of the day that motivated this desperate jaunt (the "worst journey" of the title) was based on a scientific tenet that has since been exploded—the "ontogeny recapitulates phylogeny" fallacy, in this case the presumption that the embryos of the most "primitive" species, such as penguins, would provide a direct window into the early stages of animal evolution.

This is not to say that Brad was a stellar student. Despite eventually graduating cum laude, Brad struggled to maintain a B average at Harvard. In his four undergraduate years, he got As in only two subjects: English and geography during his junior year. His worst grades were a trio of sophomore Cs, in anthropology, paleontology, and psychology. He met his language requirement by passing exams not only in French, but in his hated Latin.

As during his Groton years, at Harvard "outside activities" took too many hours and days away from Brad's studies. By his sophomore year, he was pursuing the lecture circuit more ardently than ever. Often he would take off in the middle of a school week to deliver a talk in Chicago, Milwaukee, or Saint Louis. He was paid as much as $200 for these performances.

Photos of Brad from his college years reveal a strikingly good-looking young man. In most of those pictures, he wears an open, jubilant grin. His most prominent feature is a jutting chin—indeed, a classic lantern jaw. His nose was as aquiline as any Roman's. All in all, Brad's visage looks so alert and forceful that it is easy to forget what a slight fellow he was. He never grew taller than five foot seven, and he seldom weighed more than 145 pounds all his life.

It is surprising to learn that Brad took dancing lessons in college. Despite this effort at self-improvement, Brad was shy around women.

In 2002, speaking of the social life of the whole HMC, Brad told journalist Donald Smith, "I think a lot of people viewed us climbers as sort of cockeyed people. We didn't get involved with that sort of thing. I didn't even pay much attention to girls. I suppose I was too damned busy with mountaineering and lecturing."

The team Brad assembled for his 1933 attempt on Crillon was probably the strongest he would ever launch in the field. Along with chums Walt Everett and Bill Child, the party was rounded out by Bob Bates, Charlie Houston, and H. Adams ("Ad") Carter. The last three would go on to become some of the preeminent American mountaineers of the century, as well as crafting distinguished careers outside the mountains. The 1933 expedition was the only one that ever brought together four of the Harvard Five, lacking only Terris Moore.

Benefiting hugely from the 1932 reconnaissance, Brad's team established a high camp at 6,600 feet, then climbed through an ice cliff to reach what they called the Great Plateau at 8,000 feet, some four miles south of Crillon's summit. But along the way, Brad had the most serious falling-out with a teammate that would mar any of his expeditions, when he and Houston had a bitter argument about route finding. As leader, Brad prevailed. The rest of his life, Brad always privately told the story as an I-told-you-so: had the team followed Charlie's advice, several members would most likely have been killed in an avalanche. For his part, Charlie always minimized the dispute.

Three years younger than Brad, and two years behind him at Harvard, Charlie had his own considerable teenage experience in the Chamonix Alps. After Brad, he was by far the strongest climber in the 1933 party. But he was also every bit as strong-willed and stubborn as Washburn.

When it came time to choose the summit party, Brad designated Bates and Everett to accompany him. The other three men were deputed to bag the easy summit of Mt. Dagelet, a 9,650-foot peak south

of Crillon. For Houston, Carter, and Child, Dagelet was a first ascent, but Charlie was dismayed to be relegated to the expedition's consolation prize.

Meanwhile, Brad and his two teammates marched confidently toward the summit pyramid of Crillon. Just when they thought they had the peak in the bag, they ran into slopes loaded with deep, soft powder snow. Then, as they floundered through these fiendish drifts, a sudden storm swept over the mountain. Still, the trio pushed on. In a blowing mist that limited their vision, they reached the apparent summit. The men shook hands, and Brad started to tie an American flag to a trail marker for an "official" summit photo. Then, as Bates wrote decades later,

> Walt asked, "What peak is that?" Clouds kept blocking the view, but we could glimpse a peak ahead. At first we thought it was Fairweather, but in a few minutes we had a better view. It was the summit of Crillon and still a long way off. We were on the high point of the ridge, but not on the summit.

There was no choice but to go down. Crillon was still unclimbed.

In a sense, Charlie never got over Brad's snub. The two men never climbed together again. Houston would go on to lead the landmark 1938 and 1953 American expeditions to K2, the world's second-highest mountain. It was no accident that he didn't invite Brad (who was arguably more qualified than all but one of the teammates Charlie did invite).

Remarkably, though, despite their 1933 falling-out, Charlie and Brad stayed good friends for seventy years after Crillon. Each man publicly praised the other to the skies, both as a climber and as a teammate. As of this writing, Houston, at ninety-four, is the only one of the Harvard Five still alive.

◆ ◆ ◆

Other mountaineers would have given up on Crillon after two disheart-ening failures. But for Brad the perfectionist, that last summit ridge represented a void that must be filled.

Brad had graduated from Harvard just weeks before the 1933 expe-dition. Turning his back on French literature and history, he enrolled for graduate studies in the Harvard Institute for Geographical Explo-ration. And for the summer of 1934, he put together his third Crillon expedition.

The eleven-man team was a mixture of climbers from Harvard and Dartmouth. Besides Brad, the only returnee from the previous year was Ad Carter. Bob Bates would have given much to be along, but by now he was in grad school studying English literature at the Univer-sity of Pennsylvania, and he felt duty bound to spend the summer in the library, researching his thesis subject, the eccentric antiquarian and biographer John Aubrey.

In 1934, Brad finally turned his back on the old Alaska expedition style with a vengeance. The fast-and-light alternative that he would perfect got its first real trial that summer on Crillon. And, as a born gadgeteer, Brad threw all kinds of technology into the ascent that had seldom or never before been used on Alaskan mountains.

Brad hired pilot Gene Meyring to fly the team in in his Lockheed Vega on floats. Instead of landing on Lituya Bay, Meyring put his plane down on Crillon Lake, much closer to the mountain. (According to local knowledge, the lake had supposedly "drained out," but Brad's team found it brimming with glacial melt, five miles long by half a mile wide.) Before the party flew in, however, Meyring flew Brad around the upper slopes of Crillon. To get good pictures of all sides of the peak and its approaches, Brad had the pilot take the passenger-side door off the plane. The resulting flight was so cold that Brad operated his camera from inside a sleeping bag!

During the flight, Brad memorized scores of landmarks that would later prove crucial to success. He also spotted what he thought would be a better route on the summit pyramid than the one he, Bates, and Everett had followed the year before.

Science, however, was also high on Brad's list of priorities. Brad wanted to measure the depth and motion of the South Crillon Glacier—the kind of inquiry that no one had yet undertaken in Alaska or northern Canada. Early on the expedition, Brad and teammate Dick Goldthwait (a Dartmouth geologist) figured out a way to set off sticks of dynamite on the surface to make seismic soundings. They came up with the result that the glacier was a remarkable 840 feet thick near where it calved into Crillon Lake, only 315 feet above sea level. They also proved that the massive icefield was advancing at the average rate of two inches per hour—faster on clear days, slower on rainy ones.

That kind of obsession with details would stamp Brad's whole career as a scientist. Was the daily two-inch creep of the Crillon Glacier truly important to science? No matter: the precision of the measurement was a reward for Brad—just as, many decades later, he would prove that Mt. Everest was actually seven feet higher than the altitude it had been given for half a century.

After Meyring had deposited the party on Crillon Lake, he used the Vega to make the first mountain airdrops in Alaskan history. The bane of both the 1930 and 1932 expeditions had been the weeks expended in grueling load carries from camp to camp. Even in 1933, those gear ferries had used up so much time that the team had only one shot at the summit. An airdrop might offer the 1934 party a priceless shortcut to the upper mountain.

Brad chose a broad snow saddle the 1933 party had named the Knoll, at 5,675 feet. He and Meyring loaded the plane with thirty-one padded boxes of food and gear. Then he jackknifed himself in the rear seat, like another piece of cargo.

Many a later expedition would perform disastrous airdrops, either

destroying their supplies on impact or, in several cases, ending up unable to find their precious goods, so bewildering was the mountain terrain. From a full thousand feet above the Knoll, Brad pushed the boxes out the door one by one as Meyring circled. The next day, from base camp on Crillon Lake, the team made a herculean climb of 5,300 feet to retrieve the boxes before new snow could cover them. So skillfully had Brad and Meyring managed the airdrop that, as Brad wrote in his diary, "We tallied up our heaps and found every single thing. Only six or seven cans had been ruined from a box of peas that split open. A worthwhile sacrifice."

The airdrop made a huge difference in the party's progress. So did a camp-to-camp radio apparatus, powered by a lawn mower motor, that Brad had adapted to expedition routines—yet another Alaskan mountaineering first.

On July 19, only twenty-six days after starting out from Crillon Lake, Brad and Ad Carter stood on the summit in a bitter wind. (Compare that span of time to the four months it had taken the 1925 party to climb Mt. Logan.) As Brad wrote in his diary, about the steep slope below the summit cone, "The plane trip [i.e., the aerial reconnaissance] saved us a long detour, for I had the whole route perfectly imprinted on my mind." Of the moment of long-awaited triumph: "At ten seconds before 12:30, we planted our axes atop the peak of Mount Crillon and shook hands till our wrists ached." (Those ten seconds were pure Brad—the fanatical stickler for precision.)

Brad and Ad performed "a glorious ski descent" (another Alaskan first) all the way back to their high camp at 6,600 feet. The next day, Brad made a horrible discovery—"that the lens of the still camera has been loose all this summer so far." The pictures from summit day, he was sure, were ruined.

For the precisionist, there was only one possible response—climb the mountain all over again. On July 21, just two days after the monumental first summit push, Brad, Ad, and Waldo Holcombe repeated

the grueling 6,100-foot ascent. "And this time," he vowed to his diary on the eve of departure, "we'll bring not only Ad's trusty little Kodak, but my repaired large camera and our big 35mm movie camera"—thirty-five pounds of photographic gear, all told.

The trio left camp at 12:35 A.M., in the penumbral Alaskan night. They reached the summit at 10:45 A.M., in much pleasanter conditions than two days before. "We spent over an hour on top," Brad later wrote in his diary, "then headed back down, much happier than anybody else, anywhere in Alaska, at that moment."

The only serious injury that would ever befall any of Brad's teammates on his expeditions to Alaska and the Yukon occurred on the descent from high camp on Crillon. Not surprisingly, Brad omitted any mention of the accident in the article he would write for *National Geographic*. Surprisingly—and perhaps tellingly—he also neglected to record the mishap in his Crillon diary.

In 2005, Brad recounted the accident to Lew Freedman. Among the team members carrying ninety-pound loads down the mountain was Ted Streeter, a relatively inexperienced climber from Connecticut. As Brad told Freedman,

> We were near the end of the trip, and I said at the top of a steep slope, "I think we ought to go to the left. I think it's safer to descend that way." . . . Ted went the other way, then all of a sudden, he went head-over-heels right past me. It was a miracle that he didn't knock me over. He fell all the way to the bottom of the steep slope we were descending, and he lost a finger when he hit a rock that cut it right off.
>
> I never said, "You damned fool"—which would have been very easy to do. What he did was indeed very foolish, trying to take a shortcut that didn't pay off. When you're the leader, you've got to hope that everybody else will go where you tell them.

Lost in Brad's I-told-you-so account from a retrospect of seventy years is any inkling of how Streeter reacted to the injury, or how the team treated an amputated finger (with its consequent gushing flow of blood) in the field.

At the end of July, Meyring flew the party out from Crillon Lake—but not before the expedition ended with the kind of bang that only a gang of hearty overgrown boys could have concocted (Putnam's readers would have delighted in this denouement, but by now Brad was twenty-four). Among their gear, the team still had 125 sticks of unused dynamite. The pilot was not eager to carry out such cargo. In his diary, Brad recorded the solution:

> When we established this camp, we had made a big toilet at a site between two large spruce trees. Russ [Dow] had brought along a beautiful new toilet seat, which we installed on top of two long poles, fixed halfway between the trees. Directly below the seat we dug a deep hole. During the summer, it became almost filled with you-know-what.

Rigging a long fuse, the men "cowered in a nearby safe spot and pushed the lever."

> This was not an explosion. It was a gigantic roar!
> The two trees which held the seat were laid flat on the ground, all of their branches stripped clean. A huge sheet of flame rose high above the lake. Russ insisted he clearly saw his toilet seat, swirling around, at least a thousand feet in the sky.

Washburn's first three Alaskan expeditions, to be sure, had been failures—if failure is defined as not reaching the summit. But with Crillon in 1934, he began a truly incredible string of successes. Never

again would Brad set out to climb a mountain and fall short of the summit. And all of his subsequent expeditions except two (the third and fourth ascents of Mt. McKinley) had as goals unclimbed mountains or new routes. Brad's record of success has never been matched by any climber anywhere in the world among the great ranges.

3

Blank on the Map

In the fall of 1934, Brad began his second year of graduate school at Harvard's Institute for Geographical Exploration. To save money during these still lean Depression times, he had moved back into the Deanery on Mason Street with his parents, which cannot have marked an improvement in his social life. At twenty-four, however, the ambitious explorer still did not "pay much attention to girls."

Despite his extraordinary accomplishments at such a young age, Brad's mother was worried about his career prospects. She "was very frightened that I was going to be a guide," Brad told Donald Smith in 2002. This, even though such a vocation scarcely existed at the time in the United States. "I always said to her," Brad added, "'I'm doing the climbing because I love to do it. . . . I love to take pictures of the mountains because I enjoy taking pictures. But don't worry, I'm not going to be a guide.'"

Ever since his first lecture at the National Geographic Society's headquarters four years earlier, Brad had had a cordial relationship

with Gilbert Grosvenor, the organization's president. Then as now, the NGS cultivated a small band of explorers whose derring-do validated the society's image as an organization at the cutting edge of scientific and geographical discovery (as well as helping preserve the company's tax-exempt status). The society funded the expeditions of these men, and the magazine regularly published accounts of their adventures.

Before Brad's time, that small band of NGS heroes included, among others, polar explorers Robert Peary and Richard E. Byrd, as well as paleontologist Roy Chapman Andrews. It would be hard to overstate the importance of being championed by the NGS in the 1920s and 1930s. *National Geographic* was far and away the most widely read publication in the world devoted to exploratory missions of all kinds. In the pages of the "yellow magazine," millions of Americans, young and old, gained their most vivid acquaintance with far-off cultures and lands. When, on occasion, NGS stalwarts were criticized, the society sprang fiercely to their defense.

It is by now fairly conclusively proven, for instance, that Peary faked the discovery of the North Pole in 1909, and that Byrd faked the first flight over the Pole in 1926. After decades of controversy and mounting evidence against Peary, the NGS commissioned an independent inquiry into his claim, which was conducted by Wally Herbert, the British explorer who had made the first traverse of the Arctic in 1968–69. Herbert concluded that Peary had indeed failed to reach the North Pole. In 1988, the magazine published a watered-down version of Herbert's findings, but when *Geographic* editors learned that the Englishman planned to lay out his case in great detail in a book (eventually published as *The Noose of Laurels*), the society reassigned the inquiry to an insider. In 1990, *National Geographic* published this functionary's whitewash of Peary, which in turn rejected all of Herbert's findings. (In midlife, Brad himself would devote many months to debunking the claim of another notorious American hoaxer, Dr. Freder-

ick A. Cook, who went to his grave insisting that he had made the first ascent of Mt. McKinley in 1906.)

During the early 1930s, Gil Grosvenor kept his eye on Washburn's mountaineering exploits. Now, with the ascent of Crillon, the magazine was ready to publish Brad's account of the climb. Admiring not only the deed, but also the superb photos Brad had brought back from Alaska, Grosvenor wrote, "All of us here at the National Geographic Society are much impressed by your ability and success in achieving what you set out to accomplish."

Brad lectured on Crillon at Constitution Hall at the end of January 1935. And his article, "The Conquest of Mount Crillon," ran in the March 1935 issue of *National Geographic.* At a length of forty pages, with forty-two illustrations (mostly Brad's photos, plus a few maps adapted from Brad's surveys in the field), the article got lavish treatment, and Brad was paid the handsome fee of $500 for the piece.

Right at the start, however, Brad nearly jinxed his relationship with the NGS. When Grosvenor discovered, in October 1934, that Brad had already published photos from the Crillon expedition in the *New York Times* and in a short-lived paper called the *Sunday Star,* he fired off a letter to the young mountaineer warning him that the society considered its acceptance of articles as guaranteeing exclusive rights to all text and photographs. It was a good thing that Grosvenor failed to find out that Brad had also, within weeks of returning to Cambridge, published pictures in the *Boston Herald* and the *Philadelphia Evening Bulletin* and sold images as stock to World Wide Photos. In addition, he had been interviewed by a number of newspapers and had promised articles to the Royal Geographical Society and to *Alpinisme,* the journal of the French Alpine Club.

Brad's indiscriminate hustling of publicity was naive, not duplicitous. Back in 1926, when he had had his guidebook to the Presidential Range privately published, the sixteen-year-old author and his

benefactor-uncle had pitched the book to every magazine and newspaper in the Northeast, in hopes of soliciting reviews. (Remarkably, the book was still in print in 1934; that December, Brad received a royalty check of $7.68 from Davis Press in Worcester.)

Brad had paid his way through college in part by going on the lecture circuit. It never occurred to him not to turn his Crillon triumph into a barnstorming attraction. Along with speaking to the NGS, Brad gave Crillon talks in numerous other venues, ranging from Williams College to the Explorers Club in New York City. By 1935, Brad had put together a flier promoting his talk, "Attack on Crillon." The announcement featured a picture of the explorer wearing his cold-weather gear, lugging a large-format camera, trademark grin in place. It promised "3000 feet of moving pictures" and "nearly 100 colored slides" and came stamped with testimonials from the likes of Roy Chapman Andrews ("His wonderful lectures are a delight"). A later version of the flier bragged, "Acclaimed as the most beautiful and thrilling exploratory pictures ever taken."

Over the decades, the proprietary NGS has always taken a very dim view of such authorial self-merchandising. Many a *National Geographic* assignment has been killed when the author has published a single photo or granted a brief interview, even in an obscure local newspaper. But in the fall of 1934, Grosvenor let Brad off the hook with a gentle rap on the knuckles.

Unfortunately, the fuss over Crillon also brought Brad the first serious derogations that the twenty-four-year-old adventurer would have to endure. At the time, another of the NGS's fair-haired boys was Father Bernard Hubbard, nicknamed "the Glacier Priest." Trained as a Jesuit, Hubbard had started leading expeditions to Alaska in 1927. These missions mingled geology, paleontology, ethnography of the natives, and exploration for its own sake. Hubbard specialized in the Alaska Peninsula and the Aleutian Islands, which are hammered by the worst weather in all of Alaska. In his youth, the priest had done

a little climbing in the Austrian Alps, but he never became a serious mountaineer, although he did make a number of first ascents of low volcanic peaks in his favorite wilderness. By their very nature, most volcanoes are uninteresting challenges for climbers: they tend to be walk-ups, and the rock of which they are made is usually too rotten to allow technical climbing. (Among good mountaineers, the dismissive epithet for such peaks is "slag heaps.")

Like Brad, Father Hubbard brought back excellent photos and motion pictures from his expeditions. By 1934, at the age of forty-six, he had launched a hugely successful career as a public speaker, claiming at one point to be the world's highest-paid lecturer (snagging fees up to $2,000 a talk). Hubbard once said, "I'm a good showman—God has given me the ability, and I'm using it for the work." In 1935, he would publish *Cradle of the Storms,* a very popular book about his Aleutian ramblings.

National Geographic had regularly published Hubbard's accounts of his expeditions. Though these stories were heavy on science, the Glacier Priest's work in the field was not taken seriously by professional geologists and paleontologists. Now, in the fall of 1934, Hubbard was rankled by the big splash being made by a twenty-four-year-old upstart mountaineer. Hubbard wrote to Grosvenor, sneering at Crillon as a "lousy little mountain, one that we would have taken in stride on our way to something else."

Grosvenor evidently recognized Hubbard's attack as the wounded pride of a jealous man, for he shared the priest's aspersions with Washburn. Brad shot back in kind. Hubbard was, Brad wrote Grosvenor, more of a "Frank Buck type explorer than anything else." (Frank Buck was the self-publicizing animal collector from Texas, whose *Bring 'Em Back Alive* became a runaway bestseller.) Dismissing Hubbard in turn as a "publicity hound" and a "headline hunter," Brad asked Grosvenor to judge for himself whether Crillon was not a far stiffer mountaineering challenge than the "four-thousand-foot hills of the Aleutians" on which Hubbard had made his own first ascents.

In this exchange, perhaps for the first time, another aspect of Brad's character came to the fore. Though all his life he considered it unethical to criticize other explorers in public, Brad could never tolerate ignorance or incompetence. And when attacked, he was incapable of turning the other cheek. The barbs of his wit were never sharper than when he responded to denigrations of his own deeds with fiery put-downs in return.

With Crillon under his belt, Brad was ready to tackle even more serious challenges. Already, by the early autumn of 1934, he had set his eyes on what in some ways was the finest remaining mountaineering prize in North America. At 17,150 feet, Mt. Lucania, in the Saint Elias Range of the Yukon Territory, was now the highest unclimbed peak on the continent. It was also one of the most remote. Few white men— explorers, hunters, or prospectors—had ever set eyes on it.

Only weeks after his return from Alaska, Brad started preparing for an expedition to Lucania. He was adamant that the team include Bob Bates, whose absence from the victorious 1934 Crillon trip, after he had reached a point only 400 feet below the summit in 1933, Brad keenly regretted.

Just as they began laying plans, however, Brad and Bob were contacted by Bill Ladd, the American Alpine Club dignitary who had been a member of both the 1926 attempt and the 1931 success on Mt. Fairweather. Ladd was acting as an intermediary. It turned out that another American climber, Walter Wood, was also planning to attack Lucania in the summer of 1935. A 1926 graduate of Harvard, six or seven years older than Brad, Wood had top-level connections in the AAC; he also was a bigwig in both the Explorers Club and the American Geographical Society. In addition, Wood was independently wealthy.

Ladd had volunteered to take on the delicate task of asking Brad

and Bob to step aside from Lucania. That sort of deferential sacrifice went completely against Washburn's grain. However, for the sake of harmony within both the Explorers Club and the AAC (which Brad had joined in 1931 and 1934, respectively), he acceded. "We knew Walter," Brad would recall some sixty-five years later. "We liked him. But I think Walter always thought he was a little better than anyone else." Privately, Brad hoped Wood's attempt on Lucania would end in failure.

At once, Brad cooked up a comparably ambitious expedition plan as an alternative. In November 1934, he presented a proposal to Gil Grosvenor that was shrewdly calculated to play on NGS sympathies and interests.

Mt. Fairweather, the objective of Brad's first northern expedition, stands exactly on the border between Alaska and Canada. Mt. Crillon is only a few miles southwest of the border. As early as 1890, government expeditions had explored the coastal ranges as they tried precisely to fix the boundary between the two countries. The first such jaunt had been led by Israel Russell, who worked for the U.S. Geological Survey. The expedition had been partly financed by the NGS, which had been founded only two years before. On that trip, Russell made a gutsy first attempt to climb Mt. Saint Elias, seven years before the Duke of the Abruzzi would pull off his dazzling first ascent. Russell's account of that attempt was published in *National Geographic* in 1891.

Russell also surveyed one of the loftiest peaks on that border, an ice-and-snow giant rising to 15,015 feet, some fifty miles east of Mt. Saint Elias. The USGS explorer named the peak Mt. Hubbard, after Gardiner G. Hubbard, founder and first president of the NGS.

By 1934, it had been twenty-one years since the last boundary commission had hit the field. That 1913 expedition, however, had been led by Ralph Tarr and Lawrence Martin, who were likewise sponsored and published by the NGS. Brad knew that all the efforts of the various

commissions had still left a huge area unsurveyed and unmapped—
all the terrain lying between the boundary and Kluane Lake in the
Yukon. At 6,400 square miles in extent, that region amounted in fact
to the largest remaining blank on the map of North America. In their
NGS report, Tarr and Martin had described this glaciated wilderness
as "still largely unexplored." In his November 1934 proposal, Brad re-
minded Grosvenor of the society's keen and long-standing investment
in that wilderness.

What Brad now offered to undertake was not a mountaineering
expedition, but a traverse of the great blank, surveying and mapping
along the way. It was a wildly audacious proposal, but Grosvenor loved
the idea. With very little hesitation, the society agreed to fund the ex-
pedition to the tune of $7,500—a much greater sum than what Brad
had scrounged together to pull off his Crillon climb. Grosvenor fur-
ther promised Brad, as expedition leader, a "nominal" salary of $125 a
month, to commence on February 1, 1935.

Having forgiven Brad his promiscuous publishing of photos and
granting of interviews about Crillon in the fall of 1934, Grosvenor now
offered the twenty-four-year-old grad student a job on the editorial
and photographic staff of the magazine. It was the kind of plum op-
portunity almost any young adventurer would have leaped at, but in-
stead of giving Grosvenor an immediate answer, Brad stalled for time.
Throughout the upcoming expedition, he would brood over the offer.

With Grosvenor's encouragement, Brad drafted a letterhead for ex-
pedition stationery. It was printed as:

National Geographic Society
Yukon Expedition
1935

Director
Bradford Washburn

Brad further offered to try, near the end of the traverse of the Saint Elias Range, to make the first ascent of Mt. Hubbard, the majestic peak named after the NGS's founder. (The mountain had never been approached, let alone attempted.) Grosvenor was delighted with the idea, and at once demanded that Brad keep the projected climb a secret. If the team could make the first ascent of Mt. Hubbard, that promised a major publicity coup for the NGS.

At the last minute, though, Grosvenor began to get nervous about turning loose the brash and cocky young mountaineer on so daring a project. On January 16, 1935, he sent Brad a long letter detailing "a few lines of caution." The tone, which brought out Grosvenor's (and the society's) latent pomposity, is that of a stern father lecturing his potentially wayward son:

> *The National Geographic Society has sent into the field many*
> *expeditions, and I am happy to state that in not one of them*
> *has there been any loss of life or any serious accident. . . . This*
> *fortunate record is due to the care with which the personnel has*
> *been selected and to the careful detailed planning with which every*
> *expedition has been organized. . . .*
>
> *Yours is the first expedition which we have entrusted to a man as*
> *young as yourself. . . .*
>
> *While we shall be pleased if the explorations which you desire*
> *to make are successfully carried out, we wish you to realize that*
> *The Society is more interested in the safe return, uninjured, of each*
> *member of your party.*

The kinds of dangers about which Grosvenor was leery ranged from falling into huge crevasses to freezing to death to getting lost. Grosvenor went on to wonder whether Brad's past achievements

might very naturally lead you to be a little over-confident and to
take risks in this summer's expedition that an older man might not
venture to undertake. Therefore, please realize that the National
Geographic Society most emphatically instructs you to take no
chances in flying or in mountain climbing or in surveying that may
imperil your life or the life of any member of your party.

Brad's response to this letter is not on record, but he must have reassured Grosvenor that he would traverse the blank in the map as safely as was humanly possible. In his heart, of course, Brad knew that the "emphatic" order of Grosvenor's last "instruction" was absurd: there was no such thing as exploration without risk.

That spring, Brad plunged without an iota of self-doubt into planning the expedition.

On Crillon in 1934, with his inspired use of floatplane, radio, and airdrops, Brad had begun to revolutionize North American mountaineering. Instead of the old laborious relaying of loads as the team built a pyramid of camps and supplies toward the summit, Brad was inventing a new "fast and light" style for attacking remote, massive, and lofty mountains. That style would reach its apotheosis in Brad's 1937 and 1938 expeditions. But in 1935, for his Saint Elias Range traverse, Washburn concocted a logistical plan that was sui generis—a bizarre and yet brilliant mélange of new technology with means of locomotion and transport that were already old-fashioned by 1935.

During the early winter months, Brad put together his team. Bob Bates was of course the first to be invited. Bob went to the trouble of traveling to Washington to meet Grosvenor, who wrote Brad within days, "I am much impressed by the bearing of your associate, Mr. Bates."

Brad's next choice for the party was not a Harvard chum, but Andy Taylor, the veteran of the first ascents of Mts. Logan and Fairweather. By 1935, Taylor was sixty years old, but still tough as nails. The man had an extraordinary résumé of northern adventure. He had run away from his prosperous Canadian family as a teenager, fetching up in the Yukon. During the 1898 gold rush, he had packed horses out of Skagway; he had also piloted a steamboat on the Stikine River. He liked to brag that he had "made three fortunes and lost two and a half" while based in the rough-and-tumble frontier town of Dawson City. He had served for several government surveying expeditions as a professional big-game hunter.

It was not so much for these skills or for his climbing strength that Brad invited Taylor, but rather for his decades of experience running dog teams. Taylor had learned the art from its masters, Eskimo (Inuit) men with whom he had made a winter traverse of the Brooks Range in far northern Alaska. In turn, Taylor arranged for a young man who lived on Kluane Lake in the Yukon to join the team. Johnny Haydon (known to his teammates as "Jack"), born to an English father and an Indian mother, was also an expert dogsledder. Brad offered him five dollars a day to lend his talents to the party.

Indeed, from the moment he had cooked up his proposal, Brad had decided that teams of huskies would play an integral role in the expedition. As late as 1934, dogsleds still promised the most efficient means of carrying heavy loads of supplies across vast glacial expanses.

Rounding out the party were Ad Carter, who had reached the summit of Crillon with Brad the year before, and two other climbers roughly Brad's age—Vermonter Hartness Beardsley and Ome Daiber, one of the strongest mountaineers in the Seattle area.

Brad's four previous Alaskan expeditions had all taken place during the summer. But he knew that glacier travel was far more dangerous and difficult in the warmth of June, July, and August than in the spring

months. Despite the inhuman cold his team would be forced to endure, Brad determined to launch the three-month expedition in the deep freeze of late February. (How he persuaded his professors at Harvard that missing the whole spring semester would pose no threat to his grad school progress is not on record. Adventurers themselves, his mentors in the Institute for Geographical Exploration evidently indulged Brad's hooky-playing whims.)

By February 25, most of the team had assembled in the Caribou Hotel in Carcross, a forlorn ex–gold rush outpost forty miles south of Whitehorse, the capital of the Yukon Territory. The year before, Brad had used Gene Meyring's floatplane to bring his team in to a base camp on Crillon Lake. Now Brad planned an even bolder launch—to use a bush plane on skis to land somewhere in the Saint Elias Range and set up a glacier base camp in the heart of the unexplored wilderness. The logistics would require flying in not only men, food, and gear, but dogsleds and the dogs themselves. Ski-plane landings on northern glaciers had been pioneered only three years before, with Joe Crosson's plucky put-down on the Muldrow Glacier on Mt. McKinley. A landing in the heart of the unmapped Saint Elias Range promised an even sterner challenge.

Before establishing his base camp, Brad planned to make a series of reconnaissances of the blank on the map by air, as he shot large-format pictures through the opening left by removing the plane's passenger-side door. The recon flights would not only serve to scout a route for the great traverse—they were also crucial to the mapping project. And they would conveniently feed the NGS publicity machine.

Brad made his first flight with pilot Everett Wasson on February 26. Within the first two hours, the pair discovered a forty-mile-long glacier that no one had previously known to exist. Its head spilled from the slopes of Mt. Hubbard. On the spot, Brad named it the Lowell Glacier, after the recently retired president of Harvard, A. Lawrence Lowell,

who, like the presidential candidate William McKinley in 1896, had no particular interest in Alaska or the Yukon.

As soon as he landed back in Carcross, Brad fired off a telegram to Gil Grosvenor. The NGS immediately sent out the first of what would be a string of news bulletins from the expedition. Within a few days, Brad's discovery was the stuff of headlines in the *New York Times* and other papers. (The *Boston Herald* played up the local angle: "Young Cambridge Explorer Conquers Last Hold of Ice Age in North America.")

Before the expedition was over, Brad would name a pair of hitherto unknown mountains, both rising above 12,000 feet, Mts. King George and Queen Mary, on the pretext of celebrating the Royal British Silver Jubilee (the twenty-fifth anniversary of George V's taking the throne). At the end of the long trip, Brad received a telegram from the British secretary of state for foreign affairs thanking him on behalf of the royal couple for the honor, and congratulating him for his exploratory achievement. Brad even proposed naming an unknown glacier after Grosvenor, but the NGS president wisely talked him out of it.

Simply flying over the great wilderness was a scary business. It spooked Wasson badly, and even Brad admitted to his diary just how "out there" one of the farther-flung flights was:

> We might just as well have gone into a nose dive and committed suicide if the motor had failed. The chance of ever getting found in there, even after making a perfect landing, was zero. We had no radio, and nobody had the slightest idea of where we were going since we were exploring an unmapped wilderness. We'd have just sat in the plane, eaten our emergency rations, and then frozen to death.

When Wasson ultimately refused to land on the Lowell Glacier, which Brad had chosen for his base camp, the young expedition "di-

rector" replaced him with another aviator, Bob Randall, who owned a ski-equipped Fairchild FC-2W2. In the pages of *National Geographic,* Brad would later hail Randall as "an amazing pilot," but even this intrepid flier had his moments of terror in the air over the blank on the map. On his farthest-ranging flight, Brad passed just south of Mt. Lucania and shot a series of photos. Walter Wood would be attempting to climb this handsome snow-and-ice giant in a few months, but Brad still coveted the prize.

With the plane at an altitude of 15,000 feet and the door removed, the flight was desperately cold as well as nerve-racking. Decades later, Brad remembered his exchange with the pilot as the two men cruised by Lucania. "Where the hell are we?" Randall shouted over the engine noise.

"I know where we are," Brad shouted back. "Just fly the damned airplane!"

The first landing on the Lowell Glacier occurred on March 5. The temperature was forty-five degrees below zero Fahrenheit, and it was all the men could do to get their tents pitched and themselves inside without suffering frostbitten fingers. During the next three weeks, Brad effectively commuted between base camp and Carcross, coming back out to "civilization" so that he could send off telegrams to Grosvenor, who converted Brad's new discoveries into yet more news bulletins. Brad was also able to get some of his aerial photographs developed. Carried back in by Randall on later flights, those pictures would prove vital in plotting the team's route west to the seacoast.

Meanwhile, each flight brought in gear and food, and, starting on March 7, the dogs themselves. In his diary on that date, Brad conjured up "Jack Haydon and six dogs in one yelping mass in the back of the Fairchild. They had a terrible time getting the dogs into the airplane, but it was a cinch to get them out."

Another piece of equipment that would prove vital was a prefabri-

cated hut made of beaverboard. Once assembled, it was six feet square by six feet tall. In its cozy confines, the men played chess and cards, and Brad calculated his survey data. The hut, which the team nicknamed the Empire State Building, was far warmer than a tent, and sometimes a pair of men slept inside it.

Thanks to storms and Randall's other obligations, it was not until March 28 that the whole team and nearly all its supplies were deposited at base camp on the Lowell Glacier. "Zeus, but it's grand to be here," Brad wrote in his diary that day. "There's great good humor and swell morale considering the damned mess of delays we've been through." The team also had a shortwave radio, which could receive but not transmit. To the men's astonishment, in a single evening they listened to a news report from Bordeaux in France and an episode of *Amos 'n Andy* broadcast out of New York City.

On some of the supply flights, Brad commandeered Randall for further reconnaissance forays. On one of them, he discovered that the Hubbard Glacier, previously thought to be forty miles long, was actually an ice flow stretching unbroken for ninety-two miles. Eventually Brad would demonstrate that the Hubbard was the most extensive glacier in the world outside of Antarctica.

The plan was not to set off on the traverse at once, but to use base camp as the headquarters for day-trip surveying jaunts in all directions. Brad had become a virtuoso with the theodolite, but sometimes the conditions thwarted his gamest efforts. In high winds, as he tried to peer through the instrument, the gales would repeatedly slam the eyepiece back into his face. On other occasions, the tripod sank into the soft and unstable snow, and it was nearly impossible to level the device.

Throughout the first weeks in the field, the cold reigned supreme. During one ten-day period, the temperature ranged between minus 40° and minus 56°F. Decades later, Ad Carter would vividly recall the

misery of camping in such conditions, as he and Bob Bates, sharing a tent, tried to while away the hours reading a book:

> Of course there was very little daylight. We finally got the system worked out where you would read two pages and sort of hold the book with your mittens, turn the page and give it to the other guy who would read the next two pages while you put your hands back in the sleeping bag.

Anticipating the extreme cold, the men had had sleeping bags custom-made by a firm in Ottawa. With liners made of alpaca wool, each bag weighed an ungodly twenty pounds (modern down bags of comparable warmth weigh as little as four and a half pounds). All the men except Haydon and Taylor were astounded to see that even at forty below, the huskies endured the cold by lying on a burlap sack and curling into a ball, with tail covering nose. As Bates would later write, "If snow fell or drifted at night, there was no sign of dogs in the morning. Of course each had a breath hole."

Yet the thrill of discovering new terrain outweighed the discomfort. As Bates later recalled those days, in a memoir he wrote in 1994,

> Every day we saw magnificent rock and snow peaks, unnamed and new to everyone. . . . There was continuing excitement in being where nobody had been before, and almost every day we discovered a new mountain or a new side glacier. In clear weather the snowy summits stood out magnificently against the blue sky, and even on cloudy days the blue-green ice gleamed.

The colossal scale of the Saint Elias Range stunned even these veteran explorers. On March 30, Brad recorded a six-mile hike with Andy Taylor: "You can walk for hours and never seem to get anywhere at all.

We crossed the tracks of a fox and a [mountain] goat, bound across the glacier from and to God knows where or why."

On April 22, Randall made his last resupply flight. After that date, the seven-man team would abandon base camp and head west toward the coast. From his recon flights, Brad was convinced the team could make a long zigzag journey across several glaciers to the head of Nunatak Fiord, a far inland arm of Yakutat Bay. To get to the town of Yakutat, the nearest outpost of habitation, however, a perilous float trip on ocean channels would be required. Anticipating this denouement, Brad had included in the supplies a thirty-five-pound inflatable rubber raft that could be rolled up into a three-foot-by-one-foot package, and two oars. The team carried this cargo all the way across the Saint Elias Range.

First, however, Brad launched his attempt on Mt. Hubbard. It required a long detour just to get to the base of the mountain, where the climbers discovered that another, previously unknown peak (they named it East Hubbard) blocked any approach to the summit. Brad and several teammates successfully surveyed all the way to a 12,200-foot col, but they realized that an entirely separate expedition would have to be launched to have any chance of bagging Hubbard's summit.

Just getting to that high col forced the team to cross a hazardous gauntlet, a narrow glacial corridor down upon which ice towers toppled and avalanches plunged with alarming regularity. On the descent, Brad wrote in his diary,

We prepared for a breakneck dash through this danger zone by throwing away our two ropes to lighten the load. Then we started off beneath those menacing seracs, running hell-bent for camp. We tripped over our snowshoes and ourselves a dozen times, swore,

looked up at the towers of ice above us, and then brushed the snow out of our eyes and started off again. . . . Zeus, what a good feeling to be back, safe and sound.

Hubbard would not be climbed until 1951, when, fittingly enough, its first ascent was co-led by Bob Bates.

Despite such nerve-racking episodes as the descent from the Hubbard col, the 1935 expedition was as much lark as ordeal. Brad's diary is full of cheery and corny entries that testify to the team's consistently high spirits. On April 23: "We made a major discovery at lunch. We found we could manufacture delectable peanut butter by running peanuts through the meat grinder and then frying them with butter, olive oil, bacon grease, and salt." As spring waxed toward summer, the temperatures rose, the daylight hours expanded dramatically, and life on the glaciers became almost pleasant.

On May 6, the most dramatic event of the whole trip occurred. On that day, as six dogs frolicked unharnessed, three of them (named Brownie, Fannie, and Monkey) fell into a hidden crevasse. The men tied a hundred-foot rope to a pair of skis planted as an anchor in the snow. Without hesitation, Brad tied in to the other end, then rappelled into the crevasse. "Chunks of the lip of the crack kept falling on my head as I descended," Brad wrote in his diary that evening. "The ice walls of the crevasse were covered with dog shit—those poor falling dogs were really 'scared shitless'!"

Amazingly, all three dogs had landed seventy feet down on a snow bridge that overhung the dark, seemingly endless continuation of the crevasse below. Brad chimneyed down to the terrified canines. He called for another rope to be lowered. In an extremely dangerous situation (there were huge, loose blocks of ice suspended everywhere inside the crevasse, ready to collapse as Brad slid down the rope past

them), he tied the collars of Fannie and Brownie into the second rope and watched as they were hauled to the surface. By then, Brad was growing hypothermic. His teammates pulled him up.

Ad Carter volunteered to make the second rappel, at the end of which he rescued Monkey. Brad wrote that night: "I will never understand to my dying day how those dogs could fall at least seventy feet through that maze of jagged, torn ice and come out with no more injury than two cut lips (Brownie and Monkey) and one lost toenail (Monkey)."

Another near disaster occurred on May 17, when the team's cook tent caught fire. Brad suspected that a carelessly tossed, half-extinguished cigarette was the cause: "Andy smokes continually," he grumbled in his diary. But Taylor proved the hero of the day, by smothering the blaze with his body (costing himself singed hair and eyebrows) just before the fire reached a five-gallon gas can that could have blown the whole camp sky-high.

Near the end of the team's three-month journey, Bob Bates, who, like Taylor, was an expert marksman, killed a massive grizzly bear with one shot with a 30.06 rifle. Jack Haydon expertly skinned the beast. The men dined for days on bear meat—heart and liver being their favorite portions—and turned the hide into a bearskin rug to place beneath their sleeping bags. The hide was so full of fleas, how-ever, that the whole camp became infested.

As Brad had anticipated, the end of the traverse would present the team with its toughest challenge. The fifty-five-mile boat ride in a flimsy blow-up raft was far from a sure thing, and even if it could be pulled off, the craft could carry only two men. By now, nobody in the world—not even Bob Randall—knew where the seven climbers were. If they failed to show up in "civilization," an aerial search would prob-ably be out of the question, so vast were the unknown icefields, so risky every flight over them.

Accordingly, on May 14, the team held what Brad called "a council

of war." The men decided to split the party in two. One contingent would head for Nunatak Fiord, from which shore Brad and Andy Taylor would try to paddle to Yakutat. The other group would instead return to the interior, all the way past the Lowell Glacier base camp, then make their way to Bates Lake, a large pond surrounded by Sitka spruce forest. By prearrangement, a floatplane was to land there on June 1 in case any team members had resorted to the lake as a pickup site. The rationale for dividing the party, as Brad wrote in his diary, was "so that if we run into real trouble, at least one party is sure to get to safety and then, somehow, help the other."

On May 19, the party split up, the men bidding each other "fond and almost tearful farewells." Brad, Andy Taylor, Ad Carter, and Hartness Beardsley headed for the coast. Almost at once, they were stalled by a three-day storm, during which it snowed nonstop for seventy-three hours. On May 21, Brad wrote, "It's all we can do to keep the tent shoveled out. We have food left for about twelve days or so, so I guess we're all right for a while." Seven decades later, Brad would swear that he had never seen fiercer storms or a greater cumulative snowfall than on the 1935 traverse.

From aerial photos taken on one of his reconnaissance flights, Brad and his teammates knew that to escape the hideously crevassed snout of the Nunatak Glacier, they would have to negotiate a chasm between the edge of the glacier on the left and a steep rock wall on the right. Finally, on May 24, they headed into this gauntlet, which they would nickname Hell's Half Mile. It was even worse than the men expected. Small avalanches poured off the glacier, while fist-sized rocks rained down from the cliff. Wrote Brad that evening in his diary, "I've never in my life been more worried, scared, or nervous. . . ."

That evening Brad asked the seemingly imperturbable Taylor whether he too had been terrified as the men ran Hell's Half Mile. "During the last half hour," answered the old sourdough, "the shit was right up in the back of my throat!"

Eighty-one days after first landing on the Lowell Glacier, the men had at last reached the Pacific coast. But at once their dismay deepened, as they saw that Nunatak Fiord was clogged with icebergs. They spent an anxious and dispirited night camped on the shore. In the wee hours, Brad awoke to see that the wind had opened a lead in the pack ice. After a hasty breakfast, the men inflated the raft, and Brad and Andy paddled away.

For Ad Carter and Hartness Beardsley, the next five days must have been a psychological torture. Their only recourse was to wait. And if Brad and Andy failed to make it through, they were doomed—it would be impossible to hike to Yakutat, and in 1935 no boats coasted into Nunatak Fiord and no planes flew overhead.

Meanwhile, the two oarsmen barely managed to get the raft through cracks and leads in the iceberg-clogged fiord. By midday they were making good speed in open water with a wind at their backs. An all-ocean route to Yakutat would have dictated exiting from Nunatak Fiord, taking a right-hand turn up Disenchantment Bay, then turning a sharp left into Yakutat Bay. But Brad and Andy knew that the riptides at that sharp corner were far too fierce for their fragile boat. Instead, as they exited Nunatak Fiord, they turned left, or south. Their plan was to make a ten-mile portage over the neck of land separating the inland channel from Yakutat Bay proper.

In their raft, the two men had not even enough room for a tent. Their shelter each night was a lean-to made out of a tarp and the overturned boat. On May 27, they launched the portage. Andy carried a fifty-pound pack, Brad a monstrous ninety-pound load (including the thirty-five-pound raft). The going could not have been worse: "nothing but mud, slushy snow, 'devil's club,' and God-awful alder bushes—all at an angle of at least 40 degrees," he wrote that night. The last mile of bushwhacking took the pair seven hours to negotiate.

At 2:45 P.M. on May 29, Brad and Andy rounded a last point in Yakutat Bay and saw a joyous sight—the Yakutat fish cannery in the

distance. The first locals to greet them were kids who ran down the beach, crying out, "Where did you come from?"

"From Carcoss, Yukon, Canada," Brad gloated.

As soon as the pair arrived, Taylor arranged for a boat to pick up Carter and Beardsley. Brad learned by radio from Carcross that Bates Lake was almost certainly frozen over. It was not until June 3—two days after the prearranged pickup date—that he hired a plane to fly into the interior to check on his three possibly stranded teammates.

Meanwhile, after the parting on the glacier, Ome Daiber, Bob Bates, Jack Haydon, and the dogs had set off for Bates Lake. Back at base camp on the Lowell Glacier, as the trio lounged in the beaverboard Empire State Building, the closest thing to a serious falling-out among the party occurred. Daiber was teasing Haydon about his dogs and his sled, oblivious to the fierce pride the Kluane man took in his expertise. In silence, Haydon whittled away with a sharp knife. As Bates recalled many years later, "I could see that he was becoming very angry, and I also knew there was a strain of violence in his family. (He had seen his mother shoot and kill his father, who at the time was drunk and attacking her.)"

Ever the peacemaker, and throughout his life a man who could not bear conflict, in or out of the mountains, Bates came up with a pretext to lure Haydon outside the shack, where he defused the man's rage. Daiber apparently never realized how close he had come to being physically attacked.

After that, the three men made steady progress until they ran into the Alsek River, which they had hoped to ford. Instead, the river was in spring flood, far too deep and swift to wade. Unfazed, the resourceful trio improvised a raft out of driftwood logs, two air mattresses, and two pairs of skis, with another ski as a paddle, and pulled off the dangerous crossing. The dogs managed to swim. When the team reached

Bates Lake, however, they found it, in Bob's phrase, "frozen tight from shore to shore."

June 1 and 2 came and went with no sign of a plane. The men were short on food, so they resorted to hunting, even though they were also short on ammunition. One breakfast later recorded by Bates consisted of "boiled porcupine and applesauce." Haydon managed to kill two whistler ducks with one shot. There was an abundance of fish in the lake, but the men had no hooks. Bates tried unsuccessfully to fish with a bent safety pin.

Finally, on June 3, a plane flew over, manned by a pilot and Brad Washburn. Brad tossed out three bundles. The food bag smashed on a rock, smearing the contents—oatmeal, sugar, cheese, beans, rice, butter, and coffee—into a barely palatable mush. The men were happier to retrieve another bag full of mail—but in it they found a note from Brad telling them to hang on, as a plane would try to pick them up in ten days or so.

Two days later, Bob solved the trio's food problem by shooting a 1,700-pound moose from a hundred yards. Men and dogs alike dined thereafter on moose steaks, shoulders, heart, and liver.

The ice in the lake broke up earlier than anyone expected. On June 7—not the "ten days or so" Brad's note had gloomily predicted—a new pilot landed and loaded up the men and dogs. On takeoff, Monkey promptly vomited. "That will cost you boys five dollars more!" the pilot fumed.

Meanwhile, from Yakutat, Brad was sending out telegrams and already composing dispatches for the press. He and his six resourceful teammates had pulled off an epic and totally successful journey. Despite all the hazards and close calls, not one of the men suffered a significant injury. Decades later, Brad would remember the traverse as one of the most satisfying adventures of his life. For the geographer-explorer, nothing—not even a great first ascent—could be

more gratifying than to fill in the largest blank on the map of North America.

On June 6, Brad was delighted to receive Gil Grosvenor's telegram: "Heartiest congratulations to you and to every member of your courageous and resourceful group." By then, Brad had already begun to write the first draft of his *National Geographic* article.

4

Lucania or Bust

For the ears of Gil Grosvenor and the readers of *National Geographic,* Brad played down the hazards of the expedition and focused on the zest of accomplishment. Andy Taylor's tasting the shit in the back of his throat as the men ran the gauntlet of Hell's Half Mile did not make it into the article. The most dramatic episode Brad narrated for the "yellow magazine" was the rescue of the three dogs from the crevasse. And the young author—he had just turned twenty-five as he wrote the piece—wrapped up his narrative with the kind of valedictory salute he was by now used to delivering from the podium:

> As I write the closing words of this story of the Yukon Expedition, one experience stands out for me high above all the rest. It is the thrilling experience of being the leader of these six companions. The magnificent faith and spirit of these fellows in the face of every conceivable difficulty and disappointment made it possible for our expedition to cross the Saint Elias Range.

"Exploring Yukon's Glacial Stronghold," however, was not published until June 1936, a full year after Brad and his teammates returned to civilization. The reasons for the delay were several, but chief among them was the fact that only days after getting home to Cambridge, Brad once more came close to burning his bridges with the NGS. During the expedition, he had agonized over Grosvenor's offer to join the editorial staff of the magazine. Although in January, on the eve of departing for Carcross, Brad had told Grosvenor that "my highest ambition has always been to work for the society," he had his doubts. Brad's June 1935 letter to Grosvenor taking up the question again has not survived, but Grosvenor's response hints at its content. Brad did not reject the job offer in so many words, but he evidently expressed his misgivings, which were perfectly logical ones: a staff job, he feared, would severely curtail his chances to go on future expeditions.

The NGS was not used to being turned down. At least Brad had the sense not to spurn the offer flat out, leaving Grosvenor the option of withdrawing it instead. The coolly formal tone of Grosvenor's June 26 letter bespeaks the wounded pride of the president of the world's most prestigious organization devoted to exploration:

> *Referring to my suggestion of some months ago that you become associated with the N. G. S. as a member of its staff, I have come to the conclusion, after much consideration of your frank expressions of your ambitions, that it would be unwise for you to accept the offer I made you. Your success in editorial and literary work for The Society and its Magazine would depend entirely on whether you had your heart in the work. Your main ambition, I understand, is to do exploration and research, rather than writing and photography.*

Perhaps sensing that these strictures sounded a bit harsh, Grosvenor added, "We could not ask for finer leadership than you gave this

party. . . ." *But* . . . The cool pomposity returned in the end of that sentence of praise: "but it is unlikely that The Society will undertake another Alaskan Expedition for some years."

The article languished for months on Grosvenor's desk. In November, he wrote to Brad, saying that the magazine was "in no hurry to run" the piece until Brad completed the hand-drawn map of the great blank he had filled in, from which NGS cartographer Alfred Bumstead would craft the published map.

It was not until early April 1936 that the NGS felt ready to bring out Brad's article. And only then did Grosvenor write,

> *In allocating the space for the June Magazine, it seemed advisable to curtail your paper [i.e., article]. After studying the paper and re-reading it many times, I came to the conclusion that the paper could be made more impressive by making it shorter.*

"Exploring Yukon's Glacial Stronghold" ran at thirty-four pages, six fewer than the Crillon article the year before, even though the Saint Elias Range traverse was a far braver deed than the first ascent of Crillon. The magazine ran twenty-eight of Brad's photos, fourteen fewer than it had lavished on Crillon.

Unlike the NGS president, Brad's mentors within Harvard's Institute for Geographical Exploration had no problem with a grad student who really wanted to explore. Even though he had completed less than two years of study, and had taken the spring semester off to backpack across the Yukon, Brad was flabbergasted in November 1935 when the institute's director, Hamilton Rice, offered him a job as instructor. He accepted at once. This must have rubbed more salt in Grosvenor's wounds, for within days, as Brad wrote the NGS president to announce his new post, he fawningly added, "I sincerely hope [the job] will give me many chances to write for the *National Geographic Magazine.*" Four

months later, Brad was still tendering what Grosvenor characterized as "kindly feelings toward the staff" of the NGS.

These blandishments must have thawed Grosvenor's chilliness, and the president clearly recognized that in Washburn he had discovered a classic NGS author-hero. Despite the comment about Brad's having no interest in writing or photography, the pictures Brad brought back were extraordinary. An NGS press release vaunted those pictures as the equal of Admiral Byrd's famous images from Antarctica, which had also run in *National Geographic*. Indeed, by 1936, Brad was already a serious and innovative photographer.

In May of that year, Grosvenor asked Brad if he had some other project up his sleeve that wouldn't cost the society too much money to fund. Brad at once proposed a series of flights around Mt. McKinley, during which he would take the first aerial photographs ever shot of North America's highest mountain. Brad thought he could complete the mission for $1,000. Grosvenor agreed, and he offered Brad an additional salary of $200 a month.

On the flights around Crillon and the aerial reconnaissances of the Saint Elias Range, Brad had shot his pictures with a large-format camera, a Fairchild F-8 that exposed five-by-seven-inch negatives. For the 1936 flights around McKinley, another of Brad's mentors in the Institute for Geographical Exploration lent him his own favorite camera, an even more powerful machine than the F-8.

Captain Albert W. Stevens was a pathbreaking explorer in his own right, as well as a pioneer of aerial photography. He had made flights over little-known regions in the Andes and the Amazon basin and brought back exceptional pictures. Stevens was also another of the NGS's fair-haired boys in long standing: the magazine had published his pictures since 1924, his articles since 1931. And in 1935, he had set the world record for altitude in a balloon, soaring into the stratosphere to a height of 72,395 feet. In January 1936, five months before Brad's article came out, *National Geographic* published Stevens's account of

his balloon flight. And in May, the society presented him with its highest honor, the Hubbard Medal.

Stevens, whom Brad would hold in high esteem the rest of his life, had no qualms about letting his grad student borrow his precious camera, a Fairchild K-6, which shot 100-foot-long rolls of eight-by-ten-inch pictures. The camera weighed a monstrous fifty-three pounds, but it would become Brad's instrument of choice during his next five decades of aerial photography.

Brad's unique achievement as a mountain photographer was essentially a self-taught odyssey of trial and error. But if anyone gave him an initial push in the right direction, it was Captain Stevens.

In the summer of 1936, hiring a bush pilot who flew a Lockheed Electra, Brad made three flights over and around McKinley. The photographs he captured were the finest that had ever been shot of mountains in Alaska. Many of them were published in *National Geographic* in July 1938, in Brad's article titled "Over the Roof of Our Continent."

Brad was already well on his way to becoming Alaska's outstanding mountaineer. But it was those 1936 flights and photos that truly launched Brad's second unique career, as one of the two finest mountain photographers ever. For the rest of his life, Brad would brag about coming back from his McKinley assignment under Grosvenor's thousand-dollar budget, as he proudly mailed the president of the NGS a check for $37 in unspent balance.

But in 1936, for the first time in five years, Brad did not go on a climbing expedition. And that summer, three of his Alaska mountaineering protégés did—and in the process, participated in one of the landmark first ascents of the twentieth century.

The driving force behind the expedition was Charlie Houston, who had been a member of Brad's 1933 Crillon team. Having graduated from Harvard in the spring of 1934, Houston had been accepted for the

fall at Columbia University's College of Physicians and Surgeons. That summer, between college and medical school, Houston led his own expedition—to Mt. Foraker, the 17,400-foot peak that soars out of the Alaska Range just southwest of McKinley. (The name given Foraker by the Indians who lived north of the range translates as "Denali's Bride"—Denali, or "the Great One," being McKinley.)

Foraker is the sixth-highest mountain in North America, after McKinley, Logan, Saint Elias, and the two Mexican volcanoes, Orizaba and Popocatépetl. (The last two are easy climbs—nothing more than marathon hikes. The first recorded ascent of Popo came in 1522, when four conquistadors brought back 300 pounds of sulphur from near the summit of the then-active volcano, to supplement Cortés's supply of gunpowder.) By 1934, Foraker was the highest unclimbed peak on the continent. Unlike neighboring McKinley, it had never been attempted.

Houston had the good fortune to have a father, Oscar, who was not only wealthy, but an ambitious climber himself. Father and son put together a six-man team of disparate abilities; their number included an eccentric Englishman, T. Graham Brown, who though over fifty years old had a distinguished career in the Alps under his belt. Earlier that year, Houston had met Brown in a café in Montenvers, near Chamonix. Recognizing the famous alpinist from pictures, Houston got up the nerve to introduce himself. "After some hesitation," Houston recalled in 1980, "I went up to him and said, 'I think we speak the same language.' It was rather a stiff way of introducing myself to what I thought to be a rather formidable Britisher. But we became fast friends."

Horse-packing across the tundra, Houston's party set up a base camp beneath the mountain's massive northwest face. Even though Foraker was poorly mapped, the team at once chose the most logical route by which to attempt it, up the northwest ridge. The climb went like clockwork, and on August 6, Charlie Houston, Brown, and Chychele Waterston stood on the summit.

In the same summer that Brad had finally succeeded on Crillon, Houston—a few weeks short of his twenty-first birthday—had pulled off a first ascent of considerably greater significance than Washburn's (although *National Geographic* did not come clamoring to celebrate Foraker). Houston's 2007 biographer, Bernadette McDonald, tactfully addresses the question of why Charlie didn't invite Brad along:

> Notably absent was Washburn. Washburn would have loved to climb Foraker, but Foraker was extremely remote and therefore expensive, and while Charlie's father had money, Washburn did not. Instead, Washburn returned to Crillon for the third time. . . .

The truth of the matter is that the friction between the two men that began in 1933 lingered on, and their feelings toward each other were still a bit raw. Washburn and Houston stayed loyal friends, but it was no accident that Charlie did not invite Brad to Foraker. And no accident that Brad did not invite Charlie on the Saint Elias traverse in 1935.

And thus, no accident that Brad was not a candidate for the ambitious undertaking of 1936. The plan, however, was very much an affair of the Harvard Mountaineering Club. In on it from the start were Ad Carter, Arthur Emmons (who had been a member of Brad's first northern expedition, to Fairweather in 1930), and a classmate of Carter's named W. Farnsworth ("Farnie") Loomis. Only Loomis had not participated in a Washburn expedition. His career would be one of the most meteoric in HMC history. He climbed for only two or three years, went on to become a brilliant medical researcher, but struggled with alcoholism and depression and committed suicide in his midfifties.

With Houston's confidence providing the spur, the four men decided to attempt a major climb not in Alaska, but in the Himalaya. Of the four, only Emmons had climbed on the Asian continent before. By 1936, in fact, no American had participated in a single expedition to

any of the world's highest mountains—except the German-American Fritz Wiessner, who had emigrated to Vermont in 1929, and who had been a linchpin of the German attempt on Nanga Parbat in 1932. (A remarkable American woman, Elizabeth Knowlton, had accompanied that expedition, but her German teammates refused to let her participate in the real climbing. She went on nonetheless to write a vivid memoir about the expedition, *The Naked Mountain*.)

By 1936, most of the serious Himalayan assaults had been undertaken by British or German teams. The initial objective that Houston and his friends set their eyes on was Kanchenjunga, at 28,169 feet the third-highest mountain in the world. A sprawling, complex, inaccessible giant, Kanchenjunga sits today on the border of India and Nepal, but in the 1930s it lay within the borders of British India. The peak had been attempted three times between 1929 and 1931. On the last effort, a team of Bavarians reached 26,220 feet, the highest any climbers had been in the world except for a handful of Englishmen on Everest. Houston and company planned to attack the Bavarian route.

As the team needed British permission for an attempt on Kanchenjunga, Farnie Loomis traveled to England in February 1936. Houston and Graham Brown were already friends, and part of Loomis's agenda was to try to entice Brown, as well as several other more seasoned British climbers, into joining the party. Loomis met H. W. ("Bill") Tilman, one of the greatest mountaineer-explorers of the century (and incidentally, one of the finest mountain writers who ever put pen to paper). An imposing presence, the thirty-eight-year-old Tilman let Loomis know that the Americans were probably biting off more than they could chew with Kanchenjunga. But he took a liking to these upstart youngsters from across the Atlantic. Thus the 1936 Anglo-American expedition to Nanda Devi was hatched.

For the spring of 1936, a strong team of climbers was organizing the sixth British expedition to Mt. Everest. Their number included Frank Smythe, who had reached 28,200 feet on a 1933 attempt, and Tilman's

best friend and favorite partner, Eric Shipton. Thus much of the cream of the crop of British Himalayan veterans was unavailable for Nanda Devi. In the end, however, Loomis recruited not only Graham Brown and Tilman, but also Noel Odell, whom the HMC climbers had gotten to know and revere when he was a visiting professor at Harvard, as well as an expert rock climber named Peter Lloyd.

One of the most beautiful mountains in the world, Nanda Devi stands in proud isolation in the Garhwal region of northern India. At 25,643 feet, or 7,816 meters, it does not quite join the canonic assemblage of the fourteen 8,000-meter peaks that are the highest in the world. But since the first attempt to climb it, in 1883, Nanda Devi had self-evidently presented a magnificent mountaineering challenge. Five subsequent expeditions failed even to reach the foot of the mountain, defeated by the savage Rishi gorge that drained from its slopes. Finally, in 1934, a brilliant two-man expedition—Tilman and Shipton, supported by a mere eleven native porters—solved the gorge and penetrated into the sublime highland basin they named the Sanctuary. They had discovered the key to Nanda Devi, but now, in 1936, Shipton was off on Everest, unavailable to complete the puzzle with his best friend.

It is a great pity that Brad Washburn never climbed with Tilman or Shipton, because they were utterly like-minded explorer-mountaineers. Just as Brad had begun to overhaul Alaskan mountaineering with his new fast-and-light tactics, Shipton and Tilman, alone among all the Himalayan pioneers of their day, disdained the kinds of massive, military-style expeditions that were being thrown at Everest and Kanchenjunga and Nanga Parbat, in favor of fast-and-light journeys shared by as few as two but not more than eight companions, with a minimum of food, gear, and porter support, and a maximum of daring forays into the unexplored crannies of the great ranges. (Tilman once said that an expedition that cannot be planned in a couple of hours in a café on the back of an envelope was not worth undertaking.)

Almost seventy years after Nanda Devi, Houston told his biographer, Bernadette McDonald, "It's hard to believe how naive and presumptuous we were. Four American college kids . . . inviting the best British climbers to join us on a major climb in the Himalayas." Most of the party met in May on the boat trip to India. Oscar Houston, who had paid both his and Charlie's way, had intended to be a member of the team, but on board the ship, Brown and Odell sized up the man and decided he was not fit or strong enough for the expedition, even though Brown and Oscar Houston were about the same age. It was Odell's thankless task to break the news to Oscar. "My father took it quietly," Houston told McDonald, "but he never forgave Odell—he was clearly heartbroken."

As they got to know one another on the approach to Nanda Devi, the four junior Americans and the four relatively senior Brits went through an awkward feeling-out process. "We were all quite shy," Houston recalled for McDonald. "I think they were uncertain as to what these puppies were up to. It was sniff, sniff, sniff." As Ad Carter recalled in 1980, "I think we sounded like Texans to them."

Once on the mountain, the eight men integrated the expedition by systematically rotating tent pairings. As Tilman wryly put it in *The Ascent of Nanda Devi:*

The object of this was to avoid any tendency to form cliques. . . . If a man knows that his martyrdom has only to be endured for a night or two running, he can tolerate good-humouredly the queerest little idiosyncrasies of his stable-companions. Some of us talked too much or too loudly, some did not talk enough, some smoked foul pipes, some ate raw onions, some never washed, some indulged in Cheyne-Stokes breathing [irregular respiration caused by altitude], and one even indulged in Cheyne-Stokes snoring. . . .

But these singularities, which, if endured for too long, might lead to murder, were, by our system of musical chairs, matter only for frank criticism or even amusement.

Trying to impress their elders and betters, the Americans talked constantly about Alaska—the only trump card of experience they could play against the British. One day Loomis produced a flask of apricot brandy. As Tilman later wickedly replayed the scene,

As the brandy was good so it was potent, and that distant country Alaska, of which we had already heard more than a little, assumed, along with its travellers, new and terrifying aspects. The already long glaciers of that frozen land increased in length, the trees which seemingly burgeon on these glaciers grew branches of ice, the thermometer dropped to depths unrecorded by science, the grizzlies were as large as elephants and many times as dangerous, and the mosquitoes were not a whit behind the grizzlies in size or fierceness, but of course many times more numerous. And amid all these manifold horrors our intrepid travellers climbed mountains, living the while on toasted marshmallows and desiccated eggs, inhabiting tents similar to ours, and packing loads which to think of made our backs ache.

Despite the youth of the Americans, the eight-man team was in fact one of the strongest yet fielded in the Himalaya. One by one, Nanda Devi's defenses succumbed, as the men climbed past the high point that Tilman and Shipton had reached in 1934. By mid-August they had established a camp at 21,000 feet, from which they hoped to climb to 24,000, pitch one more camp, then go for the summit. It had become clear, however, that the logistics would dictate that only two men could occupy that higher camp and try for the top.

Another of Tilman's quirks was that he believed expeditions should not have leaders. All the decisions up till now on Nanda Devi had been made by consensus. This modus operandi departed radically from the norm of the day. The British and German expeditions attacking such mountains as Everest and Nanga Parbat all had appointed leaders who truly ran the show. In some cases, such as the notorious German leader Dr. Karl Herrligkoffer, the man in charge ruled like a dictator. (In 1953, when the great Austrian climber Hermann Buhl disobeyed his leader and reached the summit of Nanga Parbat solo, making its first ascent, Herrligkoffer later tried to sue his own teammate.) Even in Alaska, Brad insisted on being the leader on all of his expeditions—though in the field, something like consensus went into making most of the decisions.

Now, on Nanda Devi, an alarming development occurred. It was evident to the others that Graham Brown was debilitated by altitude. He seemed constantly confused, and at times his skin showed the bluish tinge of cyanosis. But in that confusion, Brown suddenly convinced himself that he was the strongest member of the team. He demanded that he and Houston should go for the summit.

So the men agreed to hold a secret ballot to choose a leader. Not surprisingly, Tilman was voted in. Magnanimously (for he was the strongest man on the mountain), Tilman chose Odell and Houston for the summit pair.

On the night of August 27, those two men cooked dinner in their tent at 24,000 feet, preparing for an early start in the morning. In 1980, Ad Carter remembered the events of August 28. Just after dawn, ensconced in a lower camp, the other men heard Odell's voice yelling over the wind. Carter emerged from his own tent to try to decipher the cries. "Charlie—is—killed!" Carter heard. At once four men gathered first aid supplies and started climbing as fast as they could toward the high camp. "We figured if Charlie was killed, Noel

must be in bad shape," Carter recalled. "Probably they had had a slip or something."

Tilman and Peter Lloyd arrived at the high camp first, gasping for breath. They found Odell sitting in the tent door over a cooker. "Hullo, you blokes, have some tea," he said.

As Carter explained, "The message Odell had been shouting was 'Charlie is ill!' To us Americans, a person got 'sick,' not 'ill.'" The night before, the two men in the high camp had opened a tin of bully beef. They noticed that the can had been punctured, so they carved away the obviously spoiled meat but ate the rest. In the night, Houston got a violent case of ptomaine poisoning, but for some reason, Odell was unaffected.

By common consent, Tilman took Houston's place in the summit pair. As his teammates helped Charlie down to the lower camp, Odell and Tilman moved their tent 500 feet higher. On August 29, after what Tilman called "a long slow trudge" through knee-deep snow, the two men reached the top of Nanda Devi. In one of the more memorable summit lines ever penned, Tilman later wrote, "I believe we so far forgot ourselves as to shake hands on it."

For the next fourteen years, until the French succeeded on Annapurna in 1950, Nanda Devi remained the highest mountain climbed anywhere in the world. Missing out on the summit dash would turn out to be one of the greatest disappointments of Houston's life. At least his sense of loss was shared. In 1980, Houston recalled, "It's been reported to me that Shipton said later in life that one of his greatest regrets was going to Everest that year instead of going to Nanda Devi with us."

If Brad felt any regret about not sharing Nanda Devi with his HMC chums, he never expressed it publicly. Still, it was hard to ignore the

gulf between his summer of 1936 and theirs. True, he had made the first aerial photographs of Mt. McKinley, but he had not climbed at all. In the meantime, three of his former protégés had participated in the finest first ascent yet performed by any Harvard mountaineers.

From the hill town of Ranikhet, after the hike out, Ad Carter wrote Brad with news of the team's success. And he reported, "Charlie was a prince. I had been a bit afraid about how I should get on with him after Crillon but we are now the best of friends. He has learned a pile on Foraker and seemed much less moody and never got grouchy at anyone."

Houston was eager to patch up any lingering tensions or sense of competition between himself and Washburn. In December, four months after Nanda Devi, referring to Bob Bates by his HMC nickname, "Bistrich," Charlie wrote Brad,

> Bistrich and I were talking over the people you really started on expeditions, and we calculated there are at least eight who are doing big things, and half a dozen more whom you started in the climbing game. That's quite a record. You certainly started Bob and me going places.

Through most of 1936, Brad was involved in a drama of his own that had nothing to do with mountains. Like most men of his era, especially those who were thrust into the limelight at a young age, Brad tried to keep his private life private. But because he saved virtually every scrap of correspondence he received throughout his life, it is possible to decipher the shadowy outlines of Brad's dawning interest in women.

By the end of 1934, he was regularly receiving notes from a Connie Nutter. They are far more temperate than love letters, but they express a certain pleasure in Brad's company. Nutter signed each one simply "Yours" or "As Always."

By sometime in 1935, Connie Nutter had been replaced by a woman identifiable only as Mary, a Smith College student and musician who played in the school orchestra. None of the letters is dated, but they are signed "Love" and "Lots of love." Mary wrote, "Thank you again for a perfectly marvelous weekend." And Brad evidently invited Mary to "the Princeton game."

Mary was gone before the end of 1935. But the following March, lightning struck. It may have been Henrietta Pease, the future wife of Brad's younger brother, Sherry, who introduced Brad to Eleanor Kerns, a woman at least four years younger than Brad. Brad's first liaisons with Eleanor, or "Kernsie," as everyone called her, came when her mother invited Brad to tea in their home in Newton, a posh Boston suburb. Tea became a frequent occasion, for Brad was instantly smitten.

Impatient as hell, but stubborn—Brad's savvy 1983 self-appraisal of his photographic genius sums up his courtship of Eleanor in the spring of 1936. It seems that his impatience may have alarmed even Brad, because in April he wrote to Eleanor's mother, pleading, "Do forgive me if I am appearing at your house too often." But he went on, "I've never in all my life known anyone quite like Eleanor," and "I can't resist the temptation to come whenever I get the slightest chance."

If Brad's letter still exists, it is probably irretrievably lost. But Mrs. Kerns gave the letter to her husband, who wrote Brad on April 21, quoting back at him the above sentences. Mr. Kerns's letter is a remarkable document, almost Victorian in conception and tone. The brunt of it is an attempt to scare Brad away. The quoted phrases, Mr. Kerns inveighs, "indicate a situation which only a foolish father would close his eyes to."

"A month is a short time," Mr. Kerns lectures Brad. "A sudden fancy for a pretty girl sometimes burns itself out quickly and leaves the girl mystified and hurt." The protective father reminds Brad

more than once how young and innocent Eleanor is. At last he orders Brad "emphatically not to see so much of Eleanor" and to "gradually taper off your visits."

But then the letter makes a startling about-face. If it turns out that Brad can show that he's lastingly in love with Eleanor, and if she reciprocates the feeling, why, then, "God bless you both."

Mr. Kerns closes the letter by emphasizing that neither his wife nor his daughter knows that he is writing to the brash young suitor, and he pays Brad a backhanded compliment: "If you were less intelligent I would not have written to you like this." Should Brad want to talk to him face-to-face, Mr. Kerns would be glad to arrange the meeting. Should Brad write back, he is commanded to address the letter to Mr. Kerns's office and to write "personal" on the envelope.

There is no direct evidence of how Brad responded to this stern but ambiguous threat. By the end of May, however, Eleanor was writing Brad postcards and brief billets-doux. They are jaunty, even flapperish in tone, as she addresses Brad as "Toots" and "Tootsie" and gaily invites him to come up to Maine for a weekend at the family's summer house. By then, Brad had begun introducing Eleanor to his friends. A June 4 letter from Bob Bates announces, "It was swell to see Kernsie. I'd like to know her better."

Brad's summer was occupied with his Alaska flights. Then, in his date book, Brad wrote in a tiny hand in pencil on October 24, "Eleanor + I engaged!" The next entry was on November 1, just a week later, "9 PM Eleanor leaves for Europe."

The connection between those two events bespeaks a plan of action that was pure Brad Washburn. That autumn, Brad's father had taken another extended sabbatical, this time to Paris. He had brought along his wife and Brad's half-sister, Mabel. They had rented an apartment near the Champs-Elysées, in a comfortable hostelry called "La Résidence." Brad was still living at home, in the Deanery on Mason Street. But apparently his parents had never met Eleanor.

It is possible that Eleanor and her mother had already planned a cruise to England for that November. But it is also possible that the whole trip was Brad's idea. The main agenda, after a few days of obligatory sightseeing in England, was for the Kernses to cross the Channel, arrive in Paris, and socialize with the Washburns.

In any event, Brad's parents learned about the engagement by mail. Loyal to the end, they wrote back separately to congratulate their son. But at the same time, they were surprised and even alarmed. In his impetuosity, Brad had already planned a wedding for the end of January 1937. This would be before Brad's father could return from France. In his father's November 20 letter from Paris, after expressing his happiness for Brad, he urges that the wedding be postponed. "I do not like long engagements," he writes. "They are a great strain on the man and the woman. . . . But I never looked on an engagement of eight or nine months or a year as particularly long."

Mr. Washburn went on to wonder whether Brad's job at the institute (his initial contract had been for only one year) provided a stable enough footing for the responsibilities of marriage and, ultimately, family. But then he got to the core of his qualms:

> *Furthermore, you and she have only just got out of some pretty troublous waters. Until recently neither one of you has been sure. Your letters have been so full of uncertainty that the announcement of the engagement came right out of the blue.*

The only independent clue to those "troublous waters" lies in an October 27 letter from Bob Bates, who was in graduate school in English at the University of Pennsylvania. Bob chides Brad: "I can't believe you almost let her get away." He goes on to praise Kernsie effusively: "She's a companion—the sort you or I would pick out to take on an expedition if she were a boy." Then he returns to jocular teasing: "I've always considered you lacking horse sense in one phase of

life—women. I'm wrong. You're engaged to the only A1 girl you ever had, and by George, I'm glad of it."

From England and France, Eleanor wrote Brad often. Gone from the letters is the flapper's coy gaiety of the previous May. Kernsie narrates her doings with her mother in dutiful travelogues, as on November 11, from London: "Yesterday we slept late and then went to the shopping district to do a bit of Christmas shopping. I've bought your present already!"

No doubt Eleanor felt the strain of the impending meeting in Paris. Halfway through the trip, she was homesick, and badly missed her fiancé: "I can hardly wait to get home. I miss you so much and love you more every day."

The fateful rendezvous occurred in late November. If the letters home tell the whole story, the days the Kernses and Washburns spent together were happy ones, the mutual appraisal entirely successful. They lunched often at a favorite Café de la Paix, in the Place de l'Opéra, jotting notes on the café's postcards. One, from Eleanor, reads, "We've been wishing you were here to talk French for us but we doing [sic] pretty well." She signs, "All my love dear." And Brad's father drove the Kernses out of Paris for a day's visit to Versailles.

Mr. Washburn seems surprised to find Kernsie delightful. On November 20, he writes, "Eleanor is lovely—pretty and most companionable, and she loves you without a shadow of a doubt." Nine days later: "Eleanor is more than pretty. She has a lovely character."

In his controlling way, Brad had insisted that Kernsie and her mother take a side trip to Chamonix, just to see the village out of which Brad had done his first serious climbing. By the end of November, however, both women were exhausted, and Eleanor was desperate to get home. Yet she apologizes to Brad for not including Chamonix on her mini Grand Tour.

Heeding his father's qualms about a January wedding, Brad (and

Eleanor) agreed to put it off—but not for the eight months to a year that Mr. Washburn urged. The couple now planned to marry around Easter, which would come on March 28, 1937.

Having won his parents over, Brad moved forward with his characteristic purposefulness. As soon as Eleanor returned from France, he began introducing her to everyone he knew. Kernsie was eager to win the approval of Brad's friends. She had written Bob Bates from Paris what must have been a charming letter, for on November 25, Bob wrote Brad: "She is one damn swell girl. . . . You're a damn lucky guy." From Columbia University, Charlie Houston, who had not yet met Eleanor, wrote, "Now that you are leaving the bachelor's fold, well I hope she is the real goods."

Others who met Eleanor were favorably impressed. Brad's aunt Grace called her "a sweet, attractive girl," and Ad Carter's mother wrote, "She is so attractive and you two seem wonderfully suited to each other."

In early December, shortly after Eleanor had returned from Europe, Brad put an announcement of the upcoming wedding in the paper. In response, literally scores of congratulatory notes, some from distant acquaintances, filled Brad's mailbox.

Yet a cloud of uncertainty was building on the otherwise gleaming horizon. Brad's parents had genuinely liked Kernsie, but they still harbored misgivings. On November 29, just a day or two after the Kernses had left Paris, Brad's mother wrote him: "I realize that you may _need_ Alaska for your work. In that case could Eleanor let you go for the time necessary?"

And on the same date, Mrs. Washburn had the temerity to write Eleanor. (How the letter ended up in Brad's papers is curious.) "I still feel as I did when you were here, that you would both be happier and start with a better basis, if you wait until Brad has some sort of assured job and you have both had a chance to know each other."

Brad's father, acknowledging the postponement of the wedding till Easter, gruffly counseled, "Try to avoid Lent and Holy Week."

Brad did indeed need Alaska, not only for his work but for his soul. He had already made up his mind to go on an expedition in the summer of 1937. So had Bob Bates, after spending the summer of 1936 as a visiting scholar at Oxford University.

In the summer of 1935, Walter Wood had attempted Mt. Lucania. In a well-coordinated expedition, his team horse-packed fifty miles into the Saint Elias Range from Burwash Landing on Kluane Lake. At base camp on the Wolf Creek Glacier, Wood pulled off an innovative gambit of his own as a plane dropped supplies packed in boxes suspended from parachutes. Surviving the fall intact, the gourmet delicacies included fresh eggs and hot biscuits.

After a month and a half of climbing, Wood and three teammates reached the top of 16,644-foot Mt. Steele, making its first ascent. But to their dismay, they now realized how thoroughly Steele blocked access to the higher Lucania, which the men saw for the first time, soaring into the sky, ten miles farther west. There was no hope of traversing the swooping, crevassed, and serac-studded ridge that separated the two big mountains.

The November 30, 1936, issue of *Life* magazine—the second issue ever of the storied weekly—carried a three-page article about the climb of Steele. One of the photographs showcased Lucania. In the magazine's already patented Henry Luce telegraphese, the caption read: "Highest unclimbed mountain in North America is Mt. Lucania. . . . Expeditionist Wood mapped it from the air. Mt. McKinley in Alaska, highest (20,320 ft.) in North America, and Mt. Logan (19,850 ft.), highest in Canada, have both been scaled. But Mt. Lucania remains virtually impregnable."

Bates and Washburn had first hoped to try Lucania in 1935, but they had reluctantly stepped aside for Walter Wood. As if that sacrifice were not spur enough, the gauntlet thrown down in the last line of the *Life* caption ought to have sealed the objective for Brad and Bob in the summer of 1937. After the Saint Elias Range traverse in 1935, the young men had reached the height of their expeditionary prowess.

But the odd truth is that during the last months of 1936, Brad planned to head not for Lucania, but for Mt. Sanford, also unclimbed, and at 16,237 feet the highest peak in the Wrangell Mountains of Alaska. As Brad knew, Sanford would be far less difficult than Lucania. A letter from Hartness Beardsley to Brad in November 1936 confirmed this. Brad had seen Sanford from afar, but that old sourdough Andy Taylor had traveled all around the fringes of the mountain. Taylor told Beardsley that Sanford should indeed be an easy climb, and that "in April you could drive dogs to the base of the mountain." Though sixty-two years old, Taylor hoped to be a member of the party.

Why Sanford rather than Lucania? The answer is revealed in a November 12 letter from Sherry (who was studying in England) to his brother. Sherry had met Eleanor and her mother, had admired the engagement ring Brad had given his fiancée, but went on to ask, "What's this about Eleanor going to Sanford?"

Brad may even have leaked his scheme of a honeymoon expedition to a major Alaskan peak to his parents, for in another letter, written even before she wondered whether Eleanor would be willing "to let you go for the time necessary," Brad's mother told her son, "I also do not think Eleanor is strong enough to rough it in Alaska."

What Bob Bates thought of the idea of bringing a tenderfoot bride along on an Alaskan expedition is not on record—if he even knew about Brad's plan. In Bates's autobiography, *The Love of Mountains Is Best,*

there is no mention of any designs on Sanford, and he insists that as early as January 1937 Brad sent a photo of Lucania to the crack Valdez bush pilot Bob Reeve, inquiring whether it would be possible to land high on the Walsh Glacier directly south of the mountain. In any event, sometime in the early winter of 1936–37, Sanford was scotched in favor of Lucania.

Sanford was not all that got scotched. By March of 1937, Brad was deeply involved in planning for Lucania. Meanwhile, Eleanor moved to Philadelphia. The reasons for her relocation are unclear, but on March 15, Bill Child, who had been a member of the 1933 Crillon team, wrote Brad from Penn Valley, Pennsylvania. "Bob [Bates] tells me that Kernsie is coming to town. It is a fine thing that you could get her away from Boston. We will try to get her out here."

Ten days later, Bates wrote Brad, "By the way E. K. has gotten herself two jobs since she's been here + now is starting on a permanent one in a store. She started in by living at the Y. W. C. A. I just found out.

"I hand it to her. She has all manner of guts."

On March 29—the day after Easter—Eleanor wrote a letter to Brad from a hotel in New York City, where she reported herself "on vacation" from her Philadelphia jobs. The tone is muted, compared to the effusions she had sent from Paris the previous November. But she writes,

> Dearest Brad—
> I'm so glad you're coming to Philly again and would love to see you.
> . . . I can meet you anywhere after 5:30 on Friday if you'll let me know where. . . .
> I'm dying to hear about all the new developments in Alaska. I hear smitherings here and there from Bistrich but I like to hear the lastest [latest?] from the boss!

She signs off:

I'll see you soon

Much love
Eleanor

Except for a perfunctory note half a year later, this is the last letter Brad ever got from Kernsie—or at least the last one he kept.

What happened? Obviously, the planned wedding date had come and gone. Once again, the letters Brad kept all his life hint at the romantic drama of that spring. In an undated letter apparently sent in February, Lincoln Washburn (no relation, but a fellow climber and good friend) wrote Brad:

> *The news about E.K. did not surprise me terrifically. She is a swell girl; yet without meaning to blow hot and cold out of the same mouth, I can truthfully say that both Tahoe [Lincoln's wife] and I think you are a wise man. Naturally, the news won't go beyond us.*

At about the same time, Brad's uncle Arthur wrote, after attending one of his nephew's public lectures, "I could not speak of what was so much on my mind—your trouble and disappointment. It is hard to carry on under the strain of personal sorrow."

A further clue emerges in a mysterious March 17 letter to Brad from one Leroy Parkins, M.D. The Boston doctor may have been a psychotherapist whom Brad consulted. In any event, Parkins writes at length in an almost academic, impersonal vein, as he theorizes about love and marriage. "The perfect ideal in girls is a retreating shadow," declares Dr. Parkins. And, "If one's feelings vary it isn't a great surprise as one's feelings are like flowers that wilt then revive under proper circumstances." Only at the end of this awkward epistle does

Parkins more directly address Brad's dilemma: "I do hope that you will find the answer to your riddle. It is a deep crevasse that may require a leap with faith."

In March, the wife of Burton Holmes, the travel movie maker, wrote Brad, "Burton forwarded your note to him and I am SO sorry, so very sorry to hear of your broken engagement. I liked her very much and thought she was the one . . . but . . . better now than later."

On April 18, Holmes wrote, "I'm sorry. But it is much better to call off than to endure. . . . Unless the thing is a perfect go it must be perfect hell."

It seems clear from these notes of condolence that early in the spring of 1937, Brad had a complete change of heart about Kernsie. The falling-out might have been mutual, but Eleanor's March 29 letter seems still full of hope.

Is it possible that Brad, unable to confront his fiancée directly with his new misgivings, instead engineered her removal to Philadelphia, just as he had concocted the visit to Paris the previous November? And even worse, that by February he was telling friends and family that the engagement was broken, without having told Eleanor? If so, the final rupture cannot have been a gentle one.

Barbara Polk, who would meet Brad two years later and become his wife in 1940, eventually learned about Kernsie. She knew that the two had been engaged. And Brad told her that it was he who broke off the engagement. But whenever she pressed him as to why the relationship had ended so abruptly, he evaded the question. In the end, Barbara believes, Brad never really did win his parents' approval of Eleanor. And without that approval, marriage was unthinkable.

Whatever the amatory stress Brad underwent that spring, by March he had plunged wholeheartedly into planning for Lucania. The team

of four was by now decided: besides Bob Bates, Russ Dow (who had been with Brad on Crillon in 1934), and Norman Bright—a relatively inexperienced climber from the Seattle area, but one of the top track stars in the country (second only to Glenn Cunningham in the two-mile)—had signed onboard. As early as mid-February, Dow was already in Valdez, organizing the team's supplies while he scrounged jobs to make ends meet.

That spring also saw a new downturn in Brad's relationship with the National Geographic Society, which had declined to sponsor the Lucania expedition. (No letter from Grosvenor explaining why is preserved in Brad's correspondence, but in March the NGS president wrote, "Wishing you continued success, and hoping your vacation in Alaska will be thoroughly enjoyable and restful." Vacation, indeed!)

Already, Brad had started pitching articles to *Life* magazine, though so far without success, as the weekly turned down his proposal for a story on Alaskan glaciers. Science editor Charles Breasted, however, was very impressed with Brad's photos, and encouraged him to keep querying.

Without the backing of any magazine or institution, the budget for Lucania was truly shoestring. A series of pleading letters from Dow in Valdez came close to provoking a nasty spat with Brad, who insisted each man must pay his own way. On February 21, just a few days after arriving in Alaska, Dow wrote, "I don't mean to be heckling but the money situation is darn bad. I got here with 35 cents."

Teaching in California, Bright was close to broke himself, and he could not get away from school until June 10. Meanwhile, Bob Bates had landed an instructorship in the University of Pennsylvania graduate school, but neither his salary nor Brad's at the Institute for Geographical Exploration gave the four-man team the luxury of expedition affluence that Brad's team had enjoyed on the 1935 Saint Elias Range traverse, with the $7,500 NGS grant plus monthly salary for the leader.

Brad had launched the Lucania campaign with his January letter to

pilot Bob Reeve. He knew that Reeve was widely regarded as the finest and nerviest aviator in the territory. The biggest problem with Lucania, as Walter Wood had found out, was simply getting to the mountain. Any overland approach would rival the 100-mile gauntlet along which the Mt. Logan pioneers had laboriously packed loads in 1925.

Brad also knew that three years before, Reeve had taken a stainless steel bar out of a derelict roadhouse and manufactured a pair of airplane skis out of it. Taking off on skis from the Valdez mudflats, Reeve was able to fly supplies in to the camps of miners in the Chugach and Wrangell mountains, landing on snow in the spring and early summer months.

What Brad was asking Reeve to pull off, however, was unprecedented in the Far North—to land men and gear as high as 8,750 feet on the Walsh Glacier, directly below the massive south face of Lucania. No pilot had yet landed at anywhere near that altitude on an Alaskan glacier; the Walsh, moreover, was unknown terrain—in all likelihood, it had never felt the tread of a human foot. But Reeve responded with a jaunty telegram: ANYWHERE YOU'LL RIDE, I'LL FLY.

All spring, Brad organized the shipping of gear and food to Russ Dow in Valdez. The plan was to build up a base camp cache on the Walsh before sending the men in for the attempt—if indeed Reeve could make a landing on the glacier.

On his first attempt, the pilot had to turn around in the face of violent winds, but on the second, he made a perfect landing right where Brad had hoped to put base camp. The conditions were perfect: in what was still effectively winter at that altitude, the snow was as hard as concrete. At the time, Reeve's was the highest glacier landing with a full load of freight accomplished anywhere in the world. With Dow as cargo handler, Reeve made several trips. By the end of May, a tidy cache of 2,000 pounds of gear and food sat waiting for the team. After the ascent, if all went well, Reeve would return to fly climbers and essential gear back out to Valdez.

With the team scattered across three states and the Alaska Territory, the toil of organizing in April and May grew frantic. A March 5 telegram from Brad to the French mountaineering equipment maker François Simond reflects the frenzy: ENVOYEZ URGENCE TROIS PAIRES CRAMPONS DIXNEUF POINTES POUR EXPEDITION ALASKA. ("Urgence" ought to have been Brad's middle name.) Why he asked the French company for nineteen-point crampons—they normally come in only eight-, ten-, or twelve-point models—remains unfathomable, unless it was a slip of the telegraphic pen.

At last, everything seemed to be in place. Brad left Boston on May 30, proceeding by train and plane to Seattle, and thence by steamship to Valdez. Bob Bates and Norman Bright departed almost two weeks later, arriving in Valdez together on the evening of June 17. The united team was ready for Lucania.

Yet in the last several weeks before heading north, Brad had managed to add a potent new complication to his already overcomplicated life. The first hint of it in the record is a playful line in a May 13 note from Brad's half-sister, Mabel, vacationing in North Carolina: "I'm glad too you're all cheered up with another girl!"

The girl was Mary Whittemore, known to her friends as Whit. She was an undergraduate at Radcliffe majoring in anthropology, with a passion for classical music. How Brad met her is uncertain, although given that Sherry had concentrated in anthropology at Harvard, it may have been his wife who once again tried to fix up Brad (Sherry was in Asia at the time). In any event, on May 21, only nine days before heading off to Alaska, Brad attended a dance with Whit at her dorm, Barnard House. On the heels of his broken engagement with Kernsie, his relationship with this new flame developed with brushfire speed, even while it hovered in ambiguity.

Once again, we have only Whit's side of the correspondence by which to gauge what transpired. She kept writing Brad even after he had reached Valdez, addressing the letters care of Bob Reeve. On June

13, she insists, "I am looking forward to the gray woolly shirt, but really Brad dear, you must stop sending and giving me things!" She signs off, "Lots of love." An undated letter written sometime in early June goes deeper:

> *Exam fever is slowly creeping up on me. . . . I would probably get*
> *more done if I didn't spend so much time thinking about you. I*
> *keep quizzing myself and trying to analyze my feelings toward you.*
> *I have never felt this way toward anyone before. The only trouble*
> *is that it is not a completely comfortable feeling, but it is mighty*
> *strong. I am sure that I am really fond of you. More than that I'm*
> *not sure.*

As was not true with Kernsie, Brad evidently introduced Mary Whittemore to his parents right off the bat. They seemed to be at least as charmed with this new girlfriend as they had been by Eleanor in Paris. A June 12 telegram to Alaska reads: THANKS LETTER MARY WHITTE-MORE JOINS OUR GOOD WISHES LOVE TALLYHO—MOTHER AND FATHER.

Brad's birthday was June 7. His father sent him a congratulatory letter in the form of a doggerel ballad that wryly summed up his ambitious twenty-seven-year-old son's plight. It begins:

> *Bradford, Bradford why not rest*
> *From Alaskan labours*
> *Cant you find a nearer spot*
> *Safe with friends and neighbours?*

And ends:

> *Blessings to the Birthday boy*
> *Skies grow bright above you*
> *Glaciers melt + rocks grow soft*
> *And all the ladies love you.*

Most remarkably, before Brad left for Alaska, he helped Whit orga-
nize an expedition of her own. She had been invited to participate in an
archaeological field school that summer in Chaco Canyon, the famous
Anasazi complex in western New Mexico. Whit decided it would be
great fun to round up four friends (three fellow Radcliffe students,
and a gal from Columbia University) and make a leisurely drive via
the southern states out to the school. The key to the journey was the
loan of Brad's automobile—not the old Model A roadster he had bought
with his Putnam royalties, but a new Ford "Woodie Wagon," one of the
first station wagons ever manufactured. Brad nicknamed it the Prairie
Schooner. He not only blithely entrusted the five girls to drive the vehi-
cle some 2,500 miles to Chaco Canyon, but he helped them find special-
ists to increase its baggage capacity by adding racks and boxes to the
chassis (one of these appurtenances Whit called the Monkey Cage).

After school got out, Mary went home to her parents' house in
Scarsdale, New York, where she spent several weeks organizing her
trip. Though she knew that by now Brad was probably on the Walsh
Glacier, she kept on writing to her boyfriend all summer. Apparently
one of the biggest problems in planning her own journey was convinc-
ing the other girls' parents that an all-female trip from Massachusetts
to New Mexico in the Prairie Schooner, with overnights in roadside
"tourist camps," was a safe proposition. On July 20, Whit sent Brad a
twenty-page letter, in which she complained about the rigors of putting
together her expedition: "I don't believe you could have had any more
trouble on any of your Alaskan trips."

By her own admission, as Mary had written in June, "I have never
done any rock climbing, but am dying to try some. I appoint you chief
instructor, and leader." Yet she recognized that Brad's venture on Lu-
cania was a perilous one. "I hope to heaven you get out safely," she
wrote at the end of her letter.

Brad and Whit had made plans to meet after their respective ex-
peditions. One of the girls heading west in the Prairie Schooner had

a relative who owned a ranch near Evergreen, Colorado. She invited Brad and Whit to hole up in September in a cabin on the ranch. From Alaska, Brad would head not back to Cambridge, but straight to Colorado. Snuggling in with his new girlfriend in the foothills of the Rockies promised a romantic coda to what Brad had already begun to suspect would turn out to be the most difficult—and the most dangerous—adventure of his young career.

On June 18, Brad and Bob Bates climbed into Bob Reeve's Fairchild 51 to fly in to base camp. Russ Dow and Norman Bright would follow on a second flight. During the week before, as Brad waited impatiently in Valdez, a raging southeaster had struck the coast, bringing with it a weirdly unseasonable warm spell.

At 4:00 P.M., Reeve lined his plane up for what he assumed would be a routine landing on the Walsh Glacier. As he touched down, he was surprised at how quickly the plane skidded to a stop. Then Brad hopped out of the passenger door—and sank thigh-deep in a sea of slush. The warm spell had turned the once solid glacier into soup. In four years of glacier and snowfield flying, Reeve had never seen the like.

It would take five days, and a number of failed attempts, before temperatures dropped enough to firm up the snow sufficiently for Reeve to take off. Before each attempt, Bob and Brad would laboriously shovel out the plane, which at its worst sank up to one wing tip in the slush. The pilot would gun the plane up his makeshift runway, turn it around (with the aid of Bob and Brad tugging on the tail with ropes), then try to give it enough power to get airborne—only to have the Fairchild wallow pitifully in the watery snow and come to a halt once more.

Reeve spent most of those five days in a deep, brooding funk, seldom leaving the four-man base camp tent. Back in Valdez, Dow and Bright—and Reeve's wife, Tillie—had no idea what was happening.

The plane could have crashed somewhere in the wilderness and killed all three occupants. Brad tried to cheer up Reeve, suggesting he join him on a snowshoe stroll for exercise, but the pilot refused, muttering, "You skin your skunks and I'll skin mine."

After three days on the Walsh, Brad wrote in his diary, "Bob Reeve is so scared of cracks [crevasses] that he has not moved an inch from camp!" What the two climbers did not know, however, was that two years earlier, in a desperate rescue of a miner on the Valdez Glacier, Reeve had walked unroped in the dark into an open crevasse, barely saving himself by instinctively flinging out his hands and catching hold of a rock imbedded in one of the crevasse's icy walls.

Finally, on June 22, Reeve began a do-or-die last try at takeoff. Beforehand, he stripped the plane of every piece of gear he could, throwing out his emergency sleeping bag, his tools, and even the crank for his engine. At the last minute, Brad and Bob watched in amazement as the pilot attacked the plane's propeller with a ballpeen hammer. But Reeve knew what he was doing. By sharpening the pitch of the propeller blade, he might gain a bit more bite in the thin air at 8,750 feet, assisting a short takeoff even though this would jeopardize the plane's stability. Without a word of farewell to his two clients, Reeve climbed into the cockpit.

Decades later, Bob and Brad vividly remembered the horror of watching that takeoff, as Reeve's plane bounced down the runway, veered to miss an ice block, then seemed to plunge suicidally toward an open meltwater lake on the glacial surface. But at the last minute, just before hitting the lake, the Fairchild wobbled into the air, then disappeared from sight behind a glacial ridge. Bob and Brad literally held their breaths, anticipating the sound of a crash. Then, when they saw the plane in the distance, it canted to the right and gained speed. The pilot had pulled off what would remain the diciest takeoff of his life.

What this meant, however, was that Reeve had left Brad and Bob stranded. There would be no second flight with Dow and Bright, who

would spend the next month in and around Valdez, wondering what was going on with their friends on Lucania. The twist of fate was particularly cruel for Dow, who had been toiling away in Valdez since mid-February to make sure the expedition succeeded. And there would be no pickup at the end of the expedition. Reeve was so spooked by the whole affair that he declined even to make a checkup flight to see if the two young climbers were in trouble. As far as he was concerned, Bob and Brad were on their own.

At that moment, no two human beings in all of North America were more isolated from their kind than Bates and Washburn. The nearest outpost of civilization was the gold-rush town of McCarthy, a hundred miles to the west. Those hundred miles comprised thirty miles of unknown glacier, the rubble of chaotic moraines, and a deep canyon through which the possibly unfordable Chitina River swept from one wall to the other.

In such a predicament, nearly any other climbers would nonetheless have immediately begun the hike out to McCarthy. They had plenty of food at base camp, and no matter how rough the terrain (they had gazed intently at it on the flight in), the whole route out was downhill. Much of it, moreover, followed the path taken by the Mt. Logan climbers in 1925.

Instead, at the apogee of their youthful confidence and skill, Bob and Brad decided to give Lucania their best shot. Not only that, but they determined, if and when they reached the summit, to escape the range not by descending their route and heading down the Walsh Glacier, but by traversing over Lucania's satellite peak, 16,644-foot Mt. Steele, descending the Wolf Creek Glacier (which they had never seen), crossing miles of lowland sandbars and tundra, finally fording the Donjek River, and striking civilization at the trader's post at Burwash Landing on Kluane Lake.

Besides requiring a technical ascent of more than 8,000 feet and the traverse of a peak almost as high as Lucania, this hike-out itiner-

ary would pose a gauntlet of 140-odd miles—not the 100 to McCarthy. In 1935, Brad's team had filled in the blank on the map to a latitude just south of that potential hike-out route, but they had not surveyed as far as the Wolf Creek Glacier or the Donjek River. Now, Bob and Brad carried with them the old government survey map with the huge blank, on which, after his aerial reconnaissance flights in 1935, Brad had sketched in previously unknown glaciers in blue pencil. Those sketches, however, were guesses based on brief glimpses from Bob Randall's plane. The map, moreover, would do them little good, for it had caught fire in the cook-tent conflagration in 1935, and now its edges were burned off, creating further blanks.

For the rest of their lives, Brad and Bob adamantly insisted that the hike-out route over Steele was actually easier and safer than a descent of the Walsh Glacier and Chitina gorge to McCarthy. This is demonstrably a rationalization. The pair were so confident in their abilities— "cocky" is not too strong a word—that despite the near fiasco of Reeve's slushy landing, and the complete revision of the expedition plan it dictated, Bob and Brad were not willing to turn their backs on Lucania.

On June 21, Brad wrote a letter to his parents that Reeve carried out and mailed. The letter reveals that the two men had made up their minds almost immediately.

Just as soon as the plane leaves we are going to hot-foot it for Lucania. We plan to establish three bases between the head of our valley and the summit if we can make it. There is a bare chance two of us can do it alone. . . .

You will hear from me when we reach Burwash Landing.

The tone of Brad's letter is consistently cheery, and he makes no effort to allay his parents' inevitable fears. "The food situation is colossal," he chortles. "We had a whole ham for supper and pea soup

and corn and lemonade, and pilot crackers. I'll be fat as a pig when we get out."

Reeve took it upon himself to reassure Brad's mother, writing her on July 9, "Please don't worry about the boys for, in spite of the remoteness of their whereabouts, I am sure that everything is going to be O.K."

The correspondence Brad kept the rest of his life further punctures his and Bob's rationalization about hike-out routes. From Philadelphia on April 7, Bob had written Brad,

> *Could we send out one plane load of movie film and two men [at the end of the expedition] + have the other two men try to <u>siwash</u> it out to Kluane. . . . Walter Wood says we can use his tents and food. He claims everything should be O.K. at the foot of the Steele ridge.*

After climbing Mt. Steele in 1935, Wood's party had left a sizable cache of gear and food near their base camp. Wood's team had ridden horses in to and out from the Wolf Creek Glacier with the able assistance of professional packers out of Burwash Landing. In his April excitement, Bates was suggesting that he and Brad could backpack the route out that Wood's party had managed on horseback. ("Siwash," a corruption of the French *sauvage,* or "wild," was a sourdough coinage, meaning to "rough it"—and specifically, as one modern dictionary glosses it, "to travel quickly, deftly, and lightly, making use of natural shelters on the trail.") "To hell with horses!" Bob proclaimed in the same letter.

Bob and Brad's lifelong rationalization of their Lucania plan is further undercut by a letter Russ Dow wrote Brad from Valdez on May 8. Reeve had been worrying out loud about the scheduled pickup at the end of the expedition. The weather in August, he told Dow, was predictably stormy. So he had come up with Plan B. "If we walk out Bob

[Reeve] will meet us on the river bar with wheels," Dow wrote. In other words, if at the end of the expedition it proved too tricky to land on the Walsh Glacier with skis, the simple alternative for the four men would be to make the relatively easy hike down the thirty-odd miles of the glacier to its snout, then wait for a pickup on the flat, gravelly river bar, which Reeve would accomplish with his other, conventionally wheel-equipped plane.

Dow added a detail that, in retrospect, makes Bob and Brad's eventual achievement all the more astonishing. "There is a cabin at the foot of the glacier with some supplies," Dow wrote, "and good sheep hunting nearby."

In light of this knowledge, even if Bob and Brad were intent on having a go at Lucania, by far the easiest and safest course would be to descend the mountain to the original base camp, hike out the Walsh, and wait for Reeve's pickup on the river bar. With Bob Bates's skill as a marksman, he might easily add a few Dall sheep to the provisions stocked in the cabin.

It is possible that after spending five days marooned in the slush, Reeve wanted no part of the whole Saint Elias Range, and refused even to pick up the men on the river bar. But that refusal would have gone against the whole ethos of Alaskan bush flying, which decreed that the pilot took care of his clients, and Reeve was one of the gutsiest and most daring aviators in the territory.

The conclusion seems inescapable. Despite their predicament, Bob and Brad determined to pull off a climb of Lucania, a traverse of Steele, and a marathon hike out to Kluane Lake just for the sake of the challenge itself. To quote Mallory, "Because it was there."

During the two weeks after Reeve escaped the glacier, Brad and Bob relayed supplies up their intended route. On the relatively gentle slopes

leading to the upper cirque of the Walsh, they used a collapsible sledge they had flown in to haul gear and food. But once they started climbing on the steep headwall, every pound had to be carried on their backs. The weather varied from still and clear to all-out storm. On one day, the men watched the most gigantic avalanche they had ever seen come roaring 8,000 feet down Lucania's south face, only about a mile west of their route.

Partly because they were working so hard, the men's spirits stayed high during those two weeks. As always, Brad reserved his most ebullient diary entries for food, as in an aside about Klim ("milk" spelled backward), the now-defunct powdered whole milk that many an expedition swore by as a staple: "I have succeeded in collecting enough Klim coupons to get a free electric mixer, and have stored them in my shirt pocket!"

Yet there is no mistaking a gathering mood of dark urgency as the men tackle their climb. On June 26, after eyeing the steep icy rib that would be the crux of the route, Brad wrote, "Zeus, but that will be a climb! But we've got to make it!"

Had the plan been to climb the mountain and descend the route, the buildup of successive camps would have formed an orderly traditional pyramid, of the kind that had spelled success on Crillon. But once they had determined to traverse the range and escape it to the east, Brad and Bob knew that at some point they would have to sever ties with base camp. After a certain date, every piece of gear and pound of food they would need to hike out of the Saint Elias Range would have to be carried on their backs—eventually, in a single packload.

This meant a grievous loss of precious belongings. For Brad, the hardest thing of all to leave behind was his large-format camera, the Fairchild F-8 that shot five-by-seven-inch negatives.

So, as the two men worked their way up the huge face of Lucania, they started practicing the most radical economy of gear. Of sheer

necessity, the men now perfected the fast-and-light style that would mark Brad's lasting stamp on mountaineering. They threw away their air mattresses, sleeping instead on their unyielding packboards. They decided to jettison one sleeping bag, believing they could go to the summit and all the way out to Kluane Lake with a single bag in which they slept head to toe. This bedtime arrangement would create many a vexing nocturnal moment. Eventually, they cut the floor out of the tent, threw away the tent pegs, cut off the guylines, and finally abandoned the central tent pole. As Brad wrote on June 27, "Our motto from now on is: 'Chuck it out and we won't have to lug it!'"

On July 7, at last the pair reached the 14,000-foot saddle between Lucania and Steele, a blessedly flat, uncrevassed snow shelf that they named Shangri-La. By now they were cut off from base camp, committed to the traverse of Steele and the eastward escape to Burwash Landing.

And two days later they made the first ascent of Lucania. Brad shot his portrait of the pair standing exhausted but overjoyed on top, on a clear but cold afternoon (zero degrees Fahrenheit), with a shoelace trigger attached to the Zeiss camera he had refused to abandon, mounted on top of his ice axe. It is one of the finest summit photos ever taken anywhere—a self-evident icon of the glory of mountaineering.

Back at Shangri-La, the men turned their attention to Mt. Steele, whose summit pyramid rose 2,500 feet to the east above them. Part of the challenge was to one-up Walter Wood, for having been asked to step aside from a Lucania attempt in 1935 still stuck in Brad's craw. (Bob, ever the peacemaker, had in the meantime established a cordial relationship with Wood.) But Brad and Bob were sure that they were better mountaineers than Wood. A mantra they kept repeating to each other that summer was, "Anything Walter Wood can climb up, we can climb down."

The two men pulled off the traverse of Steele with scarcely a hitch.

Going first, held on a tight rope by Brad, Bob performed a brilliant job of route finding as the men felt their way down the steep and convoluted northeast ridge of Steele. To save further weight, they "chucked out" their crampons, which nearly brought them to grief when, low on the ridge, they hit a long section of frozen scree, a dangerous slope that would have been far easier to descend with metal spikes attached to their feet than with their boot soles alone. Here the men also discarded their climbing rope.

Back at Shangri-La, to reduce their packs to a manageable sixty pounds each, Bob and Brad had chucked out an "extra" four pounds of food, leaving themselves with a mere half gallon of white gas for their stove and only nineteen pounds of food between them. In terms of rations, the men thought they had an ace up their sleeve. Wood had not only offered Bob free use of the substantial cache he had left behind in 1935, he had itemized the copious amounts of food he had left behind and pinpointed the precise corner of the Wolf Creek Glacier where the cache had been deposited. Bob and Brad's blithe assumption of a resupply, however, would put them in direr straits than they had yet faced during the three and a half weeks since the expedition had started.

As they stepped off the northeast ridge of Steele onto the relatively benign glacier, the men's spirits soared. Brad wrote that night in his diary, "We are down in God's country again, and for some time there will be nothing but fun!"

On July 12, the men approached the glacial corner where Wood had left his cache. They topped a rise and saw ahead of them tin cans gleaming in the sun. Something was wrong with the picture, though. As they reached the spot, instead of a neatly stacked depot of supplies, they found the cans strewn wantonly in the grass. Every one was smashed, with deep holes gouged through the sides. At once Bob and Brad knew what happened. Sometime between 1935 and 1937, a bear had come across the cache and attacked it. Virtually every can had

been licked clean. The only intact container the men salvaged was a small jar of Peter Rabbit peanut butter. (For the rest of Brad's life, he would allude to the cache site as "Peter Rabbit corner.")

Utterly demoralized, the men trudged onward. They had already lost many pounds apiece, and now hunger was a constant agony.

One of the few pieces of heavy gear the two men had not chucked out was a three-pound police revolver that belonged to Russ Dow. During these desperate days, Bob managed to shoot a squirrel out of a tree and a big snowshoe rabbit. (He had to admit to his partner that he had missed the squirrel, but, in a lucky shot, had severed the branch to which the rodent clung. As soon as the squirrel hit the ground, Bob snatched it up and finished it off. As for the rabbit, Brad danced in a circle, arms outstretched like a basketball player guarding the other team's best shooter, as he tried to shoo the animal toward the marksman. As he aimed, Bob was afraid he might miss the rabbit and plug his best friend instead. That night Brad wrote, "This diary is about two inches from a big pot of rabbit meat, with ample left for at least one and possibly two more meals; so here goes!")

On July 15, the men ate the last of their food—a grand total of six dehydrated baked beans. Finally, however, they were approaching the Donjek River. If they could cross that last obstacle, they were pretty sure they could manage the thirty miles of taiga to Burwash Landing even without food.

But then, with the Donjek not yet in sight, they heard the ominous roar of its flooding current. Over the next two days, there followed one setback after another: the futile attempt to build a driftwood raft; the crossing without crampons of the snout of the Donjek Glacier; the wretched bivouac on the ice under the tent with no pole; the shock of the discovery that the true source of the Donjek was not that glacier, but another one twenty-two impossible miles farther south; the dicey rappel off the carved bollard just to get off the glacial snout.

And then, the nearly hopeless effort to ford the river where it

braided into some fifty channels, the last one proving the deepest and most treacherous. With their rope improvised from pack cordage, Bob had staggered into that last channel and lost his footing, only to be held by Brad's stationary belay. But then, as Bob forged on, he had lost his footing again, and the taut rope pulled Brad loose. Both men careened out of control, the muddy flood carrying them around one bend after another. Both men had time to think *This is it.* . . .

Then, with a genius born of desperation, Bob improvised a technique: he would let the current carry him twenty or thirty yards, then touch bottom with his feet, only to spring upward in a mad leap. Brad caught on and imitated his friend.

At last Bob eddied out on the far shore. Brad, too, crawled up into the bushes. Shivering uncontrollably, the two stripped off all their clothes and pulled their single sleeping bag around them. "We crossed the goddamn son of a bitch," Brad whispered.

Two days later, among the willows and alders, Brad and Bob ran by chance into some Indian horsepackers from the Burwash Landing trading post, out rounding up stray steeds. The men were utterly dumbfounded to discover the climbers—no one in the Yukon suspecting that any human being was abroad in the vast wilderness between Kluane Lake and the Saint Elias Range.

The ordeal was over. The packers fed the famished men such feasts of roasted Dall sheep and bread and jam that Brad got sick, threw up, then gorged again. Offered horses to ride, Bob and Brad saddled up, but they were so bony by now, the jolting on horseback proved an agony. Both men got down and walked the rest of the way. On July 19, a month after landing in the slush on the Walsh Glacier, they reached the trading post at Burwash Landing.

The crossing of the Donjek River was the closest Brad would ever come to dying in the mountains. For Bob, it was one of the two closest calls of his life—the other coming on K2 in 1953.

In Lucania, Brad and Bob had claimed the highest unclimbed peak in North America. That would have been an extraordinary deed under the best of circumstances, with a conventional expedition assault. After finding themselves marooned on the Walsh Glacier, with no further support from Bob Reeve, Brad and Bob had managed to pull off a tour de force of alpinism and survival, the likes of which has never been repeated.

Seventy years later, in fact, the first ascent of Lucania and Bob and Brad's escape from the Saint Elias Range remain probably the single bravest and most unlikely mountaineering feat ever accomplished in the Far North. The second ascent of the mountain came only in 1967, by a party of climbers who managed to fly, without a hitch, both into and out from the glaciated wasteland surrounding what is still one of the most remote peaks on the continent.

Only days after he returned to the East Coast, Brad took the train to New York City. Uninvited, he walked into the offices of *Life* magazine in the Chrysler Building. Bypassing the secretary, he barged into the sanctum of associate editor Winston Hicks and dropped a copy of the November 30, 1936, issue of the magazine on his desk, opened to the page that displayed Walter Wood's distant photo of Lucania from the summit of Steele, with the caption, "But Mt. Lucania remains virtually impregnable."

"And so what?" said the startled Hicks.

Brad laid a neat typescript and a box of photos on Hicks's desk. "Here's the story," he said, "of the first ascent of your unclimbable mountain."

Gil Grosvenor and the National Geographic Society may have dismissed Brad's summer of 1937 as a "restful vacation." Hicks and *Life* knew better. Its September 27 issue, appearing only a month after Brad walked into the Chrysler Building, celebrated the climb in an eight-page feature lavishly illustrated with the superb photos Brad

had shot with his Zeiss camera. The centerpiece of the spread was the by-now classic portrait of Bob and Brad on the summit, grinning and exhausted.

Life paid Brad a thousand dollars for the article. That single check recouped the entire cost of the expedition.

5

Perfecting Alaska

Weeks before Brad barged into the offices of *Life* magazine, he met up with Mary Whittemore in the West. Their August reunion occurred not in Evergreen, Colorado, but at Chaco Canyon in New Mexico, where Whit was still finishing up her archaeological field school.

During Brad's absence on Lucania, Mary had missed him badly. She was completing her spring semester at Radcliffe when Brad had taken off for Alaska. Only a day or two later, she wrote him in a wistful mood: "Sunday evening after seeing you off and joining your family for a gentle drive along the river I became very sentimental and went to bed on the roof with the sleeping bag, the air mattress, the little blue pillow and the rabbit's foot." Presumably, Brad had lent her some camping gear (including the rabbit's foot) to equip her for her own expedition out west in the Prairie Schooner.

In another note, Whit sighs, "One of the fourteen weeks has gone by." She kept writing Brad through the summer, even though she knew he would not be able to read the letters until after the Lucania

expedition. Her own journey across the States, with her four friends, began only on July 20. (On that date, Brad and Bob were spending their second night in soft beds in the safety of the Burwash Landing trading post, with the desperate ford of the Donjek River behind them.)

Whit's long missives from the road are full of chatty detail, as she makes no bones about her naiveté as a traveler. Halfway through the journey she exclaims, "I have never been in so many states in my life." In Tennessee, the girls attend a Holy Roller revival meeting: "The whole thing was quite fanatical and primitive." In the Ozarks of Arkansas, "We had a real look at cotton country and the darky cabins." Oklahoma was so flat and barren that "I can easily see how people could go crazy out here."

Once in New Mexico, the girls visited Taos Pueblo, which disappointed Whit: "The Indians of the Pueblo were so definitely 'on view' sitting around with their Sears Roebuck blankets. All the little children call 'Penny, penny,' and look anxiously." At Santa Clara Pueblo, north of Santa Fe, like many another squeamish tourist, Whit found the pottery excellent but the Indians themselves distressingly dirty. The girls paid a visit to the Puyé cliff dwellings, ancestral home to the Santa Clara people. The ruins "haven't been occupied for over 1000 years. No dirty Indians to worry about there."

Whit was mildly outraged by the price of the Santa Fe tourist camp, the most expensive in which they had yet stayed, at ninety-two cents per person per night. On July 30, the girls finally reached Chaco, as the field school swung into action. It was not until mid-August that Brad joined Whit there. In the meantime, Brad's mother was doing her best to abet the romance. Having shipped a suitcase to Denver for Brad to pick up on his way south, she wrote her son on August 17, "I hope you will look neat at least when you meet Mary! I hated to put in those overalls + think you should at least get new ones."

The excavation, supervised by the famous anthropologist Clyde

Kluckhohn (who would serve on Sherry's doctoral committee), imposed a grueling regimen. Digging began at 8:30 every morning. After a break for lunch, the students slaved on under the pitiless New Mexico sun until 5:30 P.M. On August 2, Whit complained,

> *Digging and not finding anything may become a bit boring but I had a thrill this afternoon when I was called in to record a burial. . . .*
>
> *The only trouble is that the main thing found is pottery and they already know too much about it already. Everyone is just hoping and praying for some skeletal material. . . .*
>
> *I am beginning to discover that Kluckhohn is actually human but oh so serious minded.*

If Brad and Mary wrote to each other about their liaison at Chaco, the letters have not survived, so it is by now impossible to know what happened during their reunion in the West. It is not even clear whether they drove the Prairie Schooner north to Evergreen and holed up in the cozy cabin together, as they had planned. Their idyll must have been brief, because Brad was due back at the institute to start teaching, and Whit was beginning her senior year at Radcliffe.

Barbara Polk, who met Brad less than two years later, knew much about Kernsie and the broken engagement of 1937. Barbara later met Mary Whittemore and never believed that Brad and Whit had had a serious romance. Yet there is no mistaking that with Whit, Brad was making a second try to establish a lasting union, for on August 21, Brad's mother wrote to him, "As to getting married, Mary is the right one + all goes well. She would want to finish her college anyway + you could have a pleasant winter both doing your work + get married in the spring!"

Evidently Mary Whittemore had won Brad's parents' wholehearted approval, as Kernsie had not. (A letter from Brad's mother sent six

days after the one quoted above adds a sad postscript to the broken en-
gagement: "We met Eleanor Kerns in Plymouth yesterday. . . . I do feel
sorry for her poor child—she has had a rough time of it and though it
could not be helped, we must do all we can for her.")

The only hint of caution in Mrs. Washburn's August 21 letter is her
gentle urging to her impetuous son to wait till next spring to get mar-
ried. Meanwhile, Brad must have told his friends about his plans with
Whit, for Tillie Reeve, the bush pilot's wife, wrote him on September
26, "Are you married yet?? Best luck." Brad's partner from the Saint
Elias traverse, Hartness Beardsley, wrote him in November, "And all
the luck in the world to yourself. Just be darned careful who she is
because if and when you get the right one, even if it takes a long time
finding her it really makes all the difference in the world."

On the other hand, Beardsley's note may hint at trouble. For some-
thing went wrong that fall and the next spring. A late October letter from
Whit still addresses Brad as "darling," and she admits with regret to
having lost the lucky rabbit's foot that had become part of her camping
gear. Then, through the winter months, there are no letters. By itself,
this means little: with Brad at Harvard and Whit at Radcliffe, they shared
the same extended campus and had no need to write to each other.

But then, in April 1938, a letter from Whit to Brad seems to allude
to problems between the two. The tone is friendly, but hardly that of a
lover or fiancée: "The family sends their best. . . . I do want to see you
before you go back to the land of ice and snow. I'm ready to see you
again any time you feel you want to see me, which I take it from your
letter, will be soon." Whit signs off not "Lots of love," but merely "As
ever." And after this ambivalent epistle, Mary Whittemore disappears
completely from the folders of correspondence that Brad kept all his
life. We can only speculate what happened to dampen the romance.
Perhaps this time it was Whit who got cold feet.

◆ ◆ ◆

Within the mountaineering world, Lucania brought Bob and Brad international recognition. Besides the eight-page coverage in *Life,* Brad wrote articles for the *American Alpine Journal,* the British *Alpine Journal,* and the French *Alpinisme.* He swung back onto the lecture tour with a vengeance, regaling audiences with a well-illustrated talk alternately titled "The Conquest of Lucania" and "Over the Roof of the American Continent." The venues ranged from the Explorers Club and the American Alpine Club to such New England colleges as Mt. Holyoke, Amherst, and Bowdoin. He traveled to Ohio to talk at the annual meeting of the Engineers Club of Dayton, and he took a very quick trip to England to speak before the Royal Geographical Society.

Congratulations on the landmark ascent poured in. One that no doubt meant a great deal to Brad came from Charlie Houston: "In my opinion, offered in due humility, your trip stacks up with the Logan show [the 1925 first ascent] and better, because you made it out against odds without any casualties." This was Houston's way of saying that he believed Brad and Bob's traverse of Lucania was the finest deed yet performed in the great ranges of Alaska and the Yukon.

Everything seemed to be turning up roses for the twenty-seven-year-old explorer. At the beginning of the fall term at Harvard, the institute reappointed Brad as instructor for another year, and the September 27 issue of *Life* made a big splash. J. Monroe Thorington, a highly respected éminence grise in the American Alpine Club, even suggested that he and Brad cowrite a history of North American mountaineering.

Then, in December, came a bombshell, arriving in the form of a half-sheepish letter from Bob Bates, who had resumed his instructorship at the University of Pennsylvania. Bob wrote,

> *Now comes what must be a tremendous surprise to you. The A.A.C.*
> *is sending an expedition to the Karakoram and I'm going. Houston*

is leading the party, which is the first Amer. group _ever_ to get
permission to go into the Himalayas.

Bob goes on to plead with Brad not to mention the trip to anyone else. He apologizes for not telling his best friend about the looming expedition sooner, because "I had kept absolutely quiet about the trip because Charley had asked me to."

The expedition's objective was K2, the world's second-highest mountain. Ever since 1926, when Captain John Noel had come to Groton to lecture on the 1924 expedition, Brad had dreamed of attempting Mt. Everest. A crack at K2 would have been even sweeter, for it is a far more difficult mountain than Everest, and while by 1938 five men had reached 28,000 feet on Everest, the three previous attempts on K2 (none since 1909) had reached no higher than 21,870 feet—more than 6,000 feet short of the mountain's 28,250-foot summit. Although the British had discovered a reasonable route by which to attack Everest on the very first expedition to the mountain in 1921, the route by which K2 would eventually be climbed had only tentatively been identified.

Before the expedition left the States in April 1938, Charlie Houston invited a number of American climbers on the expedition, most of them possessing far less experience or skill than Brad. For all the cordial correspondence that Brad and Charlie exchanged, the tensions from Crillon in 1933 must still have festered, because Houston never hinted at inviting Brad, just as he had overlooked his former teammate when he helped organize the Nanda Devi expedition in 1936.

For the rest of his life, Brad never publicly acknowledged any disappointment at being left off the K2 team. But the implicit snub must have been a hard blow to the pride of a man who, at twenty-seven, was already perhaps America's proudest mountaineer.

◆ ◆ ◆

Brad's response was to head back to Alaska, and for the summer of 1938, he planned not one expedition, but two. Mt. Sanford, the 16,237-foot snow giant that is the highest peak in the Wrangell Range of east-central Alaska, had been on Brad's back burner for a year, ever since he had laid aside that objective to set his sights on Lucania in 1937. Confident that Sanford would be an easy climb, Brad relegated it to the status of a vacationlike postscript to a more ambitious project. The Chugach Range, perpetually wreathed in some of the worst weather in the subarctic, spreads east along the Gulf of Alaska some 160 miles from the outskirts of Anchorage to the Copper River, where it merges with the Saint Elias Range. The peaks of the Chugach are not graceful pyramids of the sort with which the Alaska Range abounds; instead they tend to be lumpy and convoluted masses. The rock in the range is uniformly rotten, mostly a shattered gray-black schist. But the Chugach makes up in heavily glaciated difficulty what it lacks in aesthetic appeal.

By 1938, only a handful of easy, low summits near Anchorage had been climbed anywhere in the Chugach. The range's highest peak, the inaccessible Mt. Marcus Baker (alternatively named Mt. Saint Agnes), reaches only 13,176 feet in altitude, but it had never been attempted. Brad knew it would amount to a far sterner challenge than Sanford. He planned to assemble two separate teams, set off for Marcus Baker in May, and bag Sanford later in the summer, probably in July.

The key to Marcus Baker would once again be a flight in to a base camp on one of the glaciers that flows from the mountain's upper slopes. Bob Reeve, who had been badly spooked by his slushy five-day confinement on the Walsh Glacier the summer before, now wanted to prove to his famous client that he hadn't lost his nerve for high glacier landings. After a reconnaissance flight, Reeve cabled Washburn on February 17: AGNES LOOK OK ASCEND VIA MATANUSKA GLACIER STOP KNIK

GLACIER NO GOOD STOP LANDING CONDITIONS FAR FROM PERFECT. In a separate note, Reeve chortled, "Brad, it is made to order for us. . . ."

The team for Sanford came together in a single exchange of letters. Among the candidates Charlie Houston had invited to K2 was Terris Moore, whom Brad had befriended when he was an undergraduate and Moore was enrolled in the Harvard Business School. Teaching at UCLA at the time, Moore could not get away in April, and so had to turn down Houston's invitation. Instead, Terry wrote Brad to ask if he was still keen to climb Sanford. Moore proposed as third member of the expedition his wife, Katrina, whose climbing experience amounted to nothing more than a few Adirondack summits in winter. Since Brad had toyed with the idea of bringing Kernsie along to Sanford in 1937, he had no objection to Katrina. Moore indicated that any fourth member Brad wanted to invite would be fine with him, but Brad was content with the trio already in place.

It was harder to put together a team for Marcus Baker. In the end, Brad recruited an international party, his three teammates being Norman Bright, who had had to cool his heels in Valdez while Brad and Bob did battle with Lucania; a Swiss climber named Norman Dyhrenfurth, who would go on to lead the immensely successful 1963 American expedition to Everest; and an excellent Swiss-German alpinist, Peter Gabriel. Brad had invited Henry Hall to go on the expedition, despite his stylistic disagreements with the more conservative Mt. Logan veteran and founder of the Harvard Mountaineering Club. Hall would eventually share a single Alaskan expedition with his quasi-protégé, in 1941. But on April 10, 1938, Hall sent Brad a two-line note, withdrawing from the Marcus Baker expedition. Its chilling news: "Our boy died suddenly yesterday afternoon." What Hall's note did not spell out soon became common knowledge within the HMC: Henry and his wife, Lydia, had come home to discover that their grown son, who lived with them, had hanged himself in the attic.

On September 1, 1937, Brad had been reappointed for another one-year term as instructor at the Institute for Geographical Exploration. It is puzzling, then, to learn that by the beginning of 1938 Brad was looking for a new job. On January 27, Captain Albert W. Stevens, who had lent Brad his precious Fairchild K-6 camera for the Mt. McKinley aerial flights in 1936, and who by now was no longer affiliated with the institute, wrote Gil Grosvenor:

I had a long talk with Bradford Washburn in the course of which it appears that he is now sorry that he did not accept the invitation of the National Geographic Society to become a member of its staff. He feels that he made a mistake in not accepting.

Stevens went on to claim, "At the present time I believe that he is the equal of any aerial photographer in the world."

Grosvenor, however, may still have been miffed at Brad's ill-considered attempts to play *Life* off against *National Geographic*. There is no evidence that he renewed his offer of a staff job to Brad.

Yet Stevens's high praise, along with the McKinley pictures, which finally appeared in the July 1938 issue of the magazine, apparently caught Grosvenor's attention. Brad had proposed, after his Sanford expedition, to hire a pilot and take aerial photos of the Wrangell Range. Since explorers sponsored by the NGS from 1909 to 1911 had made the first ground surveys of the Wrangell glaciers, the society advanced Brad $1,500 for this project. And Grosvenor shipped Brad an NGS flag to carry to the summits of Marcus Baker and Sanford.

Hamilton Rice, director of the Institute for Geographical Exploration, had never stinted in his support of his brilliant young explorer-climber. In January, he wangled a grant of $5,000 for Brad's 1938 mountain campaigns. After the shoestring budget for Lucania, Brad was back on expeditionary easy street.

By the spring of 1938 Brad was full of enthusiasm for further vaga-
bondage in the Far North. The only discord came in several wistful
and nostalgic notes from Bob Bates, as he prepared for K2. On Febru-
ary 12, on official expedition stationery, Bob wrote Brad, "You know
it's going to seem mighty queer to be going on a trip without you along,
skipper." Two months later, from the German ship carrying him to
India, Bob wrote,

> *No matter what we find in the Himalayas I'll still feel that no place
> can beat Alaska. It is a country you swear at and with but it is the
> finest country I know anywhere. . . . This is the first time we've split
> up for a long time, and boy I'm going to miss you.*

Stevens's assessment of Brad's skill as an aerial photographer was
not an overstatement. In only four years, from 1934 to 1937, Brad had
virtually perfected the technique that would produce the thousands of
crystalline, superbly composed images of great mountains that would
constitute a matchless oeuvre. Every key decision in the acquiring of
that technique (except Stevens's original pat on the back) would be the
result of a ceaseless trial-and-error regimen of self-taught craft. For
Brad, the born tinkerer and gadgeteer, the process seemed natural.
And in the winter of 1937–38, he bought his own Fairchild K-6, the
twin of Stevens's camera, which would become Brad's instrument of
choice for aerial work.

During those same years, Brad had also become a crack airplane
pilot. His fascination with flight had germinated when he was a young
boy. At the age of ten, perhaps as a school assignment, Brad had writ-
ten a short story that he called "A Journey to School in 2020." In this
piece of whimsy, the boy in the far-off future wakes up at home, goes
downstairs, and pushes a button on the wall to summon an "aeroplane"
to take him to school. Soaring over the streets of his unnamed home-

town, the young passenger observes, "There had to be streets in the air, too, to prevent collisions."

At sixteen, Brad had caught his first thrilling sight of the Alps from the World War I biplane his father had hired to hop the family from Lyon to Geneva. Well before that, with his mother, he had made his first flight over Boston harbor on a brief sightseeing spin.

On June 11, 1934, out of a Seattle airport, just ten days before the start of his ultimately successful third expedition to Mt. Crillon, Brad made his first flight as a pilot, in a Kinner Fleet 2 biplane. For the next six years, he kept a careful aviator's logbook. The entries are telegraphic, but hint at high ambition: of separate flights later in 1934, he records, "spins—360—8," "Up to 13,000 ft. and back—very cold + clear," "aerobatics," and "up to 15,300." Early the next year: "practice in blind flying" and "rolls etc."

Brad's skills as a pilot served to enhance his aerial photography. Often he directed the pilot with hand signals, to position the camera for the ideal view. As Brad reminisced to Lew Freedman in 2005,

> I would say, "Give it a little bit more rudder." Or, "Give it a little bit more stick." That gave [the pilot] confidence that I knew what I was talking about, and I wasn't telling him something stupid. The pilots didn't give a rip about photography. They were just doing it because the National Geographic Society paid them to. . . .

Apparently Brad's talent as a pilot had become widely known, because in January 1937, he received a cryptic invitation from the publisher of his Boys' Books by Boys, George Palmer Putnam. Almost a decade earlier, Putnam had met and been enchanted by the renowned aviatrix, Amelia Earhart. In 1929, he divorced his first wife (the mother of David Putnam, whose *David Goes Voyaging* had launched the highly successful young-adult series); two years later he married Earhart.

Now Putnam asked Brad to come down to his house in Rye, New York, to have dinner and spend the night. All he told Brad was that he had "something very interesting" to discuss with him.

At the time of that January meeting, Putnam was forty-eight years old, Earhart thirty-nine, and Washburn still only twenty-six. During their six years of marriage, Putnam had relentlessly publicized his wife's achievements, so that by now she was the second-most famous aviator in the world, after only Charles Lindbergh (whose *We,* the best-selling account of the first solo flight across the Atlantic, Putnam had published in 1928).

Over dinner, Earhart told Brad about the still top-secret project that would crown her career: a round-the-world flight in a Lockheed Electra in the summer of 1937. Earhart would do all the flying, but she planned to take along as her only passenger not a copilot, but an expert navigator. Brad was as skilled a navigator as he was a mountaineer. In addition, he was quite familiar with the Electra, having made his aerial-photography flights around McKinley in one just the summer before.

That evening, neither Putnam nor Earhart explicitly offered the job of navigator to Brad, but a potential invitation seemed to hover in the air. Instead, Earhart asked Brad's advice about the logistics of her flight plan. After dinner, the three spread the maps out on the floor. It did not take Brad long to pinpoint the weak link in the plan: Howland Island, a flat oasis in the midst of the Pacific Ocean, only half a mile wide by a mile and a half long. Earhart's plan was to take off from Darwin, Australia, on the next-to-last leg of her round-the-world flight and land on Howland to refuel with barrels of gas carried in the Electra.

In 1984, Brad wrote, "I asked her how she planned to hit Howland at the end of a 2000-mile flight <u>without a single intermediate emergency-landing spot</u>. She simply replied: dead reckoning and star-and-sun sights."

Brad saw a simple solution to the problem, which he now proposed. Before the flight, Earhart might arrange for some passing ship to install a radio transmitter on Howland. Then she could find her target by homing in on the signal.

As he made the suggestion, Brad saw Earhart and Putnam look at each other in dismay. Putnam said to his wife, "If you go to all that trouble, the book will not be out for the Christmas sales."

In the end, Earhart ignored Brad's advice. She announced her bold plan in a press conference on February 12. Fred Noonan, a brilliant navigator but also an alcoholic, signed on for the voyage. When Earhart set out in the Electra on May 20, 1937, from Oakland, California, the whole world followed her progress. On July 2, Earhart took off not from Australia, but from Lae, New Guinea. Late that day her plane vanished somewhere near Howland Island, and Earhart was transformed into the lost heroine of one of the most romantic legends of twentieth-century exploration.

On that same date, Brad and Bob Bates were camped at 13,500 feet on Mt. Lucania, just days before they would make the first ascent of the highest remaining unclimbed peak in North America. Brad learned the tragic news only when he and Bob reached Burwash Landing.

In 1984, unwilling to fault the famous pilot for what other critics have fingered as Earhart's recklessly casual attitude toward logistics, Brad wrote, "If I'd had [sic] been asked to go along on that fateful trip, I'd have refused to go under those conditions." But, "Probably Amelia Earhart's greatest liability was her extraordinary optimism—which, in this situation, exceeded the bounds of reason."

To outfit his two 1938 expeditions, Brad had been corresponding all spring with his former teammate, Ome Daiber, who ran a camping and climbing equipment business out of Seattle. In one letter, Daiber

warns Brad that he has to take off on a "selling trip" and won't be back in Seattle until May 7. On that date, Brad planned to sail from Seattle toward Alaska. Daiber offered his wife's services in his stead: "Brad in case any of your buying needs be done during my absence Elsbeth will be pleased to take care of it." In March and April, several letters from Elsbeth cover just such details.

As it turned out, Brad's departure for Alaska was delayed, perhaps by a dock strike. On May 7, instead of sailing north, Brad rented a floatplane from the Kurtzer Flying Service on Lake Union in Seattle. It was a perfect, clear day, as Brad took off with three passengers in a Fairchild for a brief sightseeing trip toward the Olympic Mountains.

In the copilot's seat sat W. H. ("Jim") Borrow. A good climber and a casual friend of Brad's, Borrow had joined with Ome Daiber and a third partner to make the landmark first ascent of Liberty Ridge on Mt. Rainier three years before. In the backseat were Borrow's twenty-five-year-old fiancée, Dorothy Mathews, and twenty-seven-year-old Elsbeth Daiber. (Whether Ome had yet returned to Seattle from his selling trip is uncertain.)

The flight proceeded routinely, but something went terribly wrong on landing. Instead of the pontoons touching down and the plane plowing to a stop, the Fairchild skimmed across the water, then abruptly pitched forward, overturned, and sank. As water filled the cabin, Brad did not even realize the plane was upside down. Catching sight of a faint glimpse of light, he kicked desperately against what he thought was the side window, in the process breaking loose the windshield. Brad swam to the surface, followed a minute later by Borrow. The two women in the backseat were nowhere to be seen.

Without hesitation, both Washburn and Borrow dived back down to the wreck to try to rescue the passengers. The water, however, was too muddy for the men to orient themselves, let alone pull the women out of their death trap. Exhausted, the pair had trouble even finding

the door of the plane, and within minutes, they knew that the women must have drowned. Lana Kurtzer, owner of the flying service and a legendary local pilot, eventually secured lines to the wreck and towed it to shore.

In all his long life, the plane crash on Lake Union that took the lives of Borrow's fiancée and Daiber's wife was the greatest tragedy Brad would endure.

Over the decades, the accident became, if not exactly the skeleton in his closet, an event that only his closest friends knew about. (In forty-four years of close friendship with Brad, I never summoned the nerve to ask him about the plane crash, which I learned about only in 1980, when one of Brad's closest climbing partners told me about it.) Brad never wrote a word about the crash, except in letters to family and friends immediately after the accident. Two of the three biographical treatises covering Brad's life, published between 2002 and 2007, make no mention of the crash. The third, Donald Smith's *On High,* commissioned by the National Geographic Society, is a cursory account of Brad's life, the text aimed at buttressing a handsome collection of Washburn's photos. Yet Smith found out about the plane crash and devotes four paragraphs to it.

Brad was not happy with *On High,* which he thought was full of errors. He claimed that Smith, a National Public Radio producer with close ties to the NGS, spent at most a couple of weekends with him to research the complex panorama of Brad's multifaceted life. Yet Smith won from Brad what must surely be the only public comment on record as to the lasting impact of the accident on his heart and soul. "I was completely devastated," Washburn told Smith. (Brad's aviator's log lists no flights between April 20, 1938—"Northampton to Boston"— and December 11, 1938—"local 'practice'" over Boston.)

Smith gets the details of the crash wrong, as he has Brad misjudge his altitude and stall the plane high above a glassy-smooth lake, caus-

ing the craft to plummet like a stone. (One wonders where Smith got this version. Could Brad's own memory, long ago traumatized by the catastrophe, have unintentionally supplied a fictitious account of what went wrong?)

A pair of clippings from the *Seattle Times,* published just days after the crash, offers the most coherent account of the accident. In 1938, twenty-nine years before the National Transportation Safety Board would be founded, the only inquest into a plane crash such as Brad's was carried out by a local coroner's jury composed of aviation experts. Brad, Borrow, Kurtzer, and several eyewitnesses testified. The jury concluded that pilot error was the sole cause of the crash.

Borrow collapsed in tears on the stand and was unable to finish testifying. Brad admitted that he had made a crucial mistake on landing. "I thought I was back far enough on the pontoons but I wasn't," he told the jury. "And I believed we were coming in to a perfect landing. I have piloted Fairchild planes of this type—only they were land planes and not seaplanes. I tried to land horizontal, when I should have tilted the nose up."

Kurtzer testified that he had taught Washburn how to fly a float-plane in 1934, the first year of Brad's piloting. On the morning of the fatal flight, before renting Brad the plane, Kurtzer had gone up with him twice in the Fairchild. Both times, said the veteran, "He did a good job of landing." When asked if the men had done everything they could to try to save the women, Kurtzer praised Borrow and Washburn's rescue effort. "There is no doubt of it," Kurtzer replied. "I never saw two people try harder to do anything in my life."

At the inquest, Borrow raised a question that in the long run probably amounted to a red herring. He insisted that he had pleaded with the crews of "numerous boats that stood by" for an axe with which he might dive again and try to chop through the fuselage. His pleas "went unheeded," even by the Coast Guard boat that was towing the

submerged plane, which could offer only a hatchet. "I believe," Borrow averred, "if I had been on one of those boats, and not exhausted and distracted by the crash, I could have gone down and got the girls out." This is surely wishful thinking: even with an axe, by the time Borrow (who was an excellent swimmer) could have hacked open the fuselage, the women must have already been dead.

Asked in 2008 to analyze the old clippings from the *Seattle Times,* Tim Brooks, director of operations for Kenmore Air (which bought the Kurtzer Flying Service decades ago) and an expert floatplane pilot who has made countless takeoffs and landings on Lake Union, says, "The most likely scenario is that Washburn landed too fast and too flat. Landing with the nose up keeps the front of the floats from digging into the water. If he was going too fast, with all that drag on the front pontoon, the plane could well have overturned."

Brooks adds that Kurtzer's perfunctory checking out of Washburn before renting him the Fairchild would be considered "pretty sketchy" today. But he is not willing to criticize Kurtzer, given that the standards of flying safety and training were so much more lax in the 1930s than they are today.

Donald Smith, in *On High,* insists, "[D]espite this accident, Washburn and Daiber remained good friends." Dee Molenaar, who would join Bob Bates and Charlie Houston on K2 in 1953, may be the only person alive who climbed with both Borrow and Daiber (the men are deceased) and knew them well. Molenaar says simply, "I never heard Ome or Jim talk about the tragedy that took their wives' lives, although I think Ome once showed me clippings of the plane in the lake."

Accounts of the fatal crash reached the pages of the Boston newspapers. Brad evidently wrote his parents a letter detailing what hap-

pened on Lake Union, because on May 12—only five days after the accident—Brad's father wrote back,

> *How you could have worked so long and hard under water is a miracle. If only there had been some one near by with the proper tools. But, as every one of your friends here says, you did all you could, and we must not wear ourselves out imagining what might have been done. It was one of those unavoidable and incalculable accidents that happen when we are most careful.*

Unavoidable? One wonders just how slanted the account Brad sent home was. And it seems that even the Boston papers skewed the story in that direction. After the crash, Brad received scores of letters of sympathy, not one of which hints at blaming the pilot. On May 13, for instance, Harry Nichols, an older family friend living in New Hampshire, wrote, "I share your sorrow in the loss of your friends. The inquest entirely exonerates the pilot. It cannot check his regret." Another family friend, alluding to the account in the *Boston Herald,* offered, "I know that whatever happened was due to mechanical deficiency, or some such thing, and not to any fault of yours."

The inquest, of course, had come to no such conclusion, citing the cause of the accident unequivocally as "pilot error"—a verdict Brad seemed to agree with as he testified to the coroner's jury. Brad's father's May 12 letter continues, "I know that you have given the families of the girls all the sympathy and help you can. Do not let the tragedy wear too much on you."

If Brad was "devastated" by the accident (how could he not have been?), his response to it—both immediate and long term—was in some ways curious. A man more given to self-doubt, or more wounded by guilt, might have decided to surrender his pilot's license. Instead, Brad flew private planes for at least two and a half more years. (The last

date in his aviator's log is December 24, 1940: "Concord to Boston—
35 mins. Fairchild.") Barbara, Brad's eventual wife, maintains that he
gave up flying in the early 1940s not out of any lingering guilt about the
accident, but because it became too expensive a hobby.

Nor would any of Brad's friends have been surprised if, after the
accident, he had canceled his Alaskan expeditions. But the May 12
letter from his father reveals that within at most a day or two of the
crash, Brad had resolved to forge ahead with his Alaskan campaign.
"I am glad that you are going right on," his father writes. "That is the
way to live."

The letters of sympathy come from such far-flung precincts that
it seems clear that Brad must have dashed off dozens of letters ex-
plaining the accident to friends. And perhaps as he did so, the writ-
ing itself rationalized the impulse to go ahead with Marcus Baker and
Sanford. Bob Reeve, the veteran pilot who was well acquainted with
plane crashes, wired Brad almost cavalierly on May 10: SORRY ABOUT
YOUR ACCIDENT BUT DON'T LET IT GET YOU DOWN FOR SUCH THINGS ARE ALL IN
THE GAME.

A letter from Arthur Hinks, secretary of the Royal Geographical
Society, whom Brad had probably first met in February when he lec-
tured on Lucania to the RGS, is dated June 10—by which time Brad
had already been on Marcus Baker for more than two weeks. Hinks
writes,

> *But I am encouraged by your last sentence to hope that you may find*
> *in the pursuance of your work this summer something to take your*
> *mind from the tragic experience, and it is good to know that you*
> *expect in a few weeks to regain your confidence in the air.*

This vein of getting-back-on-the-horse-that-threw-you is a time-
honored tradition in mountaineering, and indeed, in the history of

exploration. Many a climbing expedition has proceeded apace even after the death of one of its team members in the early stages on the mountain. No Renaissance captain leading a voyage to the New World would have dreamed of returning home just because a few crewmen died of scurvy.

An important extenuating circumstance was that the other three members of the Marcus Baker team—Bright, Dyhrenfurth, and Gabriel—had arrived in Valdez on April 30 (a full week before the plane crash) and were awaiting their leader's arrival to launch the expedition. A significant portion of Hamilton Rice's $5,000 grant had already been spent getting those men to Alaska, and Brad was understandably loath to stand up his teammates because of his own personal tragedy.

While Brad was in Alaska, he received a letter from a Seattle acquaintance, who indicated, "Ome was quite bitter with the Coast Guard." On July 9, a Seattle lawyer wrote Brad about Lana Kurtzer's response to the tragedy. "He talked quite frankly about the accident. He is fearful that both you and he, or either of you, may be sued by the Mathews' people." The brother of Jim Borrow's fiancée had apparently been talking about pursuing a lawsuit.

Kurtzer told the lawyer that "the cost of repairing the plane is in excess of $3,000." The owner of the flying service was shocked and hurt to be offered only $1,000 by Brad, who would not budge from that figure. In the end, Kurtzer gave in. The legal settlement further stipulated "that Henry Bradford Washburn, Jr., asserts that he is not legally liable for such damage or for said accident."

Even so, the lawyer urged Brad to stay away from Washington State. Brad shared his fears of legal action with Ome Daiber, who apparently had bought the scenario that the Coast Guard should have saved the women. On August 3, Daiber wrote Brad, "Your mention of the suit is news to me. . . . I certainly can't conceive of how they can do it, at least against you, and it's pretty hard to accomplish anything

against the Government, namely the Coast Guard." Remarkably, there is no trace of anger or blame in any of the several letters Daiber wrote Brad that summer. One of them warmheartedly pleads, "I'll be glad to hear from you, Brad, any time that you might find time to write." Another offers, "I look forward to seeing you in the fall."

Finally, on August 22, Daiber wrote, "I have talked to Jim [Borrow], and you can rest assured that there will be no suit." Brad would pass through Seattle to see Daiber on his way home from Alaska. Donald Smith's assertion that Daiber and Washburn stayed good friends for the rest of their lives may well be true. If so, it is a testament, above all, to Daiber's heroic magnanimity.

After the crash, Brad lingered in Seattle only as long as he had to to face the inquest. By May 16, he had arrived in Valdez.

In 2005, as he recounted his expedition in the Chugach Range to journalist Lew Freedman, the first words Brad uttered were, "Marcus Baker was a horrible trip." The primary reference of that pithy summation was to the atrocious weather the team endured through its twenty-seven days on the mountain. Yet one wonders whether, almost seven decades later, Brad's formula reverberated with an echo of the plane crash that had so closely preceded the expedition, and with the shivers of recriminatory guilt that must have plagued Brad's nights on the Matanuska Glacier.

Thanks to the Chugach weather, the four climbers had to wait ten days in Valdez before Bob Reeve could fly them in to the glacier. Once more, Brad took advantage of the latest technology to add a new twist to the expedition game. This time the men took with them a radio telephone. Throughout the monthlong trip, they were in constant communication with Reeve in Valdez. The device proved most valuable in scheduling the pilot's pickup after the summit assault.

The weather stayed almost continuously foul throughout the expedition—the worst Brad would experience on any of his trips to the

Far North. One storm shattered both heavy bamboo center poles of the men's canvas tents. During another—a "hurricane," Brad called it, with winds up to eighty or ninety miles an hour—the men deliberately collapsed the tent and wrapped it around themselves like a shroud, for fear the shelter might be blown off the mountain. Virtually the whole route on Marcus Baker unfolded on snow slopes, but the texture ranged from slush to soft powder. The men wore snowshoes more often than they did crampons.

Brad's article about the expedition in the 1939 *American Alpine Journal* is a chronicle of near-constant misery. "We were utterly disgusted with the weather," he wrote. Because of the conditions, the men pitched their camps at much shorter intervals than Brad was used to deploying. Finally, on June 19, all four men set out for the summit from a high camp at 10,000 feet. In the *AAJ*, Brad freely admitted that Marcus Baker was an easy climb, yet as the men traversed one false summit after another, plowing a tedious trail through deep snow, the clear sky dimmed, and heavy clouds began to roll in from the Gulf of Alaska. By midafternoon, as Brad later wrote, "We had to strike now or give up the mountain."

By the time the men approached the summit, at 4:50 P.M., snow was falling and they were enveloped in a whiteout. As they finally reached the apparent highest point, the fog was so thick they could not be sure they were on top. To certify their conquest, as Brad told Lew Freedman in 2005,

> I got one of the guys to put his ice axe into a hole, and I went
> around in a circle with a hundred feet of rope tied to me. When I
> realized that it was downhill in every direction, we figured that
> had to be the top. Norman Bright and I let out a triumphant yell
> and the others followed three minutes behind. . . . We spent ten
> minutes on top of that miserable mountain, and then we said, "Let's
> get the hell out of here."

Brad had hoped to take a panoramic series of large-format photos of the Chugach Range from the summit. But with the conditions as they were, that was impossible. Brad was disappointed enough that he wrote in the *AAJ*, "The ascent of Mt. St. Agnes was a curious mixture of failure and success." In general, Brad's article about climbing the highest peak in the Chugach Range is the most dispirited he would ever publish after a mountain triumph.

One detail Brad neglected to mention either in the *AAJ* or in his recounting for Lew Freedman was that Norman Dyhrenfurth suffered rather serious frostbite of his toes on the climb. The man would recover, however, and go on to an illustrious career both as a climber and as a leader of international mountaineering expeditions to the Himalaya.

Marcus Baker would not receive its second ascent until 1966, twenty-eight years after it first succumbed to Brad's determined team.

On June 30 in Valdez, Brad met Terris and Katrina Moore. By the next evening, the trio and "an incredible amount of gear" were careening north on the Richardson Highway in a station wagon Brad had commandeered, bound for the tiny village of Chistochina, founded in 1903 as an army telegraph station.

If Marcus Baker had been pure misery, Mt. Sanford would turn out to be the blithest lark of Brad's expeditionary career, the ultimate distillation of the fast-and-light style with which he revolutionized big-range mountaineering in the Far North.

Terry (as his friends called him) and Brad had first met in the HMC, while Brad was an undergraduate and Terry attended the business school. Before 1938, however, Moore was the only one of the quintet that would become known as the Harvard Five (Washburn, Moore, Ad Carter, Bob Bates, and Charlie Houston) who had not been a member of one of Brad's expeditions. Two years older than Brad, Terry did have

a number of extraordinary climbing accomplishments under his belt. He and Allan Carpé had made the first ascent of Mt. Fairweather in 1931, the year after Brad's first expedition to Alaska had failed even to reach the mountain's lower slopes.

Moore's great deed, however, was the fifteen-month-long expedition to Minya Konka in western China, which began at the end of 1931 and ended only early in 1933. This remote, gigantic mountain had been seen from a distance only by a handful of Westerners, but they included Teddy and Kermit Roosevelt, who had undertaken a hunting expedition into the foothills of Szechwan Province. In their book, *Trailing the Giant Panda,* the Roosevelts made reference to a "Mount Koonka, 30,000 feet?"

Originally interested in getting a crack at Mt. Everest, as Brad had been since 1926, Terry turned his attention to this far less well-known peak, which might conceivably be higher than Everest. By the end of 1931, a small team had assembled. A key member was Jack Young, who, though not a climber, was a native Chinese attending New York University; he had also served as the Roosevelts' guide. The three climbers were Richard Burdsall, Arthur Emmons (still a Harvard undergraduate), and Moore. Burdsall was the least experienced of the three, for Emmons had been on Brad's 1930 Fairweather expedition and had climbed in the Alps and Canadian Rockies.

The party arrived in Shanghai by steamer in January 1932. The men had been in China only two weeks when, in the midst of lunch in their hotel, they heard a huge explosion and saw the balcony doors blown inward. A powder barge had been destroyed on the Whangpoo River: Japan had attacked China.

Instead of proceeding with their expedition, the Americans volunteered for military duty at the tiny U.S. Marine headquarters in Shanghai. Young, who had served among Chiang Kai-shek's forces in the 1927 revolution, left immediately to fight with his people. Moore, Emmons,

and Burdsall found themselves nervously patrolling the perimeter of the International Settlement, armed with rifles and bayonets.

Eventually, the men got to Peking (today's Beijing), but as the war rolled on for months, there seemed little hope of even getting a chance to see Minya Konka, let alone trying to climb it. To fill their time, the men took lessons in Mandarin. Finally, in a peaceful lull in early summer, the team got permission to travel across China.

There followed an epic journey of more than 1,500 miles by boat up the Yangtze River, across Szechwan by bus, and through the labyrinthine foothills surrounding Minya Konka by porter, yak, horse, and even cow. At one point, a group of soldiers stole one of the party's horses in the night. Young and Moore pursued them, and while Young questioned them in Chinese, Moore held a pistol trained on the thieves. The climbers got their horse back.

It is a very rare thing in mountaineering history when the first team to reconnoiter a major mountain also makes its first ascent. But Burdsall, Emmons, and Moore cannily solved the labyrinth, circling around Minya Konka from the north to the west to discover its only apparent weakness, the northwest ridge. A survey from a satellite peak, however, revealed that the mountain's true elevation was only 24,900 feet—more than 4,000 feet lower than Everest. Still, as a formidable Himalayan-scale giant, the highest peak for hundreds of miles in any direction, Minya Konka was a noble objective.

On October 26, Moore and Emmons were ensconced in a high camp, ready to go for the summit in the morning. At that point, one of those apparently trivial events that changes a man's whole life occurred. As Emmons recounted it in the expedition book *Men Against the Clouds:*

> I attempted to slice a frozen biscuit with my pocket knife. The biscuit was tough and its frozen exterior yielded but little to my ef-

forts. Suddenly it gave way and the knife broke through, cutting a
deep gash in the palm of my left hand nearly two inches long. The
wound was so deep that a number of the sensory nerves in the two
little fingers were severed.

I sat and watched the thick drops of blood ooze out and drip
slowly onto my sleeping-bag. Suddenly the significance of what had
happened penetrated my altitude-benumbed consciousness. . . .

The accident meant that Emmons had to stay in camp and nurse
his wound while Burdsall and Moore made the summit bid. On Octo-
ber 28, starting in darkness at 5:00 A.M., using flashlights to find their
way, the duo headed upward. As Moore later wrote, "In the intense
cold, it took almost superhuman willpower."

Waiting in the tent, Emmons was full of foreboding. He tried to
read a book of Kipling's ballads to kill time. Sterilized and bandaged,
his left hand throbbed with pain. In the last moments of daylight,
he heard the sound of his partners' footsteps above. Exhausted,
Moore and Burdsall piled into the tent. They had reached the
summit at 2:40 P.M. Despite a wind that, in Moore's words, "had
risen to terrific violence," the pair shot thirty pictures from the
top, including a 360-degree panorama. Though he was too modest to
say so in print, Moore had been the driving force throughout the
expedition.

In 1933, the editor of the *American Alpine Journal,* Howard Palmer,
hailed the ascent:

The conquest of Minya Konka is one of the greatest feats of Ameri-
can mountaineering, however regarded. It is the highest summit
ever attained by Americans, and it is loftier than any peak in the
Western Hemisphere. . . . [A]s a whole, it will constitute a mile-
stone in mountaineering history.

Moore and Burdsall's supremacy as American summiteers would last for a remarkable twenty-six years, until Pete Schoening and Andy Kauffman reached the top of Gasherbrum I in the Karakoram of Pakistan in 1958. The world's eleventh-highest mountain, at 26,509 feet, Gasherbrum I would be the only one of the fourteen 8,000-meter peaks whose first ascent was claimed by Americans.

As the trio began their descent from high camp, Emmons was in serious trouble. The loss of blood had weakened him, and now he noticed for the first time that his feet had gone completely numb. Taking off his boots to rub his toes did little good. As his partners pushed ahead to reclaim their intermediate camps, Emmons hobbled along in the rear. By the time he reached the hill town of Tatsienlu, thirty miles from the mountain, his toes had turned black and gangrene had begun to set in.

After excruciating delays, Emmons finally got to a Chinese hospital. In one of the most stoic statements in expedition literature, he later devoted a single sentence to the personal aftermath of his mishap: "Yachow was destined to be my home for seven months while my feet underwent renovation and my toes were removed."

For the rest of his life, Emmons would wonder whether the deep gash in his palm and his subsequently weakened condition had caused the frostbite. Most experts today would answer in the negative: the frostbite was more likely the result of innately poor circulation, or even of a pair of boots that were too tight.

Despite this terrible setback, three years later Emmons joined Ad Carter, Charlie Houston, and Farnie Loomis to form the American contingent on the landmark Nanda Devi expedition. Knowing that he could not go high and risk further frostbite, Emmons was still so keen on participating that he volunteered to serve as the expedition's base camp manager.

In 1980, Bob Bates recalled that Emmons had had a New Hamp-

shire shoemaker craft a custom-made pair of toeless boots. "Art hadn't just lost his toes," Bates remarked. "His feet were cut off about here." (He drew a line midway up the laces on his own right shoe.) "So he had to walk on his heels all the time. Since he had no toes, this meant coming down a mountain was especially hard on him, because it would be bang-bang-bang, instead of easing himself down with his toes."

Emmons went on to a distinguished career as a State Department diplomat, and he continued to climb at a modest level in the Andes and the New Zealand Alps. He died of cancer in 1962, at the untimely age of fifty-one.

In June 1933, shortly after returning from Minya Konka, Terry Moore married the former Katrina Hincks, whom he had met three years earlier on a blind date at Vassar College. After graduating in 1930, Katrina had worked briefly in New York publishing. She might well have become a professional writer had she not given up her career to focus on marriage and motherhood. All her life, Katrina continued to write poetry. She had a gift for comic verse in the vein of Hilaire Belloc or Edward Lear, as in the ditty she mailed to Terry while he was in China:

> *Behold the ever-patient Yak,*
> *With four explorers on his back.*
> *He treks for miles across the snows,*
> *Wearing a bracelet in his nose;*
> *And when they stop to have a snack,*
> *It's slices of the useful Yak!*

Or her Alaska-inspired triplet, which she said came to her whole in a dream:

> *You cannot please the caribou,*
> *No matter what you say or do;*
> *He just morosely glares at you.*

In her charming memoir of her life with her husband, *Borestone to Bering Strait,* published six years after Terry's death in 1993, Katrina remembered him saying, "Now that I'm a married man, I suppose I'll have to give up big mountain expeditions. I think I'll learn to fly."

Despite her misgivings, Katrina responded, "Great idea."

Moore started taking lessons. Half a year later, he got his pilot's license. He had such a natural aptitude for flying that within a short time, he became something of an ace. In the end, Terry turned out to be a far better pilot than Brad Washburn, eventually notching several aviation records. He remains the most accomplished mountaineer-pilot in Alaskan history.

Evidently, Terry considered Mt. Sanford a tame enough objective to justify not only coming out of retirement from big-mountain expeditions, but bringing his novice wife along. Katrina's first ascent of any sort had been a midwinter hike up Mt. Marcy, the highest peak in the Adirondacks, in 1935. Despite her inexperience, on Sanford she proved to be a game and competent wilderness traveler. Katrina was also a witty, delightful companion.

Chistochina, at the end of the road, was thirty-five trackless miles from Mt. Sanford. Brad's plan for the expedition amounted to one more idiosyncratic blend of traditional and modern techniques for overland travel. Unlike the approaches to Lucania and Marcus Baker, Sanford would not involve an airplane. Instead, the team of three hired a pair of Indian horsepackers, one Anglo and one Indian, to get their gear and food to snowline. The trek across the swampy taiga took five days. To cross the many channels of the Copper River, Terry sometimes carried Katrina on his back.

Brad's second gambit on Sanford was to use dog teams on the lower slopes of the mountain, partly to carry his heavy and priceless Fairchild K-6 as high as he could. In 1935, dogs had been the key to the traverse of the Saint Elias Range, where Brad had mastered the art

of driving teams. Now Terry and Katrina proved quick studies in dog management. The baggage, of course, had to include many pounds of dog food, but in the lowlands the Indian horsepacker, coincidentally named Adam Sanford, managed to shoot a bear, whose meat the canines ravenously devoured.

By July 10, the trio had established a base camp at 6,400 feet on the mountain's glaciated skirts. Katrina's diary of the trip is full of evocations of the glorious landscape, which was utterly new to her: "Wonderful shifting blue shadows on the Nunatak, a great ice-covered hump sticking out of the glacier at about 10,000 feet"; "The sun slowly came up out of the clouds like a fire opal. Mt. Drum sprang into flame while the shoulder of Sanford was still in shadow."

And despite a number of days of bad weather, her diary entries, published in *Borestone to Bering Strait,* brim with the zest of the adventure.

Had a very hasty breakfast, then Terry harnessed the dogs at 9 A.M., to see how they would work after their rest. To our delight, they were their old frisky selves. . . .

We went back to the hilltop cache, and brought another load up to the crevasse place. Then a wild rush back to camp, with the dogs simply rollicking. I sat in the sledge and Terry stood on the brake and down the hills we went.

On July 15, only five days after establishing base camp, the trio pitched their tents at what would be their high camp, at 10,000 feet. Brad had originally thought it possible to take the dogs all the way to the summit, but between crevasse fields and windslab avalanche conditions, the terrain proved too dangerous. After several more days of storm, the three climbers left at 2:30 A.M. in the penumbral Alaskan

night for a try for the summit. Katrina pulled her own weight, taking turns breaking trail with the men.

Alas, by sunrise there was evidence that bad weather was once more creeping in: telltale sun dogs (a sure sign of coming precipitation), and the classic lenticular cloud cap forming on the summit. Still, the three pushed on, marking their trail every hundred feet with "willow wands" (garden stakes painted green, planted upright in the snow), so that they could find their way back to camp even in a whiteout. By 11:00 A.M., they had reached an altitude of 14,500 feet—only about 1,700 feet below the summit—before they realized they had to turn around.

Two days later, as the sky started to clear around noon, Brad and Terry decided to make a dash for the summit. They wore neither crampons nor snowshoes, but skis—for both men had become expert skiers in their teenage years in the White Mountains. Knowing she could not keep up, Katrina stayed in camp. As she wrote in her diary, "Everything of course deathly still, except when the dogs fidget and whine. Fed the dogs about 7, then retired to my bag to read Jane Austen."

In the shape of their lives, Brad and Terry skied up 6,200 feet of trackless snow slopes in only seven and a half hours. They stood on top of Mt. Sanford at 9:00 P.M. As Brad later wrote, "A grand handshake and a big slap on the back for each of us followed by a happy yell of conquest." Unable to get his Fairchild K-6 all the way to the summit, Brad documented the climb with a smaller camera.

The men spent only twenty-five minutes on top, then blithely skied all 6,200 feet down to high camp in only an hour and twenty minutes. Wrote Katrina in her diary, "They skied back into camp, covered with snow, shouting that they had climbed it—hooray! . . . Into bed about 1 A.M., very happy."

Two days later, the trio met the horsepackers at the foot of the mountain. They were back in Chistochina by July 24. The round trip

from base camp to summit and back, a climb and descent of 10,000 feet on unknown terrain, had taken the party only twelve days. Never before in Alaska or the Yukon—and perhaps never before in any of the great ranges of the world—had the first ascent of a major mountain been accomplished so quickly and so smoothly.

After Sanford, Terry would once more give up serious climbing. In 1949, he became the president of the University of Alaska, and two years later, would play, not as a climber but as a pilot, an integral role in Brad's last major northern expedition.

Turning his back on big-range mountaineering, Terry launched an extraordinary career as an "amateur" aviator. His finest deed came in 1959, at the age of fifty-one. That summer, as part of a U.S. Army effort to test the capabilities of new helicopters, he flew his ski-equipped Super Cub to the Wrangell Mountains and pulled off a landing on the very summit of Mt. Sanford, twenty-one years after he and Brad had made the peak's first ascent.

Terry was too modest to boast of the deed himself, but the army announced that his landing had set a new world altitude record for fixed-wing aircraft. With characteristic self-deprecation, Terry confessed in 1980, "I suppose it was the greatest honor in the juvenile sense that I ever received."

With his climbs of Marcus Baker and Sanford—twin ascents of peaks each of which was the highest summit in its range—Brad had demonstrated his mastery of Alaskan expeditioneering. In five years, since his third expedition to Crillon in 1934, he had accomplished four major first ascents and a virtuoso traverse of the greatest blank on the North American map. Still only twenty-eight years old, however, Brad faced an uncertain future. How long could he continue to teach at the Institute for Geographical Exploration, stringing together one-

year reappointments at niggardly salaries? Had he instead found his true vocation as a mountaineer, photographer, and explorer? If so, how could he make a living that supported those passions?

And what about his personal life, now that Mary Whittemore had faded from view? At twenty-eight, Brad was still living in his parents' house on Mason Street.

Within the nine months after Sanford, the two most important turning points of Brad's life would twist his path toward certainty and happiness. Each would arrive almost by accident, yet in the long run, each would prove more fulfilling than even the finest climb of the most remote mountain.

The Two Best Decisions

Within American mountaineering circles, Brad's twin killing of Marcus Baker and Sanford garnered very high marks. But any fuss over these Alaskan first ascents was overshadowed by Charlie Houston's K2 expedition. Many of the letters sent to Brad by friends and family during his two months in the North contain such remarks as "No news yet from the Karakoram."

The 1938 American K2 expedition would go down in climbing annals as a landmark assault on one of the highest and most difficult mountains in the world. Yet the expedition was hatched in an atmosphere of doubt, controversy, and personal resentment that would linger for decades thereafter.

It was not Charlie Houston who had won permission from the government of Kashmir, at the time a semiautonomous "princely state" under the aegis of the British crown. (Kashmir is a province of India today, while K2 now lies in Pakistan.) The negotiations were carried out by a pair of high-ranking American Alpine Club officials, who fi-

nally broke through in the fall of 1937. The AAC promptly appointed Fritz Wiessner as the leader, not Houston.

Wiessner was a German-born climber who emigrated to the United States in 1929. He became a citizen in 1933: living in Vermont, he ran his own successful chemical business. By 1938, Wiessner was the only American who had been high on an 8,000-meter peak: in 1932 he had served as a strong member of the German team that reached 23,000 feet on Nanga Parbat.

In 1938, Wiessner was America's most accomplished mountaineer, despite Brad's Alaska supremacy. At the age of thirty-eight (ten years older than Washburn), Wiessner had been at the cutting edge of every different aspect of the climbing game. As a teenager in Dresden, he was a central figure in a small band of cragsmen who, in the purest of styles (often climbing barefoot), put up fiendishly hard routes on the sandstone pinnacles of a nearby set of cliffs called the Elbsandsteingebirge. At the time, this isolated group of stalwarts was pioneering the most difficult pure rock climbs yet accomplished anywhere in the world—a fact that was not widely recognized until five decades later.

In the 1920s, Wiessner graduated from his backyard pinnacles to the Alps, where he made many first ascents, including two alpine climbs—on the Furchetta and the Fleischbank—that were as hard and as daring as anything that had been done to that date in the range where mountaineering was first invented. Once in America, Wiessner continued to launch pathbreaking ascents. He was the first to climb the volcanic plug of Devils Tower in Wyoming in 1937. Wiessner's finest North American triumph was the first ascent of Mt. Waddington, the highest peak in the Coast Range of British Columbia. Before he and the outstanding New England climber Bill House arrived at the mountain's base in 1936, Waddington had been attempted sixteen times, but all previous parties had been turned

back by the formidable technical challenge of the mountain's summit tower.

In a gesture of high gallantry, on discovering that two strong teams, one of Canadians, the other of Californians, were also camped at the foot of Waddington that summer, House and Wiessner stepped aside to give their rivals first crack at the peak. The Canadians got within 1,600 feet of the top before retreating; the Californians improved on that by a scant 200 feet. Then House and Wiessner went to work. The "crux" of the climb, just below the summit, was a nearly vertical rock wall coated with ice. Wiessner solved it by changing to rope-soled rock shoes (used almost exclusively by Europeans), standing on House's shoulders, then forging a lead up the desperate pitch.

By 1938, then, Wiessner had for more than two decades been at the forefront not only of the world's hardest pure rock climbing, but also of alpine climbs such as the Furchetta and Waddington and of big-range mountaineering on his expedition to Nanga Parbat. In contrast, Washburn had had his single year of alpine brilliance in 1929, but he could not have climbed the north face of the Aiguille Verte without his guide-companions, who led all the hardest pitches. After 1929, Brad specialized in big-range mountaineering in Alaska and the Yukon. In terms of sheer technical ability, Washburn was not in Wiessner's league. But neither was anyone else in America.

Bill House, who had also been Wiessner's partner on Devils Tower, would have been the leader's first choice for K2. Late in 1937, however, Wiessner told the AAC that business commitments would prevent him from going to K2 in 1938. Since the club had won a two-year permit for the mountain, Wiessner hoped to lead an expedition in 1939. In the meantime, he recommended that Houston take charge of the 1938 attempt.

Houston jumped at the chance, though it never sat well with him to have been the AAC's fallback second choice. And Wiessner's sudden

backing out gave rise to the suspicion that the great climber had a Machiavellian ulterior motive. As Bob Bates wrote to Brad on February 16, 1938,

> *Weissner's [sic] idea, I suppose, is to have us do the reconnaissance + possibly the dirty work + then go in next year and profit by our mistakes. This is pretty surely it, but keep it to yourself.*

The team Houston put together included Bill House, Bob Bates, and Richard Burdsall, who had summited on Minya Konka with Terris Moore six years earlier. All four were easterners, a fact that dictated their approach to climbing big mountains. The fifth member—and the one who would turn out to be strongest on the mountain—was a Wyoming cowboy named Paul Petzoldt. Petzoldt had climbed in the Alps, but his home range was the Tetons, where he had put up a number of bold routes, including the first ascent of the north face of the Grand Teton in 1936—possibly the hardest alpine rock climb yet accomplished in the United States. Petzoldt had come recommended by Farnie Loomis, one of the few New Englanders who had done any climbing in the Tetons.

From the start, however, there was a cultural gulf between Petzoldt and his teammates. Having never gone to college, Petzoldt had made his living as a Teton guide since the age of eighteen. Suddenly he was to be paired with four Ivy Leaguers (like Bates and Houston, Burdsall was a Harvard graduate, and House had gone to Yale). In the perverse logic of the day, Petzoldt's station in life could be seen as a detriment on an expedition, not as an asset. Houston's biographer, Bernadette McDonald, insists that Charlie once called Petzoldt "a blue collar guide."

In his turn, Petzoldt referred to Bates and Houston, behind their backs, as "two Eastern nabobs." According to McDonald, Petzoldt

thought that, far from being sneered at as a professional guide, he ought to be paid an extra salary for bringing his expertise to his "amateur" teammates.

An equally important difference of style had to do with equipment. In the steep, rocky Tetons, Petzoldt and his partners made full use of pitons. As Wiessner's regular partner, House also believed in the value of pitons. Yet Bates, Houston, and Burdsall, under the influence of a by-now reactionary British response to the breakthroughs of German, Austrian, Italian, and French climbers in the Alps, disdained as unsporting the use of "ironmongery."

Later in life, Petzoldt told a story about how this disagreement had surfaced on the boat trip to Europe, with no resolution arrived at. In Paris, Petzoldt claimed, he had sneaked off to the mountaineering shop of Pierre Allain (one of France's top rock climbers), spent his last pennies on pitons, and smuggled them into the expedition boxes. On K2, of course (in Petzoldt's telling), those pitons proved invaluable.

Nowadays, to approach K2, climbers fly to Skardu, a village in the Baltistan district that is sixty air miles from the mountain, then travel by road to the village of Askole. From there they hire porters and hike up the Baltoro Glacier to the base of the mountain. The 1938 team, however, had to hike all the way from Srinagar in Kashmir—a 350-mile trek that took the men thirty-one days to complete. That approach was a marathon journey in its own right, as the men traversed the high Zoji La (breached today by one of the scariest truck roads in Asia) and crossed the raging Shigar River on a *zhak*—a raft made of twenty-eight inflated goat bladders held together by a framework of poplar poles.

Finally, on June 12, the men established base camp beneath K2. The mandate they had been given by the AAC was indeed merely to reconnoiter the mountain and, it was hoped, discover the most feasible route by which a 1939 expedition led by Fritz Wiessner could

attempt the climb. For several weeks, the team did just that, traversing glaciers to probe and study the great mountain's myriad flanks and ridges. Finally, they chose the southeast ridge, which had first been contemplated way back in 1909 by an expedition led by the Duke of the Abruzzi. (The duke, it will be recalled, had led the extraordinary climb of Mt. Saint Elias on the Alaska-Canada border in 1897, as his Italian team made the first ascent of any major mountain in the Far North.) That southeastern arête on K2 now bears the name the Abruzzi Ridge.

On June 27, Houston wrote home in discouraged tones: "[T]his is a bigger, harder mountain than any of us realized before—and it will take a better party than ours a much longer time than we have left, in order to get anywhere at all." But then, with several weeks of that time left, the five climbers decided to give the southeast ridge their best shot. Campsites were especially difficult to find, as there seemed to be not a single level snow platform anywhere on the ridge. But the men made surprising progress. The crux technical pitch was an 80-foot rock-and-ice chimney that House led in fine style—using a few of Petzoldt's smuggled pitons to good avail! (The pitch is still known as House's Chimney.)

By July 20, Houston and Petzoldt were dug in at Camp VII, at 24,700 feet, high on the Abruzzi shoulder. There were time and supplies left for only one attempt the next day, for, in an absentminded but hugely consequential mistake, the men had left their matches in a lower camp. Scrounging through his pockets, Houston discovered a grand total of nine matches. Without matches there was no way to light the stove; without the stove, no way to melt snow for drinking water; without water, no hope of pushing on.

The next day, roped together sixty feet apart, Petzoldt and Houston made their bid. At 26,000 feet, only 2,250 feet below the summit, Houston succumbed to exhaustion. Petzoldt gained another 150 feet before

he also gave up. The men turned and headed down. As Houston would later write, "I believe in those minutes at 26,000 feet on K2, I reached depths of feeling which I can never reach again."

(In 1963, when I was a twenty-year-old instructor at the Colorado Outward Bound School, I first met the fifty-five-year-old Petzoldt, who was one of the school's senior guides. One day I got up the nerve to ask the legendary climber about that high point on K2. Petzoldt said simply, "I wanted to go on. Charlie decided to turn back.")

At twilight, the two men collapsed in their tent at Camp VII. By now, they had only three matches left. Wrote Houston later:

> Our first thought was tea. With infinite care we waxed one of the matches, dried it as much as possible, and struck it. It fizzled and went out. A safety match broke off at the head. Paul in a gesture of bravado struck our last one. It lit and we were assured of our warm supper. Too tired for much talk, we melted water for the morning, snuggled in our sleeping bags, and drowsed off to a dreamless sleep.

The gutsy effort of the K2 team, which went so far beyond anyone's expectations, attracted international attention. With Minya Konka in 1932 and Nanda Devi in 1936, a handful of American mountaineers had demonstrated that they could compete in the Himalayan game. Still, it had been a pair of Brits, Tilman and Odell, who had claimed the summit of Nanda Devi, relegating the four Americans to a supporting role. With K2, American climbers had performed as well as the British on Everest or the Germans on Nanga Parbat. And they had come back from their bold assault with none of their members suffering a serious injury.

Every year, the *American Alpine Journal* saved its leadoff spot in the feature well for the expedition that its editor deemed the most out-

standing among the previous year's campaigns. The 1939 issue opened with Bill House's account of the K2 attempt. Elsewhere in the journal appeared Terris Moore's résumé of Mt. Sanford and Brad's account of twenty-seven days of misery on Marcus Baker.

The K2 team decided to write a book about its landmark expedition, and in 1939, Dodd, Mead and Company published *Five Miles High*. From three to five chapters each were written by Houston, Bates, House, and Burdsall. Although his name appeared on the title page, Petzoldt contributed no writing to the narrative. Was this omission the final snub of the "blue collar guide" by his Ivy League partners, or was Petzoldt uninterested in contributing? There is no telling.

Five Miles High recounts the journey to and from the mountain and the weeks spent struggling up the Abruzzi Ridge in clean, straightforward prose. By now considered a classic of expedition literature, the book is still in print.

Brad apparently sent congratulations to Houston, for a December 9 letter from Charlie to Brad thanks him for "your swell letter of a week or so ago. What you said was very kind indeed and much appreciated." (Houston kept his papers almost as assiduously as Washburn did, but lost them all decades later in a basement flood in his house in Burlington, Vermont.)

From the German ship carrying the K2 team back to the United States, Bob Bates wrote Brad. Addressing his pal as "Dear old Schnitzel," Bob (characteristically) first congratulates Brad for the "double killing" of Marcus Baker and Sanford. "By gosh," he adds, "I'm tickled silly about it." Bates goes on to confide, "Our crowd was a strong one, Petzoldt being the best man in the party (this strictly between you + me). It was a more dangerous mt. than most of the others considered it—at least that is my opinion." Bob concludes, however, that the Abruzzi Ridge which the team had been the first to tackle would ultimately prove to be the first ascent route. Nostalgically and loyally,

he closes his letter, "Wherever I go Lucania will always be the trip I'll remember most deeply."

In later years, according to his wife, Barbara, Brad insisted that he had had no desire to go to K2 because it was "too dangerous" a mountain. And sometimes (though not within his best friend's hearing) he pronounced, "Bob Bates had no business being on K2." This harsh judgment was based on Brad's estimation of Bob's relatively modest technical skills. But Bates performed every bit as well on K2 as his more technically gifted teammates.

It was the 1939 expedition that turned the collective American effort on K2 from a shining achievement into one of the bitterest—and in the end, most shameful—controversies in mountaineering history. Assuming leadership of the team, Fritz Wiessner was dismayed that none of the 1938 veterans could get away again. The five-man party that finally set off for Asia was alarmingly weak. After the team had sailed for Europe, the AAC persuaded Jack Durrance to join the effort. Though an easterner and a Dartmouth medical student, Durrance was one of the best rock climbers in the country, and his deeds in the Tetons were second in significance only to Paul Petzoldt's. Durrance caught up with the team in Genoa, where he presented Wiessner with a letter from AAC executives explaining his presence.

Once on the mountain, however, things started to go wrong. One of the younger members came down with either cerebral or pulmonary edema, a potentially fatal affliction. Two of the others seemed to succumb to a pervasive apathy (they may have simply been intimidated by the scale and difficulty of the mountain). Though initially game, Durrance found that he could not acclimatize and had to turn back at Camp VI. Among the "sahibs," only Dudley Wolfe, a wealthy forty-four-year-old Bostonian, was able to go high along with Wiessner. Though a good skier, Wolfe, who was a big man, had little technical experience and tended to be a clumsy climber.

Despite these setbacks, Wiessner teamed with four immensely capable Sherpas to establish a string of camps up the mountain. Each camp had a pitched tent, in which were stocked sleeping bags, air mattresses, food, and a stove and fuel. Incredibly, Wiessner led every single pitch all the way up the mountain. By July 18, Wiessner, Wolfe, and Pasang Lama had established Camp VIII at 25,300 feet. The next day, the trio headed upward, but deep, loose snow thwarted their efforts. Wolfe exhausted himself floundering through the drifts and had to retreat. Meanwhile, Wiessner and Pasang Lama pushed on, reached the 1938 high point, and pitched Camp IX at 26,000 feet, within reach of the summit.

The next day, the two men made their attempt. Climbing brilliantly without bottled oxygen, wearing crampons, Wiessner surged through K2's final obstacle, a 1,500-foot-high cliff of "mixed" rock and ice. The plucky Pasang followed on a tight rope. By late afternoon, Wiessner had almost topped out on the cliff at an altitude of 27,500 feet. Above the last 25 feet of easy broken rock, only 750 feet of gentle snow slopes stood between him and the summit.

His heart surging with joy, Wiessner started to climb the last 25 feet of the cliff. Suddenly the belay rope checked his progress. Wiessner turned to see what was the matter. Pasang refused to pay out any more rope. Almost sheepishly he said, "No, sahib, tomorrow."

Wiessner was perfectly willing to climb into the night (a nearly full moon would have lighted his way) to claim K2. But Sherpas believed that angry evil spirits lurked about the summits of mountains in the night. They could be safely climbed only in daylight. In that moment, Wiessner briefly entertained the thought of unroping and going solo to the top. Only his sense of loyalty to the terrified Sherpa kept him from doing so. The men began their descent to Camp IX.

Wiessner was still confident that the next day, he and Pasang could climb to the top, for the route had been solved. There were several

days' provisions stocked at Camp IX. But as Pasang rappelled over a short cliff, the rope dislodged both men's pairs of crampons (which the Sherpa had affixed to his pack). The men watched as the vital footgear plunged into the void.

Even now, Wiessner remained confident, for when he had parted with Durrance a few days earlier, the men had agreed that the other team members would climb up to Camp IX in support with yet more gear—including spare crampons.

To Wiessner's consternation, no one had arrived at IX. The two men rested the next day. In perfect weather, on July 21 they set out again for the top. Wiessner had thought he could circumvent the rock-and-ice cliff via a snow couloir, up which he hoped to kick steps. But the snow turned out to be hard ice. With crampons, he could have kicked his way up this gully, but now, laboriously carving steps with his ice axe, he recognized that it would take far more than a day to complete the staircase.

Once again, Wiessner and Pasang descended to IX. Still no sign of the rest of the team. On July 22, the two climbed down to Camp VIII, where they found a despondent Wolfe, furious at the teammates who had not arrived. In addition, Wolfe had run out of matches and had drunk only a cup of snowmelt all day.

All three men pushed on down to Camp VII—surely they would meet their teammates there. Still hoping for a shot at the summit, Wiessner had left his sleeping bag at Camp IX. During the descent, Wolfe suddenly slipped, and the tight rope pulled Pasang and then Wiessner off his feet. All three men were sliding toward the void, when Wiessner—a slight man, only five foot six—performed one of the greatest "self-arrest" maneuvers ever accomplished in the high mountains, as he rolled onto his stomach, lay with all his weight on his ice axe, dug the pick in, and stopped the falls of all three climbers.

To Wiessner's shock, not only did he find no teammates at Camp

VII, but the camp had been stripped of sleeping bags and nearly all the food. The reason for such sabotage seemed incomprehensible to Wiessner. The three men repitched the sagging tent and huddled through a bitter night with one sleeping bag and one air mattress.

By now, Wolfe was played out, so in the morning he stayed at VII to await help, while Wiessner and Pasang headed farther down. Down, down, down . . . Camps VI, V, IV, III, II—every one had been stripped of sleeping bags, gear, and food. It took two days for the men to complete the descent. By the time they reached the glacier, they were staggering and falling from exhaustion. Then Wiessner saw Eaton Cromwell, one of the apathetic teammates, approaching.

As Wiessner recalled in 1984:

> "My throat had gotten very sore, and I could hardly speak, but I was mad enough. I asked him, 'What is the idea?'
>
> "He told me they had given us up for dead. He was just out looking to see if he could find any sign of anything on the glacier. I said, 'This is really an outrage.'"

When they reached base camp, the other Sherpas embraced Wiessner and Pasang Lama, but, according to Wiessner, Durrance did not emerge from his tent for half an hour.

> "When he did, I said immediately, 'What happened to our supplies? Who took all the sleeping bags down? And why were they taken down?' Durrance said, 'Well, the Sherpas. . . .' It was blamed on the Sherpas."

The stripping of the camps remains today an all but inexplicable mystery. It seems clear that the refugees at base camp had succumbed to a defeatist mentality, and that induced a frantic desire to get away

from the mountain as soon as possible. The men may have believed that their three teammates up high had perished. It is barely conceivable that some of the Sherpas decided on their own to salvage the precious sleeping bags, but if they did, it would represent an act of vandalism without parallel in what is by now more than eight decades of faithful service by Sherpas to Western climbers.

Months later, Wiessner claimed that in his expedition papers, he found a note in Durrance's hand ordering the stripping of the camps. Back in New York, Wiessner maintained, he turned the note over to the AAC headquarters, only to have the telltale scrap of paper disappear. For the rest of his life, Durrance never publicly explicated his role in the disaster.

Had Dudley Wolfe not been marooned at Camp VII, the expedition might have packed up and gone home. On July 26, Durrance and three Sherpas tried to climb up to Wolfe, but once again, Durrance's acclimatization failed him, and the quartet turned back. Wiessner tried to go up two days later, but the ordeal of his desperate descent from Camp IX had left him with no reserves. Finally, on July 29, Pasang Kikuli and another Sherpa climbed 6,800 feet from base camp to Camp VII—an astounding feat of endurance at such altitudes. They found Wolfe lying in his sleeping bag, apparently without the will to survive—he had not even left the tent to defecate. Now he refused to descend, saying he needed another day of rest. The Sherpas could not even rouse him out of his sleeping bag.

The last attempt to save Wolfe came on July 31, when Pasang Kikuli, Pinsoo, and Kitar headed up to VII once more. They were never seen again. In all likelihood, one of them slipped and pulled all three off the mountain, or they were swept off by an avalanche.

On August 5, a full-scale storm dumped twelve inches of new snow on K2, ending all hope of rescue. The three lost Sherpas' bodies have never been found. Wolfe's was discovered in 2002 on the glacier at the

base of the mountain, evidently having been avalanched out of Camp VII sometime between 1939 and 1953.

The demoralized party headed home. With success having just eluded Wiessner's fingertips, the expedition instead had devolved into tragedy. That was bad enough: within weeks, tragedy would turn into scandal.

The American Alpine Club decided to launch an official investigation into the K2 disaster—something it had never done in its thirty-seven years of existence. This response had everything to do with historical timing. Only weeks after the battered team left base camp, Germany invaded Poland, the beginning of World War II. Wiessner had lived in the United States since 1929 and had been a citizen since 1933; in addition, he was a thoroughly apolitical person. But he was German-born, something the inner circles of the AAC thought might have contributed to the tragedy. Had only Sherpas died, there would have been no investigation. (After the 1922 Everest expedition, when seven Sherpas were killed in a single avalanche, as their English "sahibs," including George Leigh Mallory, directed them up an unstable snow slope, the Alpine Club never gave a thought to launching an inquiry.) But the fourth victim in 1939, Dudley Wolfe, was a Boston Brahmin.

The investigating committee was formed in secret. Persistent rumor over more than half a century since has it that among the dignitaries pushing for an inquiry were some of the best climbers from the Harvard Mountaineering Club. No one has linked Brad Washburn to that committee, nor did Brad ever publicly comment on the 1939 K2 disaster. In 2007, Charlie Houston told biographer Bernadette McDonald that he had been asked to serve on the committee, but had refused.

According to McDonald, "There was no animosity between Charlie and Wiessner." Yet Houston went on to criticize the 1939 expedition's leader. In McDonald's paraphrase,

Wiessner disgusted Charlie with his seemingly shallow aspira-
tions, one of which was to sell his ski [wax] business and marry a
rich widow. He also confessed that if he made the summit of K2, he
would be "set for life." . . . But his harshest criticism was saved for
Wiessner himself who, he felt, had led from the front, had shown
little flexibility or compassion for his team, and ultimately had
caused the death of Dudley Wolfe and three Sherpas.

So much for retrospect. In Brad's files, there exists a letter Charlie
wrote him on September 28, 1939, making it clear that both Wash-
burn and Houston had already harshly judged the K2 expedition. Even
before Wiessner and Durrance had returned to the States, the Ameri-
can Alpine Club had sent its leading members a confidential report
attempting to lay out the bare facts of the tragedy. The stripping of the
camps was explicitly blamed on the Sherpas.

Wrote Charlie,

> I feel as you do about K-2. The report makes it clear that the party
> was driven beyond their powers, extended much to[o] far along their
> line of attack, and very poorly prepared for the very bad luck which
> they kept enduring. There is no doubt that bad luck is far worse
> when you aren't prepared to cope with it.
>
> Wiessner is to blame for most if not all of the mishap, and I don't
> believe I can ever forgive him. I didn't know Wolfe, but I knew and
> dearly loved Pasang [Kikuli] and Pinsoo, and what they so gallantly
> did, _alone_, I can't forget.

Houston added a halfhearted caveat:

> Fisher [Joel Fisher, president of the AAC] pointed out, and I agree
> completely, that we must be very charitable until the party can tell its

own story. So I am not talking about the business at all, trying not to
be too prejudicial. When Wiessner is back and we hear his version,
and Durrance's, then I think is the time to air the business.

The timing of history was indeed everything. In August 1939, as
the K2 team headed home, a German-Austrian team was reconnoi-
tering Nanga Parbat. At the end of their expedition, as the members
were lingering in Karachi, waiting for a ship home, England declared
war on Germany. Indian soldiers arrested the climbers, who were
spirited away to a loosely guarded prison camp at Dehra Dun. One
of the interred men was the great Austrian alpinist Heinrich Harrer,
who the year before had participated in the first ascent of the Eiger
north face—considered the deadly "last great problem" of the Alps.
The team of four—two Austrians and two Germans—had been fêted
by Adolph Hitler in a huge public ceremony.

From the prison camp, Harrer and fellow Austrian Peter Auf-
schnaiter escaped, headed over innumerable passes, and arrived in
Tibet, where they passed the next seven years. During that time,
Harrer became a tutor to the youthful Dalai Lama and began his evo-
lution toward a lifelong championship of Tibetan independence, a pil-
grimage he chronicled in his bestselling classic, *Seven Years in Tibet.*

The AAC's official report on K2 was scalding. Among its strictures:
the expedition's "human organization was weak," there was "no clear
understanding" of plans between Durrance and Wolfe, and the han-
dling of the Sherpas was woefully negligent. The brunt of all these
armchair second guesses fell on Wiessner. And the jingoism of the age
came out explicitly in the report: "Confidentially," wrote one of its con-
tributors, "I believe that one of the primary factors precipitating the
dissension which finally arose was the inescapable fact that, although
on paper and by law, Wiessner is an American citizen, he is still in
many respects largely German in his outlook and actions. . . . [L]ike

every German, he is very forceful in giving commands and totally un-
aware that the abrupt, blunt manner in which the order may have been
given might have wounded the feelings of his associates."

Two members of the committee strenuously objected to its con-
clusions. One of them, Robert Underhill, though himself an Ivy-
League-educated easterner, went public with an eloquent testimonial
to Wiessner's courage and perseverance, which closed, "He had the
guts—and there is no thing finer in a climber, or in a man."

The damage, however, was done. Wiessner resigned from the AAC.
He continued to climb at the highest level, and in his eighties he was
still leading hard rock routes. His only published account of the 1939
expedition was a brief, restrained résumé that appeared in the journal
Appalachia in 1956. In 1984, Wiessner told me that in the aftermath of
the expedition, he was visited by two FBI men whose questions made
it clear they suspected him of being a German spy. Once he had dis-
solved their suspicions, Wiessner said, "Now look, fellows, I was pretty
open to you. . . . Would you tell me the names of the men who put you
up to this?"

"Naturally we can't do that," one of the FBI men answered.

"Let me ask this question," Wiessner rejoined (according to his own
telling). "Was it some climbers from the AAC?" The FBI men nodded.

Sadly, the AAC's tarnishing smear of the 1939 expedition became a
kind of received wisdom in the United States and Great Britain. Thus
Kenneth Mason, a deeply reactionary British climbing historian, sum-
marized the K2 effort in a badly garbled account in *Abode of Snow,*
sermonizing, "It is difficult to record in temperate language the folly
of this enterprise."

Well into the 1970s, the HMC climbers of Washburn's era tended
to cling to their critiques about K2 1939. Yet a younger generation,
gazing back with admiration rather than censure on such pathbreak-
ing ascents as the Eiger north face of 1938, began to rehabilitate Fritz
Wiessner. The culmination of that effort came at the annual AAC meet-

ing in December 1978 in Estes Park, Colorado. A decade before, partisans had persuaded Wiessner to rejoin the AAC. Now, at a meeting celebrating the first American ascent of K2, which had finally come in the summer of 1978, both Wiessner and Durrance were present. It was the first time the two men had met in thirty-nine years.

When Wiessner was introduced, the most prolonged standing ovation in any member's memory saluted the legendary mountaineer. Only Durrance refused to stand, his mouth twisted in a scowl.

Yet the 1939 tragedy haunted Wiessner for the rest of his life. (He died in 1988, at the age of eighty-eight.) Again and again in his mind, he replayed his decision not to unrope and go for the summit solo on July 19, 1939. As it was—and as the younger generation recognized—Wiessner's leading every pitch on K2 and getting to within an easy 750 feet of the top without bottled oxygen was one of the greatest feats in Himalayan annals. (K2 would not be climbed until 1954, when two climbers using bottled oxygen, at the head of the massive Italian effort, finally topped out.) Had Wiessner unroped and pushed into the night to reach the summit—and assuming that gambit had not cost Pasang Lama his life—Wiessner's achievement would arguably have been the greatest single deed in mountaineering history.

But as Wiessner told me in 1984, "If I were in wonderful condition like I was then, if the place where my man stood was safe, if the weather was good, if I had a night coming on like that one, with the moon and the calm air, . . . then probably I would unrope and go on alone." Wiessner paused, his thoughts wrapped in the past, then said, "But I can get pretty weak, if I feel that my man will suffer. He was so afraid, and I liked the fellow. He was a comrade to me, and he had done so well."

After the blithe first ascent of Mt. Sanford, Brad, Terry, and Katrina were back in "civilization" (if Chistochina could so qualify) by the end

of July 1938. Along with the many letters that had streamed north lavishing sympathy on Brad for the plane crash, then (in subsequent weeks) congratulations for the double triumph of Marcus Baker and Sanford, there came joyful news from Cambridge. Brad's brother, Sherry, who had passed his PhD exams in anthropology with colors flying so high that such luminaries in the field as Clyde Kluckhohn and Alfred Tozzer declared they had never had a more brilliant student, was going to marry his girlfriend, Henrietta Pease. "Hennie" had been a family friend for years, her father being a distinguished Latin teacher at Harvard and good friend of Washburn père.

The wedding, which was to be a lavish affair, was set for September 10. The family letters, including ones from Brad's half-sister Mabel and from Sherry, pleaded with Brad to return from Alaska in time for the grand event. But Brad had one more chore to fulfill in the North—the aerial photography flights around the Wrangell Range, for which the National Geographic Society had advanced him $1,500.

All his life, Brad's congenital stubbornness would dictate that he carry to the finish line any project he had embarked on. Now he cooled his heels for weeks in Cordova, where he had booked a bush pilot, as the notoriously foul August weather forestalled any photography. When it became clear that he would not make it home in time for the wedding, Brad somehow bought presents in Cordova to mail to the couple. Hennie wrote to thank Brad, but could not suppress her disappointment: "I'm so sorry you won't be at the wedding—it really seems close now."

On September 10, Sherry and Hennie were wed in Christ Church in Harvard Square. Brad's parents sent a telegram that day that managed to skirt the edge of guilt tripping: LOVELY WEDDING EVERYONE HAPPY MISSED YOU DREADFULLY ALL LOVE—MOTHER FATHER.

The aerial photography paid its dividends. In December, the NGS sent Brad a check for $3,500—an unsought bonus confirming the society's faith in its still-young explorer-mountaineer-photographer. Gros-

Brad as a teenage climber in the Alps.

Teenage Brad's photograph from Mont Blanc,
which he once declared the best picture he ever took.

Group photograph at base camp on 1933 Mt. Crillon expedition—the only expedition to assemble four of the Harvard Five. From left to right: Charlie Houston, Bob Bates, Bill Child, Washburn, Walter Everett, and Ad Carter.

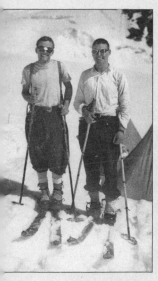

Ad Carter with Brad.

On the 1934 Crillon expedition, Dave Putnam and Waldo Holcombe canoe dangerously close to the snout of the South Crillon Glacier.

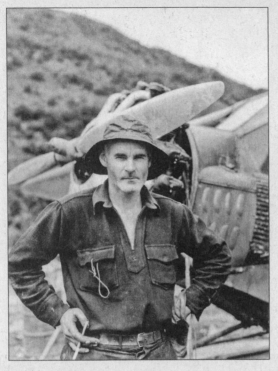

Bob Reeve, Alaska's most daring bush pilot, in 1937.

Reeve's airplane, stuck in the slush on the Walsh Glacier beneath Mt. Lucania.

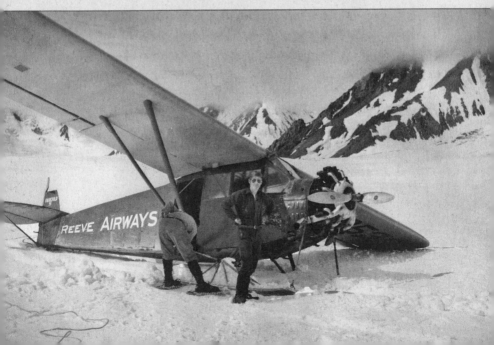

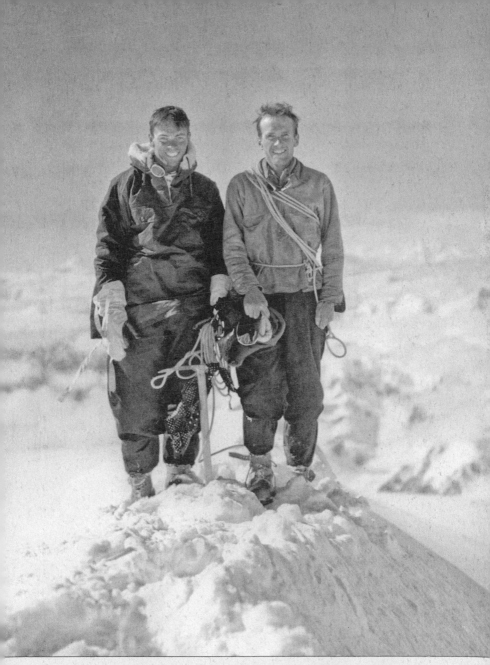

Brad's iconic picture of Bob Bates and himself on the summit of Mt. Lucania, until that moment the highest unclimbed peak in North America.

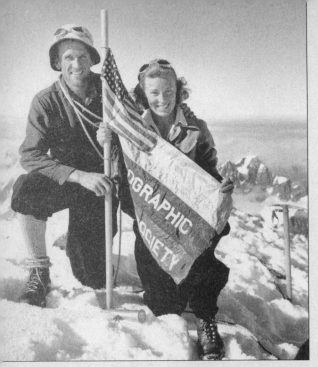

Brad and Barbara on the
summit of Mt. Bertha.

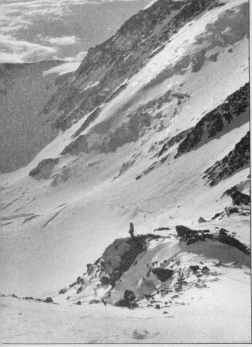

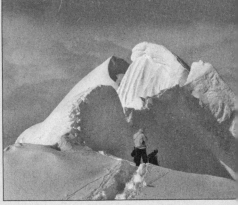

The crux knife-edged ridge on Mt. Hayes,
on which Barbara took the lead.

Barbara on Mt. McKinley, 1947.

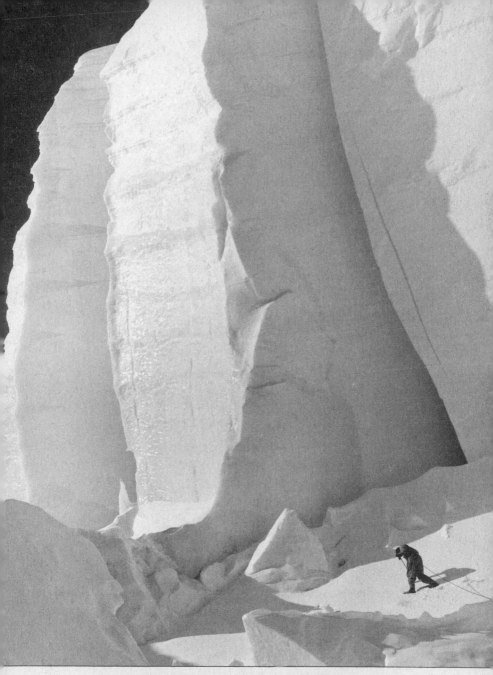

Norman Bright on the first ascent of Mt. Silverthrone, 1945.

Terry Moore with a ski-equipped airplane on the Kahiltna Glacier, 1951.

Brad holds the fifty-three-pound Fairchild F-6 camera with which he took his greatest pictures.

A bend in the Shoup Glacier, shot straight down from far above,
an example of one of Brad's "abstract" photographs.

Another "abstract"—the footsteps of a lone traveler
in a winter-struck landscape.

Brad's most famous
photograph—
climbers on the
Doldenhorn in the
Alps after a storm.

Another famous photograph—the north face of the
Grandes Jorasses in the Alps with full moon.

The Great Gorge of the Ruth Glacier.

The tiny figures of climbers in the Great Gorge.

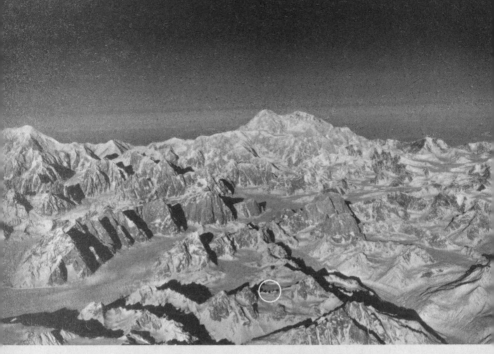

The picture that says it all about Frederick Cook's hoax.
Fake peak (circled, in the foreground) with McKinley in the distance.

The crux doubly-corniced ridge on the route by which
Cook claimed he had ascended McKinley, still unclimbed today.

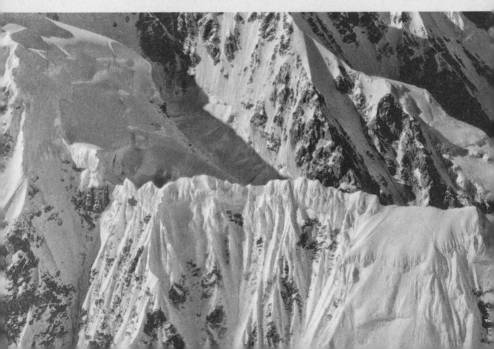

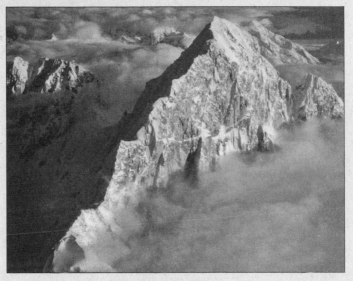

Mt. Huntington, "the most beautiful mountain in Alaska." The French team's first ascent route on the left; the author's route in right-center.

The five-thousand-foot-high southeast face of Mt. Dickey in the Great Gorge, above Don Sheldon's airplane. The author's route follows the prominent central pillar.

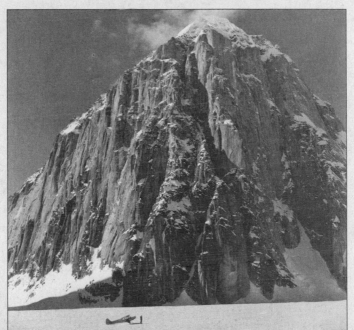

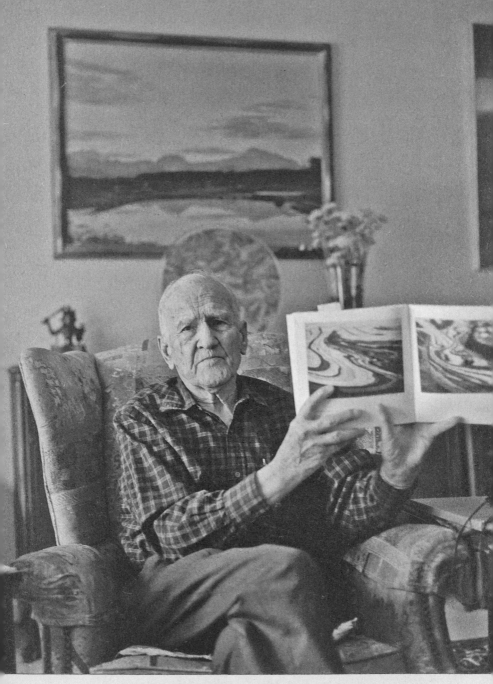
Kurt Markus's portrait of Brad at age ninety-four.

venor also asked Brad for an article on the icefields of the Chugach and Saint Elias ranges. As it turned out, it was an assignment Brad would be too busy to undertake.

Life magazine wanted an article about Brad's 1938 season. With regret, Brad declined, for he had finally learned just how jealous and possessive the National Geographic Society was, and just how sorely it irritated Grosvenor and his staff to see Washburn publishing pictures the society had financially underwritten in other media outlets—especially in a rival magazine as threatening as *Life*.

Once Brad had returned to Cambridge, he resumed his teaching at the Institute for Geographical Exploration, which on September 1 had given him yet another one-year reappointment (even though he had risen to the rank of assistant director). Despite the generosity of his colleagues, and especially his championing by the director, Hamilton Rice, Brad never felt secure or really happy in his post. Many years later, Brad told biographer Michael Sfraga that within Harvard, serious tensions focused on the institute. According to Brad, the university's geology department, a wholly separate entity, resented the institute's autonomy and glamour. Some members of the department felt Rice had "bought" his professorship, and that he was not really qualified academically; they even refused to let their own students take geography classes offered by Rice's organization. President James Bryant Conant would eventually abolish the institute in 1948. (According to Barbara Washburn, as that abolishment loomed, Brad stormed into Conant's office to protest, armed with outraged testimonials from the Royal Geographical Society in London. Brad took this action even though he was no longer employed by Rice's institute. But Conant thundered, "Washburn, geography should never have been taught past the fourth grade!")

By late autumn 1938, Brad was contemplating yet another season in Alaska. With Norman Bright, his partner from Marcus Baker (and Lucania), he corresponded about Mt. Hayes, which he had photo-

graphed on a side jaunt during his 1936 flights over Mt. McKinley. At
13,832 feet, Hayes was the eponymous high point of the Hayes Range,
a collection of steep, handsome, glaciated mountains stretching 100
miles from west to east between the Nenana and Big Delta rivers. The
peak had been named way back in 1898 by a pair of USGS surveyors,
in honor of one of their colleagues.

With Marcus Baker and Sanford, Brad had become a tenacious
challenger of the unclimbed highest summits of major Alaskan ranges.
The photographs made it clear, moreover, that Hayes would be techni-
cally more demanding than Marcus Baker, and far more so than San-
ford. In January 1939, Bright wrote Brad enthusiastically, "From the
pictures, Hayes would certainly more than satisfy any mountaineer's
desires."

Another reason Hayes appealed to Brad had to do with the fact
that the one serious attempt on the mountain had been made by
Charlie Houston in 1937, the year between his landmark Nanda Devi
and K2 expeditions. Oscar Houston, miffed at his dismissal from the
Nanda Devi team, had assembled a party to go after Hayes, much as
he had organized and financed the Foraker team in 1934. With Char-
lie as the driving force, the team reached 11,000 feet on Hayes before
turning back in the face of fierce weather and a shortage of time.
Even though Brad and Charlie vowed to remain friends, they always
felt a keen rivalry with each other, especially when it concerned Alas-
kan peaks. (In 1934, Charlie's Foraker had trumped Brad's Crillon;
three years later, Brad's Lucania far outstripped Charlie's attempt on
Hayes.)

In the end, however, Mt. Hayes would be pushed to the back burner.
All through the fall of 1938, even while he taught at the institute, Brad
continued to ride the lecture circuit, alternately presenting his Lu-
cania show and a new one, modestly titled "An Alaskan Adventure,"
chronicling Marcus Baker and Sanford. And it was on his way to one

such talk that November that fortune struck the lightning blow that would determine Brad's professional career.

As Brad always told the story, he had boarded a plane to Philadelphia, when he recognized "a familiar bald spot on the head of a man a few rows ahead of me." The man was John K. Howard, a Boston lawyer who had befriended Brad a few years earlier. Moving up to sit next to Howard, Brad listened to the attorney's soliloquy of complaint. Howard had recently been appointed president of the venerable but decrepit New England Museum of Natural History. As Brad told Lew Freedman in 2005, the museum "had a dreadful director whose only interest was studying minerals." It was Howard's mandate to replace this functionary, but, according to Brad, "he was having a heck of a time finding a young new director who could take on the old museum and make something of it."

The museum, at 214 Berkeley Street in Boston's Back Bay, was housed in a gloomy old building, its exhibits coated with dust. Barbara Washburn (née Polk) remembered depressing visits there as a child: "I had a vivid recollection of [a] whale skeleton hanging from the ceiling." The museum had a working budget of only $44,000 a year, and it attracted a mere 40,000 visitors per annum, despite charging no admission fee.

On the plane to Philadelphia, Howard lamented that two promising candidates for the job of director had already turned him down. As Brad reminisced to Freedman, Howard asked him what he was doing for a living. Brad explained the precarious status of the Institute for Geographical Exploration at Harvard, only to be interrupted by his fellow passenger: "You're exactly the fellow I'm looking for!"

Moments later, Howard disembarked at Newark airport. Brad flew on to Philadelphia to give his talk. He had scarcely had time to register surprise at Howard's impulsive offer when the moderator introducing him to the crowd handed Brad a telegram from Howard:

I MEANT WHAT I SAID ON THE AIRPLANE THIS MORNING. I
WANT YOU TO ACCEPT THE POSITION OF DIRECTOR OF THE
NEW ENGLAND MUSEUM OF NATURAL HISTORY. SEE YOU AS
SOON AS WE RETURN TO BOSTON.

More than six decades later, Brad's memory of the process that
changed his life may have oversimplified the chain of events, for a
December 7, 1938, letter from Howard notifies Brad that the trustees
of the museum had appointed him not director, but chairman of the
Lecture Committee. Nonetheless, only three weeks later the trustees
took the further step. Still only twenty-eight years old, Brad had been
instantly transformed from an instructor in geography to the youngest
director of a major museum anywhere in the country.

Once he accepted the offer, Brad never looked back. Among
the letters of congratulation in the following weeks, one from Mary
Whittemore (who by now seems to have accepted a casual friendship
with Brad in lieu of romance) hits the nail on the head: "It sounds
perfectly grand. I can just imagine how much you are dying to be your
own boss."

To Freedman, however, Brad insisted that he had serious qualms
about accepting the offer. At his initial meeting with the trustees, Brad
"told them I didn't have the slightest idea about how to run a museum,
nor did I have any experience in fund-raising." The trustees, Brad re-
called, replied, "We'll raise the money. Your job will be to have the
ideas which will make all of this possible." In the end, nothing would
be further from the truth, as Brad embarked on four decades of heroic
fund-raising.

Brad's salary as new director was a mere $3,000 per year—even at
the time, a niggardly income. For years to come, Brad would continue
to supplement that salary with speaker's fees, as he traveled hither and
yon lecturing about his Alaskan escapades.

With the responsibilities of his new job, any hope of an expedition to Alaska in the summer of 1939 went out the window. On June 1, 1939, Brad's old friend Bill Child wrote him, "I hope that Sherry was wrong when he said that he had never seen you work so hard as this year. Take it easy—life's too short! Go off to the wilds and take a rest—without work."

Launching his new career, Brad determined to transform what he later called "a three-dimensional dictionary under glass" into a vital educational museum. However earnestly the trustees paid lip service to Brad's innovative instincts, he found himself almost at once at odds with their reactionary entrenchment. An undated letter from the spring of 1939 (signature illegible) sympathizes with Brad's head-butting with "your tight-fisted millionaire trustees. . . . How you must shock them with your new office and 'new-fangled ideas.'"

From the start, Brad realized that if the museum were ever to flourish, it must relocate. It was not simply a matter of the dusty dreariness of the stone-and-brick building, erected in 1864, that housed the museum. The Back Bay was simply too crowded to accommodate the throngs Brad hoped to lure to the place. Even in 1939, parking was severely limited in the neighborhood.

Relocating, however, would prove Brad's toughest battle with those "tight-fisted" trustees. It would take nine years to accomplish the move, but the building of a massive six-story edifice on Cambridge Street, with a lordly view over the Charles River, would transform the moribund New England Museum of Natural History into the eventually world-renowned Boston Museum of Science.

One of Brad's first moves was to fire the "battle-axe of a secretary" he had inherited. As Brad told Freedman, "She was determined to do everything she could to put her foot in front of me so that I would trip, because the last thing she wanted was for the museum to move, or be run by a new director."

At once Brad started interviewing candidates to replace the battle-axe. He asked friends to recommend prospects, including a fellow nicknamed Clarkie, who had served as mailman for the Institute for Geographical Exploration. Clarkie also delivered mail to Harvard's biology department, and he mentioned the opening to Barbara Polk, who was serving as the department's secretary.

Barbara had grown up in West Roxbury, a Boston suburb, the second child of a father who worked for the Universalist Church publishing company. In her charming and modest 2001 memoir, *The Accidental Adventurer,* she conjured up childhood rambles in the woods with her father:

> I remember climbing on big rocks that were called Roxbury pud-dingstone and being told that the big rocks were like raisins in a pudding. I would climb to the top of these big boulders and shout, "I'm king of the castle!" . . .
>
> Somehow the adventurous spirit was in my blood. Even as a youngster, I preferred the company of boys. They wanted to do riskier things than girls did, so they were more stimulating to be around. I assumed that any boy I met would lead me into adven-ture.

At the same time, as a girl Barbara took ballet and piano lessons. Her family was far from affluent, but good grades earned her admis-sion to Boston Girls Latin School, which, though free, was the best academy of its kind in the city. Graduating from Latin, she won a schol-arship to Smith College, where she majored in French. With thirty-one classmates, Barbara spent her junior year, from 1933 to 1934, in France: eight weeks in Grenoble; the rest of the school year in Paris, studying at the Sorbonne. During that year abroad, she and seven fellow students accepted a two-week invitation to stay over Easter va-

cation with a family in Cologne, Germany. Hitler had become chancellor in January 1933, but Barbara and her fellow students were utterly ignorant about Nazism. As she remembered,

> We were severely scolded by the conductor of a trolley car for making fun of the "Heil Hitler" salute. He told us he would throw us off the car if we did it again.
>
> Older members of the Nazi youth movement were assigned to entertain our group of eight foreign students, and we spent evenings in bistros dancing, drinking Rhine wine, and having heated arguments about Hitler's ideas. If a Nazi wanted to cut in on your dancing partner, he would do his "Heil Hitler" salute and click his heels together. This ridiculous performance always made me giggle. But I soon learned there was nothing funny about what these young men were doing or thinking and that they didn't tolerate being made fun of.
>
> One member of our group was a Jewish student from Dartmouth College. When he was insulted by a German student, Fran [Barbara's best friend in Europe] and I rose to his defense, and it became clear to us that Hitler was dead serious about persecuting the Jews.

That eye-opening two-week visit to Germany sparked in Barbara a lifelong commitment to liberal causes, which would ensue in a career of volunteer activism. After college, she took a job at a settlement house near Boston's Chinatown, teaching arts and crafts and volleyball to poor children. But teaching, she realized, was not to be her métier, so, somewhat at loose ends, she went to secretarial school. By the spring of 1939, she was contentedly serving as secretary in the Harvard biology department.

At twenty-four, Barbara Polk was a beautiful woman, with blue

eyes, wavy blond hair, and the dimples of an ingenue. She had had a string of boyfriends, several of whom had proposed marriage. As Barbara would recall many decades later, "I was not very mad about any of them. Whenever they got too serious, I had to say to them, 'I don't think it will work out.' One of the most serious was a biology grad student. He was a nice boy, but I didn't want to marry a biologist who would be feeding his mice on Christmas morning."

Yet nearly all of Barbara's women friends had married straight out of college. Given the prevailing standards of the day, at only twenty-four she had begun to have fears that she might end up an "old maid."

When Clarkie the mailman mentioned the job opening at the New England Museum, Barbara was at first distinctly uninterested. As she would write in *The Accidental Adventurer,* "I had read in the newspaper about a famous young explorer and mountain climber becoming direc-tor of the museum, but I hadn't seen a picture of him." She told Clarkie, "I don't want to work in a dusty old museum, and I definitely don't want to work for a crazy mountain climber!"

The mailman persisted, however, repeatedly urging her to "give it a try." Finally, to get him off her back, Barbara agreed to a quick in-terview. She was so sure the meeting would come to nothing that she asked the young man she was then dating not only to drive her to the museum but to double-park outside. "I will make short shrift of this guy," she averred.

The museum was even more depressing than Barbara had remem-bered it from her childhood visits. The whale skeleton was still there, hanging from the ceiling, gathering dust. "All of the other exhibits," Barbara would write, "seemed equally dreary and I wondered why an explorer would want to work in such a dingy place."

Brad was smitten at first sight. For her part, Barbara was surprised that the young, clean-shaven director "bore no resemblance to the pic-tures of explorers I had seen in picture books, pictures of men like

Lewis and Clark." Still, the interview went badly. Brad made the mistake of talking about the museum's finances.

"I don't know anything about finances," Barbara snapped.

"But you can learn, can't you?"

Brad offered her the job and asked her to think about it. He promised to call her in two weeks. Instead, he called her every day. At last she succumbed to his persistence and accepted the job. She started work on March 28, 1939.

Despite the intensity of Brad's attentions, Barbara naively remained unaware of Brad's attraction to her. Any personal relationship between a boss and his secretary was, according to the mores of the day, strictly taboo. As Barbara wrote in *The Accidental Adventurer,* "The job was stressful. He stood behind me while I typed a report for the museum trustees. Everything had to be done in a hurry, and there always seemed to be a crisis." And: "My relationship with the boss was very formal. He was demanding, but as long as I gave him good work, he was never cross with me."

One of the strangest moments in Barbara's secretarial stint came when an attractive young woman in a great hurry brushed past her desk and strode into Brad's inner sanctum. Moments later, she fled just as abruptly, in tears. Brad emerged, thundering at his secretary, "Don't you ever let that woman into my office again!" It was thus that Barbara first met Eleanor Kerns. (By the oddest of coincidences, six decades later Brad, Barbara, and Kernsie would end up living in the same retirement community in Lexington, Massachusetts.)

One day in the spring of 1939, Brad came out of his office and abruptly asked Barbara if she wanted to go flying with him. The purpose was purely practical, he insisted, as he needed a certain number of hours in the air to keep up his license. The pair drove to the East Boston airport, where Barbara climbed into a small two-seater, "trembling with fear and excitement," as she later recalled. Once in the air,

Barbara pointed to the stick and asked, "What happens if you push it forward?"

Without a word, Brad pushed the stick, sending the plane into a sudden dive. "That's what happens!" Brad yelled, as he straightened out.

That flight took place almost exactly twelve months after Brad's fatal crash on Lake Union—a tragedy Barbara didn't learn about until years later.

Barbara soldiered away as Brad's secretary for ten months, still unaware of his feelings for her. Then, one day in January 1940, Brad traveled to Hartford to give a talk. On the same day, Barbara got a ride from a museum employee to Hartford, from which she planned to take a train to New York, where she had a date with her latest beau.

In Hartford, Barbara discovered the next New York train would not depart for hours. Her chauffeur suggested the two of them attend Brad's lecture. When the lights came up after the slide show, Brad spotted his secretary in the audience. He dashed over and blurted out, "What in the world are you doing here?"

When Barbara explained, Brad announced that he too had to travel to New York that evening. Barbara's surprise appearance must have emboldened him, for when he arranged the tickets, Barbara discovered to her discomfort that the only two available berths in the sleeping car were in the same cabin, one above the other. Brad took the upper. As Barbara later wrote,

> [S]ince we were so exhausted, we just crawled into our berths. Suddenly I saw an arm moving down the wall from the berth above, with the hand obviously trying to signal "Good night." I was in a quandary. If I squeezed his hand, he might think I was too aggressive. If I didn't, he might get angry. So I let instinct guide me. I squeezed Brad's hand gently and whispered "Good night."

In the morning, Brad insisted that she join him for breakfast with Lowell Thomas, the famous writer and broadcaster, whom Brad had known for years. (Barbara had typed many a letter to Thomas during the previous months.) Barbara demurred, "Oh, no, Lowell Thomas wouldn't want to have breakfast with me!" But Brad insisted, and, as usual, got his way. Much later, Thomas told Barbara that he had instantly known at breakfast that she would become Brad's wife. "He had seen it in our eyes," he told Barbara.

Two days later, Brad showed up on the same train platform in Penn Station, as Barbara bid farewell to her New York date. On the five-hour ride back to Boston, as Barbara later wrote, "I began to feel some tinglings of desire from Brad, and something inside me was responding."

The following evening, Brad offered Barbara a ride home from work. She invited him into the house in West Roxbury, where she still lived with her parents. In her memoir, she describes what happened next: "As we were sitting on a sofa in my living room, he suddenly asked if I loved him enough to marry him."

Despite the "tinglings," Barbara was dumbfounded. She and Brad had never had a real date. They had not even kissed. And yet all at once the answer seemed clear. "Yes," Barbara replied.

In terms of Brad's psychology, the courtship of his secretary seems both curious and at the same time perversely logical. Barbara Polk was not the first woman with whom he had been smitten. On first meeting Kernsie in the spring of 1936, Brad had been infatuated to the point of writing Eleanor's mother to ask if his visits for tea were so frequent as to become annoying. He had announced his engagement to Kernsie to the world, and set the date for the wedding, only to have that potential marriage fall apart. And however ambiguous his

relationship with Mary Whittemore had been, Brad had apparently planned to marry her, too.

What was different about Barbara Polk? Perhaps it was the fact that she did not immediately reciprocate his ardor—that she ignored his awkward flirtations for almost a year. In any event, this time Brad never got cold feet. When he announced his engagement to his staff at a tea in the museum library, Barbara's colleagues were "electrified." As she later wrote, "I immediately resigned my job. In those days that was the proper thing to do."

The wedding, attended by about 200 friends, took place in the Harvard University chapel on April 27, 1940. One of the guests, serving as an usher, was Charlie Houston. All his life, Charlie had a penchant for practical jokes, but the one he pulled at the wedding was so excessive, one cannot help wondering whether it was in some sense a late-blooming bud of the animosity between the two climbers on Crillon in 1933.

Charlie padlocked the sleeve of Brad's wedding jacket, so that he could not put it on. With 200 people waiting and watching, as Barbara wrote in *The Accidental Adventurer,*

> Brad ran to the nearest hardware story for a file to remove the lock and he was totally out of breath by the time he got back for the ceremony. As he stood beside me taking the wedding vows, his voice was so weak that I thought perhaps he had lost his courage about going through with it.

None of this stress shows in the professional studio portrait of the wedding couple. Barbara stands on Brad's right, her right hand holding a bouquet of white lilies, her left arm linked through Brad's right, a serene smile on her face. Sprouting a corsage from his jacket lapel, Brad stares confidently at the photographer, looking every bit as

pleased with his latest conquest as he had in the by-now iconic summit photo with Bob Bates on Mt. Lucania.

The couple honeymooned for two weeks, hiking and skiing, in a cabin Brad had built years before in New Hampshire, just south of the Presidential Range. Back in Boston, they moved into a small apartment on Commonwealth Avenue.

Many decades later, Brad would say, "Taking the museum job was the second-best decision of my life. Marrying Barbara was the best."

The grueling summer of 1939, during which for the first time in thirteen years he had been confined to Cambridge and Boston, had taken its toll on Brad's spirit. Only weeks after their wedding, Barbara overheard her husband talking to some friend over the telephone about an expedition to an unclimbed mountain in Alaska for the upcoming summer. Barbara knew that it was inevitable that sooner or later the restless explorer she had married would have to return to his beloved North. What she didn't know—for Brad had not bothered to tell her—was that he was counting on her to be a member of the expedition.

Back to Alaska— and into War

The objective was Mt. Bertha, a handsome, middle-sized peak in the Fairweather Range, a close neighbor of Mt. Crillon. Brad had seen and admired the mountain on his first northern expedition, the failure on Fairweather in 1930. Brad thought that Bertha should not be an inordinately difficult climb. It stood a relatively modest 10,182 feet above sea level (compared with Crillon's 12,726 and Fairweather's 15,330). In the end, it proved a bit more technical than he expected, as the only safe route traversed a long knife-edged ridge. Like most of the lower peaks in the Fairweather Range, Bertha had never been attempted.

At the time, Brad had no idea where Mt. Bertha had gotten her name. Much later, he would learn that in 1910 the International Boundary Commission, surveying in the area, had immortalized a favorite Skagway prostitute who had serviced the men during their downtime.

The team Brad assembled was a casual bunch, comparatively short on mountaineering experience. Besides Brad (and Barbara),

only Maynard Miller, then an HMC undergraduate, would go on to pursue serious expeditions in the future. Three other Harvard undergraduates came along: Alva Morrison, Lee Wilson, and Tom Winship, then the captain of the Harvard ski team, who would eventually become publisher of the *Boston Globe.* Lowell Thomas asked Brad if his sixteen-year-old son could go along, even though the lad had no mountaineering under his belt. Brad readily acquiesced. As he later annotated, "His father figured that if Barbara was going it must be easy." (Lowell Thomas Jr. would never become a mountain climber, but he would craft an outstanding career as one of Alaska's premier bush pilots.)

Rounding out the party was Michl Feuersinger, Thomas's Austrian ski instructor, a dashingly good-looking man in his midtwenties. "All the girls fell in love with him," Barbara recalls today, but she still harbors the suspicion that Feuersinger either already was or later became a spy for the Germans. While they were in an intermediate camp on Mt. Bertha, Barbara recalls, she asked, "Michl, what are you going to do if we end up in a war against Germany?" According to Barbara, Feuersinger promptly answered, "I'm going to rush off to South America."

The sum total of Barbara's mountaineering experience, at age twenty-five, was a stroll with a boyfriend up Chocorua, a glorified hill that rises to 3,490 feet in the White Mountains of New Hampshire, and then as now, one of the most popular hikes in New England. "It was hard work," wrote Barbara in *The Accidental Adventurer,* "and I was out of breath the whole time."

The first ascent of Mt. Bertha was not a cherished goal for Barbara that spring, but once she realized Brad expected her to come along, she cheerily agreed. (Already she recognized that if Brad had an agenda, it was easier to go along than to resist.) As she wrote in her memoir, "I had no real feeling about being a pioneering woman on a

serious Alaskan expedition. I only knew that as the only woman, I had to measure up."

Instead of flying in to a glacier base camp, Brad's party took a fishing boat out of Juneau, which deposited the climbers on the shore of Hugh Miller Inlet in Glacier Bay. By July 1, the team had carried loads up a hill above the coast and established its base camp. The next day, for the first time in her life, Barbara set foot on a glacier. As she wrote in her diary that evening, "Had my first experience walking on glaciers and jumping my first crevasse. It wasn't half bad."

In Bertha, Brad envisioned a lark along the lines of his Mt. Sanford climb two years earlier. Once again, he used dog teams to ferry loads to the base of the mountain. But he also hired a bush pilot to air-drop supplies to a higher glacial basin. Slowly the team strung a series of camps up the east ridge of Bertha. Barbara proved to be a natural mountaineer, and despite her slight frame, she carried loads as heavy as sixty pounds. (Lower on the mountain, some of the men hefted gargantuan packs laden with as much as one hundred pounds of gear and food.)

On July 26, the team made its first attempt on the summit, but climbed too slowly, and had to turn back 1,700 feet below the top. On the descent, Brad decided to take a shortcut involving a rappel over an open crevasse. Barbara had never rappelled before, but her husband was confident she could perform the technique.

"I swung on the rope, dangling in midair because I couldn't plant my feet steadily on the side of the icy hill," Barbara later wrote. "I was scared to death but was ashamed to admit it. I covered up my fright by laughing almost hysterically."

Barbara was not the only one who was scared. At dinner that night, Lowell Thomas Jr. suddenly burst out at Brad, "What are you trying to do to Barbara, kill her?" By now, the mountain had separated the weak from the strong. Four days later, on July 30, when a second summit attempt was launched, only five climbers composed the assault team:

Brad, Tom Winship, Maynard Miller, Michl Feuersinger—and Barbara. There was a vague promise of a second summit stab if the first team was successful, but in the end Lee Wilson, Alva Morrison, and Lowell Thomas Jr. were content to remain in camp.

Plowing through deep, soft snow in which the climbers sank up to their knees, the quintet took turns breaking trail along the sharp ridge. At 3:30 P.M., they stood on top of Mt. Bertha. Winship borrowed Brad's camera and shot a portrait of Barbara and Brad kneeling on the summit as they unfurled a small American flag and a much bigger banner from the National Geographic Society (even though the NGS had had nothing to do with funding the expedition). Brad later declared the photo the best picture of Barbara and himself ever taken, and he commissioned a painter to replicate it on canvas on a grand scale. The picture hangs in the Museum of Science today.

Back in camp, exhausted after a nearly twenty-hour round-trip climb, Barbara wrote in her diary, "Reaching the summit was an emotional experience—it had been our destination for so long, and it had seemed so far away."

By August 15, the team was back in Juneau, where two local newspapermen cornered Brad for an exclusive interview. With Bertha, he had now made his fifth successive first ascent of a major mountain in Alaska or the Yukon, punctuated by the epochal traverse of the Saint Elias Range. And Brad had only just turned thirty years old. On Bertha, Barbara had, as Brad later said, "acquitted herself superbly— as I had known she would."

For several days in the Gastineau Hotel, however, Barbara felt ill. "I thought I probably was just getting the grippe, and it would go away by itself," she would later write. But Brad knew a Juneau doctor and insisted that Barbara go for a consultation. The doctor briefly examined his patient, then opened the door and called out to Brad, "Hell, there's nothing wrong with this girl, she's just pregnant!"

That evening, as the team had its farewell dinner in the hotel, Barbara broke the news. A stunned Tom Winship blurted out, "Barbara! How could you be pregnant? I was sleeping beside you most of the time."

The couple later calculated that Barbara had conceived on the train ride west between Boston and Prince Rupert, British Columbia. On March 7, 1941, Barbara gave birth to a daughter, Dorothy Polk Washburn.

For Brad, continuing to pursue Alaskan first ascents was of paramount importance. Some of the trustees of the New England Museum, however, seemed to regard Brad's absences in the North as little better than truant flights from the serious business of directing the museum. The indulgent support of Hamilton Rice and the institute, taking pride in a teacher of geographical exploration who actually explored, was a far cry from the frowns of the museum's conservative overlords.

During Brad's first years in the job, there was considerable tension between the director with his adamantine will and some of those "tight-fisted millionaires." The issue of moving the museum to a new location, which would necessitate erecting a new building, was never far from the top of Brad's agenda. According to Barbara, at one fraught trustees meeting, while Brad was pushing for relocation, the museum's treasurer stood up, uttered the malediction, "I disapprove," resigned on the spot, and walked out of the room.

By early 1941, moreover, it seemed increasingly likely that the United States would join the war against Germany. In that event, Brad would have been eminently draftable. Perhaps to forestall such a fate, in late 1939 he had applied to the Marine Corps Aviation Reserve, arguing that his aerial photographic skills might be of some use. The Marine Corps accepted Washburn, while allowing him to remain a civilian.

In the spring of 1941, Brad and Barbara proudly showed off their infant to friends and family. Barbara assumed that the advent of "Dotty" would "change our lives considerably. We would no longer be so free to travel." That spring, as she later recalled in *The Accidental Adventurer,* "[M]ost of my time was spent being a stay-at-home mother, and I thoroughly enjoyed it."

One day in April, however, with Dotty only a little more than a month old, Brad abruptly said to Barbara, "Surely we are going to be involved in this war. This summer may be our last chance to make a trip to Alaska, maybe forever. So we ought to plan an expedition to get more lecture material."

Though Barbara insists that by 1941, less than half the couple's income came from Brad's salary at the museum, the need for new "lecture material" was pure rationalization. The old Alaska itch had not been tamed in Brad Washburn. The "we," moreover, was categorical: Brad would not think of going off on an expedition that summer and leaving his wife behind.

There is scant evidence that Brad gave a second thought to the problems involved in abandoning a newborn child for several months while he tilted at glaciers in Alaska. But the prospect gave Barbara many an angst-ridden hour (the chapter in *Adventurer* covering these events is titled "Soul-searching"). Barbara pondered staying home, but, as she later wrote, "finally decided I should attempt to share Brad's life as much as possible. If I was going to adhere to that philosophy for the lifetime of our marriage, I knew it would mean making some difficult choices along the way."

Barbara had asked her pediatrician about the wisdom of leaving Dotty behind, but he offered no advice. As she put it in her memoir decades later, "In those days we heard no talk about the importance of bonding."

The question was, with whom could she leave her daughter while

she was in Alaska? "I naively thought my mother would be thrilled to take care of my little baby," Barbara wrote in *Adventurer*. "I was mistaken. My mother said she had just signed up for a course in choral conducting at Tanglewood in western Massachusetts. . . . My mother was not yet sixty and was full of pep, with many interests and talents."

In the end, Dotty was deposited with Brad's parents, who were going to spend the summer at their seasonal cottage on Squam Lake in New Hampshire. Brad and Barbara hired a nurse to help out. Even so, Barbara would recall, when the automobile bearing her child drove off from Cambridge on June 24, "Seeing Dotty leave was a terrible wrench for me."

Brad's goal for the summer of 1941 was no relatively easy peak such as Sanford or Bertha, but a major challenge: Mt. Hayes, the 13,832-foot apex of the Hayes Range, on which Charlie Houston's team had failed in 1937. The dream of Hayes, originally hatched in Brad's mind in late 1938, had been deferred for two and a half years. This time, he put together a strong party, including Ben Ferris, Sterling Hendricks, and Bill Shand, all of whom would go on to make first ascents of their own in Alaska and Canada. Rounding out the team was Henry Hall, Brad's original HMC mentor, who had participated in the great 1925 first ascent of Mt. Logan. By now, however, Hall was forty-six years old and past his prime—a condition that would make itself evident on the mountain.

One of the biggest obstacles to climbing Hayes was access. No road ran anywhere near the mountain, and the glaciers surrounding it were either too steep or too riddled with crevasses to permit a bush plane landing. But Brad knew of a gravel bar eleven miles northeast of Hayes on which pilots had landed big-game hunters. When Johnny Lynn, a canny aviator out of Fairbanks, flew over the gravel bar with Brad, Barbara, and a first load of gear, all three saw at once that braiding rivulets had carved deep gouges in the makeshift strip, rendering it unusable.

The pilot circled and circled, looking for an alternative, then found an even cruder strip on the edge of the Dry Delta River that a pair of prospectors had recently leveled. The strip was 1,200 feet long, but only 30 feet wide, and the plane had to land downhill. On each successive touchdown, Lynn came to a stop with his wingtips overhanging dense alder bushes at the end of the strip.

Brad had planned from the start to supplement the approach with an airdrop. Leaving Hall and Hendricks in Fairbanks to supervise the packaging, the other climbers spent two days hiking at top speed ten miles across a muskeg plateau (a squishy, ankle-twisting trudge), then three miles across the snout of the Hayes Glacier, to a tundra bench at 4,900 feet that would serve as base camp. On July 17, Lynn dropped 200-pound boxes from an altitude of 250 feet, each gentled by a parachute. The airdrop worked to perfection. By July 20, the whole team was ensconced in base camp, ready to start up the mountain's soaring northwest ridge. The only thing dampening the party's spirits was the omnipresent hordes of mosquitoes, some of the thickest Brad had ever seen in Alaska.

With few level spots on the ridge, Brad was determined to place a second camp on a snow shoulder at 8,350 feet. This meant a grueling climb with heavy packs, gaining 3,450 feet in a single day.

Barbara took this challenge in stride. As she would write in *Adventurer,* "We climbed a long gully with horribly loose rocks until we reached snow. It took us about four hours to reach the site of the advanced camp, and I was the first to get there—surprised by my own stamina." The climbers spent most of a week, with pauses for bad weather, ferrying loads up that steep gauntlet, until on July 25, all six were camped at "advance base" on the snow shoulder at 8,350 feet.

A long, almost horizontal ridge stretching ahead promised easier going, but from camp the members could see the razor-sharp final knife-edge that crowned Hayes's northwest ridge. It was obvious that

the crux of the climb would come way up there, less than a thousand feet below the summit.

Brad felt that one more camp, pitched at the end of the long horizontal ridge, would position the team for a summit bid. More ferrying of loads ensued, in often bitter conditions, with temperatures in the twenties and blistering wind. One night it snowed twenty-four inches. But by July 28, the "Notch Camp" was erected at 9,500 feet. The team had three days' food stocked in their tents, and a cache only 500 feet lower that contained six additional days' provisions. It was just above Notch Camp that Houston's party had turned back in 1937.

The diary Brad faithfully kept on Mt. Hayes followed a rigid formula. Each evening entry started with a weather report. Thus on July 27: "9 AM 35° (fog + light snow) // 10—48° fog + sun // 8 P.M. 22° hard, fine snow." And every entry ended with an encomium on that night's dinner: "We are mopping up the last dripping pools after a huge supper of ham with raisin sauce, beets, potato + strawberry jam."

Barbara would recall in her memoir how she distracted herself on Hayes from the relentless ordeal of carrying heavy packs through loose, deep snow:

> I went through mental exercises, planning make-believe dinner parties. I worked out the menus and decided which interesting people would come and who would sit next to whom. Being very practical, I did not imagine inviting famous people, just professors we knew back home in Massachusetts.

Despite the vagaries of the weather, the party had progressed up the mountain with marvelous efficiency. Notch Camp had been pitched only two weeks after the first landing on the prospectors' airstrip far below and to the north.

On July 29, the team made its first summit attempt. That Brad could

occasionally yield decision making to his teammates is revealed in a characteristic I-told-you-so diary entry that evening:

> Much against Barbara's + my wishes + advice, the whole party tried the mtn. today, despite a stiff SW wind + deep fresh snow—camp wasn't established properly and we hadn't even had a chance to pack our meat up from the cache. . . . We struggled for 6 hours through deep drifted snow without willow wands, pickets or fixed ropes + finally quit right at the base of the summit cone at 13,000 feet. Henry completely pooed out about 200 yards back on the ridge.

Turning back, Brad wrote, was "a wise decision, because the whole peak was swept by a storm as we reached camp + we surely would have got caught in it on the worst part of the ridge." Yet he sized up the serpentine crux that loomed beyond more with zest than apprehension: "The ridge between the 13000 shoulder + the top is superb—sharp as a knife + with magnificent cornices all along it."

As Barbara remembered that day's effort decades later,

> Henry, on the rope with me and Brad, complained that we were going too fast. Brad said we would have to move even faster or turn back because of an approaching storm. Henry said he couldn't go any faster, so Sterling took him on his rope. . . .
>
> I was really frightened by the idea of a storm blowing in and forcing us to make a dash to camp for safety. . . . After making a little more progress, we had another discussion, and we all agreed we should turn back. The clouds were piling up rapidly. It was a bitter disappointment to give up when the summit seemed so near.

Three days later, on August 1, the team made its second summit attempt—all except for Henry Hall, who decided to stay in camp. As

Barbara put it, Henry "didn't feel he could go—it just wasn't his day."
(Brad's diary indicates that Henry had worn himself out on the previ-
ous attempt.) Departing at 6:30 A.M., the five climbers moved much
faster than they had on July 29, for the steps they had kicked in the
snow three days earlier were frozen and stable. Conditions were far
from perfect, as a stiff wind whipped across the ridge and clouds ob-
scuring the summit alternated with sunbursts. The temperature was
18° Fahrenheit.

Around 11:00 A.M., the team reached the start of the wildly billow-
ing knife-edged crux. And now they made an extraordinary decision:
they asked Barbara to take the lead.

As she would explain in her memoir, with characteristic self-
effacement,

> The difficult ridge required all of our attention. As we approached
> a cornice I was told, "All right, Barbara, you go first because you're
> so light."
>
> They put me first on the rope to test the cornices along the
> ridge, figuring that if I fell because the overhanging snow of the
> cornices collapsed, they could hold me easily on the rope with
> their strength and weight.

This is surely less than half the story. The crux pitches on a moun-
tain such as Hayes should have been led by the best climber, which in
this case was Brad. He weighed only about thirty pounds more than
his wife. Could it be that the men were afraid of that delicate tightrope
walk in the sky and made Barbara the guinea pig? Did they believe
their own rationalization about holding her if she fell?

In Alaska, the cornices—wind-blown plumes of snow weighing
as much as several tons that lap over the void like curls of whipped
cream—are notoriously unstable. A single step can break a cornice

loose. And the snow conditions on knife-edged ridges in Alaska are perhaps the worst in the world: their texture typically feels underfoot like rotten, crumbly Styrofoam. Had Barbara slipped off the ridge, or broken loose a cornice or even a chunk of the ridge, she would have taken a long, horrific pendulum fall down the sheer precipice on either the east or the west side. Even held on belay, she might have seriously injured herself, and it would have been no easy matter to get her back up to the ridge.

Barbara did as she was told. In *The Accidental Adventurer* she wrote,

> I tried to appear calm and confident, but I was really trembling with fear as I climbed ahead. This was much more of a climbing challenge than I had faced the previous year on Mount Bertha. But I did not slip and none of the cornices gave way, and everyone followed safely behind me.

At 1:45 P.M., the five climbers stood on top of Mt. Hayes. Shand, Hendricks, and Ferris pulled confetti out of their pockets (they had stolen the stuff on shipboard on the way to Alaska) and threw it into the air as they whooped with joy. "It was like being at a wedding reception," Barbara remembered. The climbers spent an hour on top—"one of the shortest I've ever spent anywhere," Brad wrote in his diary that evening.

In the 1942 *American Alpine Journal,* Brad's "The Ascent of Mount Hayes" won pride of place as the leadoff article, hailing what the editor judged to be the finest achievement in American mountaineering during the previous year. It is significant that Brad completely obfuscates the fact that Barbara led the knife-edged crux. In the article, an unspecified "we" accomplishes that deed.

Many decades later, Brad would say that that knife-edge traverse

was probably the hardest bit of technical climbing he ever did in Alaska. Perhaps it was simply too unflattering to his ego to acknowledge that he had turned the crux lead over to his wife, the mother of his now five-month-old daughter, and a mountaineer with only a little more than a year's experience under her belt.

The second ascent of Mt. Hayes did not come for another forty-three years. In 1984, a strong American team climbed a different route, but descended the northwest ridge. In *Climbing* magazine, Geoff Radford, an immensely gifted mountaineer who had tackled such formidable peaks as Gasherbrum IV in the Karakoram, wrote that as his party headed down the Washburn route, its members figured that anything accomplished way back in 1941, with the primitive equipment and rudimentary technique of the day, would be a piece of cake for strong climbers in 1984.

But on Barbara's knife-edge, Radford wrote, "The climbing was delicate, nerve-wracking, extremely exposed, and very difficult to protect." Radford tipped his cap to the pioneers: "It's clear that the first ascent was a 'classic'—in its style and simplicity and ultimate success."

With the bombing of Pearl Harbor four months later, the United States plunged into World War II. Even before that momentous event, however, Brad was approached in late September by an army colonel who asked him to serve as a consultant on cold-weather equipment. Anticipating war, the government had duly taken note of the ravages that had occurred in the Russian invasion of Finland in November 1939, as large numbers of soldiers suffered severe frostbite or froze to death. The armed forces fully anticipated fighting the Germans in Iceland or Greenland, and after Pearl Harbor, it was clear that a battlefront against the Japanese would take place in Alaska.

Brad's good friends from the HMC, Bob Bates and Ad Carter, were

likewise conscripted as cold-weather experts. (Ad's fluency in foreign languages would be vital in providing quick translations of many a European document.) Other climbers signed on for the effort included Bill House, veteran of the 1938 K2 expedition, and Walter Wood, Bates and Washburn's former rival for Lucania. Eventually the elite consulting group would also embrace the famous polar explorers Sir Hubert Wilkins and Vilhjalmur Stefansson, as well as sixty-eight-year-old Leon Leonwood Bean, who way back in 1912 had founded the outdoor equipment company L.L. Bean.

By the beginning of 1942, Barbara was pregnant with her second child, a boy who would be christened Edward Hall Washburn, but nicknamed "Teddy" or "Ted." Brad accepted his new role as consultant to the army, took a leave of absence from the New England Museum, and moved to Washington to serve in the Office of the Quartermaster General. Barbara and Dotty abandoned the family's Commonwealth Avenue apartment and moved back in with her mother in West Roxbury. (Barbara's father had died shortly before.)

As Barbara would write in *The Accidental Adventurer,*

> Brad was given a short leave to come home for the birth, but Ted was stubborn and arrived three weeks late. Brad had to return before the birth. Ted was born on September 25, 1942, and weighed over nine pounds. In those days you were given pain medicine that made you lose control of your behavior, and this was a delivery I didn't forget in a hurry. The doctor told me he was shocked to hear such foul language coming from such a refined little lady. I explained to him later that I had been taught the language so I could drive a dog team effectively in Alaska!

For Barbara, the onset of the war would trigger the dreariest and loneliest stretch of time she would ever endure, as Brad "pretty much

disappeared from my life for the next three and a half years." Brad, however, plunged into his new duties with his characteristic zest and energy. And despite his fear in the spring of 1941 that he might never again be able to climb in Alaska, he leveraged his consulting role to promote a boondoggle of a mountaineering expedition to his favorite wilderness.

By the time Brad recalled these years in 2005, he had convinced himself that the army ordered him to organize an expedition to Mt. McKinley to test equipment. "To be honest," he told Lew Freedman, "we didn't need to test a damn thing on the trip to Mount McKinley in 1942. We all knew what would work and what wouldn't, but the Army insisted that there be an actual cold-weather test made by the Army itself."

Bob Bates remembered the chain of events differently. In his autobiography, *The Love of Mountains Is Best,* Bates insisted that the climbers in the consulting group convinced the colonel in charge that a testing expedition would be the ideal way to experiment with different kinds of clothing, footwear, food, stoves, and tents. It was not a hard sell. Wrote Bates in 1994,

> The first question was where the tests should be held. Walter Wood and I had discussed testing in the Yukon area we knew well, but Brad Washburn urged Mt. McKinley, and we soon saw that he was right.

It might seem curious that before 1942, on ten separate expeditions to Alaska and the Yukon, Brad had never showed any interest in climbing Mt. McKinley (this despite having the NGS sponsor his aerial photography of the mountain in 1936). The reason, however, was simple: McKinley had already been climbed—while Lucania, Hayes, Crillon, and the other peaks Brad tackled had not. As recounted in Chapter 2,

a fierce competition to reach the highest point in North America had launched eleven expeditions in the early years of the twentieth century, culminating in the first ascent by the party led by Archdeacon Hudson Stuck in 1913.

For nineteen years after that triumph, however, no one attempted McKinley. Then, in 1932, by sheer coincidence, two expeditions independently went after the prize. The first, a four-man team led by Alfred Lindley and Harry Liek, followed the same route as Stuck's party had, up the Muldrow Glacier from the northeast, along Karstens Ridge, onto the Harper Glacier, then from Denali Pass to the summit. The party's innovation, however, was to wear skis most of the way up the mountain. Without incident, all four men topped out on May 7.

While the Lindley-Liek party was high on McKinley, a five-man team led by Allen Carpé made another innovative approach, as pilot Joe Crosson brought the party in to the Muldrow Glacier at 5,700 feet, accomplishing the world's first mountain ski landing. With his first ascents of Mt. Logan and Mt. Fairweather, Carpé was probably the outstanding big-range mountaineer in the United States at the time. The rest of the team, however, was quite weak, with only Theodore Koven, a Sierra Club member, up to the challenge. On Fairweather, moreover, Carpé had terrorized his summit partner, Terry Moore, with his predilection for traveling unroped on crevasse-scored glaciers.

Bob Bates, who knew Lindley and Liek, vividly describes the discovery their party made on the descent:

> The Lindley-Liek team, on returning from the top of Mt. McKinley, found two tents pitched . . . on the upper Muldrow Glacier, but nobody in them. Fresh snow partly covered the only tracks, and the last diary entry had been made the day before. Continuing on down the glacier, they found Koven's body face down in the trail, where he had been trying to get back uphill to his camp. He had a

bruise on his face. They followed his tracks back to a crevasse, into which he and Carpé had apparently fallen, and from which, hurt, he had emerged. Some of the crevasses in the area were more than 200 feet deep, and Carpé's body was never found. The only rope was found at the tents.

After 1932, for another ten years no one attempted McKinley. The logic of Brad's choice of the mountain for the army testing expedition was as simple as the reason he had previously ignored McKinley: in midsummer, its upper regions were the coldest place in North America. (No one said so in the 1940s, but thirty years later, after a number of leading European, British, and Japanese climbers ascended the peak, it became a commonplace to allude to McKinley as "the coldest mountain on Earth.")

Nowadays Denali (as McKinley has been unofficially renamed) is by far the most popular mountain in Alaska. Like Everest, Denali suffers today from a massive trash and garbage problem. Yet in 1942, the apex of North America remained virtually as unexplored as it had been in 1913.

Brad's expeditions before McKinley had been increasingly virtuosic exercises in the fast-and-light style he had invented. The army cold-weather gear-testing experiment would prove quite the opposite, though that summer Brad would demonstrate another kind of virtuosity. No fewer than seventeen members participated in the expedition. The personnel ranged from experienced climbers to a dog musher, a cook, and various military officials. The "commanding officer" of the expedition was one Lieutenant Colonel Frank Marchman, who had no climbing experience. As a bachelor, Bob Bates had been conscripted into the army, while Brad, as a married father of two small children, was allowed to remain a civilian throughout the war years. Bates was thus appointed the official climbing leader, though as the expedition unfurled, Brad became the de facto director of the show.

The expedition also served as a happy reunion for some of Brad's chums from other Alaskan ventures. Besides Bob Bates, Terry Moore, Sterling Hendricks, and Peter Gabriel (the Swiss guide from the Marcus Baker expedition) were aboard. Walter Wood, who might have relished the chance to climb with the man who had aced him out of the first ascent of Lucania, was instead delegated to stay in Anchorage, where he directed radio contact with the climbers and supervised the packing of gear to be airdropped to them on the mountain.

The raison d'être of the trip was gear testing, not ascent. The members planned to climb to 18,000 feet on the Harper Glacier, just below Dcnali Pass, and camp there for weeks as they put the gear through the most rigorous possible trials by storm, wind, and sun. As Bob Bates recalled, "We had some 30 items to test, mostly clothing and equipment but also a mountain ration, cold-water soap, and such experimental medical issues as Chapsticks and paper underwear."

Even before the climbers got on the mountain, Brad and Walter Wood had supervised the airdropping (with parachutes) of massive amounts of gear to the shelf at 18,000 feet. Most of the climbers started overland from Wonder Lake on June 20. Taking their sweet time, testing away, the best climbers slowly advanced up the Muldrow route, establishing a series of camps. By early July, Brad had led the first party of four to top Karstens Ridge and break through to the Harper Glacier plateau. Just below Denali Pass, as he told Lew Freedman decades later,

> I noticed a little lump in the snow with a dark end, a hundred yards
> to our left. It was a "delivery unit." We cut the top open and brought
> out dried food, cigarettes, bacon, cocoa, macaroni, candy, fifteen
> pounds of sugar, and five pounds of flour.

The gasoline container, however, that had been air-dropped so the men could fire up stoves and convert the dried food into dinner was nowhere to be found.

In the end, Brad spent three weeks at 18,000 feet or higher—by far the longest anyone had ever lived at such an altitude in North America. With the summit so near at hand, it seemed a crime not to go for the third ascent. It was not until July 22, a perfectly clear day, that Brad, Bob Bates, Terry Moore, and Einar Nilsson got the order from Colonel Marchman over the radio from base camp: "McKinley will be climbed today!" Perfectly acclimatized by now, the men marched easily up the final 2,000 feet, reaching the top at 4:00 P.M. There they shook hands, hugged, and took pictures of each other holding an American flag— backward, as it turned out, because, as Bates pointed out, it looked the right way to the men grasping it. The next day, three more climbers topped out.

At the time, it would have seemed unlikely to both Bob and Brad, but McKinley in 1942 was the last expedition these best friends ever shared.

Back at base camp, the expedition cook celebrated the success by baking 118 doughnuts. By early August the entire team was back in "civilization."

In one sense, the whole McKinley trip had been an extravaganza of military overkill. Yet at the same time, for the climbers, it had been something of a lark. While other Americans were dying in the trenches of Europe or getting shot out of the sky over the Pacific, it was a joy for old friends to camp and climb and hang out and gossip on one of the finest mountains in the world.

As for whether the expedition accomplished its purpose, well. . . . Ever the good soldier, Bob Bates would write half a century later:

> We had given our clothing and equipment the most thorough arctic and mountain testing it could find in North America, and when we all gathered at base camp some days later, every man wrote his own evaluation of every item of equipment he had used. We had

tested and photographed every item sent to us, including the paper underwear. . . .

Even before McKinley, as a special consultant to the Army Air Corps, Brad had been scandalized by the shoddy equipment that was routinely issued to soldiers in combat. Throughout the war years, he would shuttle among Washington, D. C., Wright Field in Dayton, Ohio, and Alaska. Since much of his work was top secret, Barbara not only had only the vaguest sense of what he was doing, but for weeks at a time she did not know where he was.

Shortly after Ted was born, Barbara found a $75-a-month apartment on Brattle Street in Cambridge, into which she moved with her two small children. At one point in the early 1940s, when Brad thought he might be more or less permanently stationed in Dayton, he invited Barbara and the kids to come and move into a little house that had been provided for him. But, as Barbara recalled in 2008, "He kept going away to one place or another, so I just picked up and came home."

If the war years were lonely for Barbara, they would amount to the most intensely frustrating period of Brad's whole career. Throughout most of that time, he focused his work on improving gear and clothing for aviators. Already, by 1942, thanks to leaky, unheated aircraft and bad gloves, boots, and flying suits, pilots on bombing missions over Europe or even simply ferrying planes to Alaska were suffering bad cases of frostbite.

No one in America knew more about travel and survival in arctic conditions than Brad. Unfortunately, the collective wisdom of the armed forces on such matters fell just this side of sheer ignorance. Aviators, for instance, were issued twenty-eight-pound sleeping bags as survival gear. The bags were certainly warm enough, but as Brad pointed out, if a pilot made a forced landing in a northern wilderness and had to hike out, the weight of the bag could prove a fatal liability.

Not content to base his critiques solely on his own opinions, Brad interviewed dozens of pilots in Alaska immediately after coming off McKinley. His report to his superiors quoted verbatim from their scathing remarks (without identifying the complainers). A sample:

"I am not in favor of using shearling for underlined anything." [Shearling, the wool from young lambs, was the chief substance in the makeup of the flying suits.]

"Shearling clothes are O.K. only when you're sitting motionless."

"I walked 7 miles at Pt. Barrow in the Army flying outfit. I had to take off my pants and carry them."

"Our rotten clothing forces us to descend right into the anti-aircraft [zone] or we can't do our job."

"When you have all this stuff on it is such a damned mess you can't do anything."

"We'd a lot rather suffer cold and discomfort than be inefficient and shot dead."

When virtually none of his recommendations was acted upon, Brad responded at first with indignation, then with fury. It was a good thing he remained a civilian, for his reports were so bluntly critical that they might have led to a court-martial for an enlisted man. Even so, Brad could have been fired from his consulting job, had such august fellow experts as Vilhjalmur Stefansson not consistently gone to bat for his conclusions.

Some of Brad's work focused on issues other than clothing. A report

titled "Negro Troops in Arctic Regions" overturned some of the racist thinking of the day. Brad concluded that black soldiers were every bit as good as white men at withstanding extreme cold. Yet, "The morale of negro units in the North is seriously impaired, as they cannot mingle with friends or relatives when on leave. Certain Arctic towns have publicly discouraged or forbidden the appearance of negroes on the streets."

In March 1943, Brad marshaled all his frustration into a comprehensive report intended to dislodge the bureaucratic inertia of the Army Air Corps. Its last paragraph rises to genuine outrage:

> My sole interest in this entire mess has been to get the right sort of clothing to our men in cold regions. While the Air Corps have been haggling and avoiding responsibility for fourteen months, the Quartermaster has been doing everything in his power to develop the right sort of stuff and get it into the field. A group of men should be chosen to take control of this mess at Wright Field who are interested in production and distribution to the fighting fronts rather than in politics, corruption and rank.

Somehow Brad got hold of—and kept the rest of his life—the note his immediate supervisor scribbled to an aide, as he rejected Brad's report: "Do not concur with the almost vituperative criticism expressed. Believe this will do more harm than good if released in its present form."

The nadir of Brad's war service came during the more than seven months at the end of 1943 and the beginning of 1944 that he spent at Wright Field, where the Clothing and Equipment Division of the Army Air Corps was headquartered. The boss of this unit was General Bennett E. ("Bennie") Meyers, widely regarded as one of the ablest officers in the armed forces. But Brad began to suspect that Meyers was

engaging in outright fraud, as he sublet contracts to gear and cloth-ing manufacturers that were semicompetent, but appeared to have an altogether too cozy relationship with Meyers. Blunt as ever, Brad claimed in his confidential reports at Wright Field that the Procure-ment Division was "letting contracts to unqualified manufacturers" and engaging in "unscrupulous sub-contracting to even lower-grade manufacturers."

One day during the period Barbara and the children were living with Brad in Dayton, the family was dumbfounded to receive a gift, ap-parently from some higher-up in the Air Corps. As Barbara recalls, "It was a very expensive doll. Dotty loved it, but Brad said we had to give it back. He suspected he was being set up." As Brad told biographer Michael Sfraga about this period, his Wright Field bosses "were doing everything they could to trip me up and I'm sure that they ransacked my room occasionally."

A less stubborn man, or one less confident in the absolute right-ness of his judgments, might have given up his reform efforts at this point. Instead, Brad redoubled them. Reports of terrible frostbite suf-fered by American pilots in Europe had filtered back to Wright Field. Loyal Davis, who served as a consultant to the Neurological Survey, managed to photograph scores of aviators' gangrenous and blackened hands and feet, as well as amputated toes and fingers.

As Barbara remembers, Brad started smuggling reports and photos wrapped in newspaper out of the Wright Field offices and into his house. "He was terrified," she recalls. "He would have lost his job if they found out."

With another civilian consultant of like mind, Brad bypassed the whole chain of command in which he was embedded. Through an acquaintance named Grace Tully, Franklin D. Roosevelt's personal secretary, Brad got some of the photos and his anonymously penned "Report on A.A.F. Material Center, Wright Field" onto the president's

desk. FDR acted immediately. Through the rest of the war, thanks to the president's intercession with Brad's superior officers, most of his recommendations were carried out. The gear and clothing were revolutionized, and the incidence of frostbite plunged dramatically.

Brad's ultimate vindication came two years after the war ended. General Bennie Meyers had retired in 1945, but what turned out to be a career riddled with corruption and fraud finally caught up to him. In its December 1, 1947, issue, *Time* magazine announced,

> The U.S. people last week watched an extraordinary and absorb
> ing spectacle—the public disgrace of a U.S. Army general. Never
> in modern times had a high officer suffered such dishonor, seldom
> had one brought more upon himself and his service than did stiff-
> backed, sharp-eyed Major General Bennett E. Meyers.

Among the charges against Meyers was that he subcontracted much of the Air Corps's work to a firm called Aviation Electric Corp., of which he was the covert owner. Over the years, Meyers made $140,000 of personal profit out of the corporation. To cover his tracks, he bribed a number of "stooges" (*Time*'s word) with feather-bed jobs at generous salaries, including his secretary's husband, the husband's brother, and his wife's father, who had spent the previous sixteen years as a bus driver. All the transactions were carried out in cash—usually $1,000 bills. Wrote *Time* of Meyers: "He was a man of cheap little schemes who hid behind cheaply bought dupes while he enriched himself."

At the Senate investigation, Meyers further disgraced himself by inexplicably confessing that the secretary had been his longtime mistress, with her husband's "knowledge, approval and acquiescence." An outraged senator cried, "Isn't it a greater disgrace to do what you say you did than what they say you did?"

The granting of contracts to shoddy manufacturing companies of which Brad had bitterly complained had thus been simply a part of Meyers's flagrant but well-camouflaged pattern of fraud throughout the war. The doll for Dotty had been one more cheap attempt at bribery or potential blackmail. Four months after the Senate investigation, declining to defend himself against charges of perjury, Bennie Meyers was sentenced to twenty months to five years in prison.

Brad's letters from the 1930s are scattered to the winds. But from 1942 through 1945, while he was so much apart from Barbara, he wrote his wife often. Though Barbara's letters back to Brad have apparently not survived, he kept his own epistles to her. They offer a surprisingly intimate insight into the ordeal of the war years.

The letters, of course, are full of gripes about having to work with colleagues Brad disliked or thought only marginally competent:

> It's _hell_ writing a report with a sociology professor (McKennon) + a doctor (Foster)—they insist that every sentence + _word_ be weighed as to its grammatical use + proper choice + sometimes they take 10 or 15 minutes deciding whether to put an adverb before or after a verb! . . .
> Foster + McKennon are of little real social fun around here because their main joy in life is loading up with liquor + [the] group that they enjoy is of no interest at all—some people seem to be unable to enjoy anything unless they are at least half-pickled.

In December 1944, to simulate the plight of downed aviators in winter, Brad camped out with three other men in the bitter cold of the Muldrow Glacier on Mt. McKinley. He wrote Barbara:

> Bob Sharp is the best man I have ever _been in the field with_. . . . The 2 other fellows are nonentities: the major a goddamn loafer who is

*as conceited and selfish as he is young—the lieutenant a good sport
but in misery from the cold all the time.*

Insofar as he could share with Barbara the substance of his often
secret work, Brad veered between optimism and disgust. In February
1945, after FDR's intervention,

*This afternoon we received word from Washington that our Alaskan
report has <u>really produced results</u>—the Air Staff are going behind
Sharp + my recommendations for changing the whole theory of AAF
emergency equipment, <u>not only in Alaska but all over the world!</u>*

But a year or two earlier (the letter bears only "June 14" for date)—
and perhaps presciently:

*I hear that Bennie Meyers is now on the skids—that would be
terrific news + I scarcely dare think anything so good would happen!
I wonder if they'll get that old bastard Sims at last. That would be
real justice if they went down the slide together. Belsen + Dachau
would be lenient treatment for that scheming son of a bitch!*

More surprising in the letters is the unabashed expression of his
love for Barbara and the children. In taking off with Barbara for Mt.
Hayes when Dotty was less than four months old, Brad might have ap-
peared to be a distant father more interested in climbing than family.
Yet during the war years, especially toward the end, in Alaska, he
missed his children badly.

*Your letter about Dotsy and you sitting alone looking at the ocean was
horrible. I wish to God that we could all get together somewhere soon.
 It's hard to believe that I have never been with Teddy on
Christmas. [Written from Fairbanks on December 25, 1944.]*

He missed Barbara every bit as keenly as he did his children.

I'm <u>groaning</u> for a letter from you, as I haven't heard for simply weeks.
 I think of you <u>constantly</u>. For some reason this seems to be our
longest separation.
 I never felt bluer than I do tonight.
 I tried to get you a very pretty pair of ear-rings, but they are all
made for pierced ears which seem to be the rage now, + I didn't want
to see your pretty little ears defiled!

Sometimes in his letters to Barbara he passed on corny jokes or
bits of salacious gossip.

Remember the definition of a sourdough = a guy who's _____ a squaw,
killed a bear + p'd in the Yukon!

 [From some Alaskan village]: The WACS have come here at
last, 150 strong, in a beautiful new barracks. The price of the local
brothels has dropped from $5 to $3!

Brad invariably addressed Barbara as "Darling" or "Sweetheart,"
and typically signed off with some variation of the following:

<u>All my love to you all</u>. A <u>kiss</u> to Dotsy, Teddy + 3 to you—

Your
Turtle.

"Turtle" had become Brad's private nickname of endearment, and
he spun riffs on it in his closings, such as

Your one and only
fertile turtle

Or:

All my love [typed]
Turtle [signed in ink]
H. Turtilius Washburn [typed].

Brad missed Barbara's company in bed, too, for he sometimes closed a note with "Your sexual husband." But he was capable of writing a genuine love letter, as on January 3, 1945, from Fairbanks:

I read a long article on marriage in a magazine the other day and as far as I can make out we are destined to live together till they nail us in pine boxes unless the war has ill effects on our mental balance! . . .

It's wonderful to hear that you're in love with me. You never can write enough of those cute wee little letters because I'm in love with you every second, and I just can't wait to get my arms around you and not let you go for a long long time.

The wartime letters also reveal a pair of nagging anxieties about which, when asked in 2008, Barbara had no recollection. Apparently Brad thought that his prolonged absence from the New England Museum might result in his dismissal as director. In one undated letter, he lamented, "If I was released I really would scarcely know what to do." In another, he pleaded with Barbara to ask Terry Moore (who was a museum trustee) to write a letter on Brad's behalf. And at some point, he alluded cryptically to "Kasper's offer," which apparently involved "becom[ing] a sporting-good merchandiser full time" in New York City. (In retrospect, it is almost impossible to imagine Brad Washburn hawking fishing gear or Coleman stoves out of a Manhattan store.)

The other source of anxiety was the fear that despite his service as a consultant to the Army Air Corps, he might still get drafted after the

war was over. On April 23, 1945, he wrote Barbara, "I certainly don't want to get out of the A.T.S.C. [Army Training Support Center] + then have the draft send me to China!" In another letter, he asked Barbara to see if she could get Terry Moore to "intervene in my draft situation." (How Moore might have done so remains unclear.)

In the end, Brad would never serve in the armed forces. But in 1946, he was decorated by the secretary of war for "exceptional civilian service."

Before the war ended, Brad managed to parlay his field-testing junkets into two more Alaskan first ascents. Between March and May 1945, with several companions—including Norman Bright, Brad's teammate from Marcus Baker and Lucania—Brad hung out on the glaciers north and east of Mt. McKinley. In April, he led the climb up a graceful but easy snow pyramid that he named Mt. Silverthrone. At 13,220 feet, the peak is the fifth highest in the Alaska Range. But its "conquest" was so routine that Brad and his cronies spent four days on the summit, testing gear they already knew to be perfectly adequate for the job. From the summit on April 23, Brad wrote Barbara a letter crowing about his team's success, as he observed that during the four days above 13,000 feet, the warmest temperature the men had recorded was 4° Fahrenheit. But in the next breath he ruefully noted that his and Barbara's fifth wedding anniversary was only four days away—"five years of separation," he lamented, thanks to his wartime service.

The first ascent of Mt. Deception had been a more dramatic affair. On September 18, 1944, an Army Air Force C-47 with nineteen crewmen aboard disappeared on what should have been a routine two-hour flight from Anchorage to Fairbanks. A massive air search ensued, and three days later, the wreckage was sighted on a steeply inclined glacier just below the summit of an unnamed 11,000-foot peak in the

Alaska Range. The plane had struck with such force that one engine lay embedded in the slope a full 1,600 feet above the debris of the body of the plane. It was obvious that there were no survivors.

Despite the self-evident difficulty of the mission, the AAF determined to try to retrieve the bodies of the dead soldiers. Grant Pearson, acting superintendent of Mt. McKinley National Park, who had reached North America's highest summit on the 1932 Lindley-Liek expedition, was put in charge. Pearson's team took aerial photos of the crash site and sent them to Brad, who at the time was on his way to Alaska for his late-autumn gear-testing "experiment" on the Muldrow Glacier. (Ironically, Brad's mandate for that foray was to simulate the plight of survivors of a military plane crash in the Alaska wilderness.)

Brad took one look at the photos and wrote in his diary:

An amazing spot—just about as inaccessible as you could possibly imagine. . . . [The pilot] literally hit the peak of the mountain. If he'd have been a few hundred yards either way he'd have missed it completely. One could probably reach it, but oh what a climb it would be.

Meanwhile, the AAF, failing to comprehend the danger and delicacy of the retrieval effort, launched an absurdly bottom-heavy overland expedition from Wonder Lake, deploying huge snow tractors just to get to the base of the unnamed mountain. It was not until November 1 that Pearson formally invited Brad to join the search. Brad had seen at once that the only feasible way to get to the crash site was to climb *over* the unnamed mountain from the opposite side to gain a high col just above the debris.

It was not Brad's nature simply to join someone else's expedition, and by November 5, he was effectively in charge. On that day, he and Pearson and six soldiers reached the col, some 500 feet below the top

of the peak. The slope beneath them leading to the wreckage was a natural avalanche trap. Only after Brad had fixed more than a thousand feet of fixed ropes could a few men gingerly descend to the crash site.

The violence of the impact was intensely vivid to these witnesses. By now, Brad had long since realized there would be no possibility of retrieving bodies. But after two days of intensive searching, including digging a tunnel through the snow ten feet below the fuselage, the men had found bloodstains but not a single body part—only such bizarre artifacts as an intact bottle of Scotch, a box of chocolates, and a carton of chewing gum.

Pearson called off the mission. On their last trip back up to the col, Brad and Jim Gale (who would later join him on Mt. McKinley) were seized with summit fever. Rounding up the last remaining members of the mission, a private and a sergeant with no climbing experience, Washburn and Gale trudged up the easy slope to the top of the previously unclimbed peak. As Brad rationalized in his diary, "We figured that the Army would not mind our taking a 45-minute leave of absence for this little side trip, now that our jobs were done."

Pearson wanted to name the peak Mt. Furlough, recognizing that fifteen of the nineteen servicemen were heading home for furlough when they died. Brad recommended Mt. Deception, in homage to the mysteries surrounding the cause of the crash. As usual, Brad's choice prevailed. Sixty-four years later, Mt. Deception remains the icy tomb of the lost soldiers, none of whose bodies has ever been seen again, let alone recovered.

8

Mastery .

In the end, Brad's twin wartime fears about his future—whether he would be drafted into the armed forces after the fighting was over, and whether the New England Museum would dismiss him as director—proved groundless. The country's gratitude for his "exceptional civilian service" exempted him from further duty. With respect to the museum, Brad grabbed the trustees' bull by its collective horns.

In mid-December 1945, he fired off a memo to the trustees. In effect, he castigated the board for not taking a more active role in the museum's welfare and finances. Brad's cardinal demand, which had been formulated back in 1939 as he took the helm of the museum, was to move the institution out of its creaky Back Bay building. He had already found the location for a new structure, as he rode into Boston one day on a commercial flight from New York. Peering out the window as the plane glided over East Cambridge, he saw what he later called "an area that intrigued me." Inquiries revealed that the five-acre patch of land was owned by the State of Massachusetts.

Brad managed at last to badger the trustees into approving the move, and to win a lease from the legislature. As he recalled for Lew Freedman in 2005, one of the committee members put his hand on Brad's shoulder as they walked out of the statehouse. "Young man, you've got what you wanted," the politician gibed. "Now, why the hell do you want that museum looking out over the Boston and Maine freight yards?"

"We're going to look the other direction!" Brad shot back. Which meant a lordly overview of the Charles River Basin. (Once the new building was occupied, Brad claimed the best seat in the house—a southeast corner office on the fifth floor—so that he could take in that sovereign prospect daily.)

Brad also demanded a name change. Against the more conservative trustees' better judgment, the New England Museum of Natural History thus became the Boston Museum of Science. The ace up Brad's sleeve was a job offer from the Rochester (New York) museum, which just after the war had tried to lure him away from Boston. As implicit recognition of his value, the trustees raised his salary from $3,000 a year to a still not quite princely $4,200.

The heroic fund-raising that the trustees had originally promised Brad he wouldn't have to worry about ended up being conducted almost entirely by Brad himself. On December 14, 1949, the cornerstone of the new building was laid.

The eventual success of the Museum of Science owed everything to the building move, but also to Brad's vision of what a museum ought to be. As he told the National Geographic Society's Donald Smith in 2002,

I wanted to touch on all branches of science, not just natural history. I especially wanted to captivate and inspire children, as I had my own and knew what worked for them. Too many museums had a look-but-don't-touch policy. At our museum children would be able to pet a porcupine, play in a locomotive, sit in a model of a real spacecraft.

On any given day in 2009, a visitor to the Museum of Science bears witness to the fulfillment of Brad's dream, as he or she dodges hundreds of joyously shrieking schoolchildren running from one exhibit to the next. (Whether the visitor will actually behold a child petting a porcupine, however, is doubtful.)

In 2004, biographer Michael Sfraga compiled statistics that documented the museum's bold leap into the late twentieth century. The 1939 budget of the New England Museum was $32,000. When Brad retired as director in 1980, the annual budget of the Museum of Science was $3,500,000. In 1940, only 35,000 visitors trod the antiquated Back Bay halls, despite the museum's free admission. The 1980 visitation count was one million. During his forty-one years as director, Brad single-handedly raised $45,000,000 for everything from physical plant to exhibits.

Late in life, Brad often vowed that if he were to be remembered for only one accomplishment, he would like that to be his directorship of the Museum of Science. In some private calculus, those decades of ceaseless toil outweighed all his deeds as mountaineer, explorer, photographer, and mapmaker. Yet generation after generation of younger adventurers will continue to dispute that self-assessment. As marvelous an institution as the Museum of Science is today, it cannot stir the blood the way the mere retelling of Brad's boldest exploits in the Far North inevitably does.

After Japan's surrender in August 1945, Brad came home to Cambridge, where he, Barbara, Dotty, and Ted took up residence in the cozy Brattle Street apartment. A third child, Betsy, was born on June 21, 1946.

With America's entry into the war looming in the spring of 1941, Brad had organized his expedition to Mt. Hayes partly in fear that he would never get to climb in Alaska again. Indeed, the war had virtually

shut down mountaineering worldwide, not only in Alaska but in the Himalaya and even the Alps. With peacetime came a new frenzy of mountaineering ambition, in which Brad would play a pivotal role.

The incentive for Brad's first postwar expedition came, however, from an unlikely source. In 1945, James Ramsey Ullman had published a novel called *The White Tower*. A mountaineering melodrama, the book posits an unclimbed face on a virtually Himalayan-scale mountain in the middle of the Alps. The war is still raging, but in neutral Switzerland an international team assembles to tackle the peak. The roster mongers all the ethnic stereotypes the war had stirred up: the cruel, stoic German Nazi, determined to bag the peak solo; the romantic, alcoholic Frenchman; the doughty Brit (based on Noel Odell) who had caught the last sight of Mallory and Irvine on Everest in 1924; the precocious and beautiful Austrian woman who has fled her husband when she learns that he has become a Nazi; the crusty but cautious Swiss guide, whose father had died on the mountain; and of course the brave and guileless American bomber pilot who has bailed out over Switzerland, and who in the end gets both the summit and the girl.

The novel was a runaway bestseller. By 1946, RKO Pictures had taken an option on the book. The studio, however, was aware that mountain climbing remained for most Americans an arcane, poorly understood pastime. Both to increase public awareness of the "sport," and as a kind of documentary dry run testing camera equipment in alpine conditions, RKO decided to sponsor a filmmaking expedition to Mt. Everest. In November 1946, a studio executive flew to Boston to ask Brad to lead the expedition.

Brad pointed out that much as he had always yearned to have a crack at Everest, it was now impossible, because during the immediate postwar years both Tibet and Nepal were closed to foreigners. (The first postwar expedition to Everest—a reconnaissance of the then-unknown southern approach through Nepal—would not take

place until 1950.) Brad suggested that RKO shift its attention to Mt. McKinley. The studio bit.

Thus was launched Operation White Tower, the most extravagant boondoggle of Brad's mountaineering career. No fast-and-light shoe-string effort of the sort that had claimed Lucania, Sanford, and Hayes, McKinley in 1947 was almost an exercise in overkill. Brad put together a team of thirteen climbers who, thanks to massive air and overland support, could dawdle their way up the Muldrow route through the spring and early summer months.

As Barbara recalled the turn of events in *The Accidental Adventurer,*

> Initially my heart sank at this news because I knew it meant Brad
> would surely disappear from our lives again, just as the children
> were getting to know him after his absence during World War II.
> Then, very quickly, it became apparent that Brad wanted me to be
> a part of the expedition.

At first, the mountain had no appeal for Barbara. "Brad had already told me many times," she would write, "after his Army expedition of 1942 just how cold a place Mount McKinley is." Despite her smooth success on Bertha and Hayes, she thought McKinley was beyond her abilities. But the strongest factor disinclining Barbara was the dismal prospect of once more abandoning her small children for months of dangerous adventure in Alaska. By the spring of 1947, Dotty was six years old, Teddy four and a half, and Betsy only nine months.

But Brad—and RKO—were relentless. In Brad's recollection (as told to Lew Freedman), "[W]hen they found out that Barbara might want to go on the climb, they got excited. . . . RKO Pictures said, 'This is marvelous. This will give us more publicity, to have along the first woman who has ever climbed McKinley.'"

The studio went so far as to offer to pay for a nurse to take care of

the children in their parents' absence. Once more, Barbara consulted
a pediatrician, who told her the prolonged disappearance would cause
no lasting damage to the young kids' psyches. "They put a tremen-
dous amount of pressure on me," she later recalled. "After much soul-
searching I gave in."

To lend the expedition a scientific cachet, and to justify yet another
leave from the museum, Brad built a cosmic-ray-detecting component
into the RKO circus. A University of Chicago physicist, Hugo Victoreen,
joined the team. The theory of the day was that because cosmic rays
were far more powerful at high altitudes than at sea level, researchers
needed to go up in balloons or onto lofty mountains to study them.
(Shortly after the 1947 expedition, that mandate was vitiated, as cloud
chambers, first invented in the 1920s, became sophisticated enough to
detect the rays better at sea level than any physicist could in the cold
and wind of Mt. McKinley.)

On March 23, 1947, Brad and Barbara spent their last day in Cam-
bridge at Brad's parents' house. As Barbara wrote that night in her
diary,

> Gave the children supper and tucked them into bed as if tomorrow
> would be just another day. It was very difficult for me, knowing that
> I wouldn't see them for some time. This is probably the most dif-
> ficult decision I will ever have to make, but Brad seems to want so
> much to have me share his experiences, I feel I must.

To shortcut the approach from Wonder Lake, Brad hired a bush
pilot to land the party at 5,700 feet on the Muldrow Glacier. Yet to fa-
cilitate the herculean load-hauling such a multifarious expedition re-
quired, he also hired a champion dog musher, Alaskan Earl Norris, to
drive huskies pulling heavily laden sleds all the way to the head of the
Muldrow at 10,000 feet.

The Birdseye company had donated massive quantities of frozen food to the expedition. Ever eloquent about the joys of camp fare, Brad recalled decades later, "We ate strawberries our first night on the glacier, and the next night had delectable green beans and chicken a la king, with fresh peaches for dessert." And Barbara later recorded another Birdseye-enhanced repast: "We had a delicious dinner that evening of beef and gravy, dehydrated potatoes and frozen peas, topped off with frozen strawberries."

To bolster the publicity effort, RKO assigned an International News Service reporter from Los Angeles to the expedition, despite the fact that the man, Len Shannon, had never before been near a glacier. As Barbara observed, during the first days of the expedition, as the team managed the routine jobs of ferrying loads, Shannon "was sending out stories that we all thought sounded outrageously dramatic. And we told him so in no uncertain terms.

"'Your activities may seem routine to you,'" Shannon rejoined, "'but to the public and to me they are as dramatic as going to the moon.'"

At home in their subarctic playground, the climbers failed to recognize just how freaked out Shannon was on the Muldrow. One day the pilot flew in to evacuate the reporter. As Barbara later recounted,

> Apparently he had sent out a secret SOS, begging to be rescued from our dangerous adventures. The poor fellow, we learned later, hated to fly, hated life on the glacier, and hated the cold. His parting words to us were, "When I get back to Los Angeles, I'm going into the darkest nightclub I can find, smoke a big, black cigar, and never look at snow again."

On April 27, at Camp II at 7,400 feet, Brad and Barbara celebrated their seventh wedding anniversary together. Shortly after that, however, Brad assigned Barbara to the company of other teammates while

he and Jim Gale forged into the lead. Gale brought another innovation to Brad's Alaskan mountaineering, as during the war he had been taught by Inuit (Eskimos) how to build an igloo. In 1947, for the first time, all the high camps on McKinley consisted of stable igloos rather than tents bending and flapping in the wind.

Barbara badly missed her children. On Mother's Day, in a gloomy funk, she went for a solo "walk" all the way up to 12,000 feet. An airdrop at 14,600 feet brought mail, including letters from the kids decorated with "cute drawings" that only made Barbara's heart ache more. By June 1, she had been gone from Cambridge for ten weeks. "In an attempt to bolster my morale," she later wrote, "I spent time picturing the children playing in their sunsuits in our yard back home."

In *The Accidental Adventurer,* Barbara unabashedly dramatized her low moment on McKinley, as, roped between Bill Hackett and Hugo Victoreen, she slipped off Karstens Ridge. The men had no trouble stopping her fall, but she was badly shaken:

> It took a huge amount of effort and willpower to climb back up the slope to Bill and Hugo. I tried to be a good sport about it, to act as if nothing had happened. But I was shattered—not only frightened, but exhausted. . . .
>
> Suddenly I burst into tears. Bill looked down at me, very sympathetically, and said, "Why did you come on this trip, Barbara?" Still sobbing I murmured, "Because Brad wanted me to, and I wanted to be with him." Bill was undone by the tears. A boy never knows what to do when a girl cries.

Barbara and Brad had expected their separation on the mountain to be brief, but in late May, a storm stranded Brad and Jim Gale in an "emergency" igloo hastily built at 15,500 feet. Meanwhile, Barbara, Hugo Victoreen (the cosmic ray scientist), and Bill Hackett were stuck

in Camp IV, at 14,600 feet. The storm lasted nine days without a lull—as long and as violent a tempest as Brad had ever endured in Alaska. Brad and Barbara were in radio contact with each other, and with the remainder of the party lower on the mountain, but the wait took its psychological toll. Barbara's diary entries became clipped expressions of disgust: "A terrible day"; "Another terrible day"; "Worst day yet."

To kill time, Barbara and her tentmates played endless games of "Ghost." As she later wrote, "We often had heated arguments about the correct spelling of a word. I usually stopped the disputes by saying we should check with Brad during our morning radio hookup. We considered him a walking dictionary." (All the more reason to wonder about Barbara's retrospective conclusion that her husband was dyslexic.)

More seriously, Hackett and Victoreen disagreed on moral and political issues. As Barbara recalled, "On interracial marriage, for instance, Hugo was married to a black woman, and Bill was not in favor. I chose to offer Bill a short lecture on tolerance."

Finally the storm blew itself out. The trio struggled up the route in deep, fresh snow. They caught up to Brad and Jim Gale only at Denali Pass, at 18,200 feet. Just short of the pass, Barbara spotted her husband coming down to greet her. "When I realized it really was him," she wrote, "an extra spurt of energy propelled me into his arms, and with tears rolling down my cheeks, I whispered, 'Thank God you're here.'"

One more airdrop arrived before the advance team could go for the summit. Among the vital supplies that RKO planned to drop—not at Denali Pass, but smack on the summit—was, Brad learned by radio, a life-sized doll of Rita Hayworth. That was too much for Brad, who instantly nixed the publicity stunt. But Barbara recalls, "Back in the airport after the expedition, we saw Rita Hayworth standing up in the corner." What the doll might have added to the publicity coup RKO envisioned never became clear.

At Denali Pass, Brad peered long and hard off a steep snow slope to

the west. His aerial photography flights around the mountain, begin-
ning in 1936, had planted the germ of an idea for an alternative route
to the Muldrow. Now, as he appraised glaciers and ridges on which no
human had ever stood, Brad convinced himself that what he would call
the West Buttress would prove to be the shortest, easiest, and safest
route up Mt. McKinley.

At last, on June 6, nine members of the expedition set out for the
summit. By now, Barbara had rounded into such good shape that she
outpaced the men she was roped to. One of them, fifty-year-old Park
Superintendent Grant Pearson, had climbed McKinley in 1932, but now,
fearing that he was overstraining his heart, he turned back at 19,000
feet. Barbara abandoned her plodding teammates and roped up with the
faster climbers, including Brad. At 4:00 P.M., the advance guard reached
the summit. Conditions were bitter—twenty below zero Fahrenheit with
winds gusting to twenty miles an hour—but Brad surveyed obsessively,
using bare fingers on his instruments and lingering for an hour.

Back at Denali Pass, Barbara anticipated a quick descent. But the
next day was Brad's thirty-seventh birthday, and when it dawned clear
and still, he blurted out, "Let's climb the North Peak! We'll never get
such a perfect day again!"

At 19,470 feet, the north summit of McKinley is 850 feet lower than
the south or true summit, but from the upper Harper Glacier, it is
hard to judge which crest is higher. By 1947, the north peak had been
climbed only once, at the culmination of one of the most extraordinary
expeditions in Alaskan history. Way back in 1910, in the midst of the
keen competition to claim the first ascent of North America's highest
mountain, a small group of sourdoughs with no climbing experience
took on the challenge, spurred by a wager in a Fairbanks tavern.

Tough and fearless, these prospectors forged their way smoothly
up the Muldrow route, pioneering virtually all its passages. From a
camp at the radically low altitude of 10,900 feet, three of them set out

to go for the top in a single push on April 1. One man turned back, but the other two forged on. To add to the difficulties, they took turns carrying a fourteen-foot spruce pole that they planned to plant on top, in the vain hope that it could be seen by telescope from Fairbanks, providing proof of their accomplishment. For the same reason, Pete Anderson and Billy Taylor chose the north peak rather than the south, because the latter was not in sight from Fairbanks. At 3:25 P.M., they stood on the sharp northern apex.

Nobody in Fairbanks ever saw the spruce pole, but in 1913, when a member of Hudson Stuck's first ascent party spotted it from only two miles away, the sourdoughs' incredible deed was validated.

Now, on June 7, 1947, Brad and Barbara and four teammates made a routine climb to the north summit. The ascent was far more pleasant than the effort of the day before, because, as Barbara later wrote, "there was no wind, the air was crystal clear, and the view was cloudless as far as the eye could see."

A complete success, the expedition included the first party to claim both summits of McKinley. Brad became the first man to climb the mountain twice, and Barbara the first woman ever. (The second female ascent would not come for another two decades.)

By June 8, the team had been on McKinley for an unprecedented seventy days—a longer stretch than even the 1942 gear-testing expedition had spent on the mountain. Everyone—even Brad—was eager by now to descend the route and go home.

Brad roped up with Barbara to climb down the tricky ice-step ladder on Karstens Ridge. With heavy loads and a storm moving in, the descent turned into the most dangerous episode of the whole expedition. Barbara went first, trying to feel with her boots through new drifted snow for the ice steps chopped weeks before. Belaying her from above, Brad hectored her to hurry.

Besides being hard to find, the steps had been placed awkwardly

far apart for the diminutive Barbara. In *The Accidental Adventurer,* she recalled the ensuing contretemps:

> Once again he told me to hurry and I got very angry. I glared at Brad looking down at me from the crest of the ridge and yelled, "Goddamn the son of a bitch who cut these steps!"
>
> Brad was surprised by my outburst and politely responded that he was the one who cut them. Whereupon I swiftly shouted back with great force, "That goes for you, too!"

That semicomic exchange did not dissolve the real danger of the predicament.

> Brad jerked the rope and shouted to me, "You've simply got to move faster. The storm is approaching rapidly."
>
> I looked at him, fifteen feet away, and said calmly, "I am the mother of three small children and I've got to get down from here safely."
>
> He replied immediately, "Don't forget, I'm the father of those small children and I want to get down safely, too."

It was not until mid-July that Brad and Barbara returned to Cambridge. Wrote Barbara:

> As we approached the front steps, my heart began to pound, and when the door opened and I heard the shrieks of joy from the children, I simply couldn't hold back the tears.
>
> Dotty and Teddy grabbed us by the hand and dragged us to see the model of Mount McKinley they had built out of a pile of books covered with a snow-white sheet. Betsy was in a playpen nearby and perhaps wondered why these two people were hugging her so

tight. She was just beginning to say her first words and it did not take her long to start calling us Mummy and Daddy.

The documentary film *Operation White Tower,* with riveting footage all the way to the summit, eventually showed in theaters around the country. It was not until 1950 that RKO released its feature film *The White Tower.* In that eminently forgettable movie, Glenn Ford played the American hero, Claude Rains the alcoholic Frenchman, and, inexplicably, Lloyd Bridges the doomed Nazi.

The rousing success on McKinley garnered Brad more publicity than any of his previous expeditions had, and Barbara was inundated by interviewers. There was also, however, a small current of criticism. The single stricture that would most have disturbed Brad was an opinion of which he remained ignorant for another half century, until biographer Michael Sfraga dug it out of private correspondence archived at the University of Alaska in Fairbanks.

Adolph and Olaus Murie were Minnesota-born brothers, the sons of Norwegian immigrants, who as early as the 1920s had performed extraordinarily bold, lightweight explorations of the Brooks Range in far northern Alaska, as they studied the migration patterns of the caribou. They were among the pathfinders in the Far North whose example Brad most admired. What was more, Brad had met the Muries and considered them his friends.

In the wake of the RKO McKinley expedition, however, Adolph Murie wrote to a geologist friend in Fairbanks, "We all feel that Washburn, with his commercialization of the Mountain, has already desecrated it enough, enough for one little man." And Olaus denigrated Brad's scientific projects on McKinley as a transparent gambit to "pull all possible strings to . . . get lecture material."

Had he known about them, these criticisms would have cut Brad to the quick. In his early years in Alaska, he had been a purist himself, who had no compunctions about taking potshots at such self-publicizers as Father Bernard Hubbard. But in the meantime, Brad had become a skillful self-publicizer in his own right. Short of the Rita Hayworth doll, none of the RKO shenanigans seemed to give Washburn pause.

Back in Cambridge, Brad found himself busier than ever with the Museum of Science, as it prepared the landmark move to the banks of the Charles River and the construction of a state-of-the-art new building. It is not surprising that three years would pass before Brad led another full-scale expedition, although in 1949, he made a surveying trip to McKinley, during the course of which he supervised the first helicopter landings ever on the mountain.

McKinley indeed was in Brad's blood by now. That view from Denali Pass west into the unknown had lodged in his consciousness. In 1951, Brad decided to demonstrate his hunch by leading an attempt on McKinley's West Buttress. That expedition would in effect become Brad's mountaineering swan song—but it was a glorious anthem that he would compose from the lower Kahiltna Glacier to the summit.

A mountain's first ascent is almost always achieved by its easiest route. This would not, however, be true of McKinley. Brad would later claim that some observers thought his West Buttress pipe dream was a crazy scheme. In 2005 he told Lew Freedman, "There were people who said I was going to ruin my reputation, and that we might even get killed on this new route up McKinley."

The project gained urgency when Brad received a letter from a Denver climber, Henry Buchtel, announcing that he was going to try the West Buttress. Buchtel had put together a strong team of five Coloradans, including Barry Bishop, who in 1963 would become one of the first Americans to climb Mt. Everest. Somewhat disingenuously, Brad wrote Buchtel back, asking if he, Jim Gale, and Bill Hackett could be

invited to join the Denver team. On the mountain, as usual, it would be Brad who ran the show.

In May, Brad flew to Denver to meet Buchtel's team. The upshot was a plan for a twin-pronged assault. The Denver climbers intended to hike in all the way from Wonder Lake, crossing the tundra to the Peters Glacier, then ascending it to its head, a major col at 10,200 feet that the team would name Kahiltna Pass. Brad was bent on flying in to the mountain, and initially hoped to make helicopter landings on the lower reaches of the unknown Kahiltna Glacier.

In the end, it was Brad's old Harvard friend Terry Moore who would facilitate the aerial approach. Even though at the time he was serving as president of the University of Alaska, Moore had continued to hone his expertise as a bush pilot. He had recently modified his Super Cub with ski-wheels, becoming the first aviator in the territory to do so. A hydraulic device operated from the cockpit allowed Moore to take off on wheels from a conventional airstrip, then lower the skis past the wheels so that he could glide to a stop on a glacial surface.

Buchtel joined Brad, Jim Gale, and Bill Hackett in opting for the airplane approach, while the other four Denver climbers horse-packed in from Wonder Lake. On June 18, with Brad as his sole passenger, in threatening weather, Terry flew up the Kahiltna from its rocky lowland snout. Brad had previously scouted a hoped-for landing zone between 7,000 and 8,000 feet. At precisely 6:00 P.M., as Brad recorded in his diary, "a thin streak of sun hit the spot that we wanted and we pounced on it, landing immediately—and perfectly, without even a bounce and using half-flaps."

Turning the plane around in slushy snow was hard work, but soon Moore took off. Left alone in the huge wilderness, Brad erected a seven-by-seven-foot Logan tent, brewed up a cup of tea, then (despite the peril of hidden crevasses), stomped out a 400-foot runway in his snowshoes. Even for Brad, the isolation was eerie. "It is <u>totally</u> calm

here," he wrote in his diary—"so quiet that you can hear your own heart beat with the stove off."

In weather that was further deteriorating, Moore made a second landing at 8:50 P.M. to deliver Henry Buchtel. Hackett and Gale would come in on subsequent flights, but their arrival was delayed by academic bureaucracy. As Brad wrote in his diary, "Talkeetna tells us that 'Dr. Moore unavoidably detained in Fbks because of a conference with the chairman of the [University of Alaska] Board of Regents to prepare a special report (on the student prank of raising the Communist flag at Commencement!) for the Un-American Activities Committee'—What utter rot!"

By June 21, the four climbers in the advance guard had started packing loads up the pristine Kahiltna Glacier. The Denver quartet did not take off from Wonder Lake until June 23. Throughout the expedition, the Denver men would lag in the rear, condemned to "sloppy seconds" by Brad's impatient leadership.

(It is significant that in the account of the climb Brad dictated to Lew Freedman, he neglected to mention the Colorado climbers at all after the initial handshaking in Denver. The first ascent of the West Buttress, in this telling, was an affair conducted by Washburn, Gale, and Hackett alone.)

Brad's diary tells the fuller story. Late on the evening of June 21, the vanguard party set up an advanced base camp at 10,000 feet, just south of Kahiltna Pass. Five days later, Terry Moore succeeded in making "a perfect landing" (Brad's words) at that camp. He thus broke Bob Reeve's fourteen-year-old record for the highest glacier landing in Alaska. (As recounted in Chapter 5, eight years later Moore would land on the 16,237-foot summit of Mt. Sanford, setting a new world altitude record for fixed-wing aircraft.)

It was not until June 30 that the overland party from Wonder Lake crested Kahiltna Pass and caught up with the rest of the team. Brad

sympathized with the rigors of their journey: "They had a 5-day pack-train trip with all sorts of miseries from rain to mosquitoes to bogged horses."

Meanwhile Washburn, Hackett, and Gale kept pushing the new route. On the Muldrow approach in 1942 and 1947, every landmark Brad's teams had bypassed—Karstens Ridge, Browne Tower, Harper Glacier, Archdeacon's Tower—had been named years before after the pioneers of the 1912 and 1913 expeditions. On the West Buttress, Brad and his companions felt free to name their own landmarks. The tentatively designated Peak Z, a 10,790-foot subsummit the trio climbed for survey purposes, became Kahiltna Dome. Windy Corner marked the tricky sidehill passage where the upper Kahiltna ran smack into the West Buttress proper. And so on.

Buchtel, in solidarity with his teammates, had dropped back to help them carry loads above Kahiltna Pass. Meanwhile, Brad and his two companions established farther camps at Windy Corner (13,000 feet) and at what they called Bergschrund Camp at 15,500 feet. (A bergschrund, or schrund, is a crevasse marking the ultimate separation of the eternally moving glacier from the stationary wall that stretches above it. Schrunds can be notoriously difficult to cross.) Directly above their high camp loomed what Brad had long suspected would be the crux of the route—a very steep snow and ice slope leading up to the granitic crest of the West Buttress. On July 7, Brad and Jim Gale attacked that obstacle. Brad's diary recorded the fiendish toil:

We tackled the slope above the schrund at 3:35 and chopped steps steadily till 7 o'clock in the most wretched snow imaginable—thin crust on top (crampons), then granular snow for a few inches, then 2 thin layers of blue ice with powder between—20-30 chops per step. We clambered up the rocks a bit—steep granite—on crampons at 7:15 and actually got above our 16,000-ft shoulder.

Though there is no mention of it in the diary, that slope was also a natural avalanche trap. Eventually Brad, Gale, and Hackett strung 800 feet of fixed ropes up the crux to safeguard the passage for the other climbers (and for their own descent).

The granite towers along the crest of the buttress proved easier going than Brad had suspected. One more camp, using an igloo rather than a tent, was placed in a snow basin at 17,200 feet. On July 10, the trio set out to climb the steep slope between the basin and Denali Pass, at 18,200 feet—the last unknown sector of the whole West Buttress route. This too turned out to be easier going than the men expected (though in future years it would be the site of several serious accidents). Arriving at the pass at 12:15 P.M., Brad was pleased to find his cosmic ray cache from 1947 still intact. The weather was holding, so there seemed no reason not to forge on toward the top.

That July, Brad was forty-one years old, but on the final ascent, he really came into his element. As he noted that evening in his diary,

> Jim and Bill were having a bit of hard going with the altitude, so I took all the trail markers and my Graphic camera and put them together in my pack. It's the only time I've ever seen Jim really tired. Curiously enough I've never felt better and the 40 lb load of cameras (Leica, 141B movie camera and Graphic) and film seemed not to bother me a bit.

At 5:30 P.M., all three men stood on the summit. Brad was further tickled to find the bamboo pole his team had left there in 1947 still sticking upright in the snow. In that moment, Washburn became the first man to climb McKinley three times, while Hackett and Gale became the only other men with two ascents of the continent's highest peak.

Despite their joy, it was an emotional hour the men spent on top. Both Brad and Jim later confessed that tears had streamed down their

cheeks as they headed down, knowing as they did that this was most likely the last time they would stand atop McKinley.

Brad's trio and the Denver five had never really coalesced as a team. The first ascent of the West Buttress has always officially been credited to all eight men. But after July 10, Brad was as impatient to get off McKinley as he had been to climb it. He managed to radio Terry Moore, who came in late on July 12, landed at the 10,000-foot camp, and whisked Brad back to civilization on the first flight. In the wee hours of July 13, Moore returned to pick up Hackett and Gale.

Buchtel and two teammates reached the summit only later on the thirteenth. The last two Denver climbers topped out on July 14.

The casual student of climbing history today associates the West Buttress only with Brad Washburn. Few could name a single one of the other participants in that triumph—not even Barry Bishop, who would later gain fame on Everest.

Above all, Brad had proved his proposition. Today, the West Buttress is overwhelmingly the route of choice of the more than 1,000 climbers who attempt Denali each year. In 2007, for instance, no fewer than 1,218 aspirants assaulted the mountain. Among them, 1,099 attempted the West Buttress. Yet despite fifty-six years of improvement in gear and food and airplane support, and despite the incalculable taming of the route through collective familiarity and sheer numbers (nearly all of those 2007 climbers never had to break trail or fix ropes, and not a few camped up high in igloos and snow caves built by others), only 47 percent succeeded in reaching the summit.

After the West Buttress, usually in conjunction with his survey work, Brad made several ascents of minor Alaskan mountains, such as Mt. Brooks and Scott Peak (both second ascents), but nothing again on the ambitious scale of McKinley.

By the age of forty, most mountaineers—even the greatest ones—have either quit climbing altogether or drastically lowered their sights. In part, this tailing off comes from the same physical limitations that, for instance, afflict professional football or basketball players. But for climbers, the scaling down of ambition has a far more profound psychological dimension than it does a physical cause. Expeditionary mountaineering, even at its most glorious, necessitates untold hours of sheer misery, thanks to the cold and wind and storms and sheer hard work that characterize life in the big ranges of the world. And mountaineering remains ineluctably hazardous. What climbers call "objective danger"—all those potentially lethal events over which the adventurer has little or no control, such as avalanches, rockfall, hidden crevasses, and sudden storms—inevitably come with the country in the Himalaya or Alaska. Other, more specialized versions of the climbing game, such as "sport climbing"—ascending short, very hard routes on clean cliffs, safeguarded by expansion bolts driven into the rock every few feet—can virtually eliminate objective danger. Thus it is not surprising that there are far more active fifty-year-old sport climbers than there are fifty-year-old big-range mountaineers.

To put it simply, most climbers get tired of risking their lives. And every serious mountaineer keeps a roster in his or her head of friends and acquaintances who were killed climbing. The mellowing out or backing off may be viewed in this light as a humane process of maturing, as one begins to realize that one's ties to others are more important than one's egomaniacal hunger to put up cutting-edge new routes.

Some climbers mellow out when they get married, and many quit altogether when they first have children. As we have seen, neither marriage nor parenthood slowed Brad Washburn down one whit. But by the mid-1950s, in no small part because of the burgeoning demands of

the Museum of Science, Brad effectively turned his back on the kinds of climbing that had earned him a certain immortality as the greatest mountaineer in Alaskan history.

It is interesting to compare Brad's career trajectory as a climber to that of the other four members of the so-called Harvard Five. Terry Moore had given up mountaineering (for the second time) after the blithe ascent of Mt. Sanford in 1938. He was then only thirty years old. But after Sanford, Moore poured every bit as much ambition into flying, and he took risks equal to those he had survived on such pioneering first ascents as Fairweather and Minya Konka.

In 1953, Bob Bates and Charlie Houston led another American expedition to K2, fifteen years after their bold first attempt on the world's second-highest mountain. As they hiked up the Baltoro Glacier that June, Bob was forty-two years old; Charlie, thirty-nine. The two friends had assembled a strong team, including Pete Schoening of Seattle, who would become a legendary mountaineer in his own right, and who, five years hence, would be one of only two men to reach the summit of Gasherbrum I in Pakistan, the sole 8,000-meter peak whose first ascent would be claimed by Americans. Once more, however, Bates and Houston did not invite Washburn to K2.

The great mountain had not been attempted since the tragic expedition led by Fritz Wiessner in 1939. Building on their own thrust to 26,000 feet in 1938, and on Wiessner's near miss the following year, Bates and especially Houston fully expected to climb K2 in the summer of 1953. (Just a month before, Mt. Everest had finally succumbed to Edmund Hillary and Tenzing Norgay.)

The team had reached a high camp in good form when, on August 7, a completely unforeseen predicament canceled all their hopes. Art Gilkey, a geologist from Iowa, collapsed on a routine walk between tents. Houston, the doctor, at once diagnosed thrombophlebitis, a blood clot in the leg. Gilkey could not walk, and there was a consider-

able chance that even trying to move the man could cause the blood clot to travel to the lungs or the brain, killing him.

Nonetheless, his teammates gave up all thoughts of the summit. Strapping Gilkey into a sleeping bag attached to an improvised sled, they began the virtually impossible task of lowering the victim all the way down the torturous Abruzzi Ridge. In a storm on August 10, as the men, roped in pairs, tried to maneuver the balky sled, one man slipped and pulled off his partner. Their rope intersected with another, pulling two more men from their stances. And then the fiendish chain reaction pulled yet another man (who was roped to Gilkey) off his feet. Five men hurtled out of control toward a fall of some 9,000 feet.

It was now that Pete Schoening performed what has ever since been known as "the miracle belay." At the top of the pyramid, securing Gilkey from above, Schoening saw what was happening. At once, he plunged his ice axe into deep snow just above a small boulder, then hung on to it for dear life. Astoundingly, one man's belay stopped the interlinked falls of five teammates. Had Schoening been wrenched loose, seven of the team's eight members would have plunged to their deaths. In the history of mountaineering, no comparable deed of salvation has ever been performed.

Despite the miracle, the team was now in desperate shape. Houston, having suffered a concussion, was completely disoriented, as he raved crazily and tried to cut his way out of the tent in which he had been laid. During the night, the other men struggled with their darkest thoughts.

That night, another kind of salvation—albeit a macabre one—befell the team. Having left Gilkey anchored to an ice axe, the men set out to continue lowering their stricken comrade—only to find that Gilkey had vanished. An avalanche had apparently ripped the anchor loose and sent Gilkey on the long ride. (Four decades later, his body was found on the Baltoro Glacier.)

It was hard for the men to admit it, but Gilkey's death had probably saved their own lives, because the effort to lower their comrade down the mountain was so perilous it put their own safety in dire jeopardy. As it was, the men staggered carefully down the Abruzzi Ridge and eventually regained base camp.

The party left the Karakoram battered and full of gloom. Yet the survivors stayed best friends for decades, organizing a laid-back reunion in the Wind River Range of Wyoming on the twenty-fifth anniversary of the fateful expedition. Bates and Houston wrote a chronicle called *K2: The Savage Mountain,* which has become one of the indelible classics of mountaineering literature.

Despite the tragedy and near catastrophe, Houston and Bates had a permit to try K2 again in 1955, and they fully expected to return. But the Italians, who had the 1954 permit, put together a huge expedition run along military lines and presided over by a martinet of a leader, Ardito Desio. At the end of a long and rancorous struggle up the Abruzzi Ridge, two men, Lino Lacedelli and Achille Compagnoni, reached the summit. The Italians had stolen the first ascent of the "American" mountain.

Bob Bates took this philosophically. But for Charlie Houston, the Italian success was deeply disturbing. Within a day after learning of the Italian triumph, Charlie (in the words of his biographer, Bernadette McDonald) "wandered into the local hospital in Nashua, forty miles from [his home in] Exeter, with no idea of who or where he was and with absolutely no identification on him." Diagnosed with global amnesia, Charlie was admitted to a hospital. A psychiatrist friend who visited him found him "weeping inconsolably," with his short-term memory gone. He was soon sent home to his wife, but it took several weeks to recover.

Houston quit climbing for good that year, at the age of forty-one. But Bob Bates kept going on mountaineering expeditions—exploratory

jaunts rather than technical challenges—for another three decades. Remarkably enough, at age seventy-four, in 1985, Bates participated in a grueling reconnaissance expedition to the remote and virtually unknown 22,877-foot Ulugh Muztagh on the northern Tibetan plateau.

Whatever their setbacks on K2, both Bates and Houston crafted distinguished careers away from the mountains. Bob taught English for many years at Exeter Academy in New Hampshire, where he inspired legions of climber protégés. Charlie became the world's leading expert on high-altitude medicine and physiology. His book *Going Higher,* now in its fifth edition, remains the definitive treatise on the subject.

During the Kennedy years, Bates served as director of the Peace Corps in Nepal, Houston as director in India.

The fifth member of the Harvard Five, Ad Carter, taught languages at Milton Academy in Massachusetts throughout his professional life. At the same time, for thirty-five years, from 1960 to 1995, Ad edited the *American Alpine Journal,* which he single-handedly transformed from a parochial publication into the world's most authoritative reference for mountaineering achievements, not only by Americans, but by Slovenes, Japanese, Poles, and the like. Never paid a dime for his work, Ad used his formidable linguistic skills to translate many an article from the French, German, Italian, or Spanish, and with a little help he could cobble together a readable text from a Slovene or Japanese original.

Meanwhile, more than any of the other Five, Ad kept up serious mountaineering well into his sixties. In 1959, he led the first of eleven expeditions to the Andes. (He remains the only HMC figure ever to conduct major campaigns in the mountains of South America.) And in 1976, at the age of sixty-two, on the fortieth anniversary of his participation in its first ascent, Ad co-led an expedition to Nanda Devi to attempt a new route on the majestic mountain.

The wonderful conception of this project foundered on generational conflict. Another strong member, Willi Unsoeld, had paired with Tom Hornbein to perform the epochal first traverse of Mt. Everest in 1963. By 1976, however, Unsoeld was forty-nine years old and hobbled by the missing toes he had lost to frostbite in a forced bivouac just below the summit of Everest. Unsoeld insisted on bringing along his daughter, Nanda Devi Unsoeld. He had named her after the mountain he considered the most beautiful in the world. Devi was a good climber, but perhaps not up to the challenge of a new route on the great mountain.

Rounding out the party was a trio of young guns, crack big-range mountaineers in their twenties. The strongest of all, John Roskelley, was at the time the leading American Himalayan climber. From the start, Roskelley was highly critical of the less-qualified members of the team, and he clashed acrimoniously with Devi.

Suddenly, in a high camp, Devi developed peritonitis. Her condition deteriorated rapidly, until she died in her weeping father's arms.

Roskelley and his young partners completed the difficult new route. But what should have been a rousing success turned bitterly sour. The team limped back to civilization riddled with mutual antagonisms. Back in the United States, the rumor mill went into overdrive. To answer his critics, Roskelley published an account of the climb, *Nanda Devi: The Tragic Expedition*. A tell-all exposé, the book pulled no punches when it came to airing its author's grievances. A brilliant climber with fierce ethical principles, Roskelley nonetheless seemed incapable of admitting that he was ever wrong about any mountaineering decision. In his telling, even the death of Devi Unsoeld came across as an I-told-you-so.

Like Terry Moore, Brad redirected his exploratory ambitions into new channels after he turned his back on serious mountaineering. The

survey work he had undertaken on virtually all his mountains, from Crillon onward, was no mere hobby. By 1951, with the climb of the West Buttress, Brad had determined to produce the definitive map of Mt. McKinley. The topographic charts put out by the United States Geological Survey, produced mechanically from aerial oblique photographs, were barely adequate, and not easy for anyone other than specialists to read.

Once he felt his surveying of the great mountain was complete, Brad sought for several years to find a mapmaking firm whose standards matched his own. Eventually he teamed up with an outfit called Landestopographie, near Bern, Switzerland. The McKinley map came out in 1960. As Brad told Lew Freedman,

> [T]hat was the first time the Swiss officials had printed a map on any subject outside Switzerland. The Swiss are watchmakers and watchmakers do everything with precision. They love perfection. I'm a perfectionist, and I like working with perfectionists.

The McKinley map remains the chart of choice for climbers today, nearly half a century after it was produced. Besides being accurate down to the last detail, the map is a work of art. Contour lines follow the conventions of the USGS, but on Brad's map, the glaciers are drawn in blue, rock outcroppings in brown, and features crucial to mountaineers (crevassed icefalls, for instance, or rock arêtes protruding from faces) that do not show up on the USGS topo maps are sketched in freehand.

Brad would go on to produce equally precise and beautiful maps of the Grand Canyon, in 1978, and of Mt. Everest, in 1988. Both were distributed to the vast readership of *National Geographic,* folded into the pertinent issues, thereby rounding out five decades of Brad's alternately warm and cool (though mostly warm) relationship with the

NGS. Also in 1988, he produced the definitive map of Mt. Washington and the Presidential Range of New Hampshire. The chart was published by the Museum of Science and distributed by the Boston-based Appalachian Mountain Club. In a sense, this last production marked the closing of a long circle that had begun with the hand-drawn map Brad had included in his privately published *Trails and Peaks of the Presidential Range* at age sixteen.

The maps of Everest and the Grand Canyon required herculean labors. Brad surveyed the world's highest mountain almost entirely from airplanes, but in the Grand Canyon, he spent months stretching across five years hiring helicopter pilots to deposit him on remote buttes and canyon rims, where he wielded his surveyors' tools. On these jaunts, Barbara served as his faithful data recorder, jotting down the numbers from thousands of observations in a logbook as Brad dictated them to her. Over the course of those five years, Brad and Barbara made no fewer than 697 chopper landings, "some of them on very precarious perches," as Barbara wrote in *The Accidental Adventurer*. Now entering their sixties, Brad and Barbara had found an exhilarating collaboration in the field to replace the grueling Alaskan expeditions of their youth and prime.

The same partnership carried them through the fieldwork in the White Mountains. Much of the toil took place in winter, and the ferocious weather turned surveying into a true ordeal. In later years, Barbara often told the story of a particularly vexing day on the summit of Mt. Washington. "It was bitterly cold," she recalled, "and the numbers weren't coming out right. Brad kept telling me to do the calculations over again. And then it occurred to me, I could sabotage the whole thing if I just wrote down the wrong numbers."

All during these years, of course, Dotty, Ted, and Betsy were growing up. At times Brad may have been a remote father, preoccupied with his museum as well as with his mapping and climbing, rather than

attending his kids' school and sporting events. None of the three children became a climber, though Ted, a superb athlete, developed into an Olympic-caliber crew coxswain and later an expert crew coach.

In the summer of 1955, as if to atone for the months of absence from their Cambridge home, Brad and Barbara drove across country with their children. Dotty was fourteen, Ted twelve, and Betsy nine at the time. It is significant that the parents devoted a chapter each of their memoirs to this rather mundane adventure, of the sort that most American families routinely managed in the 1950s and 1960s. Brad lavished six pages of his dictated autobiography to the episode, titling his chapter "Exploring America with Our Children"; Barbara took up seven pages of *Adventurer* with "Motel Camping," as she hymned the delights the kids discovered in the swimming pools and television sets of each roadside refuge.

Setting aside Brad's own estimation that his greatest accomplishment was founding and directing the Museum of Science, one must single out the man's aerial photography as a lifelong achievement of such high order as to rival his preeminence as an Alaskan mountaineer. The most extraordinary aspect of that craft is that—with the exception of the brief mentorship offered him at Harvard's Institute for Geographical Exploration by Captain Albert W. Stevens—Brad's career as a photographer followed a completely self-taught trajectory. What is more, he kept it up long after he had given up climbing, so that in the end, his work spans more than seven decades. One could argue that he did his best photographic work in the 1950s, 1960s, and 1970s.

Even as a child, Brad had been fascinated by photography. His first camera, which he acquired at the age of ten, was a No. 2 Brownie. (He kept that simple but beloved apparatus the rest of his life; it reposes today in a cardboard box in his archive at Boston University.) By the age of thirteen, Brad was using a Vest Pocket Autographic, made by

Kodak. "You could shoot only at 1/25th [of a second] or 1/50th," Brad reminisced in 1983, "and you got six pictures on a roll."

Ironically, the Vest Pocket Autographic was the very same make as the camera Mallory was carrying when he vanished on Everest in 1924. When Mallory's body was found in 1999, the camera was not on his person. Everest theorists still hold out hope that someday Sandy Irvine's body will be found, and if he was carrying the camera, and the film, frozen for decades, could still be developed, those last images might finally clear up the mystery of the denouement of that bold, doomed assault on the highest mountain on Earth.

In the Alps between 1926 and 1929, Brad took many good pictures with his Autographic. He always claimed that his first critic was his mother: "She said to me, 'Brad, the problem with your pictures is that they don't have people in them.'" Looking back more than fifty years later on that stricture, Brad grinned sheepishly, then admitted, "I was only interested in scenery." For years after his mother's critique, he strove to include fellow climbers in his majestic mountainscapes. Indeed, some of his finest large-format pictures, shot from the ground rather than the air, position the tiny figures of his teammates in the far distance as they trudge up a glacier or along a summit ridge, thereby demonstrating in the blink of an eye the truly colossal scale of Alaskan mountains.

Though it remains a little-known facet of his work, Brad also had considerable talent as a portrait photographer. His base-camp group photos of his expedition teams look like professional studio pictures. On every summit he reached, no matter how grim the conditions, Brad was determined to take good photos of himself and his fellow conquerors. The self-timed portrait, triggered with a shoelace, of Brad and Bob Bates atop Lucania, exhausted but radiant with happiness, is one of the finest summit photos ever taken anywhere in the world.

Even less well known in the Washburn oeuvre is a series of comic

portraits of local Alaskan types—fishermen, guides, hunters, and prospectors—that Brad exposed in the remote villages from which he embarked on his Alaskan expeditions between 1932 and 1940. A 1937 picture of Bob Bates's and Bob Reeve's lower trousers and boots ankle-deep in the Valdez mudflats captures the swashbuckling aplomb of the pilot's innovative ski-plane technique, and an oft-published portrait of Reeve in front of his Fairchild 51, eyes squinting, sardonic smile in place, hands on his hips as he flicks the ash off a cigarette affixed to a stylish holder, could have served as a prototype for the Marlboro Man.

Just as in his development as a mountaineer, Washburn the photographer was influenced by virtually no masters who preceded him. The notable exception was Vittorio Sella, whose magnificent glass-plate photos adorned each folio volume celebrating the latest exploits of teams led by the Duke of the Abruzzi.

By 1929, Brad had replaced the Vest Pocket Autographic with an Ica Trix that shot ten-by-fifteen-centimeter (roughly four-by-six-inch) negatives. This was Brad's camera of choice on the ground through 1942, when, as he told his future agent, Tony Decaneas, "it just plain wore out on my ascent of Mount McKinley." (The Trix resides today in the same cardboard box with the Brownie in the BU archives.)

Brad's aerial photography, however, began in earnest in 1934 on Mt. Crillon, after he followed the lead of Captain Stevens and acquired his first Fairchild camera, an F-8 that exposed five-by-seven-inch negatives. By that date, however, very little serious photography of wilderness shot from airplanes had been accomplished anywhere in the world. There was a myriad of logistical problems to overcome. But what Brad had known in his bones since his first flight past the Alps in 1926 was that the bane of mountain photography is foreshortening. From its base, a peak always looks less steep and less impressive than it really is. Even Sella's magisterial images of K2 and Mt. Saint Elias

were diminished by foreshortening. By 1934, Brad had realized that only by photographing mountains from midheight could he capture their true grandeur on film. What began as an experiment ended up as a lifelong mission.

From the start, Brad knew that he had to shoot from a high-wing plane (in a low-wing craft, the wing itself would spoil the picture). And it was obvious that he couldn't get good pictures through the window—the whole passenger-side door had to be taken off. By 1936, as he flew around McKinley for the NGS, he was using Stevens's Fairchild K-6, which shot eight-by-ten-inch negatives. (Shortly thereafter, he bought his own K-6.) With the film magazine attached, the camera weighed an unwieldy fifty-three pounds. Because of the size of the negatives, the slightest jiggle could ruin the photo, even if Brad shot at a high speed (almost all his Fairchild pictures were taken at a focal length of F8 and at a speed of 1/225th of a second).

Few photographers would have been willing to tackle such complications, but it was just the sort of challenge Brad relished. Flying at altitudes upward of 15,000 feet in Alaska and the Yukon with the door off the plane made for an extremely cold ride, even for the pilot. Knowing he had to lean clear of the door to get the photos he wanted, Brad dressed in his warmest mountaineering suit, complete with leather aviator cap and fur-lined hood. He rigged a tie-in with a rope around his waist, anchored to the opposite interior of the fuselage, so that he wouldn't fall out of the plane. As he shot, he wore a heavy mitten on his upwind hand, a glove on the other, which manipulated the shutter.

There was still the problem of vibration from the airplane engine—that alone could blur every image. So Brad manufactured a kind of cat's cradle of webbing to hold the precious Fairchild suspended in the center of the open door. As Tony Decaneas explains, "The webbing took the weight of the camera off Brad and gave him mobility, and it isolated the Fairchild from the engine vibration."

As a pilot, Brad ordered the aviator he hired to turn and dip and slow the plane into just the right positions for him to get the pictures he wanted. Brad conveyed his commands either by shouting over the engine noise or by signaling with his hands. To Decaneas's astonishment, Brad explained decades after he had discovered it another critical technique. "You have to take the picture at the top of the bounce," Brad told his future agent.

"What?" replied Decaneas.

"The plane's bouncing like crazy. You have to wait for the top of the bounce. That's the one still moment to get the picture."

The only film available for the Fairchild K-6 came in 250-foot rolls. These were too heavy and cumbersome for the magazine, so Brad routinely cut them in half. To do so, in complete darkness so as not to expose the film, Brad measured the rolls by feel, with calipers, judging by fingertips alone until he had the width of each half exactly matched.

Another demonstration of Brad's phenomenal dexterity came on Mt. Bertha in 1940. He had brought along his K-6 to shoot photos both from the ground and from the air, but on one of the first days, as he related to Lew Freedman in 2005, "When I wound up the shutter curtain there was a horrible noise. And then the shutter refused to work at all." Most photographers would have given up on the complicated apparatus, but there, at base camp, Brad took the Fairchild apart and discovered that a tiny bolt, critical to the shutter mechanism, had sheared in half. Scrounging about for a jury-rigged repair, Brad resorted to a safety pin.

After several hours of work, he had filed the pin down to the requisite size and inserted it. The shutter worked again, but Brad had no way of judging its speed. As Brad told Freedman,

Over and over again we tightened that spring, until I thought I heard the kind of bang I usually heard each time I took a picture.

Then, putting my trust in God, I took 242 aerial photographs over the next month. When we at last reached home at the end of the summer, I got the shutter assembly examined at Kodak's research laboratory in Rochester, New York. They told me that instead of the 1/225th of a second the camera was originally set for, I had taken my pictures at 1/215th of a second. Wow. That's about as close as you can get by feel.

Brad's most famous pictures are lordly panoramas of big mountains. Yet he also had a keen eye for detail, and during his flights he often urged the pilot to skim low over the ground and cant the plane on its side so that he could shoot at a sharp angle or even straight down. The resulting compositions—of glacial moraines, desolate glacial snouts pocked with rock debris and meltwater pools, crevasse fields savagely scoring icefalls, patterns of sastrugi (windblown plumes of snow), rivers threading through winter-struck lowlands, and the like— have the look of abstract paintings. Arresting in their own right, these images soon attracted the attention of geologists. Trained in geology himself, Brad was far more pleased when the publisher of a geology textbook sought permission to use one of his photos than when some aesthete praised the "artistry" of such pictures.

Brad's photos of the Grand Canyon are unique and almost bizarre. While virtually every other painter and photographer has sought to capture the colossal depths and soaring buttes and towers of America's most celebrated canyon, Brad's photos flatten the place out. A photo of the Bright Angel Trail, for instance, has the zigzag simplicity of an abstract design. Brad loved the Grand Canyon, but in a sense his photos of it sneer at the gentleness of its ramparts and slopes, compared to the towering immensities of the mountains in the Far North.

From the start in 1934, Brad knew that a pair of photos shot from the same altitude a few seconds apart as the plane flew parallel to a

mountain face could produce a stereo view. Stereo pairs looked at through a viewer make the mountain suddenly pop out in three dimensions. Such images would eventually prove invaluable for climbers trying to judge the safety and difficulty of unclimbed routes.

It is worth bearing in mind that Brad's impulse throughout his many decades of photography was documentary, not artistic. Much of the effort was to scout routes for his own expeditions. It was from aerial photos that Brad deduced the easiest routes up Crillon, Lucania, Sanford, Bertha, and—eventually—the West Buttress on McKinley. With his characteristic impatience, Brad often needed to develop his photos in the same season in which he took them. So he resorted to hauling all the gear he needed to Alaska where, in some light-sealed cabin, he concocted his own darkroom, complete with processing tank and huge wooden drying racks.

As early as the 1930s, other climbers had begun writing to Brad to request photos of unclimbed mountains so that they could scout out their own ascents. Brad was always happy to oblige. And once his own mountaineering had tailed off, Brad enjoyed nothing more than pointing out possible routes to younger climbers. He routinely sold contact prints to impoverished mountaineers at the cost of printing them.

In a Swiss publication, the 1957 edition of the widely read *Mountain World,* Brad published a twenty-four-page article about Mt. McKinley. The text was essentially a primer on how to climb North America's highest peak, but the pièce de résistance was eight glorious foldout double-page photos of the mountain from every side. And Brad identified the central rib on the south face as the finest possible route on McKinley. "[N]one but the most uniformly experienced and powerful team of climbers should even think of attempting it," Brad wrote. "But I mention it here because to omit it would be to sidestep the greatest remaining pioneer ascent in North America."

Brad was soon in correspondence with some of the leading Italian mountaineers, who had already been contemplating an Alaska expedition. (No Italians had climbed in Alaska since the Duke of the Abruzzi in 1897.) Thus in 1961, a six-man team under Ricardo Cassin took up the challenge. One of the greatest mountaineers of the twentieth century, Cassin had pioneered some of the hardest routes in the Alps, including the Walker Spur on the Grandes Jorasses, which Brad had set his precocious eyes on way back in 1929. By 1961, Cassin was over fifty years old, but he was still climbing at the top level.

After a desperate monthlong struggle, Cassin's team made the first ascent of the rib. (Considered one of the great classic routes today, it is known simply as "the Cassin.") But the Italians had underestimated the cold and ferocious weather of Alaska. Climbing in knickers, knee-socks, and single leather boots as they would have in the Alps, all six men suffered frostbite, several of them seriously. Yet their triumph won a congratulatory telegram from none other than President John F. Kennedy.

Four years later, Brad lured another great European climber to Alaska. The Frenchman Lionel Terray is often ranked as the finest expedition mountaineer of all time. In 1950, he was the strongest man on the storied Annapurna expedition, but he gave up his chance for the summit to support (and save the lives of) his teammates Louis Lachenal and Maurice Herzog. Still in the 1950s, he spearheaded the first ascents of Makalu (the world's fifth-highest peak), another Himalayan giant called Jannu, several splendid peaks in the Peruvian Andes, and the sheer Patagonian pyramid of Fitzroy.

Brad enticed Terray with some spectacular photos of unclimbed Mt. Huntington, just south of McKinley. Though only 12,240 feet high, Huntington has often been called "the most beautiful mountain in Alaska." Like the Italians, Terray's eight-man French team underestimated Alaska. Intending to knock off Huntington as a warm-up for

a new route on McKinley, the French found May on the Ruth Glacier unbearably cold and stormy. After a struggle every bit as grim as Cassin's, the team climbed the northwest ridge and claimed Huntington's first ascent. Then forty-five, Terray came as close to dying as he ever would on an expedition, when he was saved by a fluke from a thousand-foot fall. He severely dislocated his elbow in the accident, but managed to forge his way up the route essentially one-handed.

Throughout the 1960s, Brad published articles in the *American Alpine Journal* tempting the best young American climbers to consider unclimbed routes they had never seen. The articles bore such titles as "Mount McKinley: Proposed East Buttress Routes." A retrospective look at Brad's 1968 piece, "Challenges in Alaska and the Yukon," proves how prescient he was at identifying the finest lines for the next generation. One picture showcased the north ridge of Mt. Kennedy, the peak (then know as East Hubbard) Brad had reconnoitered during his 1935 traverse of the Saint Elias Range. This superb, steep, 6,000-foot arête was first climbed by two members of a tough four-man team that same year, instantly becoming one of the classic Yukon routes—a distinction it retains today. Likewise the "Infinite Spur" on Mt. Foraker, identified by Brad as the finest route on Denali's neighbor, conquered by the brilliant duo of George Lowe and Michael Kennedy in 1977. In the same article Brad unveiled the south face and ridges of Mt. Hunter, third-highest peak in the Alaska Range, and in doing so unleashed a frenetic competition that saw one crack team after another defeated. The ultimate coup of this approach to Hunter came in the astonishing (and, some thought, slightly insane) 145-day-long solo ascent of the hardest of those southern ridges by a Fairbanks eccentric, Johnny Waterman, in 1978. The southeast face of the Mooses Tooth, also paraded in Brad's 1968 article, was first climbed by a trio of college students (including Jon Krakauer, long before he became a bestselling author) in 1975.

During his long career, Brad developed close friendships with several pioneering photographers, including MIT's Harold ("Doc") Edgerton and Edwin Land, the founder of Polaroid. After meeting Ansel Adams in the 1930s when Brad gave a talk at the California Academy of Sciences, he formed a lifelong rapport with America's greatest nature photographer. Adams and Washburn shared a predilection for large-format negatives, for strong contrasts in black and white, and for razor-sharp image clarity. Yet despite Adams's intensely theoretical bent, the two men seem never to have discussed photographic technique. In sum, Brad learned almost nothing about photography from these innovative giants of the art of taking pictures.

One proof that Brad made no bones about artistry is that he had little patience for the task of printmaking. He left most of that work up to a technician at the Museum of Science, who, according to Tony Decaneas, was a skilled printmaker. But by and large Brad was content to fill album after album with contact prints of every one of the thousands of aerial photographs he took over the decades.

Decaneas, a highly acclaimed collector and the founder of Boston's Panopticon Gallery, was introduced to Brad by his uncle, Brad's old HMC friend Ad Carter. According to Decaneas, after retiring as director of the Museum of Science, Brad was having a hard time marketing his pictures. Decaneas became Brad's agent in 1990. The professional realized at once that even the Museum of Science's printmaker wasn't getting the best out of Brad's negatives. But Decaneas was bowled over by the sheer quality of the compositions.

Leafing through a collection of Brad's photos today, Decaneas expresses amazement, as if seeing the pictures for the first time. "Look at these," he exclaims. "These aren't *cropped*. Everything's there in the picture, perfectly composed."

The gallery owner goes on, "If you're immersed in the art of photography, you understand how the photo is supposed to look. There's

only one way a print *should* look. But Brad's negatives are works of art. All the info for the perfect print is in the negative."

Brad's most famous photograph of all was shot from a plane in the Alps in 1960. In it, against a background of clearing clouds, six tiny figures are outlined as they traverse a steep ridge on the Doldenhorn. The sunlight rakes the glaciated face of the mountain, giving glorious texture to snow flutings and seracs, and projecting the shadows of the two lead climbers onto the slope eighty feet below their steps. It is characteristic of Brad that he always claimed this masterly image was born of a sheer lucky accident of weather, sunlight, and timing.

Even before Decaneas started producing the enlargements that brought out the best in Brad's aerial photos, savvy observers were starting to acclaim Washburn as a large-format genius. In a 1983 introduction to Brad's coffee-table picture book-cum-history of Mt. McKinley (published only in 1991), Ansel Adams wrote, "[T]he photographs look almost inevitable, perfectly composed. They are not simply documents . . . ; we sense in each one the presence of an individual, highly intelligent eye. The photographs are the result of the explorer's consistent energy of mind and spirit—and so they truly *mean* something."

In 1983, Brad was the subject of a feature profile in *American Photographer*. Eventually, the International Center of Photography in New York, the Museum of Fine Arts in Boston, and Harvard's Museum of Natural History filled their galleries with Washburn one-man shows. Today, signed, archival enlargements of Brad's aerial photographs— the very same pictures he used to sell to climbers for the cost of making a contact print—routinely fetch $2,400 apiece through Panopticon.

Decaneas tells a story about Brad's indifference to what others considered artistic integrity. One day the Kelty company, a manufacturer of backpacking gear, called Panopticon, offering to pay $4,500 for the use of a single Washburn photo. But, the company spokesman made clear, the photo would be printed light and used as a mere background

screen, over which would be pasted vignettes of Kelty's latest products. Decaneas was appalled, but promised to ask Brad.

"I called him," remembers Decaneas, "and explained the offer."

"Sounds good to me," Brad chirped.

"They're willing to pay $4,500."

"Forty-five hundred—sounds even better."

"But Brad," Decaneas objected, "they're going to print it all middle gray, and paste models of their gear all over it."

"What do I give a shit what they do with it?" Brad spat back. "Take the money!"

In 2001, Kurt Markus, a professional large-format nature and adventure photographer and a keen historian of the medium, was given a copy of Decaneas's 1999 volume, *Bradford Washburn: Mountain Photographer,* by the famed portrait photographer Bruce Weber. Markus was stunned by the pictures, and he was all the more incredulous because he had never heard of Washburn. As Markus later wrote, on learning that Brad, in his nineties, was still "very much alive and active in the Boston suburb of Lexington," he formed a fixed resolve: "I'd go to Lexington and make him confess to being something no self-respecting photographer should ever call himself: an artist. Even if I had to claw it out of his nonagenarian body."

In the September 2005 issue of *Outside* magazine, Markus published "Visibility Unlimited," a beguiling account of his quest. It was a tough assignment. Over the course of several days, Brad, then ninety-four, kept veering from one subject to another—his early expeditions, mapmaking, his days as a pilot. Markus doggedly steered him back onto course.

What the interviewer could scarcely believe was that the magnificent work he had come to know was the result of a purely self-taught aesthetic. He cornered Brad to question him about the influences on his work.

I asked him if he'd read any of [Ansel] Adams's how-to books on exposure, development, and printing.

"No."

"Did you ever subscribe to photography magazines?"

"No."

"Did you collect books of photographs by other photographers?"

"No."

"Do you know the work of Henri Cartier-Bresson?"

"I don't know anything about him."

Markus's mission, as he had made clear, was to get Brad to admit that an artistic impulse guided his work. But the best he could wring from the ninety-four-year-old, during his last hour with Brad, was a "maybe." Then Brad amplified, "I was interested in bringing to other people the thrill I was getting when I saw the scene."

Markus could not resist closing his piece with a heartfelt encomium. "Looking at [Brad's] pictures, however," he wrote, "one thing is certain. He loved the mountains, and they loved him back. Colossally."

9

Explorer Emeritus

As he rounded into his forties and fifties, with his pioneering ascents behind him, but with the Museum of Science steadily gaining worldwide recognition and acclaim, Brad Washburn sat, impatient as ever, in his director's chair while honors and accolades fell into his lap. Between 1951, with the University of Alaska, and 1996, from Boston University, Brad received no fewer than eleven honorary doctorates (in between came Tufts University, Colby College, Northeastern University, Suffolk University, University of Massachusetts, Boston College, his own Harvard University in 1975, Babson College, and Curry College).

He was also voted an honorary member by some sixteen organizations, ranging from the Harvard Mountaineering Club (which he had joined and virtually taken over as a freshman in 1929) through the Explorers Club, the American Alpine Club, and the (British) Alpine Club, and including such esoteric societies as the Chinese Association for Scientific Expeditions and such posh fellowships as Boston's Saint Botolph Club. (It is impossible, however, to picture Brad relaxing in a

leather armchair at Saint Botolph's as he smokes a cigar or sips from a brandy snifter.)

In a résumé Brad prepared in 2001, at age ninety, he listed no fewer than twenty-nine "Awards & Medals" that he had received between 1938 and 2000. These, too, ranged from the relatively homely (the Joe Dodge Award from the Appalachian Mountain Club, "in recognition of outstanding service to the public in the White Mountains 1921–1991") to the undeniably prestigious—the Discovery Lifetime Award of the Royal Geographic Society, the Centennial Award (with Barbara) from the National Geographic Society, and the very first Alexander Graham Bell award, given by the Institute of Electrical and Electronics Engineers, the world's leading professional association for the advancement of technology.

On that same seven-page résumé, Brad listed twelve photographic exhibitions devoted to his black-and-white pictures, and twenty-three maps that he created, beginning in 1924 with "a boy's chart" of Squam Lake, New Hampshire, where the Washburns had their summer home. ("Only one copy exists," Brad chortled.) On the other end of that spectrum comes Brad's magnificent Mt. Everest map, completed in 1991, of which, as the résumé brags, "an edition of 11 million maps printed and circulated worldwide"—one, of course, in every copy of that month's issue of *National Geographic.*

A whole page is given over to publications to which Brad contributed articles or photographs. No magazine or newspaper is too humble to rub shoulders on that list with *National Geographic* and the *New York Times* (e.g., *We Alaskans, The Sportsman Pilot, Rock and Ice*). For the reader who peruses the résumé, and who is familiar with Brad's illustrious achievements, the strangest omission (characteristically Washburn, however) is that Brad records not the faintest hint of any mountains that he climbed—let alone the most extraordinary roster of first ascents in Alaska and Canada ever compiled by any mountaineer.

Brad's long career was so consistently spangled with triumphs and honors that it is tempting to see only an exemplary life—that rare case of a man who achieved virtually everything he set out to do. Along the way, however, Brad suffered a few setbacks, failures, and even tragedies. The 1938 plane crash on Lake Union, which cost the lives of the two young women in the backseat, and which apparently was due entirely to pilot error, remains the darkest stain on Brad's record. As to how lastingly he agonized over that accident, or how cruelly he was haunted by his fatal mistake, not even Barbara can say today.

Tragedy is one thing, but frustration is another. There is no doubt that by far the most frustrating experience in Brad's life spun out of his fifty-year crusade against the true believers in Frederick A. Cook—the "Cookies," as Brad derisively called them. And therein lies one of the strangest sagas in the history of American exploration.

Among the parties attempting Mt. McKinley in the decade before its 1913 first ascent, one of the strongest was launched from the south in 1906. The seven-man team was led by Belmore Browne, who in 1912 would come within about a hundred yards of the top before being forced back by a violent blizzard, and by Herschel Parker and Frederick A. Cook. A graduate of New York University medical school, Cook had launched an unsuccessful doctor's practice in Manhattan. His real passion, however, was exploring, and by 1906, at the age of forty-one, he was already the veteran of six major expeditions.

In 1903, Cook organized his first attempt on Mt. McKinley. Daunted by the huge northern precipice of the Wickersham, Cook abandoned his attempt on the mountain, but ended up completing a monumental five-month, 540-mile lowland circumnavigation of the McKinley massif. (The second circumnavigation would come only in 1978.)

That journey ought to have gone down as a major accomplishment,

but Cook had the misfortune to include among his party a New York newspaper reporter named Robert Dunn. A protégé of the muckraking journalist Lincoln Steffens, Dunn was determined to write a no-holds-barred account of what really happened on the 1903 expedition. Published in 1907, *The Shameless Diary of an Explorer* is a classic today, one of the funniest and most acerbic expedition narratives ever written, the first true tell-all book in American mountaineering. The vignettes of his teammates were scurrilous enough that Dunn felt he needed to use pseudonyms. His indelible portrait of his leader paints "the Professor" as a pompous bumbler, an explorer who is lost much of the time, a man who fakes countless readings with the surveying devices he is incompetent to use.

Three years after the circumnavigation, the 1906 party ascended the Susitna and Yentna rivers to probe the mountain's labyrinthine southern defenses. Several members, including Cook, struggled onto the terminal snouts of both the Tokositna and Ruth glaciers, becoming almost certainly the first humans to tread any part of those massive ice flows. (Cook named the Ruth after his daughter.) Simply sorting out the topography had worn down the explorers, however, and on July 25 the team turned around and headed back to the lowlands.

The party eventually reached the Pacific Ocean at Cook Inlet (named for the great eighteenth-century British explorer, not for the doctor). At this point, to his comrades' surprise, Cook announced that he wanted to return to McKinley for a further reconnaissance. With a single companion, Montana horsepacker Edward Barrill, Cook set off again for the interior in mid-August.

The two men were back in civilization in only a little over a month. Now Cook made his bombshell announcement to the world: he and Barrill had stood on the summit of McKinley on September 16.

Browne and Parker knew at once that the doctor was lying. As Browne later wrote, "I knew it in the same way that any New Yorker

would know that no man could walk from the Brooklyn Bridge to Grant's Tomb [a distance of eight miles] in ten minutes." As soon as the two claimants for the first ascent had regained the coast, Browne took Barrill aside and questioned him. According to Browne, the horsepacker said, "I can tell you all about the big peaks just south of the mountain, but if you want to know about Mount McKinley go and ask Cook."

Nonetheless, Cook went ahead to write a book about his alleged triumph. *To the Top of the Continent* was published in 1908. Hudson Stuck, archdeacon of the Yukon, who would lead the true first ascent in 1913, later wrote:

> [T]he writer well remembers the eagerness with which his copy (the only one in Fairbanks) was perused by man after man from the Kantishna [gold] diggings, and the acute way in which they detected the place where vague "fine writing" began to be substituted for definite description.

In the book, Cook committed a fatal error: he published a "summit photo." It shows Barrill standing in profile atop a rock-and-snow promontory, holding extended an American flag on a staff.

Even so, the controversy might have remained an almost private quarrel, a jealous dispute among former comrades, had Cook not used McKinley to launch an even bolder expedition in quest of the North Pole. By the time *Continent* was published, Cook was off in the wilds of Ellesmere Island, with only a pair of Eskimos as teammates, preparing his polar dash.

In doing so, he got the jump on his former colleague, Robert E. Peary, who was mounting his eighth attempt on the Pole. In his own grandiose way, Peary had come to think of the Arctic as *his* terrain, and he was furious upon learning of Cook's preemptive strike. By now

fifty-two years old, having lost all but two of his toes to frostbite on previous expeditions, Peary knew that this eighth attempt would be his last.

Cook emerged from the Arctic in April 1909, claiming he had attained the North Pole a year before. Peary returned to announce his own success only five months later, on September 6. Unlike McKinley, the polar controversy was front-page news around the world.

The consensus of today's leading experts is that both men perpetrated hoaxes. Cook probably wandered for months with his Eskimo companions along the shores of Ellesmere Island, making no real attempt to head for 90° North. If, as Dunn implied, "the Professor" didn't even know how to use a theodolite, he would have been hopelessly lost once out of sight of land.

On his last attempt, Peary probably got fairly close to the Pole, perhaps within a hundred miles. But a host of circumstantial evidence argues against his having closed that last gap—including the requirement that, after averaging only about nine miles a day for most of the journey, on the final dash, with no companions who could verify his survey observations, he would have had to sledge some fifty-three miles a day—a rate that no Arctic explorer since has been able to come close to matching.

In 1910, with the polar controversy at white heat, Belmore Browne and Herschel Parker launched another attempt on McKinley from the south. Their jaunt had as its secondary purpose an effort to figure out just what Cook and Barrill had really accomplished four years earlier. This time, the men headed straight for the Ruth Glacier, which they ascended, entering the awesome corridor of the Great Gorge.

It has often been remarked that had Frederick Cook taken credit only for the voyages he genuinely pulled off, he would be esteemed today as a first-rate explorer. Browne and Parker recognized that the doctor and the horsepacker, with no real mountaineering experience,

had been the first men to traverse a good part of the Great Gorge, weaving their way through potentially lethal crevasse fields. Stern mountains that Cook had named in the captions of photos published in *To the Top of the Continent* now unveiled themselves to Parker and Browne on either side of the glacier. Cook and his partner might even have reached 5,400 feet, not far from the base of Mt. Dickey at the head of the Great Gorge.

But now, Browne and Parker pulled off a spectacular piece of detective work. Wandering up a small side-glacier of the Ruth, matching their surroundings to Cook's photos, they discovered the diminutive lump on the top of which the doctor had shot Barrill holding the American flag. The two sleuths climbed this trivial summit in a matter of minutes and duplicated Cook's bogus summit photo. Though the snow cover was different (there was much more snow on the peak in July 1910 than in September 1906), many small rock features in the two photos unmistakably matched.

Fake Peak, as the 500-foot-tall knob has been known ever since, stands nineteen miles south of McKinley's summit and 15,000 vertical feet below the highest point in North America. An oft-published Brad Washburn photo says it all—the magnificent bulk of McKinley at the top, the savage walls of the Great Gorge running left to right through the center of the picture, and Fake Peak at the bottom, so minuscule a bump that Brad had to draw a circle around it to identify it for the viewer.

Browne published his narrative of the detective work in *Metropolitan Magazine* in 1911, and two years later in his own book, *The Conquest of Mount McKinley,* one of the outstanding classics of Alaskan mountaineering.

And so, one would think, case closed. Cook was dropped from the American Alpine Club, of which he had been one of the founders in 1902, and from the Explorers Club, of which he was a past president. Cementing the man's disgrace was a sworn affidavit published in the

New York Times in 1909. In it Edward Barrill testified that in 1906, he and Cook had gotten nowhere near the summit of McKinley. The doctor had dictated diary entries to the semiliterate horsepacker, then ordered him to leave blank the pages after September 12. Cook later filled in the blank pages with his own fictitious narrative. And on September 16, Barrill confessed, as the two men had strolled up Fake Peak, Cook had said, "We will go back down and get a picture of this. . . . That point would make a good top for Mount McKinley." Barrill had gone along with the hoax for three years in hopes of getting more money out of Cook, and in the naive belief that the faked ascent would never attract much attention.

Yet the twin controversies—McKinley and the North Pole—brought out of the shadows an odd collection of Cook's defenders, motivated in large part by a classic American sympathy for the underdog. Some of them accused the Peary Arctic Club (a powerful and munificent group of backers) of bribing Barrill to write a phony affidavit. In 1913, a geographer maintained that Browne had *painted* the duplicate summit photo. (Browne was in fact an accomplished painter, and late in life he supplied splendid dioramas of Alaskan landscapes to Brad's Museum of Science.) Cook claimed that as he was off in the Arctic when *To the Top of the Continent* was published, he was not responsible for the erroneous captions that accompanied the pictures in the book—including the incriminating summit photo, boldly glossed as "THE TOP OF OUR CONTINENT. The summit of Mount McKinley, the highest mountain of North America. Altitude 20,390 feet." (Cook never explained why he would have bothered to shoot the horsepacker hoisting an American flag on an insignificant 5,386-foot-high bump far to the southeast of McKinley.)

The rest of Cook's life was a dreary pageant of stoic denial and public humiliation. He went on only one more expedition, an anthropological excursion to Borneo. In the 1920s, Cook reinvented himself

as an oil promoter, selling land stock by mail in his Texas-based Petroleum Producers' Association. In 1923, a federal court ruled that the supposedly oil-rich land was worthless and convicted Cook of mail fraud. He spent five years in Fort Leavenworth prison. In 1930, he was paroled at the age of sixty-four. He spent his last decade in poverty, his claims to the North Pole and Mt. McKinley supported by his fanatically loyal daughter, Helene.

The double hoaxer never cracked. In Robert Dunn's autobiography, *World Alive* (1956), the ex-newspaperman recounted a chance meeting with Cook in New York City in the late 1930s:

> One night I walked into the Waldorf's old square bar, deserted but for one man alone at a table, sipping champagne. I went over; Doc beamed placidly.
>
> "Hey, Doc. Put it all over on the world, didn't you?" I greeted him.
>
> An hour we must have talked, his stream of words repeating his published story. Whether or not he believed what he said, I couldn't tell, but his justification of his claims grew pathetic. I never saw him again.

Cook died in 1940. On his deathbed, he was pardoned by President Franklin D. Roosevelt.

Later in life, it would recurrently vex Brad Washburn to reflect that, sometime during the 1930s, he could easily have sought out Frederick A. Cook, chatted with him about Mt. McKinley, and perhaps even have conducted a real interview. Brad had done just that with two McKinley pioneers, Charlie McGonagall from the 1910 sourdough expedition, and Harry Karstens from the 1913 first ascent.

Despite his 1936 aerial-photography flights, however, throughout the 1930s Brad had no intention of climbing McKinley. It was other, untouched mountains that held him in thrall. Brad did not turn his own ambitions toward "The Top of the Continent" until the 1942 gear-testing expedition for the armed forces. And by 1942, Cook had been dead for two years.

By the mid-1950s, of course, Brad had climbed McKinley three times and pioneered the West Buttress route. In the early spring of 1955, as he completed his survey of the great mountain for the map that would be published in 1960 by the Swiss Foundation for Alpine Research, he spent thirty days in the field, most of it in and around the Great Gorge of the Ruth Glacier. It was during this trip that he made the first ascent of the handsome peak he would name Mt. Dickey.

Inevitably that spring, Brad's thoughts turned to Frederick A. Cook. He had brought along copies of the photos published in *To the Top of the Continent.* Every bit as good a sleuth as Belmore Browne, Brad was able to match these pictures to the topography of the Ruth Gorge. Cook had evidently hoped to use these photos to "document" his climb toward the summit. A picture of a fog-shrouded, spiky rock ridge above a broad glacier, for instance, was captioned "In the Silent Glory and Snowy Wonder of the Upper World, 15,400 feet." Brad duplicated it perfectly from the middle of the Great Gorge, around 5,000 feet. In the 1956 *AAJ,* he wrote:

> For legal (copyright) reasons, it is impossible to relate the results
> of this fascinating bit of geographical detective work until next fall
> (50 years after Cook's trip). Suffice it to say that we precisely lo-
> cated the spot from which every one of Dr. Cook's key unidentified
> photographs was made and not a single one of them was exposed
> at an altitude of more than 5,400 feet!

The case against Cook's McKinley climb did not hinge solely on the photos with their misleading captions. Browne's comparison of the purported Cook-Barrill feat to a ten-minute walk from the Brooklyn Bridge to Grant's Tomb reflected what every mountaineer familiar with McKinley would see as a self-evident impossibility—the sheer distance Cook claimed to have traveled and the sheer altitude gained and lost in a period of less than two weeks.

McKinley from the south turns out to be a formidable challenge. The first ascent of any of its southern routes would not come until 1954, and then by the South Buttress, a line far to the west of the one Cook claimed he and Barrill had negotiated. That line, in fact, is so difficult that its "crux"—a fiendishly corniced horizontal knife-edged ridge at 11,400 feet—has still never been traversed, despite attempts by some very good mountaineers.

In *Continent,* Cook narrated the last steps of his and Barrill's ascent in a now-famous sentence: "We edged along a steep snowy ridge and over the heaven-scraped granite to the top." This description, vague as it is, was evidently tailored to match the summit of Fake Peak, where granite outcrops are interspersed with patches of permanent snow. But as Brad knew from his three ascents of McKinley, there is no exposed rock anywhere near the summit. As he would write in 1958, "There is no rock of any sort *on the top of the South Peak* nor within several hundred yards of it on the surface, except on the south face, because the granite underlies a mantle of solid snow, possibly 50–75 feet deep."

Yet over the years after 1906, defenders of both of Cook's claims kept crawling out of the woodwork. Two self-styled "experts" published analyses of Browne's and Cook's summit photos, claiming to identify six significant differences that invalidated Browne's assertion that he had duplicated the picture of Barrill with the flag. Meanwhile, Helene Cook Vetter, the doctor's daughter, made it her life's work to rehabilitate her father's reputation. In 1940 she founded the Frederick A.

Cook Society, one of the strangest collections of true believers ever to rally around an exploratory cause. Their number included a fair share of wackos, armchair pundits who had never been near McKinley or the Arctic, and dyed-in-the-wool conspiracy theorists. Today, 103 years after Cook's adventure on McKinley, the society flourishes.

Thanks to the "Cookies," Browne was subjected to an endless barrage of personal attacks for the rest of his life. As his grandson, Brock Browne, told me in 1979, "What Aunt Evelyn always said was that what we should have done was simply offer *anybody* $50,000 to climb McKinley by the route Cook claimed, with the gear he had, in the time he said it took. That would have settled the whole thing."

Piqued by his 1955 discoveries in the Great Gorge, and bemused by the obstinate persistence of Cook's true believers, Washburn determined to return to Fake Peak and nail shut the coffin of Cook's McKinley hoax for good. One of Brad's weaknesses—the by-product of his somewhat naive faith in the power of reason—was his conviction that a watertight rational demonstration ought to sweep aside all possible counterarguments.

So Brad led a three-man trip back to the Ruth Glacier in August 1956. Just the month before, one of the few real mountaineers who believed in Cook, Seattle's Walter Gonnason, had led a four-man attempt on the doctor's alleged route, the east ridge of the East Buttress. Gonnason's team was partly funded by Helene Cook Vetter. Instead of hiking in from the lowlands, the party was deposited by a ski-equipped plane in the Ruth Amphitheater. After three dogged attempts, the climbers were turned back by that terrifying knife-edged ridge at 11,400 feet. As Brad would gleefully write in 1958, "In 14 days they covered a round trip of 25 miles and climbed only 6000 vertical feet, while Cook claimed to have climbed and descended no less than 85 horizontal miles and 19,000 vertical feet in 12 or 13 days."

One of Brad's 1956 teammates discovered a note left at the base of

Fake Peak. Still readable, it documented Browne's visit to the place on June 28, 1910. Then Brad lugged his large-format picture up to the point at which he calculated Cook had shot his photo of Barrill. There he took a series of razor-sharp photos.

There was only one glitch: as Brad recognized, a huge snowfield on which Cook had stood to take the picture had either melted out or sloughed off in the intervening fifty years. Brad's perspective on the summit features of Fake Peak came from a point some forty or fifty feet lower than Cook's.

Still, so many features matched—a prong of rock on the left skyline, a broad rocky slab in the lower left foreground—that the duplicate photos ought to have sealed the case. At this point, however, Brad's perfectionism infected his old Alaskan partner Ad Carter, who was also editor of the *American Alpine Journal*. In July 1957, Ad led a ten-man party back to Fake Peak. On the critical shoulder of the mountain, the men erected a fifty-foot aluminum pole and guyed it securely to surrounding rocks. Then Ad climbed the pole to its top, where with a borrowed large-format camera similar to Cook's, he duplicated the 1906 photo from a point in midair very close to where Cook had stood fifty-one years earlier.

The 1958 *AAJ* led off with a thirty-page analysis by Brad of the results of three summers' investigation of Cook's claim. A four-page foldout juxtaposed Cook's "summit photo," Browne's attempt to duplicate it, Brad's best 1956 shot, and Ad Carter's midair photo from the top of the aluminum pole. On the photos, Brad superimposed Arabic letters. "B" in Cook's, Washburn's, and Carter's pictures labeled the same unmistakable diamond-headed knob on the summit skyline, about fifteen feet behind Barrill's back; "H," "J," and "K" identified the same ascending trio of parallelogram-shaped slabs just below the summit. If Browne's photo conceivably left some margin for doubt, Brad's and Ad's pictures demolished all objections. No two mountains look alike.

The 5,386-foot lump Brad and Ad photographed was incontrovertibly the same peak on which Cook had manufactured his summit photo.

Brad's analysis, however, went far beyond identifying Fake Peak. He nailed down the true locations of Cook's other miscaptioned photos meant to carry the reader through McKinley's upper slopes. And in a "Critique of the Text," Brad raked over the crucial pages of *To the Top of the Continent* with a fine-tooth comb, exposing one absurdity after another. He summarized the work of the 1956 and 1957 field trips. While he concluded that "Cook's story has always bordered on the incredible and impossible," his peroration was almost magnanimous:

> It probably seemed beyond belief to Dr. Cook that anybody would ever revisit his insignificant little "summit," lost as it was amid the vast complexity of the Alaskan wilderness. It must have been a staggering shock to have it discovered in only four years. . . .
>
> The amazing length of time that Cook's supporters have continued to stand by him despite all of this adversity is probably due more to the bitter attacks of Peary and his followers than because of any inherent strength in Cook's own story. Americans always seem to rally nobly around an underdog at bay, and nobody ever likes to face the facts of a gigantic lie or hoax.

No one reading Brad's definitive case study in the 1958 *AAJ,* one would think, could ever again doubt the conclusion that Cook had faked the first ascent of McKinley—that in fact he had never climbed higher than 5,400 feet or farther north than the gateway of the Great Gorge. In my own 1982 book, *Great Exploration Hoaxes,* a survey of kindred fakers from the Renaissance navigator Sebastian Cabot to Donald Crowhurst (the sailor who tried to fake victory in the first solo around-the-world sailing race in 1968–69, went mad, and committed suicide by jumping overboard), I wrote, "In the history of exploration

no hoax was ever more conclusively exposed than the claim by Dr. Frederick Cook to have reached the summit of Mount McKinley in September 1906." Twenty-seven years later, I have no reason to alter that statement—thanks to the impeccable logic and precision of Brad's research.

What has happened to Cook's reputation during the fifty years since Brad thought he had closed the case, however, defies credibility. Helene Cook Vetter and the Cook Society only redoubled their efforts, turning their sniper fire away from Belmore Browne and onto Bradford Washburn. Two biographies of Cook appeared in 1961 and 1973, both exonerating the doctor of any deceit either on McKinley or in the Arctic. In the latter, *Winner Lose All: Dr. Cook and the Theft of the North Pole,* Hugh Eames concedes that Cook faked his McKinley summit photo, probably because he couldn't get his camera to work in the extreme cold up high on the mountain. Eames's argument that Cook and Barrill indeed reached the summit depends on vague similarities between his text and the accounts of later McKinley climbers. Thus Cook had written of the summit, "We felt like shouting, but had not the breath to spare." Eames matches this statement with Grant Pearson on the summit in 1932: "It was much too cold to yell."

Brad's hunch about the American love of the underdog came true in spades vis-à-vis Cook. Eames eulogized his hero thus: "He stands, in the history of the American democracy, as its most uniquely grand and somehow royal person, its Prince of Losers."

In the face of this willfully ignorant canonization, a more philosophical or equanimous man than Brad—someone like Bob Bates, for instance—might have shrugged his shoulders and turned his back on the controversy. But Brad couldn't let it go.

For one thing, the Frederick A. Cook Society kept up its relentless attacks on Washburn for decades. The society's files, archived in Columbus, Ohio, include reams of speculation scribbled on legal pads

by "experts" who have never walked on a glacier. More shocking is the sometimes obscene vituperation the Cookies have heaped on Brad in their indignant letters to one another. For these champions of the Prince of Losers, Washburn clearly represented the Exploring Establishment. His very stature as a Boston Brahmin and museum director singled him out for bitter scorn. The Cookies assumed that Brad had access to limitless funds of cash that he expended gratuitously tarnishing the long-dead doctor's reputation.

In 1994, a Cookie named Ted Heckathorn organized another expedition to attempt the east ridge of the East Buttress. A modest climber, Heckathorn recruited two world-class mountaineers and guides, Scott Fischer (who would die leading his team on Everest in the famous 1996 tragedy) and Vern Tejas, the first man successfully to solo McKinley in winter and the youngest person to bag the Seven Summits (the highest peaks on each continent, including McKinley and Everest).

Yet just like Gonnason's party in 1956, Heckathorn's strong team was stopped cold by the serpentine knife-edge at 11,400 feet. Stung by this apparent setback, Heckathorn later claimed that the party had never intended to climb the whole route, but rather only to match views with the pictures in *To the Top of the Continent*—a mission Heckathorn insisted he had accomplished.

It seemed bizarre to me that a very good mountaineer intimately familiar with McKinley could have believed in Cook's claim. A few years after Heckathorn's expedition, I asked Tejas whether he hadn't viewed the 1994 trip as simply an all-expenses-paid boondoggle to get himself on a new route on the mountain. Tejas strenuously denied such an ulterior motive. He was not willing to say that he was sure Cook and Barrill had reached the top, but he felt that it was a distinct possibility.

A distrust of authority, I realized, was a common trait of top climbers. It was what drove them to feats that "experts" had deemed im-

possible. And in terms of the Cook controversy, Brad Washburn represented authority.

In February 1996, three judges in Fairbanks presided over a mock trial to resolve Cook's McKinley claim. Brad let himself be lured to this circus, where he spoke for the prosecution. The Cookies haughtily declined to appoint a defense attorney. In the end, two of the judges ruled against Cook, while the third abstained.

The next year, at a Mt. McKinley symposium in Portland, Oregon, Heckathorn and Brad locked horns in an impromptu debate. In attendance was Walter Gonnason, now seventy-four years old, who at one point shouted out, "People have no right to question Dr. Cook! Belmore Browne was a liar!"

Brad gave a slide show that focused on his own photos of McKinley's summit, demonstrating how its true appearance could not be reconciled with anything Cook had written or photographed. Later he derided the Cookies to a writer, saying, "They're a perfect team, because they're all as good at lying as Cook was."

But the next day, Heckathorn got in a last word of sorts. Patiently and pedantically, he ticked off the "evidence" in support of Cook that he had spent years gathering, including a canceled $5,000 check, the alleged bribe for Barrill's affidavit to the *New York Times*. At the end of his presentation, he pleaded, "Read Dr. Cook's own account. Don't take someone else's word for it." When he asked for questions, Heckathorn was greeted with a stony silence.

Later, in the Cook Society newsletter, *Polar Priorities,* Heckathorn wrote, "Perhaps the most amazing aspect to my Mount McKinley investigation has been the behavior of Brad Washburn. He is one of the most intelligent and charming people that this writer has ever met. . . . Yet, where Dr. Cook is concerned he displays an anger and vindictiveness that is hard to explain."

In his declining years, Brad developed a quirky habit. Having barely

mastered the use of a word processor (he never learned how to save or back up his files), he would compose brief manifestos or rosters of arcane facts, such as the total number of steps he might have taken on one of his expeditions. He would print these up in bold 24-point type, then laminate the pages. When I would visit Brad, sometimes even before saying hello or shaking my hand, he would thrust one of these plasticine broadsides into my hand, saying, "Take a look at this."

One document Brad showed me five or six times was the case against Dr. Cook on Mt. McKinley, reduced to two pages, each sentence accentuated with an exclamation mark or two. It was as if Brad feared that the truths he had spent his life ascertaining might vanish with his passing. The laminated, big-print declaration was his way of shouting out the facts in the face of eternity.

In December 1997, Brad handed me another laminated page. It was a challenge he planned to issue to the Cook Society, daring it to finance a two-man team of mountaineers over the age of forty (Cook and Barrill had been forty-one and forty-two, respectively, in 1906) who would carry the same equipment that the doctor and the horsepacker had. The climbers would be allowed twelve days in early September to go eighty-eight miles round-trip, up the east ridge and East Buttress to the top, and down and back again to the lowlands.

I read the challenge, then said, "Hell, Brad, the strongest mountaineers in the world couldn't pull that off. Forget over forty; let the Cookies send anybody they want."

Brad's face lit up in a weathered grin. "Sure," he responded. "Why not?"

But the true believers continued to drive Brad to distraction. And so, in 2001, with cowriter Peter Cherici, Brad published *The Dishonorable Dr. Cook: Debunking the Notorious Mount McKinley Hoax.* This 185-page volume, illustrated with dozens of Brad's photos and period pictures of Cook and his cronies, is the complete dossier on the controversy.

In the end, however, the Cookies have outlasted and outlived Brad Washburn. On April 21, 2008, the Cook Society celebrated what it called "The Centennial of the Discovery of the North Pole." And the society's website contains a long diatribe by Ted Heckathorn, which ends, "During his lifetime Brad's significant contributions to the Museum of Science, mountaineering, photography and other fields rightfully earned him a large entry in 'Who's Who.' On the other hand, he never publicly apologized for his false statements and dirty deeds he perpetrated against . . . Dr. Frederick Cook."

The website also archives Heckathorn's 2005 review of *The Dishonorable Dr. Cook.* It begins, "Four years ago Brad Washburn advised me that he was writing a book about Dr. Cook that 'would knock my socks off.' Recently, when this new book finally arrived, I tied my shoelaces with double knots before opening the odd-sized volume." And the review ends, "Frederick Cook and Brad Washburn will go down as the two competing giants in Mount McKinley history. That is how I will remember them, and after reading this book, it appears that my socks are not endangered."

The Prince of Losers must be chortling in his grave.

By the 1950s, Brad had become the acknowledged expert on the mountains of Alaska and the Yukon. The articles he published touting challenges for the next generation signaled his eagerness to share the wealth of his knowledge as broadly as possible. In 1965, however, he was instrumental in orchestrating a first ascent that, however blithe a publicity coup it turned out to be, would never sit well with the hardcore fraternity of mountaineers who cared about the Far North.

On his monumental traverse of the Saint Elias Range in 1935, Brad's team had discovered a soaring 13,905-foot peak that was hitherto unknown. A satellite to the slightly higher Mt. Hubbard, named back in

1891 by a USGS surveyor, the "new" peak was given the rather soul-less provisional name of East Hubbard. On later photographic flights around the mountain, Brad discovered that from the south side the mountain would be a walk-up. But its north ridge—a stunning, arrow-straight vector leading 6,000 feet from glacier to summit—is one of the finest routes in North America. It was first climbed by two tough and determined mountaineers in 1968 in classic expedition style, using tent camps and fixed ropes. Decades later, one of the aspirants for the first alpine-style ascent called the north ridge "the most beautiful route in the world."

In 1965, however, East Hubbard remained unclimbed. The peak stands just a mile or two east of the Alaskan border, which passes through the summit of Hubbard itself. In January of that year, the Canadian government agreed to rename East Hubbard Mt. Kennedy, in honor of the assassinated American president. (What part Brad played in negotiating this renaming, he never made clear, but one guesses that he was instrumental in the process.)

In March 1965, Brad organized an expedition both to survey the area and to make Mt. Kennedy's first ascent. Brad would do none of the climbing, which was turned over to a strong team headed by Seattle mountaineer Jim Whittaker. Two years earlier, Whittaker had been the first American to reach the summit of Mt. Everest, instantly becoming the most famous American climber ever—a distinction he would wear for a good two decades thereafter. Meanwhile, Whittaker nursed political ambitions, as he pondered a bid for the U.S. Senate.

The publicity coup—evidently the joint brainchild of Whittaker and Washburn—was to have Senator Robert F. Kennedy join in the first ascent. Bobby Kennedy may have been a good touch football player, but he had never climbed a mountain of any size or shape. Nonetheless, he was persuaded that bagging the first ascent of the remote peak in the Yukon named for his brother might pay political dividends in his own eventual campaign for the presidency.

Logistical overkill was brought to bear to ensure that no glitches might endanger the walk-up. Before Kennedy even flew to Whitehorse, a party of four good climbers and NGS photographer Bill Allard landed at a base camp at 8,750 feet on the Cathedral Glacier, then promptly climbed Mt. Hubbard (making its second ascent) and reconnoitered Mt. Kennedy to a point only 900 feet short of the top, where they left a hefty cache.

On March 22, Whittaker and Kennedy flew in. On the very next day, eight climbers left base camp at 8:00 A.M. and reached the 13,000-foot cache without incident. The rest of the climb was a routine stroll to the summit, though conditions on top were rugged, with a temperature of five degrees Fahrenheit and wind gusts up to twenty-five miles per hour.

The ascent made its predictable splash. *National Geographic* ran with it, devoting the first thirty-four pages of its November 1965 issue to three separate articles: "Canada's Mount Kennedy: The Discovery," by Brad; "A Peak Worthy of the President," by Bobby Kennedy (or his ghostwriter); and "The First Ascent," by Whittaker. Brad also wrote up the expedition for the 1966 *AAJ*. Although he admitted that the route "does not involve any technical problems of consequence," Brad added, "The most extraordinary aspect of the climb of March 1965 was the fact that Senator Kennedy made the round trip to the summit of Mount Kennedy from Washington, D.C. in barely 5 days—an incredible tour de force and a remarkable accomplishment for someone who had never climbed before."

Walk-up or no, the idea that the first ascent of a major subarctic mountain had been turned into a political publicity stunt stuck in the craw of most serious climbers. And the scuttlebutt emerged that Bobby Kennedy had freaked out the minute he landed on the glacier and demanded to be flown out. Whittaker's crew, however (so rumor had it), had shamed him into staying, then virtually dragged him on a tight rope up the mountain.

Barbara Washburn's recollections furnish an impish epilogue to this travesty of an adventure. According to her, during his brief time in Whitehorse, Kennedy hosted lavish cocktail parties in his hotel, then left town without paying a penny of the bill. "The National Geographic Society ordered Brad to stay up there to clean up Bobby's mess," Barbara recalled in 2008.

Furthermore, according to Barbara, after the climb, as Kennedy was boarding the airplane that would take him back to Washington, he suddenly blurted out, "Brad, I forgot to buy presents for the kids! Can you do it?"

"How many kids do you have?" Brad answered.

Kennedy hesitated. "I'm not sure," he said, as he tried to count up his numerous offspring. Then he was gone.

Dutifully, Brad visited the Whitehorse gift shops and bought dolls and figurines crafted by local natives, which he then mailed to Kennedy's office. According to Barbara, the senator's secretary called Brad to thank him, adding, "You have wonderful taste." But shortly thereafter, Brad got a return package in the mail. "It was the dolls and figurines, all broken up," Barbara remembered. "The senator said he didn't want them."

While still in Whitehorse—again, according to Barbara—Brad had to walk into Kennedy's hotel room to plead with him to give a last talk to the local schoolkids, who had greeted the famous senator with a heartfelt reception. "Bobby was taking a shower," Barbara relates. "He walked out of the bathroom stark naked. 'Brad, do I have to?' he complained. 'Yes, you have to,' Brad told him. 'Those kids have really put themselves out for you.'"

With a sigh, Kennedy faced his obligation and delivered a talk to the kids. "And wouldn't you know it?" Barbara remembered. "Brad said it was the best speech he had ever heard."

◆ ◆ ◆

Although Brad was lavish with advice for climbers interested in new routes in Alaska and the Yukon, he did not suffer what he considered fools gladly. In May 1967, he received a letter from one Joe Wilcox, a twenty-four-year-old mountaineer Brad had never heard of, who was planning to lead a nine-man expedition that summer up the West Buttress route on McKinley. The letter both puzzled and irritated Brad.

Strapped for cash, Wilcox's team had put out feelers to various potential sponsors. Although commercial sponsorship for climbers is a commonplace today, it was a rarity in American mountaineering in 1967—even though Brad had been sponsored, or at least subsidized, on several expeditions by RKO Pictures, the NGS, and Harvard's Institute for Geographical Exploration.

Wilcox knew that by now, another ascent of the West Buttress route was no mountaineering breakthrough. Evidently, however, he thought that if his team promised to pull off certain "firsts," the sponsors might come through with cash support. So he asked Brad a series of questions about McKinley:

According to the Park Service, some climbers spent the night on the summit in 1960. To the best of your knowledge:

1. Has anyone else spent the night on the summit?
2. Has any group climbed both peaks simultaneously?
3. Has anyone camped on the north summit?
4. Has anyone camped on both summits simultaneously?

Your help will be greatly appreciated. I do not want my group to claim a "first" unless it is, indeed, a "first." . . .

Brad's response was prompt and withering. His May 17 letter said in part, "I have answered hundreds of queries about McKinley over a long period of time, but never before have I been faced with the prob-

lem of answering one quite like this. In fact, I am amazed that the National Park Service would grant a permit for such a weird undertaking." He went on to point out that both his own 1942 and 1947 expeditions "could easily have spent a week or more on top of either or both of the peaks if we had had the slightest inclination to do so."

Brad closed his letter with a memorable—and, it would turn out, prophetic—put-down:

> *For your information, according to our records, McKinley has not yet been climbed blindfold or backwards, nor has any party of nine persons yet fallen simultaneously into the same crevasse. We hope that you may wish to rise to one of these compelling challenges.*

Baffled and hurt by Washburn's derision, Wilcox went on to assemble his team. At the last minute, the Park Service, deeming the climbers' experience a bit thin, demanded that the Wilcox team join up with a three-man party from Colorado, led by another little-known climber, Howard Snyder.

That pairing was unfortunate and rancorous, as frequent disputes about where and when to camp and climb broke out, and the leaders squabbled over load-carrying duties. By mid-July, however, most of the combined team was camped high on McKinley in a combination of snow caves and tents. And then a vicious storm hit the mountain—a storm that would last for ten days.

That same storm struck our party in the Revelation Range, 110 miles southwest of McKinley. I remember it as one of the nastiest and most prolonged tempests I ever endured in thirteen years of expeditions to the North, but it was not truly life-threatening. On the other hand, our team was camped much lower than the Wilcox-Snyder climbers.

By the time the storm blew itself out, seven members of what is now called simply the Wilcox party had died of hypothermia. That

1967 disaster remains the most deadly in the history of expeditionary mountaineering in North America.

I thought at the time, and still think, that the climbers who died had simply blown it. They had panicked in the storm, or lost the will to take care of themselves. They should have been able to survive the ten-day blizzard. Brad felt the same way. He had endured a comparable prolonged storm high on McKinley in 1947, in which none of his teammates had suffered even minor frostbite. And Brad had easily survived other all-out tempests on Lucania, Marcus Baker, and in winter in the Saint Elias Range.

Because of the magnitude of the disaster, the Park Service afterward conducted a thorough inquiry, inviting Brad to contribute his expertise to the task. Brad threw himself into the investigation, perhaps with a bit more I-told-you-so zeal than was seemly.

In later years, both Snyder and Wilcox, who survived the storm, wrote books about the tragedy. Snyder's *The Hall of the Mountain King* and Wilcox's *White Winds* both tell the story of the unfolding disaster with sympathy and drama, yet each book is vitiated by a self-serving effort to shift the blame away from its author.

In 2007, casual mountaineer and veteran outdoor writer James M. Tabor published *Forever on the Mountain*. The definitive book about the Wilcox disaster, Tabor's opus won the grand prize at the Banff Mountain Book Festival in November 2007.

During one day in May 2005, Tabor visited Brad in his Lexington, Massachusetts, home to interview him about his role in the 1967 inquiry. Not surprisingly, the ninety-four-year-old's memory of the Wilcox details by then was a bit fuzzy. Tabor read back to Brad the closing paragraph of the letter that had so wounded Wilcox. As Tabor later wrote, "Brad regarded the letter silently for a moment, then broke into a grin and chuckled."

But Tabor pressed the matter, insisting, "This seems an unusually

sharp letter. . . . I'd like to know what Joe Wilcox did to tick you off so much."

When Brad hesitated, Barbara, who sat in on the interview, chimed in. "Yes," she said, "but why were you so mad, Brad?"

"I wasn't mad," Brad answered. "I was just disgusted. Because they were doing a *publicity stunt.*"

Forever on the Mountain was published several months after Brad's death. In one sense, this is a shame, for Brad never got the chance to answer the rough criticisms of his role in the investigation that Tabor leveled. In particular, Tabor flung back in Brad's face the "publicity stunt" imputation, as he gave a résumé of Brad's own RKO-sponsored McKinley expedition, closing his chapter with the taunt, "[T]he 1947 climb was bankrolled by a classic Hollywood caper to the tune of $240,000 in today's dollars. . . . It was, in other words, a grand publicity stunt."

Tabor's central premise is that a rescue could and should have been mounted to save the stranded men's lives. In Tabor's view, all kinds of potential saviors, ranging from Park Service personnel to bush pilots to air force officers, dithered and procrastinated, rather than plunging into a rescue mission.

As Tabor is a good friend of mine, he consulted with me several times while he was writing the book. When I told him that in the 1960s in Alaska, we never dreamed of getting rescued—that we knew that if we got into trouble, we had to get ourselves out—he professed incredulity. In the long run, given the force of his verdict that the Wilcox party should have been rescued, Tabor evidently didn't believe me.

At the end of her memoir, *The Accidental Adventurer,* Barbara struck a characteristically modest and even subservient note:

My children sometimes tell me that I led "Dad's life." That is true—but what a fool I would have been to go my own way and miss all of those adventures. I was very lucky to have a husband who wanted me to share his life and who constantly gave me credit for what I did. He opened up a whole new world for me.

What Barbara barely acknowledges in that memoir, however, is that for twenty years, starting in 1964, she had her own career, teaching children with dyslexia and other reading disabilities at Shady Hill school in Cambridge. Only two pages of *Adventurer* reflect what must have been the enormous satisfaction of her breakthroughs with her students. Even then, Barbara recounts her successes disarmingly:

Not many years ago, Brad and I were attending a reception at the Royal Geographical Society in London, and I noticed a young man hovering near us.

"Are you waiting to speak to my husband?" I asked him.

"No, Mrs. Washburn," he said. "I'm waiting to speak to you. You taught me in the fourth grade at Shady Hill when I couldn't read very well."

The student was now a banker in Europe, married to a lawyer, and obviously very successful. With a smile he said, "I don't have to spell very well now. I have a secretary."

In 1984, Brad and Barbara were in Nepal, after Brad had cleared away a massive roadblock of Chinese red tape to get permission to fly over Everest and take aerial photos, in aid of the mapping project that had become so dear to his heart. On November 10, some American friends in Kathmandu threw a seventieth birthday party for Barbara, but she had come down with a 104-degree fever and was too ill to attend. Her condition rapidly worsened, with a highly elevated white

blood cell count. Local physicians puzzled over the malady, testing for various tropical diseases. (A Nepalese lady prescribed pomegranate seeds as a folk remedy.) Finally one of the doctors urged Brad to take his wife at once to Bangkok, where better treatment was available.

By now Barbara was in a wheelchair. In Bangkok, she was admitted to a hospital for the first time in thirty-eight years, since Betsy had been born. There, a doctor diagnosed lymphoma. In the already antiquated protocol of the day, he informed Brad but not Barbara. And he added, "Your wife is going to die within a week. If you want her to die at home, you'd better get her out of here in a hurry."

Brad did not tell Barbara the awful diagnosis. He simply told her they were flying home immediately. As Barbara wrote in *Adventurer,* "I was relieved, but my first thought was that I had to wash my hair, that I couldn't arrive home looking ill and disheveled."

On the plane, Barbara felt worse and worse.

> I was beginning to guess I might have a fatal illness. I even began musing about the woman Brad should marry if I died. I mulled over a list of widowed friends and I couldn't think of a single one who would fit Brad's requirements in a wife. I decided I had to concentrate on getting well.

What saved Barbara's life was a canny hunch by one of her doctors at Mass General Hospital in Boston, who remembered an obscure lesson from his second year in medical school. Wegener's granulomatosis is an exceedingly rare blood disease, but the doctor recalled that it fit most of Barbara's symptoms. A kidney biopsy confirmed the diagnosis. She was immediately given massive doses of prednisone and Cytoxan, and for the first time since her birthday, her temperature dropped to normal.

Barbara was released from Mass General on Christmas Eve, but it would take four years for her to recover, during which time she faith-

fully continued to take the powerful medicines, all the while worry-
ing about their sometimes dire side effects. The disease and recovery
ended her Shady Hill teaching career, but twenty-five years later, at
the age of ninety-four, Barbara is going strong, her mental faculties as
acute as when she was a precocious student at Smith College.

Brad was able to complete his aerial survey of Mt. Everest, and the *Na-
tional Geographic* published his beautiful and spectacularly accurate
map in 1988. Then, more than a decade later, he pulled off another
Everest tour de force, remeasuring its altitude, which had been fixed
at 29,028 feet since 1955. Brad's ultimate surveying deed required the
coordination of his own aerial trigonometry, triangulation by Chinese
scientists from the ground, and the work of American climber Pete
Athans and Sherpa Chewang Nima, who carried a high-precision GPS
to the summit. In Explorers Hall at the National Geographic Society
one day in 1999, Brad took the podium to announce to a large cocktail
party throng that Mt. Everest was now officially 29,035 feet tall. Those
seven added feet meant everything to Brad, who grinned from ear to
ear as he made his announcement.

Despite the bad scare with Barbara's illness, despite some nasty
squabbles with the administration of the Museum of Science after
he retired as director in 1980 (the nastiest being a dispute over who
owned Brad's thousands of large-format negatives, once that body
of work proved to be worth a not inconsiderable fortune), and above
all despite the heartbreak of the scandal that engulfed Ted, Brad re-
mained throughout his life an incurable optimist. In 2005, he told Lew
Freedman:

> I would have loved to have climbed Everest. Other than that, I don't
> have any regrets in life. I am gratified and happy. We had three neat
> kids and nine grandchildren. The museum, which was my lifetime

job, is a great success. And I am very lucky that I had a marriage
with Barbara that is still going strong after sixty-four years. That
is clearly the best thing of all.

That optimism effervesces in Brad's three favorite quotations, ones
he cited so often they might be regarded as epigraphs to his life. One is
the famous couplet from Rudyard Kipling's "The Explorer":

> *"Something hidden. Go and find it. Go and look behind the Ranges—*
> *"Something lost behind the Ranges. Lost and waiting for you. Go!"*

Another is the equally famous injunction attributed to Goethe:

> *What you can do, or dream you can do, begin it.*
> *Boldness has genius, power and magic in it.*

The Goethe quotation—probably his best-known lines in English—
has a curious history, for Goethe scholars could not find its German
equivalent anywhere in the poet's vast oeuvre until recently, when an
expert named Katja Moser hunted it down in a "very free translation"
of *Faust* rendered by one John Anster in 1835. First of all, the lines in
question, which come from the prelude of Goethe's long play, appear in
the context of a rhetorical debate among the poet, the director, and the
actor. The director essentially says, Enough chitchat—let's get on with
the play. (The lines, then, speak for Goethe's own beliefs no more truly
than Polonius's "To thine own self be true" does for Shakespeare.)
 Worse, a clunky but very literal translation of the famous Anster
lines would go something like this:

> *What doesn't happen tonight, is not done tomorrow.*
> *And you should not miss a single day.*
> *Resolve should grasp the Possible,*
> *Courageous by the forelock.*

It then will not let it go.
And work on, as it must.

No matter, of course, whether the quotation should be attributed to Anster or Goethe. The lines meant much to Brad, as they have to every adventurer, athlete, or coach who tosses off mottoes to the nearest newspaper to the effect of "Anything you really try to achieve, you can do."

Brad's third touchstone quotation is the poem "High Flight," written in 1941 by nineteeen-year-old John Gillespie Magee Jr., an American who illegally crossed the border to join the Canadian Air Force during the Battle of Britain, before the United States had entered the war. Magee was then sent to England for pilot training. The poem was inspired by a breathtaking flight to 30,000 feet, a few days after which Magee sent it in a letter to his parents. Three months later, he was killed in a collision of two RAF planes over a field in Lincolnshire.

Sentimental or not, "High Flight" captures the sort of transport Brad Washburn felt not only as an aviator, but when he stood on the summits of mountains that had never before been climbed.

Oh! I have slipped the surly bonds of Earth
And danced the skies on laughter-silvered wings;
Sunward I've climbed, and joined the tumbling mirth
Of sun-split clouds—and done a hundred things
You have not dreamed of—wheeled and soared and swung
High in the sunlit silence. Hov'ring there,
I've chased the shouting wind along, and flung
My eager craft through footless halls of air.

Up, up the long delirious, burning blue,
I've topped the wind-swept heights with easy grace

Where never lark, or even eagle flew—
And, while with silent, lifting mind I've trod
The high untrespassed sanctity of space,
Put out my hand, and touched the face of God.

Until the end of his life, when asked what credos had guided his career, Brad would quote the whole of "High Flight" from memory.

Mentor and Protégé

I first met Brad Washburn when I was nineteen. The occasion was, for me, a momentous one, and Brad seemed every bit the intimidating legendary figure I had read about in climbing journals. But during that first meeting, I had no inkling that Washburn would become the mentor of my own mountaineering career, to such an extent that I would spend the next twenty years in effect emulating Brad's campaigns in the Far North.

In the fall of 1961, only a few days after arriving for my freshman year at Harvard, I had joined the mountaineering club. Having been a fairly serious climber in my native Colorado since the age of sixteen, I didn't expect much from the HMC. Were there even any real mountains in New England, where the highest summit (Mt. Washington) rose to a paltry 6,288 feet above sea level? I anticipated an assemblage of hearty backpackers, like the members of the Colorado Mountain Club, who gathered forty strong in alpine meadows to sing campfire songs and conduct blister clinics.

At that first HMC meeting, however, my preconceptions were shred-
ded. Back from their summer forays, several juniors had made mul-
tiple ascents in the Coast Range of British Columbia, including that of
storied Mt. Waddington. Another junior and a senior had participated
in the third ascent of the east ridge of Mt. Logan, North America's
second-highest peak. One of the upperclassmen, moreover, was Rick
Millikan, who I soon learned was George Mallory's grandson.

At the time, indeed, the HMC embraced by far the most ambitious
aggregation of college-age mountaineers anywhere in the country. Its
Advisory Council was presided over by Henry Hall, who had founded
the club back in 1924. At the age of sixty-six, Henry still attended every
meeting. Other Advisory Council members included Brad Washburn's
former teammates Ad Carter and Ben Ferris. Before our twice-yearly
"banquets" (ordinary dining-room meals dignified with a separate
room in the Lowell House commons), the Ad Council solemnly de-
liberated the finances of cabin repair or the parameters of member-
ship requirements. The generational continuum was a huge boon to
the HMC, for we undergraduates were quickly imbued with an awe-
struck appreciation of the deeds of our HMC predecessors in the great
ranges—none more shining than the expeditions carried out in the
1930s and early 1940s by Washburn's teams.

Brad was, however, too busy for the HMC, so it was not until the
spring of 1963 that I met the man. At the end of my sophomore year, I
joined six other students who had decided to try to climb Mt. McKin-
ley that summer. Only one of us had been on an Alaskan expedition
before. We had chosen as our objective the second ascent of the South-
east Spur. The youngest of the group, I was thrilled to be invited but
terrified by the audacity of our project.

Somehow Brad got wind of our plans and invited us to his house on
Sparks Street. Opening the door, dispensing with introductions, Brad
(fifty-two years old that spring) said, "I've got something to show you

boys." Since the Washburn legacy had hung over our HMC meetings, I was surprised on first meeting the man to see how slight he was. There was no mistaking the force of his will, proclaimed in the very design of his jutting chin and hawk-nosed visage.

Brad led us into the living room. "You don't want to make just the second ascent of the Southeast Spur," he said dismissively. "Here, take a look at this."

On the table, side by side, lay a pair of Brad's photos. They were of the Wickersham Wall, McKinley's north face, at 14,000 feet from base to top the largest precipice in North or South America. By 1963, it had never been attempted, let alone climbed. Brad slapped a stereo viewer on top of the photos.

One by one, we peered through the viewer and saw the massive wall leap out at us in three dimensions. "You get the most god-awful avalanches off the Wickersham," Brad announced. "But look how this rib divides 'em right and left." With his thumb he traced the central buttress, which indeed seemed to protrude from the face. "I guarantee you it's a safe route," Brad went on. "And you fellows are up to it. Besides, you damned well better grab it before someone else does."

Well, we sensed that evening, when Brad Washburn orders you to do something, you do it. Over thirty-five days in June and July, we hiked in from the Denali Highway, climbed the central buttress on the Wickersham Wall, made the first traverse of both summits of McKinley, descended the West Buttress, circled via the Peters Glacier back to base camp, and hiked out. Brad's estimation of the safety of the route was a bit sanguine: down low, we nearly got taken out by rockfall, and a few avalanches stopped way too close to our tents. Up higher, however, we were indeed secure on our buttress. As we watched the most gigantic avalanches we would ever see go roaring down the face on either side of us, we yelled ourselves hoarse.

For some reason, despite our success, the route gained the reputa-

tion of being unjustifiably dangerous. In the forty-five years since our ascent, it has never been repeated.

As we waited out a five-day storm on the Wickersham, snug in our tents at 17,000 feet, our pilot, the legendary Don Sheldon, tried to check on us (we had no radio). Flying through snow and cloud, he glimpsed our tracks disappearing into avalanche debris (in reality, the avalanches had demolished our tracks days after we had passed safely by). Sheldon sent out the alarm, and for three days we made national headlines. On the Huntley-Brinkley report, we were declared missing and feared dead.

Our parents went through the agony of waiting for news, but only Brad seemed insouciant. "What's the big fuss?" he told reporters. "Three or four days of bad weather is nothing on McKinley. Those boys know what they're doing."

Before the expedition, I had bought a cheap army surplus parka, dyed it magenta, and printed in black ink on the back a motto from one of Brad's *AAJ* articles, which saluted the Wickersham as "one of the greatest precipices known to man." On July 16, as we topped out on the north summit in fifty-mile-an-hour winds, five-below-zero temperatures, and smothering whiteout, one of our members, Hank Abrons, paused just long enough to plant a snow picket, to which he affixed a small bottle. Inside the bottle, he folded a note he had written that morning, recording the date and our names, and citing Brad's epigraph, "one of the greatest precipices known to man." (I have no idea if subsequent climbers ever found our marker and read the note.)

During our five-day wait at 17,000 feet, we had cut our rations to two small meals a day. As we traversed over the north summit, we were ravenous with hunger. At Denali Pass, we discovered a cache. From markings on the packages, we deduced that the depot had been left by Brad's expedition in 1947. And inside one box, there were several packets of chipped beef.

We hesitated, but hunger got the better of us, so we cooked up and

devoured the sixteen-year-old meat. A few hours later, we were all suffering from sour burps, but none of us came down with true food poisoning, and besides, it seemed an honor to digest rations left on Mt. McKinley by Brad Washburn.

In retrospect, I wonder why Brad was so confident in our abilities. He had little or no idea of our individual climbing résumés. We were obviously not in the league of Ricardo Cassin or Lionel Terray. Perhaps our youthful enthusiasm for the Far North simply reminded him of himself at the same age.

In 2007, when I read *Forever on the Mountain*, my friend Jim Tabor's book about the Wilcox disaster, I stumbled across a little jibe that Tabor had never told me he was going to write:

> In 1963, the [National Park Service] allowed seven Harvard undergraduates to attempt the unclimbed, incredibly hazardous Wickersham Wall. Not one of the climbers had ever been on a major expedition, and only one had even visited Alaska. They had nothing to recommend them for such an audacious attempt except Brad Washburn's urging that they should try it. . . . But their astonishing, against-all-odds victory should not obscure the fact that, in allowing them on the mountain at all, the NPS was wildly violating its own policy.

More tickled than miffed as I read this stern paragraph, I drifted dreamily back to the evening in Brad's Sparks Street living room, when he had given us his collective slap on the back and told us to go climb the Wickersham Wall.

Of our team of seven on McKinley, only two—my classmate, Don Jensen, and I—became afflicted with a Washburn-like passion for

Alaska. Determined to organize another expedition to some un-
climbed route in the summer of 1964, Don and I spent many an hour
in the HMC clubroom (a dank warren in the basement of Lowell
House, cluttered with ropes, ice axes, and old books) leafing through
copies of the *AAJ*. One day Don suddenly exclaimed, "Hey, Dave, look
at this."

The article in the 1955 issue of the journal detailed the first and
only ascent of Mt. Deborah, a 12,339-foot peak in the Hayes Range of
central Alaska. Two of the three pioneers on that climb were already
heroes in Don's and my mountaineering cosmos: Fred Beckey, who
would eventually make more first ascents than any other American,
living or dead; and the Austrian Heinrich Harrer, who had been one of
the four climbers to solve the deadly Eigerwand in 1938, and who had
gone on to write *Seven Years in Tibet*. In 1954, the trio had attacked
Deborah by what they considered the only feasible route, a long, steep
snow-and-ice wall on the west side. In the article, Beckey wrote, "It
was our unanimous conclusion that Deborah was the most sensational
ice climb any of us had ever undertaken."

What had caught Don's eye was a photo of Deborah's north face. It
was evident at a glance that the mountain was one of the sharpest and
steepest in North America: twenty miles to the east, the pyramid-
like Mt. Hayes, of which Washburn had made the first ascent in 1941,
was almost gentle by comparison. To Don's and my dawning excite-
ment, it became clear that no one had ever set foot on the east side of
Deborah, divided between the Gillam and Susitna glaciers. In profile
on the left edge of the photo rose the daunting vector of the east
ridge, a knife-edge of rock interspersed with curling cornices of
snow and ice.

The photo, of course, was one that Brad had taken from an air-
plane. In that moment, Don and I chose our goal for the summer of
1964. Though far smaller than the Wickersham Wall, the east ridge

of Deborah was patently much more difficult than anything we had climbed on Mt. McKinley. And in the end, Don and I decided to tackle Deborah as a two-man team, even though that modus operandi went against all the received wisdom of the day. (Except for Lucania, and then only by accident, even Brad had never gone after an expeditionary mountain with a single partner.)

Despite our conference in his Sparks Street home the year before, and his championing of us in the press, at twenty I still found Washburn daunting. Somehow, though, that winter I got up the gumption to call Brad and ask if he had other pictures of the east ridge of Deborah that we might see. "Sure," he answered at once. "Come on over to my office."

I made the pilgrimage to the Museum of Science. Being ushered by Brad's secretary into his fifth-floor corner headquarters felt like intruding upon some royal sanctum. I believe Brad delayed my mission long enough to shake my hand; he may even have congratulated me on the Wickersham. The walls of his high-ceilinged lair were hung with huge enlargements of some of his best photos. It was here that I first saw the famous picture of the six tiny climbers on the Doldenhorn: blown up to mammoth proportions, the image was breathtaking.

Without further ado, Brad led me through an adjoining conference room and into a kind of walk-in closet. The bookshelves there were lined with bound blue albums, each with a date embossed on its spine, ranging back, as I recall, to 1932. Brad riffled through one, as I glimpsed contact print after contact print, each glued in the center of a black page, every one, it seemed, a stunning composition. He showed me how to use the typed index, then left me to browse at will.

I spent a charmed hour and a half in that airless closet. Though Brad had never intended to climb Mt. Deborah, the peak had caught his eye, and he had shot it from an airplane from every possible angle. I saw God's-eye views of the east ridge from the south, the east (head-

on, it looked almost vertical), and the north. I jotted down the catalog numbers of the most compelling pictures.

When I emerged, Brad said, "Which ones do you want?" It was then that he explained, to my considerable surprise, his practice of selling contact prints to climbers. In 1964, those matchless photos cost something like $1.49 apiece.

In subsequent weeks, Don Jensen—as obsessive a documentarian in his own way as Brad—spent many days peering at the photos, as he drew in pencil a large-scale "topo" of our route that tried to flesh out in three-dimensional detail every fluting, cornice, rock outcrop, and couloir on the east ridge. Once on the mountain, we carried both Brad's photos and Don's topo in our packs.

The east ridge proper, only 3,000 feet from base to summit, really began halfway up the 6,000-foot-high east face of Deborah. As it turned out, thanks to fiendish storms and harrowing logistics, we did not set hand or foot on the base of the ridge until the twenty-second day of the expedition. There, for the first time, we recognized the astonishing precision of Brad's pictures, for in them we could plainly see fissures, ledges, and prongs that on the ground were only a foot or two wide. A Washburn photo could indeed serve as a guide to an unknown mountain route.

Alas, Brad's photos could not get us up Mt. Deborah. After four weeks of struggle more intense than even the Wickersham Wall had required, we gave up 2,000 feet below the summit. (The east ridge of Deborah would finally be climbed by a crack international team eighteen years later, in 1982.) The rations we had planned were inadequate for the rugged toil we performed; as our forty-two-day failure ground on, we grew hungrier and hungrier, lost weight, and succumbed to a wasting lethargy. The tension between Don and me built into a gnawing, ceaseless fact of life. To cap things off, near the end of the trip, on the Gillam Glacier, Don fell sixty feet into a hidden crevasse, in a

plunge that could easily have killed him. It took half a day to extricate him from that potential death trap. All in all, the Deborah expedition would prove the most relentlessly miserable journey of my life.

You would think that such an experience would have turned us away from Alaska. Instead, the defeat rankled our spirits, until Don and I agreed that only another Alaskan expedition to a different but equally formidable mountain could serve as the proper revenge. By December of my senior year, I was back in Brad's walk-in closet, on the second of what over the years would turn out to be scores of visits, as I researched a satisfyingly daring objective.

Not once did Brad ever warn us away from a route. He never uttered the slightest word of discouragement, even while other veteran advisers did ("That looks pretty dangerous to me," or "What happens if that summit icefield cuts loose?"). I suppose Brad trusted our mountain judgment almost as much as he had his own, even though he freely admitted that the routes we tackled were harder than anything his generation had pulled off. (Such steady upping of the technical standards decade by decade has been true of mountaineering worldwide since its "invention" at the end of the eighteenth century.)

By now, Don had dropped out of Harvard and was working construction in his native California. It was thus entirely up to me to perform the research in Washburn's walk-in closet. Don and I traded letters every few days. For months we toyed with possible objectives—a new route on Foraker, Mt. Russell (which had been climbed only once), even a return to Deborah. But one day I came across a stunning series of pictures of Mt. Huntington, shot by Brad just the year before. The magnificent northwest ridge by which the French had made the first ascent in May 1964 was the obvious route on the mountain. But just to its right unfolded the sheer west face.

I could see at a glance that the face was steeper than any wall that had yet been climbed in Alaska. It would obviously be beyond our tal-

ents . . . and yet, was there the hint of a central rib protruding ever so slightly from the precipice? A pair of photos face-to-face on adjoining pages formed a stereo pair. Don had taught me a trick: by crossing my eyes but focusing them at the distance of the page, I could see in stereo without a viewer. Yes—there was a protruding rib, a possible line. I ordered the pictures and sent them to Don.

We enlisted two younger Harvard students to form a team of four. Our Huntington expedition would last forty days, only two days shorter than our ordeal on Deborah. And once again, incessant storms and logistical complexities seemed to doom our chances. After twenty days, we were not yet halfway up the route.

The climbing was even harder than what we had performed on Deborah. But there was one hugely consequential difference. The rock on Deborah was black schist, crumbly and shattered; holds routinely came loose in our hands or underfoot. But Huntington was made of a solid, clean brown granite. Climbing it, we could trust our holds and piton placements.

At last we got a spell of six consecutive days of perfect weather. Pushing as hard as we could, we arrived all four together on the summit at 3:30 A.M. on July 30, 1965. A few hours later, we collapsed in our highest camp, all four crammed into a two-man tent pitched narrow on an ice ledge. We fished out our bottle of "victory brandy"—a pint of blackberry-flavored Hiram Walker. Our first and heartiest toast was to Brad Washburn.

The west face of Huntington remains the finest climb of my life. It would have been a perfect expedition, except that it ended in tragedy. In the middle of the night of July 31, as the youngest member of our team, Ed Bernd, and I descended in semidarkness, we paused to set up a rappel. Suddenly, as soon as he leaned back on the rope, Ed was flying through the air away from me. He never uttered a word.

Somehow the anchor had failed—and to this day, I do not know

why. It was obvious, however, that Ed had fallen 4,500 feet to his death. The "perfect expedition" turned into a survival ordeal, as I had to climb without a rope down to the next camp, then wait two days for my other two partners to join me. Ed had fallen to a glacial basin so inaccessible that we never had a chance to search for his body.

Among the friends who offered us both congratulations and sympathy upon our return to civilization, none was more supportive than Brad. And he wrote to Lionel Terray to tell the great French mountaineer about the college kids who had made the second ascent of Huntington.

Among all the climbers in the world, Terray was Don's and my ultimate hero, ever since we had read his autobiography, *Conquistadors of the Useless* (still, in my view, the finest mountaineering memoir ever written). On Huntington, Don had memorized whole passages from Terray's 1965 *AAJ* article, which he would quote out loud in ironic homage at appropriate moments. Confined by a tempest in our base camp snow cave, Don would proclaim, "I have read somewhere that in this range the big storms can last for eight or ten consecutive days."

Now the thought that we might win the respect of our hero—might even correspond with him across the Atlantic!—sent our hearts soaring. But Terray, unable to believe that unknown college boys could have climbed a harder route than his on Huntington, wrote Brad back, wondering whether our ascent was a hoax. Brad immediately responded, vouching for our deed, but Terray never read the letter. On September 19, 1965, on what should have been a routine one-day climb for him in the Vercors, a limestone massif just south of his hometown of Grenoble, Terray and his partner fell roped together a thousand feet to their deaths.

Not even Don continued to pour all his ambitions into the Far North as I did. Between 1963 and 1975, I went on thirteen consecutive expedi-

tions to unclimbed peaks and routes in Alaska and the Yukon. In this respect, I followed Brad's example with a vengeance. Over the years, I turned down invitations to go along on expeditions to the Himalaya and the Andes. For several months in the winter of 1968–69, I was one of the principal organizers of the first American attempt on Dhaula-giri in Nepal, the world's sixth-highest mountain. Then I backed out, because I didn't like the leader's style, and because I didn't want to at-tempt a serious climb with strangers. Ever since, I have regarded that decision as one of the luckiest in my life, for on one of the first days on the mountain, the Dhaulagiri team was struck by a massive avalanche, killing seven men, including two good friends of mine.

On the other hand, I now keenly regret that I twice turned down in-vitations from Ad Carter to join his Andean expeditions. What I might have learned from that master among the Harvard Five! And, as I re-alized later, when Ad and I became close friends, what a good time I would have had simply hanging out at base camp with him.

Like Brad, I found it intolerable to go on an expedition led by anyone else. After the Wickersham Wall, I was the leader or coleader of all twelve of my subsequent expeditions. As products of the egalitar-ian late 1960s, we never really designated anyone as official "leader," in the sense that the nationalistic campaigns in the Himalaya in the 1950s unfailingly had. In the mountains, we made our decisions by consensus. But it was I who chose which mountains to climb, and usu-ally, in what style to do so.

Meanwhile, Brad and I became closer friends. Starting in 1966, however, and persisting through 1973, I ventured into ranges that Brad had never explored or photographed. Seventy miles southwest of McKinley in the Alaska Range, as I discovered from an intense study of the USGS maps, there was a small pocket of relatively low but fiercely steep and jagged granite peaks, called the Cathedral or Kichatna Spires. The highest summit rose only to 8,985 feet. But the

faces typically towered 4,000 feet sheer from the diminutive glaciers that cradled them.

The range was so little known that we were hard put to find a single photo of any of its peaks, or even an eyewitness account of what they looked like. In September 1966, however, our team made the first ascent of the highest peak, which we called Kichatna Spire, by a severe and bitterly cold northern route. The Spires, it is acknowledged today, contain the greatest concentration of technically difficult mountains anywhere in North America.

Sometime in the late 1960s, I asked Brad why he had never photographed the Spires. The pictures he might have brought back from a plane circling those savage monoliths would have been stupendous portraits, rivaling his canonic images of the Grandes Jorasses and the Matterhorn in the Alps. But the farthest southwest along the spine of the range that Brad had shot was the snow pyramid of Mt. Dall, still thirty miles away from the Spires.

"You mean down there by Rainy Pass?" Brad answered. "They call that the asshole of the Alaska Range."

Startled by his answer, I needed a moment to realize that his epithet referred to the weather, not the quality of the mountains.

During those interim years, I also organized an expedition to an unnamed and completely unexplored range a good fifty miles farther southwest beyond the Spires. After fifty-two days among peaks virtually as steep and difficult as the Kichatnas, we emerged with a handful of first ascents, and we also got to name the place. The Revelation Range is its official title, and today, forty-one years after our expedition, it still abounds in unclimbed peaks.

Three times I put together expeditions to the Brooks Range in far northern Alaska—a place that, as far as I knew, Brad had never been interested in. Once again, as on Huntington, we found clean granite, and made the first ascents of two of the range's finest peaks, Igikpak and Shot Tower.

It was only in 1974 that I returned to Brad's stomping grounds. The Great Gorge of the Ruth Glacier is one of the world's most colossal chasms. The glacier springs from the southeast flanks of Mt. McKinley and flows thirty-one miles south and east to its terminus in the lowlands. Below the broad basin at its head (known today officially as the Don Sheldon Amphitheater), the Ruth enters an eight-mile-long corridor, where it is flanked on both sides by near-vertical granite walls rising as much as 5,000 feet from the ice.

Washburn had first seen the Gorge on his aerial flights around McKinley in 1936. The place fascinated him, and, flying low over the glacial surface, he later made some of his most arresting "abstract" pictures of crevasse patterns and jumbles of seracs. In the mid-1950s, usually with Don Sheldon as his pilot, Brad made many landings in the Great Gorge, as he investigated on the ground the mysterious and controversial 1906 expedition, which had tried to climb McKinley via the Ruth Glacier.

At the head of the Great Gorge stand two of Alaska's most majestic peaks, the Mooses Tooth on the east, Mt. Dickey on the west. Dickey was named for the prospector who in turn had named Mt. McKinley way back in 1897. On one of his investigative jaunts, in 1955, Brad had made the first ascent of Dickey via its easy "back side" on the west, where it rises gently from Pittock Pass.

For years I had admired Brad's photos of the peaks hemming in the Great Gorge, and I had long since singled out what I thought might prove to be one of the finest routes on any of those colossal walls—the southeast face of Mt. Dickey. It rose in one continuous sweep 5,000 feet from glacier to summit. It was steeper than the west face of Huntington, and nearly twice as tall. Yet just as on Huntington, a slightly protruding rib—really a series of pillars interspersed with ledges—seemed to offer a less than suicidal line.

By 1974, no one had yet attempted any route on the walls of the Great Gorge, but the place was obviously going to be high on the

agenda of the eternally rivalrous "next generation." That summer, two friends—Ed Ward and Galen Rowell (just beginning to come into his own as one of America's finest wilderness photographers)—and I decided to give Dickey a try. With all three of us now in our early thirties, we could already feel the young Alaskan hotshots breathing down our backs.

By 1974, mountaineering in the great ranges was undergoing one of the few fundamental changes in its long history. The thrust was to replace the time-honored "expedition style" with what is called "alpine style." On an expedition-style assault, the team ferried loads between tent or igloo camps, stocking them in a logistical pyramid that crept slowly toward the summit. On the more difficult climbs, hundreds or even thousands of feet of fixed ropes were strung in place, to safeguard each subsequent load-carry and descent. From the highest camp, the team, or at least two of its members, would make the dash for the summit.

Expedition style was necessarily slow and cumbersome. On Huntington in 1965, we had strung fixed ropes on virtually every pitch. It was not surprising that it had taken us thirty-two days to reach the summit. And we had left all those fixed ropes in place on the descent. The second team to climb our route would find them, fraying and rotting in the sun and wind here, frozen into the ice there.

In the early 1960s, there was no sense that by leaving gear on the mountain, we were desecrating or polluting it. To the contrary, whenever we came across baggage left behind by some other party, like Washburn's chipped-beef cache at Denali Pass, we felt the thrill of archaeological discovery.

By the 1970s, however, there was a dawning sense that it was bad form to leave one's junk scattered up and down the mountain. A much cleaner style, practiced in the Alps for more than a decade, began to seem barely conceivable in the greater and more remote ranges. Attacking a mountain in alpine style, a team would leave

no fixed ropes, would camp in bivouac sacks instead of tents, and would carry only "half-bags" and down jackets instead of conventional sleeping bags, also eschewing air mattresses or foam pads, cushioning one's body instead at night by reclining on packs or laid-out ropes. The party would try to go from base to summit in a single, rapid thrust, with no ferrying of loads or stocking of camps.

In the 1970s, alpine style in the Andes, Himalaya, or Alaska was pretty "out there," for it left the climbers intensely vulnerable to storms or even to minor accidents. But its very boldness had an appeal. In a way, climbing alpine style in Alaska was the logical continuation of the fast-and-light revolution Washburn (and a few kindred souls such as Eric Shipton and Bill Tilman) had wrought back in the 1930s.

Ed, Galen, and I resolved to attempt Mt. Dickey's southeast face alpine style. We hoped to climb it not in a month, but in a single push lasting from three to five days. Nothing in Alaska of that scale or difficulty had yet been climbed in this style, but with Dickey, we had a built-in advantage that we could not have had, for instance, on Huntington. That was the "back side" that Brad had pioneered in 1955.

In July, we flew in to the Ruth Amphitheater with Don Sheldon, who was battling colon cancer and who had only six months to live. (After his death, that gloriously situated basin would be renamed for the greatest Alaskan bush pilot of his generation.) The very next day, we climbed Dickey by Washburn's easy west-side route. Our plan was to leave a gear cache—food, sleeping bags, stove, fuel, and a tent—on or near the summit. If we got to the top of our route, that cache could furnish a blessed refuge in a storm. Then, instead of descending our route, as we had on Huntington, we could clomp down the back side of Dickey and return to the Ruth Amphitheater for Sheldon's pickup.

As we climbed the gentle snow slopes, however, skirting crevasses here and there, it began snowing. Soon we were enveloped in a dense

whiteout. We could not see the summit, nor even be sure where it was. At last, we planted our cache high on the west ridge, within, we hoped, a few hundred yards of the top. We marked it with a long pole that we prayed would not melt out and collapse in the subsequent days. Peering through the fog, I tried to memorize the ephemeral landmarks of the place. Then we descended to Pittock Pass and camped.

Within a few days thereafter, we had circled the mountain by climbing down a tributary glacier that no one had ever before traversed, by which we gained the Great Gorge, and had set up our base camp beneath the soaring and intimidating southeast pillar. On July 17, only a week after Sheldon had deposited us in the Ruth Amphitheater, we started up the mountain.

As a route guide, I carried, folded in my shirt pocket, Brad's best contact print of the face. And this time, a Washburn photo may have actually saved our lives.

For two days, we climbed with superb efficiency. On the first, we managed to tame twenty-seven pitches in a nonstop seventeen-hour effort—by far the most I had ever accomplished (or would ever) in a single day. But by the second afternoon, a storm had started moving in from the south. We debated retreating, but if we did so, thanks to all the hardware we would use up setting rappel anchors, we would get no second chance on the route.

We bivouacked the second night in coffinlike lairs among the rocks of a broad ledge. We were 4,000 feet off the glacier. We had climbed four-fifths of our route, but now we had passed the point of no return.

By morning, a fierce storm engulfed the mountain—heavy snow, fifty-mile-an-hour winds, near-whiteout conditions. Foolishly, we had brought only one ice axe and one pair of crampons, and the last thousand feet of the route was a bewildering complex of steep ice grooves and flutings interspersed with rotten bands of black schist—the only part of Mt. Dickey that was not made of granite. I took the axe and

crampons and led all day, chopping steps for Ed and Galen, who had to use their rock hammers for purchase in lieu of axes.

Protection was almost nonexistent. If one of us slipped and fell, he would likely pull the other two off, and we would take the big ride. It was crucial to our survival that we find the cache near the summit, but I felt that I was heading blindly upward into a maze of bleary white treachery. At regular intervals, I pulled out of my pocket the crumpled Washburn photo, as I tried to correlate its details with the real world. Yes, amazingly, that serpentine fluting over there, that prong of schist here, showed up on Brad's picture: so I needed to angle a bit farther left.

Ice coating our beards and eyelashes, hypothermia just a careless step away, we struck the summit ridge only a hundred yards from our cache. We pitched the tent, crawled into our dry sleeping bags, and brewed up a victory soup. Once more, our first and heartiest toast was to Brad Washburn.

Eight years after our climb of Dickey, Brad added a beguiling footnote to our comprehension of the Great Gorge. From his first McKinley flights on, he had suspected that the Ruth Glacier had a colossal depth where it flowed through its eight-mile corridor. On Crillon in 1934, it will be recalled, Brad and Dick Goldthwait had set off dynamite on the surface of the South Crillon Glacier near its snout to make seismic soundings, which had allowed them to calculate an ice depth of 840 feet.

On the much more massive Ruth Glacier, such crude methods would prove inadequate. But in 1982, Brad commissioned a team of University of Alaska geologists to tackle the problem. Using the latest technology—far more sophisticated than Brad's dynamite (which was a sophisticated technique for its time)—the scientists discovered that the ice was an astounding 3,800 feet thick at the upper end of the Great Gorge. The true height of the southeast face of Mt. Dickey was thus some 9,000 feet from base to summit.

The Great Gorge, then, is half again as deep as the Grand Canyon at its deepest, and three times the depth of Yosemite Valley. Using the geologists' conventional definition of a "gorge" as a canyon deeper than its walls are wide, the ice-filled chasm southeast of Mt. McKinley emerged as probably the deepest gorge in North America, and maybe in the world. And the place where the Great Gorge is the deepest is right at the base of Mt. Dickey, where Ed, Galen, and I had pitched our base-camp tents in July 1974.

After 1975, though I never quit climbing for good, the scope of my ambition slackened considerably. By then, despite the thirty-three-year age gap between us, I could say that Brad and I were friends, not merely mentor and protégé. In 1979, I quit teaching as I launched out on a career as a freelance writer. It seemed only natural to turn to Brad as a subject. The first piece, for *Harvard Magazine,* was a joint profile of the Harvard Five: Brad, Bob Bates, Terris Moore, Charlie Houston, and Ad Carter.

I got carried away, producing a seventy-seven-page typescript. The magazine published only a small portion of this supramagnum opus, but I sent a copy of the original to each of my five subjects and received warm thanks from all of them (even the oft-crotchety Houston). That piece in turn cemented my friendship with Brad.

By 1982, an editor friend of mine had taken over the helm at *American Photographer.* When she asked if I would write for the magazine, I told her I knew nothing about photography. "That's okay," she said, adding: "We want good profiles of people, not techno-babble. We often get better results from writers who aren't photography buffs."

So I proposed Brad as a subject. The editor had never heard of Washburn, but after one glance at a selection of his aerial photos, she gave me the green light. The April 1983 piece was the first national

magazine article to make the case for Brad as a photographic artist, not merely a documentarian.

I had never seen Brad blush, but he came close to doing so after I handed him an advance copy of the issue—not solely because he thought my praise of his work was perhaps a bit over the top, but because the cover featured a very sexy, nearly naked model.

In the late 1980s, I collaborated with Brad on a coffee-table picture book about Mt. McKinley, with a text narrating the history of climbing on the mountain. It was a project Brad had had in mind for years, but thanks to his fussy perfectionism, our coauthorship almost turned into a disaster.

I was completely unprepared for what happened when I delivered my text to the publisher. Brad got hold of it, and though he did not kill it, he rewrote virtually every sentence. When I saw the mess our "collaboration" had thus created, I was not only dismayed—I was furious. Though I do not remember doing so, apparently I wrote Brad an angry letter. Just last year, Barbara reminded me of it, telling me for the first time how hurt Brad had been by my outburst.

The impasse nearly cost Brad and me our friendship. For several years, we were effectively estranged. Either the first publisher gave up on the book, or Brad simply withdrew it. The "project" languished in limbo for a number of years. Finally, Brad and I worked out a compromise—we would alternate authorship of the various chapters. Brad could be his obsessive self in the episodes that mattered most to him, while I could take charge in such chapters as "The Age of Washburn" and "The Legacy of Washburn," which it would have been immodest for him to pen. An excellent editor at Harry N. Abrams laid a smoothing hand on the wrinkles of our prose, and the book finally came out in 1991.

I am proud today that *Mount McKinley: The Conquest of Denali* has become a collector's item—almost entirely because it serves as such

a grand showcase for Brad's photographs. And I am ashamed to recall my petulance about Brad's revising. The book, I must confess, is a better one than I had originally written, thanks to Brad's being such a stickler for accurate detail.

For decades Brad had wanted to write about his Lucania expedition, but he was always preoccupied with other business. In the year 2000, I agreed to write the book. Late that fall, Brad, Bob Bates, and I sat down in Bob's retirement apartment in Exeter, New Hampshire, for the first of several marathon interview sessions. The two old cronies started reminiscing. And as I let the tape recorder play, and sat back to enjoy the tales and jokes as they unfurled in the wintry indoor air, I realized what a privilege it was to bear witness, in a process that was as old as Homer, to the telling and retelling of a heroic saga.

Brad had lent me his Lucania diary; Bob had misplaced his. The men's recollections were sometimes at odds with what Brad had written in 1937, and once I interrupted them to tease, "You know, Brad, if I have to choose between your diary and your memory, I'm afraid I'll have to go with the diary."

Those sessions during which the two nonagenarians told me their story in minute detail turned into the most magical interviews I have ever conducted. As for Brad—a man who I thought would never mellow had done so before my eyes.

In the summer of 2001, as fodder for the epilogue I hoped to write, I persuaded Brad and Barbara to go to Alaska with me, where we would hire a bush pilot out of McCarthy and retrace by air the route of the 1937 expedition. Brad had not even seen the mountain of his greatest adventure during the last sixty-four years.

That was the best thing Brad and I ever did together. By then, at the age of ninety-one, my mentor-turned-friend might have forgotten the names of certain former business associates or campaigns the Museum of Science had once embarked on, but he remembered every

turn of the Walsh and Wolf Creek glaciers. It was a perfect, sunny, windless day. Throughout the flight, Brad stared out the passenger-side window, whistling softly to himself, muttering "Will you look at that?" and "I'll be darned." It was then that I recognized, as if for the first time, Brad Washburn's finest quality. Throughout his long life, he had never lost his quenchless, almost childlike sense of wonder about the world. That was, I thought, the key to one of the greatest explorers of the twentieth century.

We swung far to the east, descending the Wolf Creek glacier 500 feet above the deck, staring at the empty landscape where Bob and Brad's hike out had started to turn desperate. Brad saw it first. "The glacier's surging!" he exclaimed. We flew closer. Entering from the southwest, the Donjek Glacier, across whose snout Bob and Brad had had to make their perilous climb before fording the Donjek River, had advanced radically over the decades. It now completely breached the turgid river. "We could have just walked over on the ice!" Brad groaned.

We had only enough gas for the return flight, so our pilot circled and headed back west. In June 1937, as Bob and Brad had left their base camp on the Walsh glacier, they had had to turn their backs on all kinds of precious possessions, including the large-format Fairchild F-8 camera.

Over the years, Brad had wondered whether the gear cache was still intact. Lucania is so seldom climbed that it was entirely possible no one had passed by the erstwhile base camp during the previous sixty-four years. Now, on the return flight, our pilot dipped to 200 feet over the Walsh and slowed the plane to a hundred miles an hour. The complex glacier baffled me, but Brad knew exactly where the cache had been placed.

All three of us—Brad, Barbara, and I—stared out our windows, but we could see nothing but snow and a long ribbon of morainal gravel.

Most likely, I thought, the base camp gear had sunk into the glacier over the years and now lay far beneath the surface, entombed in ice.

Our plane had wheels, not skis, and in any event our pilot was not authorized to land in this part of Canada. But now Brad blurted out, "You know what we should do? Come back here with a helicopter, land, and just walk down that moraine. I'll bet we could find that camera."

In that moment, I could picture the scene—Brad hopping out of the chopper, too impatient to put on a parka, and setting off down the ice in search of his lost possessions. I doubt he would have even bothered to rope up.

In 1998, Brad and Barbara had sold the house in Belmont in which they'd lived for several decades and moved into Brookhaven, a newly built retirement community in Lexington, Massachusetts. Scouting out the place, Barbara and Brad had toured Fairfield, one of a number of "cottages" that were composed of adjoining two-bedroom apartments. "Oh, Brad," Barbara said at once, "this is adorable."

In 1991, Brad had received a health scare in the form of triple-bypass heart surgery. But if moving into an "old folks' home" signaled an acceptance of the frailty that comes with entering one's ninth decade, Brookhaven didn't slow Brad down much. He continued to travel all over the world. Our 2001 flight retracing his route on Lucania was something like Brad's seventy-first trip to Alaska. He continued to drive a car (according to some passengers, with reckless abandon) into his nineties.

At Brookhaven, however, mortality was in Brad's thoughts. Several times when I visited him there, he would say, out of the blue, "When I go, I want to just drop dead of a heart attack. Like that!" He would bang the palms of his hands together. And once, when we entered the main building to go to the cafeteria for lunch, he repeated that formula, then

added, "I don't want to end up like that fellow over there." With the crook of a bony finger, he indicated a wheelchair-bound denizen of the home, slumped over, spittle drooling from his mouth.

By 2005, at age ninety-five, Brad was beginning to suffer from a mild form of dementia. For years, he had told me and anyone else who would listen the same old war stories over and over again. His friends accepted Brad's repetitions as the welcome price of admission to the presence of a great man and adventurer. But now, he lapsed into the curious practice of asking the same question over and over. In 2005, I gave a slide show at the Harvard Travellers Club about the first traverse of the Comb Ridge in Arizona and Utah, which two friends and I had accomplished the previous September. I was delighted to see Brad and Barbara in the front row. (That was in fact the last meeting of the club, which he had joined in 1931, and of which he was by then the longest-tenured member, that Brad would ever attend.)

Brad knew the Southwest, but he was apparently unfamiliar with the Comb Ridge. In the Q & A session, he asked, "What I want to know is, how did you find out about this place?" I answered. Two minutes later he raised his hand: "But how did you know about this place?" And again, two minutes after. . . .

Late in life, introducing himself at gatherings, Brad would rise and say, "I'm afraid this is all that's left of Brad Washburn." The joke never failed to elicit a hearty burst of laughter from the crowd.

But by 2005, according to Barbara, Brad was "beginning to be hard to handle. He was obsessed with writing down his stories and his lists, but he was so frustrated with his computer. By now I was doing the driving. Every day he would ask me to drive him to Staples so he could buy more plastic to laminate his writings. I'd say, 'You don't need that stuff. It's expensive.' But he would insist.

"I'd say, 'Brad, it's time for dinner.' He'd just go on typing. I'd say, 'Stop and take your pills.' I was getting to be a real nag."

On Easter morning 2006, Brad got out of bed, came into the living room, and spoke to an assembled family group: "I've got an important announcement to make. I don't feel well enough to go to Anthony's Pier 4." At the famous Boston restaurant, the Washburns took their annual Easter dinner. "I feel so weak," Brad went on, "I just want to go to sleep."

A doctor determined that Brad had suffered massive heart failure. Barbara doubted that he would last until June. But he hung on as tenaciously as he had climbed all his subarctic mountains, clinging to life for another nine months. It was not an easy decline for a man of such adamantine pride and will.

Brad had to be moved to the nursing home at Brookhaven. "He hated going there," Barbara recalls. "In the nursing home, he became an angry person. He would rant and rave, 'Get me out of here. Please let me die.' I would have to say, 'Brad, I can't let you die.'"

The last time I visited Brad, he was so feeble, he had a hard time sitting up. But I was surprised when he shook my hand with a powerful clench. "Feel that grip!" he bragged.

Tony Decaneas, Brad's gallery agent, visited him in the nursing home in the fall of 2006. "Tony, this is no way to live," Brad told him. "I'm going to starve myself to death."

Four to six weeks later, Decaneas paid another visit. "Brad had definitely lost weight," he recalls. "But he said, 'This starvation thing's never going to work. I've given up eating—except for the foods I really like.'"

Brad lasted until January 10, 2007. "The night he died," Barbara recounts, "he fell out of bed. I got a call at ten at night. The nurses were already there. Brad was lying on the bed, while a guy was trying to take an X-ray of his hip. I said, 'Don't bother, sir. He's not going back into the hospital.'

"Brad was groaning—whether in pain, or from almost dying, I

couldn't tell. I pleaded with the nurse to give him enough morphine to end it. She said, 'Mrs. Washburn, I bought his book today with my own money. If he dies, I won't be able to have him sign it.'"

The book in question was the memoir Brad had dictated to Lew Freedman. "I told the nurse," Barbara adds, "'Don't worry, I'll come down first thing in the morning and sign it myself. That'll be okay, because I'm in the book a lot.' And I did—I came down in the morning and signed it for her.

"I'd been expecting Brad's death for a long time. I just hoped he would go peacefully. When it finally came, it was absolutely a relief."

At the time of his death, Brad was ninety-six years, seven months, and three days old.

Even before Brad died, the American Alpine Club had decided to expand its headquarters in Golden, Colorado, with a museum dedicated to him. In February 2008, the club celebrated the opening of the Bradford Washburn American Mountaineering Museum with a gala weekend event, touting its lavish installation as "the first and only museum in the United States dedicated to the heroism, technology, culture and spirit of mountaineering." Those four nouns amounted to an apt summing up of Brad's own expeditionary aesthetic.

As he had hoped, the Museum of Science stands today as the most conspicuous monument to Brad's long career, attracting two million visitors per year. A 2008 *Boston Business Journal* survey ranked it third among the city's tourist attractions, after only the Faneuil Hall Marketplace and the Freedom Trail, and ahead of such meccas as the New England Aquarium and the bar on which the TV show *Cheers* was based.

For those who care about adventure, however, Brad's legacy of ascents in Alaska and the Yukon remains his greatest achievement. No

other American ever came close to revolutionizing mountaineering to the extent that Brad did. His "fast-and-light" ethos flourishes today in the proliferation of twenty-first-century ascents that stand as the logical sequelae of climbs such as Hayes and Sanford and Lucania— astoundingly bold alpine-style attempts, some of them solo, on walls in the great ranges so difficult that no one in Brad's era even contemplated them.

Several generations of younger American mountaineers, moreover, have come to realize firsthand the excellence of Brad's routes. In 2006, two tough and grizzled climbers, Paul Barry and David Hart, completed a thirteen-year quest to be the first to reach the summits of the twenty-two highest mountains in Alaska and Canada. In the *American Alpine News,* they annotated their "superlative summits." Mt. Logan, they felt, was the "most beautiful peak," but they added, "Most underrated route (for quality): Washburn/Bates route on Mt. Steele and Mt. Lucania."

The 2007 *American Alpine Journal* ran a small anthology of tributes to Brad, called "Washburn Remembered." Appended to that piece was a reprint of an article Brad had published in *Rock and Ice* in its April 2000 issue. Titled "A Call to Action," it was the first challenge Brad had issued to the young tigers of the day in more than twenty years, and the last he would ever pose. The challenge was the only remaining unclimbed face on Mt. McKinley (or Denali, as everyone had begun calling the mountain by 2000)—the east face, which looms 9,000 feet above the west fork of the Traleika Glacier. A classic Washburn black-and-white photo occupied the left-hand page of the two-page spread; Brad's analysis, the right. In yellow, Brad had drawn in the line he considered the only possible route, even indicating with a yellow triangle the best spot to place an "advanced base camp." The magazine blurbed the piece on its cover as "The Greatest Unclimbed Route in North America."

Two years before Brad wrote, the brilliant German climber Thomas Bubendorfer, who had made numerous free solo (ropeless) climbs, including the north face of the deadly Eiger in the Alps, had made his way onto the Traleika Glacier, studied the route, and then, in Brad's phrase, "prudently backed off." For it was obvious in a glance at Brad's photo that the east face would be incredibly dangerous—a nearly endless gauntlet of steep icefalls, hanging glaciers, avalanches, and ribs threatened by falling rock.

Complicating the challenge were the logistics of access. As Brad wrote,

Although the utterly crevasseless Traleika Glacier would permit a DC-10 to land at Base Camp, the National Park Service prohibits all aircraft landings in the area. Air drops—free-fall or by parachute—are likewise a no-no. In short, the East Face is very, very remote.

The only way to get to the face, as Brad indicated, was via a thirty-mile overland trek from the Denali Park highway, with all of a team's gear ferried in several backbreaking loads.

Spurred by the challenge, two young mountaineers from Iowa, both with stellar big-range credentials, attempted the east face in 2002. They ended up enduring a forty-three-day "epic" of close calls, miserable weather, and perilous glacier travel. It took them twenty-five days simply to get to the base of the face. Brad had written, "Before setting foot on the East Face, climbers would be wise to spend *at least a week* studying its avalanche patterns." The Iowa pair spent four days watching the face, without gaining the slightest clue to its patterns of rockfall, snow slides, and cornice collapses. There followed a four-day storm during which visibility was reduced to seventy-five yards. And then, a monstrous avalanche broke off somewhere in the miasma far

above them. The "plume"—a hurricane-strength wind pushed ahead of the cascading snow and ice—flattened their camp, shredding the tent, but the avalanche thundered past, missing them by only 500 feet.

Terrified and worn out, the pair gave up without so much as setting foot on the daunting route. In a long Internet blog, Brian Block later wrote,

> For the first time ever I was actually conceding that I had failed on a big objective. I felt like I was in a trance, and even though I was walking over debris from the big slide some 500 feet beyond camp, I found little consolation in having survived. It'd be like telling Michael Jordan that although he lost the NBA championship that he was still alive.

On the hike out, the pair nearly drowned fording the McKinley River.

By five years later, when the *AAJ* reprinted Brad's "A Call to Action," no one else had attempted the fiendish face, and it remains unclimbed today. The editor added a paragraph about the logistics of approach that he had elicited from Brad in a letter during his last years. Brad wrote,

> *I suggest a simple end-run around the Park Service regulations: Hire a competent sled-dog driver to haul a big cache of food and fuel from Kantishna to an excellent position for a base camp on the West Fork of the Traleika at an altitude of 7,500–8,000 feet. This could be done early enough in the spring to be certain that the McKinley River is still frozen solid enough for sledge traffic to cross it safely and easily.*

Pure Washburn!—at the same time a canny potential solution and a wildly anachronistic gambit, for in the sixty-nine years between Brad's own first ascent of Mt. Sanford and the publication of the 2007 *AAJ*,

only a handful of mountaineering expeditions had incorporated dog teams in their logistical attacks on Alaskan peaks.

That 2007 reprint was in a sense a better tribute to Brad than all the encomiums published in the pages that preceded it. The history of mountaineering is spangled with what climbers call Last Great Problems. In the 1860s in the Alps, once all the other highest summits had been reached, the Last Great Problem was the first ascent of the Matterhorn. By the 1930s, there were several Last Great Problems looming above alpine valleys and glaciers. The Eiger north face was one, and the Walker Spur on the Grandes Jorasses was another. It was a measure of just how precocious Brad's ambitions were that already in 1929, at age nineteen, he had thought seriously about going after the Walker Spur, hiring guide Alfred Couttet to camp beneath it for several days and study it with field glasses for rockfall—in the same way that, seventy-one years later, he would urge Denali aspirants to study the east face for avalanches for "at least a week" before setting foot on the route.

The east face is indeed the Last Great Problem on North America's highest mountain. But, as Brad knew, the very concept of a Last Great Problem is an eternally dissolving fantasy. After the Eigerwand was finally climbed in 1938, the next generation set its sights on the Eiger *direttissima*—the straightest possible line up the murderous face, an ascent finally accomplished in 1966. By now, nearly every plausible route on Mt. Everest has been climbed, but the boldest mountaineers speak in hushed tones about a continuous traverse of Nuptse, Lhotse, and Everest—a "project" so dangerous and audacious that no one has yet tried it. Yet once that Last Great Problem is finally solved, another generation of alpinists will devise even more fiendish challenges.

There was nothing of the reactionary curmudgeon about Brad Washburn. One of the qualities that his admirers always held in high esteem

was his faith in the future of mountaineering, his boundless encouragement of the youngsters whose burgeoning ambitions reminded him of himself in his teens and twenties. Thus in "A Call to Action," Brad wrote as if he were still in the game at age ninety: "If I were to try this route, I'd leave Kantishna in mid-June and make the climb in early- to mid-July." And while he made no bones about the hazards of the route above the Traleika, he also wrote, "But this is the kind of face that eventually gets climbed, no matter how difficult or dangerous."

Brad closed "A Call to Action" with an exhortation that, in its own way, could stand as yet another epigraph to his exemplary life of adventure. "Only one thing is certain," he wrote: "An attempt should only be made in excellent weather. The race is on!"

Acknowledgments

My first and greatest debt in the writing of this book, of course, goes to the incomparable Brad Washburn. In mountaineering, as in any other art form, one is lucky to find a mentor at all. Even while it was happening, however, I was only dimly aware that Brad's example, far more than anyone else's, had determined the shape of my own climbing career. I suspect that it was the sheer intensity of his will that bent my own path along the trails he had pioneered.

Many years later, after both Brad and I had retreated from serious mountaineering, our friendship was reinvigorated by collaborating on his magnificent picture book, *Mount McKinley: The Conquest of Denali*. And then, in the year 2000, it was further enriched by Brad's invitation to me to write the story of his greatest adventure, which emerged as *Escape from Lucania*. It's a rare privilege to be even a casual friend of a great man; it's even rarer to share a close friendship with such a person for forty-four years.

Only inches behind my gratitude to Brad stands my admiration

for and debt to Barbara Washburn. I first met Barbara one day in my junior year at Harvard. As I went through the lunch line in the Dunster House dining hall, I noticed a woman sitting alone in a far corner. (This was years before the Harvard dorms were integrated by mixing "men" with what we called 'Cliffies.) Somehow I recognized Barbara, so I went over, introduced myself, and plunked my tray down on her table. "Why are you here?" I asked.

"I'm on the Food Committee," she promptly answered.

"What's that?"

"We're supposed to take a meal every month or so in the dining rooms, to make sure the boys are being fed properly." Her son, Ted, I realized, was then also a Harvard student. Barbara smiled: "I must say, it seems rather silly."

Whether or not Barbara's efforts helped improve the Dunster House cuisine, during that lunch we had the first of scores of delightful conversations. Barbara casually mentioned a book I had never heard of—Robert Dunn's *The Shameless Diary of an Explorer.* That same day, I went to the library, checked out the only copy, read it cover to cover, and discovered one of the classics of mountaineering literature.

During the forty-three years that I've known Barbara, I've found her more approachable than Brad, who for decades remained somewhat intimidating to me. Barbara gave her unstinting help and support to this book, as well as supplying some of its funniest anecdotes. In 2008, after considerable arm-twisting on my part, she spoke to the Harvard Travellers Club about her stellar career as a mountain climber. She had the audience alternately in stitches and gasping with appreciation.

Brad and Barbara's daughter, Betsy Cabot, shared with me materials and memories to which I would otherwise have had no access, and she was a loyal believer in my project from the start.

This book had its genesis in a eulogy I wrote for *National Geographic Adventure.* When the piece I wrote exceeded my allotted word limit by fivefold, John Rasmus and Mike Benoist made the rash deci-

sion to publish the whole damn thing. John has been my editor at three different publications over the last twenty-eight years, during which we've developed what is for me by far the happiest relationship in the magazine world. During the last four or five years, Mike has been my hands-on editor at *Adventure,* a job he performs with consummate skill and (rarer yet) sensitivity.

After reading my eulogy to Brad, Henry Ferris at William Morrow/ HarperCollins approached me to suggest that I expand it into a book. The process of putting down on paper almost everything I knew and felt about Brad, as well as much that I learned anew, turned into an exercise that was four-fifths delight compared with one-fifth hard work. My gratitude goes out to Henry; to his capable assistant, Peter Hubbard; and to an enthusiastic copyeditor, Laurie McGee.

Brad's voluminous files housed at Boston University in the Howard Gotlieb Archival Research Center were a matchless source for this book. On each visit, I was aided by the tireless efforts of either J. C. Johnson or Ryan Hendrickson.

In Seattle, Dee Molenaar, Alice Gifford, and Tim Brooks, director of operations for Kenmore Air, helped me sort out the details of the tragic 1938 plane crash on Lake Union. By rescuing some of Brad's old movie footage and incorporating it into his own films in homage to Washburn, Thom Pollard gave me a vivid grasp of the explorer in action on Alaskan mountains. Kurt Markus's deft profile of Brad in *Outside* remains the definitive assessment of Washburn as master photographer. Kurt generously supplied a splendid portrait of Brad at ninety-four for the photo insert of this book.

Much gratitude, as usual, to my agent, Stuart Krichevsky, who vastly improved my proposal; to his colleague Shana Cohen; and to his assistant Kathryne Wick. My wife, Sharon Roberts, and my longtime climbing buddy Ed Ward both read my manuscript in draft and offered many useful comments.

Three previous books devoted to Brad's life, though none a com-

prehensive biography, helped guide my way through corners in the past with which I was only vaguely familiar. They are Donald Smith's *On High* (2002), Michael Sfraga's *Bradford Washburn: A Life of Exploration* (2004), and Lew Freedman's *Bradford Washburn: An Extraordinary Life* (2005). I am indebted to those books also for supplying pithy quotes from their authors' own research. Barbara's own book, *The Accidental Adventurer,* which she never intended for publication, is an absolute gem of a memoir. Greg Glade of Top of the World Books supplied a useful copy of his definitive edition of Brad's 1951 diary from the West Buttress of Mount McKinley.

Tony Decaneas, founder and director of Panopticon and Brad's indefatigable photographic agent, was hugely helpful to me throughout the writing of this book. Tony also gave me many shrewd insights into Brad's self-taught technique as a photographer, and into a Washburn aesthetic that Brad himself was inclined to pooh-pooh all his life. Tony's colleague Mark Sandrof also shared his wisdom with me and helped facilitate the photo selection for this book.

Just as it was a privilege to become Brad's protégé, the friendships I developed with some of his mountaineering cronies were precious to me. Particularly impressive were the other four in the Harvard Five— Bob Bates, Ad Carter, Charlie Houston, and Terry Moore. I also cherish the warm friendships I formed with Gail Bates, Ann Carter, and the late Katrina Moore.

Mountaineering has become so popular today that it no longer embraces a worldwide or even regionwide fraternity (or sorority) of likeminded souls. But it was different in Brad's day, and even in my first years in climbing. Writing this book has served as a wistful reminder of a time when you were happy to meet a fellow climber at the local crag, and even happier to head off to a bar together, where over the second beer you might even start scheming up expeditions not unlike those that Brad Washburn perfected decades earlier.

Introduction to the Excerpt of
Among the Alps with Bradford

In 1927, at the behest of publisher George Palmer Putnam, the seventeen-year-old Brad Washburn wrote *Among the Alps with Bradford*, the first of his three memoirs for Putnam's immensely popular series Boys' Books by Boys. This excerpt details the critical passage of the Charmoz-Grépon traverse, one of the hardest routes then established in the Chamonix Alps of southeastern France.

Brad actually climbed the route twice, returning because he was so disappointed with the few pictures he'd brought back from his weather-plagued first traverse. On the second effort, recounted here, Brad's teammates were his younger brother Sherry, the crack Chamonix guide Georges Charlet (who led each pitch), Charlet's colleague Antoine Ravanel, and the Chamonix photographer and filmmaker Georges Tairraz.

An Excerpt from
Among the Alps with Bradford

With a heart beating like a pile-driver, I descended nearly to the bottom of the crack and crossed into it. I looked up a moment and saw Georges way at the top grinning down at me. He always laughed when I was in a bad fix, and I couldn't see anything at all that was funny about my situation! Then and there I made up my mind to climb that crack from top to bottom without being pulled one inch. Georges claimed I couldn't do it. I yelled to him to loosen up the rope entirely, and just to hold it so as to be a safeguard in case I should fall. Then I stuck my right elbow and knee in the crack. My left knee and elbow just slipped smoothly up and down, when I tried to find something to get a hold on!

It was just as I had found it the day that I had climbed it before. There was but one difference—this time I had on a pair of sneakers. That was a big difference however. Where the nail boots would slip, the sneakers stuck like glue. What was still more—I could not possibly get my sneakers jammed in a fissure the way Georges had caught his

shoe. The sneakers were soft, and I could pull them out again easily.

In a minute I was on the first platform, puffing and blowing from my exertion. Twenty seconds saw me off again. There was a difficult spot for about two or three feet above the platform, then I got hold of a little stone jammed in the fissure. In a jiffy I had my knee on it, and with a little more twisting I was standing up.

I jammed my knee and elbow into the crack again and went a few feet more until my foot was on the highest of the three little rocks. There I rested a minute or so to get my breath, and looked down over what I had climbed.

I have never been dizzy once on a mountain, but I must confess that one glance down the crack was the supreme test! The fissure went absolutely straight down for about fifty feet. The first platform already looked far away. And below the crack that awful slope of ice-covered rocks ran downwards, right to the Glacier des Nantillons! I turned to my climbing again with a desire to get out of that fissure as fast as I could. And I don't think that anybody could blame me for it! My left hand soon had the good hold, and up I went to the last platform, with my feet swinging wildly in the air.

Good handholds now appeared on the right. One more effort! I jammed myself into the crack, and with three great pushes and twists I reached the top, and stretched myself out among the knapsacks, panting for breath. That fissure is a great test of one's endurance, because every single moment all the way up, every one of your muscles and nerves from head to foot, is used to the very extreme. No wonder you are so exhausted when it's over!

Georges shouted down to Sherry that I had done the crack without being pulled, and challenged him to come on. Sherry started out, and a few minutes later his head appeared over the edge of the platform; he was puffing and blowing like me. He too had come all the way without being pulled. Antoine came next, and he was followed by a tremendous

sack of photographic equipment. Before Tairraz had a chance to get to the top, Georges, Sherry and I were off again.

We went through the Cannon Hole, and then we climbed over some easy blocks of granite, until nearly to the crest of the part of Grépon ridge. A smooth wall of rock now confronted us. However, there was a tiny hole right through it. In fact, it was so small that Georges had to take off his sack to get inside.

There was a terrible little spot just before going through the hole, where I lingered for ages with a good handhold, my waist stuck between two rocks, and feet kicking in the air! I finally managed to get myself dislodged, and, by the way of the hole, came out on the other side of the mountain.

I stood up now and surveyed the next difficulty. It is called the Râteau de Chèvre (Goat's Back). You climb it by placing one foot on each side of the Goat's Back, which is a long, steep slab of rock, and then pulling yourself upward with your hands. The very backbone of the slab is a little rough, and by using your hands almost entirely, you can pull yourself all the way to the top.

When I came out of the hole, Georges was already half way up the Râteau, and in a minute his feet went up into the air, as he got to the top and disappeared behind a big rock. Sherry was right on my heels, and to my surprise Antoine and Tairraz were already with us—they certainly must have hurried!

Georges cried out from above that it was my turn. But just at that moment the clouds rolled in. We waited for a couple of minutes until they disappeared once more. Then I took the opportunity to climb the Râteau as fast as I could for a movie. The sneakers stuck so well that I hardly had to use my hands at all, as is necessary if you have boots on. I got to the top in no time.

Sherry, who had put his sneakers on, now made just as good time as I had. When we three were all on top, however, I remembered that

no still picture had been taken of either of us climbing the fissure. So I descended again all the way to the bottom, and had Tairraz take a couple of me as I climbed it once more. That's why in the picture you don't see the rope between Sherry and me coming down behind me. You can see *two* ropes leading upward from my waist—one is the end that goes to Georges, and the other goes to Sherry.

At the top there is an absolutely flat platform, even larger than the Esplanade of the Baton Wicks. On one end of it was a monolith, much in the same position as the Baton, but about three times as large. It was the north peak of the Grépon, only twelve feet lower than the real summit, which was just in sight, about a hundred yards away along the ridge.

The North Peak has been climbed by people many times, but they have always thrown a rope over the summit, with which to help themselves up. Last summer Georges climbed it alone, and without any rope thrown at all to aid him. If Sherry and I climbed it that way, we would make the first "tourist" ascent of the North Peak without thrown rope. Besides, it was a stunning place to take pictures.

When Tairraz arrived, Antoine gave him his camera out of the sack, and he went to the end of the flat rock to take pictures of us as we climbed.

When all was ready, Antoine leaned against the end of the North Peak and Georges got onto his shoulders. At first he swayed terribly. Then Antoine steadied himself and they got firmly fixed. Next Georges climbed up on Antoine's head and got hold of a very, very tiny crack running along the edges of the steep rock. In vain, he tried twice to get started and then descended to the platform once more.

He said that he would have to change to a pair of sneakers because his shoes slipped so badly. He soon had them on. This time things went well. Once he had his hands in the crack, he gave a graceful little leap from Antoine's shoulders and landed astride the narrow ridge.

The climb was so delicate that he had to keep moving constantly,

for fear that he might lose his balance! There were no handholds or footholds at all on the ridge. The top of it was flat and about a foot wide, rising at an angle of about fifty degrees. He mounted this right to the top in about a minute, by walking in a bending position, and using the pressure of his hands on the sides of the ridge to steady himself!

Breathless, we waited at the bottom, and there wasn't a single sound to be heard, except for the clicking of the movie camera and our heavy, tense breathing. I gave a gasp of relief when he reached the top and took off his cap, waving it above his head triumphantly.

I now mounted gingerly on Sherry's shoulders. Being taller than Georges, I reached the crack without having to jump. I struggled for a moment with every muscle in my body tense with effort, and with one hand I managed to get myself astride the ridge. From there to the top I did just what Georges had done. With my sneakers I had no trouble at all, and was soon seated on top beside Georges. Sherry followed me with success. Neither of us was pulled.

Coming down was worse than going up, because I could not see a single thing unless I looked between my feet. That was positively sickening for it made everything look upside down! It seemed as if I had been stepping for hours when I felt the crack in my left hand. I grabbed it, let my legs swing, and at last landed on Sherry's shoulders. He let me down again to the platform.

Even though we weren't pulled during the ascent of the North Peak, the very presence of the rope, and the feeling that I was safe with it around my waist, made me do easily things that would otherwise have been very difficult.

I don't see how Georges ever dared to climb that slab of rock without anything to give him the feeling of safety in case he should slip. For, even with the rope around his waist, he would have fallen a good twenty feet and landed on the rock platform where we were standing. The first man up must have real confidence in himself and iron nerve!